SCULPTURE CONSERVATION:
PRESERVATION OR INTERFERENCE?

SCULPTURE CONSERVATION:
PRESERVATION OR INTERFERENCE?

Edited by

Phillip Lindley

SCOLAR PRESS

Publication of this book was aided by a generous grant from The Henry Moore Foundation

Published by
SCOLAR PRESS
Gower House
Croft Road
Aldershot
Hants GU11 3HR
England

Ashgate Publishing Company
Old Post Road
Brookfield
Vermont 05036-9704
USA

British Library Cataloguing-in-Publication data

Sculpture conservation : preservation or interference?
 1. Sculpture —Conservation and restoration
 I. Lindley, Phillip
 730.9'4

Library of Congress Cataloging-in-Publication data

Sculpture conservation : preservation or interfererence? / edited by
 Phillip Lindley.
 ISBN 1-85928-254-7 (cloth)
 1. Sculpture —Conservation and restoration. I. Lindley, Phillip.
 NB1199.S28 1996
 731.4'8—dc20 96-4097
 CIP

ISBN 1 85928 254 7

CONTENTS

PREFACE

The papers assembled here were all delivered during the international conference hosted by the Merseyside Maritime Museum at Liverpool and the Henry Moore Institute in Leeds, from 16 to 18 June 1993. Delegates visited the *Eric Gill* exhibition in Leeds City Art Gallery and were also welcomed to the inaugural exhibition of the Henry Moore Institute, *Romanesque: Stone Sculpture from Medieval England*, curated by Ben Heywood. The conference was generously sponsored by the Henry Moore Sculpture Trust, the Gabo Trust for Sculpture Conservation, Mr John Lewis, and the Conservation Unit of the Museums and Galleries Commission. The complex organisational issues were handled by the United Kingdom Institute for Conservation, the National Museums and Galleries on Merseyside (NMGM), and University College, London (UCL). The City of Liverpool made available St George's Hall and the Lady Lever Gallery for evening receptions, and a demonstration of the uses of lasers in sculpture conservation was provided in the GWR Building, which houses the sculpture conservation unit of the NMGM. Those who were fortunate enough to attend this remarkable conference owe a particular debt of gratitude to David Leigh, Bruce Boucher of UCL, and John Larson of the NMGM conservation unit, who first conceived the project.

I was asked to edit this volume in 1994, and most contributors provided their papers that year, although the final plates of one contributor did not arrive until August 1995. The arduous task of word-processing many of the essays was first undertaken by Esther Holm and subsequently - for the majority of the book - by Debbi Francis. Ellen Pawley provided the computing expertise which enabled me to convert the texts into camera-ready copy and proof-read many of the essays. She has also been responsible for meticulously entering the final amendments onto disk. Sophie Oosterwijk read and commented on every chapter. I should like to extend my warmest thanks to all of them. Finally, I should like to thank Rachel Lynch of Scolar Press for her careful selection of plates, for her work on the camera-ready copy and for her synchronising of plates and captions, an onerous task in a book of this complexity.

Phillip Lindley

ILLUSTRATIONS

Figures

Black and White Plates

Colour Plates (at the end of the book)

INTRODUCTION

P. Lindley

Sculpture Conservation: Preservation or Interference?

The field of sculpture conservation has long been a contentious one. As Gerard Vaughan reminds us below, a hostile response to the restoration of classical sculpture can be traced back into the early nineteenth century: he highlights the decision in 1816 of the British Museum *not* to restore the Elgin marbles as the symbolic break with previous restoration practices.[1] It is ironic that some of the eighteenth-century restorations of classical sculpture - those by Bartolomeo Cavaceppi or Pietro Pacilli, for instance - are today themselves the subject of sophisticated art-historical research.[2] Such research has implications for the conservation of these restored sculptures: in the case of the Getty Museum, it has led, first, to the dismantling of Carlo Albacini's additions to the *Lansdowne Hercules*, and then to their recent restitution. Decisions of this type, which have so drastic an effect on the sculpture concerned - and on viewers' perceptions of it - rely on a subtle series of evaluative judgements, balancing assessments of the importance of the original sculpture, or sculptures, against the significance of the restorer's work in transforming the image for the eighteenth-century marketplace, and the cultural history of the sculpture after its restoration. These judgements both influence and are influenced by the requirements of contemporary curators and conservators (there may well be a tension between those who are more interested in the period of the sculpture's original production and those for whom the restorer's work is of greater significance). The new respect accorded to eighteenth-century restorations of classical sculpture is witnessed by Trevor Proudfoot and Christopher Rowell's essay: the sculptures and paintings of the north gallery at Petworth House, are currently being conserved by the National Trust with the primary objective of recreating the nineteenth-century appearance of the gallery. Here antique sculptures collected by the second Earl of Egremont and the neo-classical sculptures and paintings purchased by the third Earl are exhibited in a holistic approach to the questions of conservation, exhibition and historical context. In the process of conservation, remarkable discoveries have been made about eighteenth-century restoration techniques, discoveries which would have been obliterated if the previous cleaning policies had been retained. The whole shifting nexus of aesthetic and cultural factors gives one an uneasy feeling that current attitudes to conservation cannot be viewed as final.

In removing or reinstating a restorer's work, critical judgements sometimes appear to be made on the basis of whether the aesthetic impact of the restored portions on the original piece of

[1] By the nineteenth century, such attitudes were increasingly prevalent with regard to the restoration of medieval imagery, although the practice continued (and still continues today). Compare Sir G.G. Scott's comments on Lincoln's Judgement Porch (J.C. Buckler, *A Description and Defence of the Restorations of the Exterior of Lincoln Cathedral*, Oxford, 1866, p. 11) July 1859: 'I hear too that the statues which exist near to this portal have been restored, a work at which I should have thought that the first sculptor in the land would have trembled'.

[2] See also C.A. Picón, *Bartolomeo Cavaceppi: Eighteenth-Century Restorations of Ancient Marble Sculpture from English Private Collections*, London, 1983.

sculpture is benign or malign.[3] Such judgements are by no means restricted to classical sculptures or eighteenth-century restorations. The restored arms and polychromy which adorned a French Virgin and Child of c.1310-30 when it first entered the South Kensington collection in 1860, and which have subsequently been removed, may never be returned to the figure.[4] On the other hand, the extensive additions - only detected in recent conservation - by Boutron (who worked for the Parisian dealer Demotte in the early twentieth century) to another fourteenth-century French Madonna and Child still remain in place:[5] the removal of Boutron's additions - even though they are sophisticated enough to be quite misleading - would entail the reduction of the sculpture to the headless ruin with which the restorer must himself have been presented. The decision whether such restorations should be effaced is focused less on their intrinsic cultural significance (or on the intentions of the restorer or dealer to deceive a contemporary purchaser) than on the purely formal effect the removal of restorations would have on the composite sculpture in reducing it to its surviving medieval 'core'. So, modern conservation may entail the retention of deliberately misleading restorations in the interests of leaving a sculpture with some aesthetic quality: precisely *what* aesthetic quality such an object possesses, though, seems extremely difficult to define.

Where later restorations are removed, it is vital, of course, that the assumptions about what is original and what is restoration are themselves correct: disastrous conclusions about treatments can follow perfectly logically from erroneous premises. Kaja Kollandsrud's saddening paper on the once-magnificent Haug crucifix, seriously damaged when restorers - labouring under the misapprehension that oil-painting had only been invented in the fifteenth century - employed conventional paint-stripper to remove oil-based overpaint from it, and John Larson's comments on the treatment meted out to terracotta portrait busts in the Victoria and Albert Museum, illustrate the perils of methodically applying what subsequently turn out to have been completely inappropriate treatments. The use of the word 'conservation' is often intended by its contemporary practitioners to differentiate their actions from the reconstructive interventions or recreations produced in the past by sculpture restorers. However, as is manifest from many of the essays in this book, it is impossible in practice always to draw a distinction: the divisions between conservation, removal of restoration ('derestoration'?) and restoration are, at times, imperceptible. Thus, the simple binary distinction posited in this book's title between preservation and interference will break down when conservation issues are at all complex. We should resist the inevitably reductive temptation to construe 'preservation' and 'interference' as dichotomous.

The point can be illustrated by reference to architectural sculpture. The nineteenth-century restorations of the statues associated with the Judgement Porch and Angel Choir of Lincoln Cathedral pose a complicated problem for the conservator (plates 1-3).[6] Should these additions be

[3] Dr Vaughan notes (below, p. 199) that the removal of a reworked Roman head from an archaising group known as *The Tyrannicides* in the Museo Nazionale in Naples was made on the grounds of its aesthetic infelicity.

[4] P. Williamson, *Northern Gothic Sculpture 1200-1450*, London 1988, p.19.

[5] *Ibid.*, pp.19-22.

[6] The tympanum of the Judgement Porch itself was restored separately in 1897 (see A.F. Kendrick, *The Cathedral Church of Lincoln*, London 1899, p.68). For the porch, see W.R. Lethaby, 'Notes on Sculptures in Lincoln Minster: the Judgement Porch and the Angel Choir', *Archaeologia*, 60 (1907), 379-90; L. Stone, *Sculpture in Britain: the Middle Ages*, Harmondsworth, 1972, pp.125-7; T.A. Heslop, 'The Iconography of the Angel Choir at Lincoln', in E. Fernie and P. Crossley (eds), *Medieval Architecture and its Intellectual Context*, London, 1990, pp.151-8; P.G. Lindley, 'Westminster and London: Sculptural Centres in the Thirteenth Century', in H. Beck and K. Hengevoss-Dürkop (eds), *Studien zur Geschichte der Europäischen Skulptur im 12./13. Jahrhundert*, Frankfurt, 1994, pp.237-8.

removed in the forthcoming conservation campaign? To a modern medievalist, the early Victorian heads are troubling and visually intrusive, vitiating appreciation of the magnificent mid thirteenth-century statuary.[7] Yet, a nineteenth-century head, that added to the '*Queen Margaret*' figure (plate 1), deceived one of the most important scholars of English Gothic sculpture, Arthur Gardner, into believing it was original: indeed, he defended it as thirteenth-century in a paper which is compulsive and chastening reading for medieval art-historians.[8] Although a really good restorer can mislead a contemporary or near-contemporary audience, his work often seems, viewed from a later perspective, irredeemably located in its own chronological context: this can, indeed, often constitute much of his work's interest.[9] Should such restorations be stripped off, even if the restorations have themselves become significant elements in the sculptures' history? And if so, should the restorations of the tympanum imagery also be removed? How long does it take before restorations become 'significant'? The quality of the early restoration work - stylistically, in terms of its interpretative understanding of the original imagery, and in the transformation of meaning wrought by the restorations to the medieval statuary - is an important matter which has to be sensitively considered when deciding whether to denude the original sculpture of its later additions. The viewer's own understanding and interpretation of the sculpture will certainly help to condition his response to the restoration and to the original imagery. It will also, of course, affect his attitude to modern conservation.

In a fascinating recent paper, Charles Saumarez Smith has argued that 'the life-cycle of an artefact is its most important property. It is a species of contemporary arrogance which regards it as possible to reverse the process of history and return the artefact's appearance to exactly how it was

[7] The problem here is a complicated one, since a drawing in the Edward James Willson (1787-1854) collection now in the library of the Society of Antiquaries, shows the head to be very like the present one: the figures of the so-called *King Edward I* and *Queen Eleanor* are, in other drawings in the same collection, still untouched by Victorian restoration. Yet the style of the restored *Queen Eleanor*'s head is virtually identical to that of the *Queen Margaret*: there is the same calm facial type, pointed nose with clearly defined nostrils; the eyebrow and mouth shape appear to be articulated in precisely the same manner and the very distinctive treatment of the eye, markedly different from any English mid thirteenth-century work, is the same (plates 2-3). This observation gives some point to a letter written by the Dean of Lincoln, J.G. Ward, to George Gilbert Scott on 22 July 1859: referring to sculptures near to the Judgement portal, the Dean writes 'the two *or three statues* [my emphasis] to which you allude have been restored by the hand of an eminent sculptor, under the advice of a well-known architect. The south eastern portal remains untouched, together with its sculpture.' J.C. Buckler, the architect who superintended the restorations at Lincoln, provides further information in his rambling, repetitive and aggressive defence of his actions: (Buckler, *Defence*, pp.12-13 and 75). On the subject of the restored statuary, he writes: 'Assuredly Mr G. G. Scott is among the last who could with consistency call in question what was scrupulously done after mature deliberation - to restore two [sic] of the headless figures at Lincoln'. It seems possible, therefore, that Buckler was somewhat disingenuous, and that the *Queen Margaret* statue had already been restored, perhaps in the late 1840s or early 1850s (Lincoln Archives Office, A/4/16 'B' referred to by T. Cocke, 'The Architectural History of Lincoln Cathedral from the Dissolution to the Twentieth Century', in *British Archaeological Association Conference Transactions, Medieval Art and Architecture at Lincoln Cathedral*, Leeds, 1986, p.156, n.57).

[8] A. Gardner, 'The "Queen Margaret" Statue at Lincoln', *Antiquaries Journal*, 29 (1949), 87-9. Later scholars have, accordingly, seized on Gardner's mistake with a mixture of puzzlement and amusement: see A. Andersson, *English influence in Norwegian and Swedish Figure Sculpture in wood 1220-1270*, Stockholm, 1950, p.87: 'How a connoisseur of English 13th century art could ever accept this Victorian charity bazaar lady as an example of English art of the reign of Edward I defeats me'.

[9] M. Jones (ed.), *Fake: the Art of Deception*, London, 1990, p.12.

when it popped out of its maker's hands.'[10] For Saumarez Smith, then, it is the historicity of the object - rather than its imbrication within the specific chronological context which saw its creation, or its original appearance - that is its 'most important property'. This surely cannot be accepted entirely without demur. In the case of Torrigiano's monument for Dr Yonge, for instance, the conservator, Carol Galvin, and the clients, the Public Record Office, made the decision to remove all post sixteenth-century overpaints, and to retrieve as much of the original polychromy as could be uncovered, once it had been established that there were considerable remnants of Torrigiano's paintwork intact. Here, an aesthetic and scholarly choice was made to excavate as much of its original appearance as possible, at the cost of sacrificing later overpaints. The decision was taken because the overpaints were of poor quality and greatly distorted the appearance of the object: in other words, the aesthetic impact of the sculpture's original polychromy was construed as more important than preserving its 'life-cycle' (a revealing choice of biological metaphor in itself). The conservation of the polychromy did not lead to wholesale restoration of its original appearance, but the retrieval of as much of that appearance as possible: the original artistry was revealed where it survived, but the image was not returned to the artist's 'original intentions' for the sculpture, nor to its original appearance.

Barbara Schleicher touches on analogous problems in her discussion of the problems raised in the cleaning of polychrome wood sculpture. She remarks that the object's original appearance cannot be recreated, and highlights the fact that some colours change over time, according to the type of pigment and media used. This is not an argument, though, for the retention of clumsy overpaints. In the case of the crucifix from Massa Marittima discussed by Schleicher, repaintings had caricatured the sculpture's original qualities, and the removal of the six overpaint layers revealed the astounding quality of the work which could then be attributed to Giovanni Pisano. Jackie Heuman's fascinating paper on the repatination of outdoor bronze sculptures shows just how complex decisions to conserve the patination of sculpture may be, and how the relationship between the object and conservation strategy has continually to be rethought. Agnese Parronchi, discussing the ageing process of marble, argues that conservators must distinguish between the removal of atmospheric deposits and the natural - and irreversible - ageing processes. It seems clear that both scholars and conservators must retain a highly self-conscious and reflective attitude. For, essentially, these matters are questions of judgements based on experience and knowledge, and a theoretical approach which excludes such judgements may become as dogmatic as those views which it opposes.

For Barbara Hepworth's *Two Forms (Divided Circle)* discussed by Heuman, the conservator has to assess how to restore the polished gold interior to a bronze image where the colour changes to the patination caused by ageing have affected the original colour contrasts. To some extent, the conservator has here to produce a new formal relationship, especially where the artist's own attitudes to the ageing of her work are unclear. Nor can the conservator simply refer the decision to the object's owner. Robin Fry shows not only that there may be no consensus between the views of the owner and those of the conservator, but that an owner's attitude to a sculpture may even conflict with that of the living artist: in the case of David Smith's *Seventeen H's*, the owner had the sculpture stripped of its layers of cadmium red and aluminium powder, to the outrage of the

[10] C. Saumarez Smith, 'Museums, Artefacts and Meanings, in P. Vergo (ed.), *The New Museology*, London, 1989, p.20. The viewpoint which he chastises as modern seems to me to have much more in common with nineteenth-century restoration techniques. It appears to be perfectly consistent with Dr Saumarez Smith's position that even if sculpture has been subjected to the most drastic and damaging treatment in the past, once it has become part of the 'life-cycle' of the object such treatment cannot be remedied.

sculptor himself. Fry's important paper reveals that conservators - particularly those working on twentieth-century sculptures - must familiarise themselves with their legal position, and he outlines a series of steps which the prudent conservator should take. If the case of David Smith's *Seventeen H's* underlines the essentially arbitrary nature of a sculpture's 'life-cycle', and shows how an owner's wishes may affect contemporary sculpture, John Farnsworth's fascinating paper on the Telgte Madonna shows how the continuing function of a medieval devotional image may threaten its very survival: the object's 'life-cycle' may be directly at odds with its continued existence, and the conservator has to respond sensitively and imaginatively to those for whom the function of an image is of great significance. Farnsworth shows the conservator's advice to provide a copy of the Telgte Madonna was disregarded because the liturgical function of the authentic image was considered by the local bishop to have a greater claim on the object.

New work is currently taking place in much of western Europe to provide secure institutional frameworks within which increasingly complex conservation policies can be managed. Richard Gem's paper shows how, in England, a new statutory context for the care of cathedrals has introduced a measure to regularise and systematise the previously somewhat chaotic situation. Martin Caroe and John Baily give contrasting views, from the architect's perspective, of the effects such changes have had on established practice. The English institutional situation can be compared with that in France, detailed by Isabelle Pallot-Frossard, in Germany, outlined by John Farnsworth, and in Italy, on which Professor Nardi's essay sheds new light. All these authors highlight specific case studies through which the actual practice of conservation can be examined. Lena Wikström's brief survey of the situation in Finland illustrates the effectiveness of the co-operative enterprise of the Helsinki Bronze Group, especially in analysing the causes of deterioration of fifteen bronze sculptures in the city: it is disheartening that there is not sufficient financial support to continue the group's important work.

There is still a surprising scarcity of hard empirical data about the causes, speed, and effects of deterioration, such that treatments can sometimes exacerbate the very problems they were designed to remedy, or generate new problems. Kate Foley's paper highlights some of the recent and current research undertaken by English Heritage in order to remedy these deficiencies, whilst Jane Porter's essay details some problems caused by well-intentioned but inadequately researched conservation treatments in Scotland. In the case of one figure from the Scott Monument in Edinburgh, the treatment meted out to it was both astonishing and difficult to excuse. For sculpture in an outdoor environment, Porter shows, the effects of the weather and pollution have to be clearly understood *prior* to any conservation work. The problems here are analogous to those which led to the mistaken treatment endured by the Haug Crucifix.

The monument to George Home, first Earl of Dunbar, by Maximilian Colt, in Dunbar parish church was so severely damaged by fire that it had to be completely dismantled for conservation in the workshop by Keith Taylor but the problems faced by this monument after conservation are lessened by the fact that it is now housed in a relatively stable indoor environment. For architectural figure-sculpture in an outdoor environment, the problems are much greater. The vast majority of such sculpture will doubtless continue to be returned to its architectural location after conservation or even conserved *in situ*. This means that the debate about chemical treatments, on which Porter focuses, is of considerable importance. Of equal significance is the sometimes acrimonious controversy about the effects of limewashing sculpture, on which powerfully contrasting views are expressed by John Larson and Nicholas Durnan in their essays below. The debate is of vital significance, particularly given the strong preference of English Heritage for the retention of architectural sculpture *in situ*.

The current conservation programme of the internationally important Romanesque sculptural frieze which runs across Lincoln Cathedral's west front provides an excellent framework for discussing many of the conservation issues discussed in this book. In employing this case study as an illustration of the varied and complex problems of the field of sculpture conservation as a whole, I hope I have been sufficiently aware of the risks expressed in an old Tuscan proverb, once quoted by Millard Meiss in another context:

<div align="center">

Chi due volpe caccia

L'una per l'altra perde.

</div>

The Romanesque Frieze Sculptures of Lincoln Cathedral

Romanesque sculpture is, quintessentially, architectural sculpture, and the formidable problems of conserving the Lincoln imagery highlight the complexity of conservation decisions where architectural imagery is concerned. The frieze sculptures (some of which were never properly completed) appear to have been inserted by Bishop Alexander (1123-48) into a pre-existing facade, dating from the time of Bishop Remigius, as part of a programme of embellishment and alteration (plate 4). Subsequent enlargements and insertions in the thirteenth century (with a large west window now dated to c.1242-4) and important later fourteenth-century intrusions, have obscured our understanding of the frieze and its context.[11] A whole range of problems has been posed by the conservators' recent discoveries. Quite aside from the art-historical conundra, the alarming revelation that most of the panels were end-bedded and some were laminating vertically has necessitated the removal of more than one panel from the facade for conservation in the cathedral's conservation workshop. In the case of the panel with the *Death of Lazarus* and *Dives in Hell*, the work is now exhibited inside the cathedral. In the opinion of John Larson, who helped mastermind the conservation programme in its early stages, it is 'certain that, even in its conserved state, to return the panel to the west front would only result in its further rapid decay'.[12] Set against these conservation concerns is the weighty opinion of one eminent art-historian that such Romanesque sculpture 'cannot be taken away, out of its original context, and exhibited elsewhere without destroying the profundity of its original meaning. It has to remain in the place for which it was conceived. If taken to a museum, it would lose its sacred character and be degraded to no more than an interesting artefact'.[13] Professor Sauerländer's view, expressed forcefully and repeatedly in an important article delivered at a conference on the Lincoln frieze, deserves to be taken seriously: it is deliberately intended to influence the attitude of the cathedral authorities to the conservation of the frieze. But a close reading discloses that his statement - at least in so dogmatic a formulation - cannot be uncritically accepted.

Sauerländer claims that the depth of the sculpture's original meaning is essentially linked to its architectural situation and that out of this context the sculpture is 'degraded'. There are some very complicated questions which this statement simply bypasses. In the first place, it is implicitly assumed that the original meaning of the sculptures is not just apprehensible in principle but is actually apprehended today. Sauerländer's bald formulation neglects the historicity of the work of art. The sculpture is embedded within the culture which saw its production, a culture to which art-

[11] For Remigius' facade, see R. Gem, 'Lincoln Minster: Ecclesia Pulchris, Ecclesia Fortis', in *BAACT, VIII, Medieval Art & Architecture at Lincoln Cathedral*, pp.9-28.

[12] J. Larson, 'The Lincoln Frieze: a problem of conservation and historical investigation', in B. Heywood (ed.), *Romanesque: Stone Sculpture from Medieval England*, Leeds, 1993, p.29.

[13] W. Sauerländer, 'Romanesque Sculpture in its Architectural Context', in D. Kahn (ed.), *The Romanesque Frieze and its Spectator*, London, 1992, p.22.

historians have access largely through textual and material survivals: we have no unique recourse to some authentic historical context.[14] Given the limited nature of our current knowledge of the intellectual, theological and philosophical background of the Romanesque audience, patron and sculptor, it is not self-evident that the modern art-historian possesses a finalised insight into the sculpture's original meaning. Or meanings: for sculptor, patron and audience might have interpreted the imagery in slightly - or even radically - different ways. As a number of scholars have shown, there are profound epistemological problems in distinguishing different viewers' perhaps divergent expectations of the sculpture, even in the period of its carving.[15]

A second point is that the historian himself is culturally, historically and institutionally located. To neglect this is to return to the flawed Panofskian definition of iconological interpretation, where the art-historian objectively scrutinises 'the intrinsic meaning' of the work of art, apprehending this meaning by 'ascertaining those underlying principles which reveal the basic attitudes of a nation, a period, a class, a religious or philosophical persuasion - qualified by one personality and condensed into one work'. For Panofsky, the 'essential tendencies of the human mind' were expressed by specific themes and concepts under varying historical conditions, and what the historian needed was a familiarity with these essential tendencies conditioned by personal psychology and *Weltanschauung*. In order to penetrate to an iconological interpretation of the work of art, the historian was required to check 'what he thinks is the intrinsic meaning of the work...to which he devotes his attention, against what he thinks is the intrinsic meaning of as many other documents of civilisation historically related to that work...as he can master'.[16] As a heuristic principle for understanding the relationship between the work of art and the age which saw its production, this formulation is inadequate because it is inherently circular. Moreover, as Margaret Iversen has recently underlined, Panofsky's inability to regard his *own* work as historically determined is a consequence of this search for an absolute viewpoint from which to interpret the art of the past.[17] Yet, it is hardly a discovery of new historicism that 'there is no transhistorical or universal human essence and that human subjectivity is constructed by cultural codes which position and limit' even the supposedly objective historian.[18] 'The quest of an older historical criticism', as Louis A. Montrose has shown, 'to recover meanings that are in any final or absolute sense authentic, correct, and complete is illusory.'[19]

It is arguable, I suppose, that we should eschew a potentially abstruse debate about our ability simply to 'recover' a unitary 'original meaning'. However, even if the claim that the 'original meaning' would be lost if the sculptures were removed from their 'original context' in the west front is unquestioningly accepted, the question should surely be posed whether this meaning is the only or most important factor to be considered. The responsibility to preserve cultural heritage may necessarily demand a higher priority than the retention of the image's 'original meaning'. Conservation requirements may necessitate serious interference: to preserve a sculpture, it may be

[14] Louis A Montrose,'The Poetics and Politics of Culture,' in H. Aram Veeser (ed.), *The New Historicism*, London, 1989 p.20.

[15] E.g. W. Cahn, 'Romanesque Sculpture and the Spectator', in Kahn (ed.), *Romanesque Frieze*, pp.45-60.

[16] E. Panofsky, 'Iconography and Iconology: an introduction to the study of Renaissance Art', in *Meaning in the Visual Arts*, New York, 1955, pp.26-54 (esp. p.39).

[17] M. Iversen, *Alois Riegl: Art History and Theory*, Cambridge Mass., 1993, chapter VIII. For Panofsky, see also M. Podro, *The Critical Historians of Art*, Yale, 1983, chapter IX and M.A. Holly, *Panofsky and the Foundations of Art History*, Cornell, 1984.

[18] J.L. Newton, 'History as Usual? Feminism and the "New Historicism"', in Veeser (ed.), *New Historicism*, p.152.

[19] Montrose, 'Poetics', in Veeser (ed.), *New Historicism*, p.23.

essential to remove it to a stable and controllable indoor environment, even at the expense of removing it from its original context. In the case of the Lincoln frieze, the discussion of the sculpture's original context is itself quite complicated. The Romanesque imagery was added to a pre-existing facade, whose architectural iconography was itself transformed, by this addition (and that of the associated doorways below).[20] Subsequently, Bishop Alexander's frieze has also been disrupted by later additions, removals and alterations: elements of the frieze may well have been moved from their original locations.[21] Not only, then, was it intruded into a pre-existing architectural structure, but this context, for which it was apparently conceived, is not the same context that the sculpture now occupies.[22] Secondly, during the frieze's chaotic voyage through time, the religious, political, cultural and intellectual concerns of those for whom and by whom it was originally created, have themselves been subjected to an analogous process of effacement, displacement and destruction. The religion for which the cathedral church of Lincoln was created is separated by profound caesuras - the Reformation, for example - from the present-day Anglicans who currently have control of the building. Today we live in an essentially secular society, where the vast majority of church-goers are tourists, not worshippers. To this culturally heterogeneous audience, the sculpture is multivalent and its meanings are not, and cannot be, circumscribed by its original sculptor's or patron's intentions. The art-historian's task must include the interpretation of the sculpture in relation to the cultural nexus within which it was formed; a discussion of the transformation of meaning through time (the relationship between changing interpretations of the frieze and its mutating physical form is not consistently reciprocal); and he must also remain aware that his analysis is itself temporally and culturally located. To conclude, then, we must reject totemistic claims that some trans-historical meaning is necessarily 'destroyed' if sculptures are removed from their architectural environment in the cause of their preservation. The same point applies *mutatis mutandis* to other sculpture and other buildings. Conservation requirements, not an inflexible theoretical posture, ought surely to be critical factors in determining whether sculptures should be moved?

The next, closely related, issue to tackle is the effect of moving sculpture into a museum or gallery. Sauerländer uses the emotive word 'degrade' to describe what would happen to the sculpture in a museum, as if the image were a pure thing not, as Stephen Greenblatt has put it, 'the product of a negotiation between a creator or class of creators...and the institutions and practices of society'.[23] Sauerländer appears to suggest that the 'sacred character' of the relief narratives resides in them only whilst they are in this particular location. It is difficult to see how this could be the case, for it would imply that every object removed from a religious setting - Christian or otherwise - is degraded by being displayed in a museum or gallery. Nor is it evident whether or how the ostensible subject-matter of the frieze sculptures is to be viewed as 'sacred' today. Many of the

[20] Dr Gem's reconstruction of the original appearance of the Lincoln facade highlights the very significant change in its meaning and function caused by Bishop Alexander's additions and embellishments.

[21] G. Zarnecki, *Romanesque Lincoln: the Sculpture of the Cathedral*, Lincoln, 1988, pp.55-58, gives a judicious assessment of competing explanations for the placing of the *Daniel* panel out of sequence. A late eighteenth-century panel replaces an original image in the hell scenes.

[22] Much more dramatic disruptions have taken place in the case of the sculpture of Shobdon Priory: see G. Zarnecki, 'The Future of the Shobdon Arches', *Journal of the British Archaeological Association*, 146 (1993), 87-92, where the twelfth-century church was replaced in the mid-eighteenth century and its sculpture re-erected as a Gothick ruin in the park. These sculptures obviously have a different meaning in their eighteenth-century context from that with which they originally invested, but there is no convincing argument, other than financial, against removing them to the safety of an interior location, so long as they are replaced with copies.

[23] S. Greenblatt, 'Towards a Poetics of Culture', in Veeser (ed.), *New Historicism*, p.12.

moral strictures of twelfth-century imagery would now be rejected: the condemnation of sodomites to Hell in the Lincoln Romanesque frieze, for instance. The definition of the sacred is itself culturally determined.

If there are no secure theoretical arguments against the removal of sculpture from its architectural environment, two major areas remain for discussion. First, how should the sculpture be displayed and secondly, how should its absence be made good on the exterior of the building? The *Romanesque* exhibition in the Henry Moore Institute's galleries, and the reaction of critics to it, can be used to illustrate a number of issues at stake here.[24] The exhibition included recently conserved sculpture from Lincoln Cathedral's narrative frieze alongside statues from the original facade of the Romanesque York Minster.[25] Critical reaction to the display of weatherbeaten and fragmentary images from York Minster and Gisborough Priory raised the question of whether it was worthwhile to conserve such imagery and display it at all. Frank Whitford, writing in *The Sunday Times* for 25 April 1993, declared 'to the non-specialist at least, this is a show of mute, meaningless fragments and total ruins, of cracked and battered bits and pieces of heads and robes, of decorated capitals almost worn smooth, and of life-sized standing figures in limestone which have been reduced to insignificance by the wind and the rain.' Certainly, a medieval art-historian T.A. Heslop, phrased his response rather differently in the *Burlington Magazine*: 'In the exhibition...the combination of decay and sculptural conception is very much to the fore. It is indeed intriguing that the figure of a king can be so holed and pitted that it is more absent than present, but can still manage to display the drama of the original pose'.[26] The opportunity for specialists to see this newly conserved imagery at close range, often for the first time, resulted in new and penetrating readings of how the sculptors at York and Lincoln had manipulated and developed the formal language they inherited, how they coped with the functional requirements of conveying sometimes esoteric iconography, as well as posing new questions of how they may have influenced later sculpture, how the workshops were structured and so on.[27]

However, it is one of the obligations of the specialist to interpret the sculpture to more of the modern audience than just other specialists. The austere formalism of the *Romanesque* display was fundamentally ill-suited to displaying medieval sculpture to any other than a chosen few scholars, a problem which arises in permanent displays as well as temporary exhibitions.[28] The importance of making sculpture meaningful to a larger section of the audience has been underlined by the recent difficulties in raising £7.6m to retain Canova's *Three Graces* in Great Britain, a controversy in which the popular and elite media were largely unsympathetic to national museums. Where the sculptures are not superb neo-classical sculptures but damaged medieval works, the difficulties in raising funding for their preservation and conservation may be insuperable unless there is a radical

[24] The Henry Moore Foundation, formed in 1976 and based at Perry Green, near Bishops Stortford, has for nearly two decades been a potent influence on the study and practice of sculpture in the UK. In 1988 the Foundation formed the Henry Moore Sculpture Trust: Henry Moore had wished the Foundation to support sculpture and sculptors in the widest sense and the Trust was formed to discharge that task more effectively. In April 1993, the Henry Moore Institute was opened in Leeds, as a research centre, with an exhibition floor and study centre with library and archives.

[25] The York images (together with other sculpture, mainly from Gisborough Priory) were conserved in the NMGM sculpture conservation studios prior to their exhibition.

[26] T.A. Heslop, 'Leeds; English Romanesque sculpture', *Burlington Magazine*, 135 (1993), 495-7.

[27] *Ibid.*, 495-6.

[28] This is a problem highlighted by Philip Wright, 'The Quality of Visitors' Experiences in Art Museums', in Vergo (ed.), *The New Museology*, chapter 7.

change in thinking.[29] Two of the *Queen Eleanor* figures fortunately removed from the Waltham Eleanor Cross, and on 50 year loan to the Victoria and Albert Museum, are not currently on display, and have not yet been conserved, partly because of cost constraints and partly because of the limited availability of gallery space. But it is also clear that the images are in such a deteriorated state that they are no longer of interest to anyone but a specialist. More attention has to be devoted to informing the whole audience, both by using conventional reconstructions of contexts and models and by the deployment of modern information technology. New technology could precipitate a radical rethinking of the function, scope and methodology of museum and exhibition display in which the 'archaeology' of the sculpture might play an important role. Since it is now possible to convey vast amounts of visual and textual data and to access them through a computer monitor, curators can - given appropriate resources - provide the audience with an interactive catalogue or guide: using CD-ROMs, alternative reconstructions and a variety of interpretations of evidence, or conceptual frameworks for understanding - thematic, chronological, formal and so on - or an arrangement of materials for the reader to construct his own argument, can be presented. In this way, the choices made by restorers, conservators or curators about methods and techniques of conservation, display and context, might be critically documented, analysed or reversed without the need for any further physical interference with the object.[30] The Waltham Eleanor cross images, for instance, could benefit fom this type of analysis. A hitherto unpublished old photograph (in the Conway Library of the Courtauld Institute) showing one of the figures before the front of the draperies disintegrated, reveals its stylistic proximity to some of the 'weepers' on the tomb of Edmund Crouchback in Westminster Abbey (plate 5). The Waltham cross image could be restored on screen by reference to the weepers, the obviously anachronistic nineteenth-century head could be replaced by a more appropriate one carved by the sculptor - Alexander of Abingdon - who carved the lost original, the polychromy could be returned to it on the basis of scientific examination, reference to the polychromy of the Crouchback weepers and contemporary manuscript illumination, and the image positioned in a variety of contexts: the reasons for the construction of the Eleanor crosses, their geographical location and history; the causes of the destruction of most of the crosses; the identity of Queen Eleanor of Castile whom they commemorate and have transformed in the popular historical imagination; the techniques and methods of the sculptor and painters; the influence of the sculpture and so on.[31]

The possibility now exists of producing perfect or near-perfect replicas using computer-controlled milling of digitally scanned material. On the one hand, of course, such technological developments may raise insoluble problems of authenticity. On the other hand, they may also resolve the thorny issue of replacing displaced sculpture with copies.[32] In some cases it may not be considered desirable or necessary to replace sculpture with copies, rather than with reinterpretations of the image or completely new work, but I do not want to prejudge the question here. However, where copies are required, the quality of the replacement image has long been a

[29] Hence the distinction between the exhibition and interpretation of the object on the one hand and its conservation on the other may be a false dichotomy.

[30] The author is currently involved in the production of a CD-ROM on the Romanesque sculptures of Lincoln Cathedral which will include a multi-media interactive archive.

[31] For these sculptures see now P.G. Lindley, *From Gothic to Renaissance: Essays on Sculpture in England*, Stamford 1995 and D. Parsons (ed.), *Eleanor of Castile 1290/1990*, Stamford 1991.

[32] A modern figure has recently been inserted on the west front of Bath Abbey, to replace a severely deteriorated figure. Recent insertions of figures, perhaps more problematic than this instance, include the work at Wells Cathedral by David Wynne.

particularly thorny issue in Britain (rather less so in France or Italy, for example, where copy-carving traditions are long established and the principles of removal are more generally accepted). The problems are exacerbated when copy-sculptures have to be harmonised with original material which remains in place. This may well be the case at Lincoln Cathedral if it is found necessary to remove some, but not all, of the Romanesque frieze panels which adorn the west front. If copies which are visually indistinguishable from the objects they reproduce are available, some of the tension will be removed from the argument about copy-carving. Some old questions, though, are framed again, more insistently: if there is good evidence (for example, photographic) of what something looked like before its current deteriorated state, should the copy be brought to the first point at which one has evidence? What is the historical status of the copy in this case? If analytical work enables a reliable reconstruction of the polychromy, should this be attempted? If it is the conservator's duty to return to the original appearance of the work, it seems clear that the copy should be repolychromed. It is one thing to recreate the polychromy on paper - as in the case of Eddie Sinclair's reconstruction of the polychromy of the images on the west front of Exeter Cathedral - or in a CD, quite another, of course, to perform the same operation on a physical object, even a copy sculpture.[33] Moreover, if the original image received several different layers of polychromy, does it matter if they are not represented?

There may be no unequivocal answers to such questions, which require a methodological approach informed by a cool-headed pragmatism. What *is* clear is that attempts to establish secure and reliable procedures and frameworks within which conservation procedures should take place must not be clouded by personal and professional antagonisms as they have been in the past. One thing that emerged very clearly from the Liverpool conference, and which I believe is evident in all the essays below, is the common conviction that the issues we discuss are so important that it is imperative that the conservator's dialogue with the sculpture is informed by contributions from colleagues, administrators and art-historians, and that they, in their turn, listen to what the conservators have to say, if we are to ensure that the monuments of the past are preserved for the present and for the future.

[33] E. Sinclair, 'The West Front Polychromy,' in F. Kelly (ed.) *Medieval Art and Architecture at Exeter Cathedral*, Leeds 1991, pp.116-133.

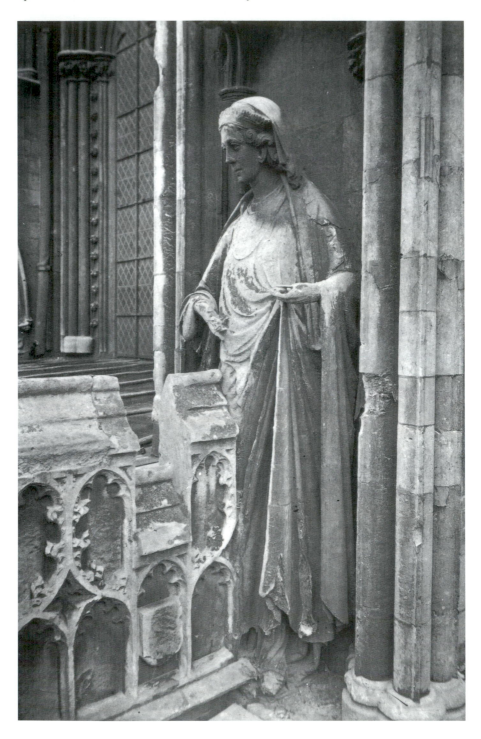

Plate 1 Lincoln Cathedral, statue of *'Queen Margaret'* from the south side of the Angel Choir.

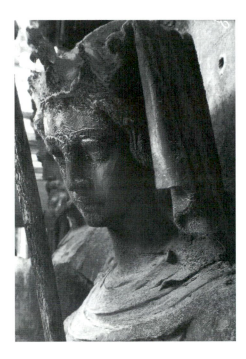

Plate 2 Head of *'Queen Eleanor'* from the south side of the Angel Choir.

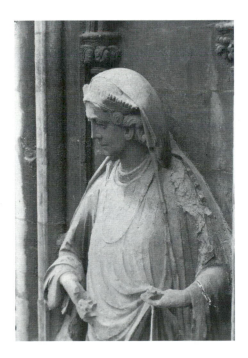

Plate 3 Head of *'Queen Margaret'* from the south side of the Angel Choir.

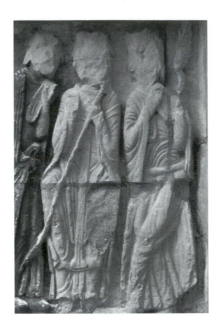

Plate 4 Detail of *The Elect in Heaven* panel from the Lincoln frieze, during conservation (the figure to the left has not yet been cleaned).

Plate 5 *Queen Eleanor* figure from from Waltham Eleanor Cross, before the damage to the front of the image resulted in the loss of most of the drapery detail. There are grounds for believing that the present head of the statue, dating from c.1834, was carved by Sir Richard Westmacott.

CHAPTER 1

CATHEDRALS IN ENGLAND: THE STATUTORY CONTEXT FOR CONSERVATION

R. Gem

Introduction

The cathedrals of the Church of England provide the location of a significant proportion of the surviving medieval religious sculpture of this country: one has to think only of such great ensembles as Lincoln, Wells and Exeter. The Reformation of the sixteenth century and Civil War of the seventeenth destroyed much more that must have existed; but in their wake came a flowering of monumental commemorative sculpture. The medieval revival of the nineteenth century then brought a return to the creation of major programmes of religious sculpture, and this trend has continued up to the present, following more or less closely the changing aesthetic conceptions of each generation - the most recent addition is Elisabeth Frink's figure of Christ on the west front of Liverpool's Anglican cathedral.

English Church Law

The statutory arrangements that regulate the care and conservation of historic sculpture, and also the commissioning of new sculpture, are comparatively recent in their present form; but they have a larger history behind them and have been formulated, in typically English fashion, through a process of negotiation and compromise.

Ecclesiastical law in England stands in direct continuity with the canon law of the early Church. It preceded English secular statute law in origin, and when Anglo-Saxon statute law came into being it recognized the legitimacy and autonomy of the law of the Church. From the seventh century church law had concerned itself with matters relating to church buildings and in a synod of 1237, presided over by the papal legate Otho, an injunction was issued forbidding the demolition of churches without the permission of the bishop of the diocese: this may claim to be by many centuries the first piece of conservation legislation in the country.

The 1237 injunction is generally held to be the origin of the 'faculty jurisdiction' which, 766 years later and subject to various developments and statutory revisions, still regulates what happens to the parish churches of the Church of England.[1] The essence of this system is that no repairs, alterations or additions may be carried out to any parish church without the authorization of a faculty from the consistory court of the diocese, granted either by the diocesan chancellor or by one of the archdeacons. Expert advice on matters of architecture, archaeology, art and history, and on matters of use, care, planning and design, is provided by a Diocesan Advisory Committee and by the central Council for the Care of Churches. The most recent reform of the system is embodied in the *Care of Churches and Ecclesiastical Jurisdiction Measure 1991*, but it would not be the place

[1] On the Faculty Jurisdiction and Care of Churches and Ecclesiastical Jurisdiction Measure 1991, see G.H. & G.L. Newsom, *Faculty Jurisdiction of the Church of England,* London, 2nd edn., 1993; also *Care of Churches and Ecclesiastical Jurisdiction Measure: Code of Practice*, London, Church House Publishing, 1993.

here to analyse the details because the theme assigned to this paper is that of cathedrals.

The Government of Cathedrals

Again for deep-seated historical reasons, cathedral churches are not subject to the faculty jurisdiction. In the early church there was agreement that monasteries were essentially places of prayer and were not directly involved in the pastoral work of the bishops: they would be better, therefore, if they had a measure of independence from the diocesan bishop. Such independence, however, came to be valued as a mark of status and privilege in its own right so that, during the middle ages, it became the desired norm for many churches served by communities of clergy. The medieval English cathedrals were served by either monks or secular canons, but in both cases these chapters enjoyed a measure of independence from the bishop - despite the fact that the cathedral contained the bishop's official seat.[2] This independence survived the Reformation when, however, all monastic cathedral chapters were replaced by secular canons.[3] In all these cases responsibility for the fabric of the cathedral church rested with the dean and chapter rather than with the bishop - although some post-Reformation bishops continued to act as generous benefactors to the fabric of their cathedrals, following the pattern of some of their great medieval predecessors.

A new category of cathedral came into existence in the nineteenth century[4] in the form of 'parish church cathedrals'. These were existing parish churches which were raised to cathedral rank but retained their parish and their parish council. In some cases the parish council, now the cathedral council, is the body responsible for the fabric of the building. The actual body responsible for the fabric of the cathedral, whether the dean and chapter, the cathedral chapter or the cathedral council, may be called by the single designation 'administrative body'.

The administrative body of each cathedral has the sole reponsibility for the cathedral fabric in accordance with the particular statutes of the cathedral. These statutes are granted by the Queen in Council, but may be and have been modified from time to time by legislation. In addition, legislation may lay obligations directly upon the administrative body. Here we come to the first key point in understanding how the conservation of cathedrals in England works: it is the responsibility of the administrative body of each individual cathedral to conserve and care for the fabric, to take all executive decisions and manage their implementation, and also raise all necessary funds to discharge these responsibilities. The burden and privilege of caring for our cathedrals thus begins and ends with the administrative body: all other involvements are either an extension of this basic situation or a check upon it.

The Architect, the Archaeologist and the Conservator

The most important extension of the administrative body's role is provided by its appointment of a cathedral architect and a cathedral archaeological consultant - posts which became statutory in 1963 and 1990.[5] The functions of these posts are not generally spelt out in the legislation, but there

[2] On the cathedrals of the so-called 'Old Foundation', see K. Edwards, *The English Secular Cathedrals in the Middle Ages*, Manchester, 2nd edn., 1967.

[3] On the Reformation and its aftermath, see S.E. Lehmberg, *The Reformation of Cathedrals*, Princeton, 1988; D. Marcombe & C.S. Knighton, *Close Encounters: English Cathedrals and Society since 1540*, Nottingham, 1991.

[4] On cathedrals in the nineteenth century, see P. Barrett, *Barchester: English Cathedral Life in the Nineteenth Century*, London, 1993.

[5] *The Cathedrals Measure 1963* (repr. *Halsbury's Statutes of England*, 10, *Ecclesiastical Law*); *The Care of Cathedrals Measure 1990*, London, HMSO, 1990.

is a specific requirement for the architect in consultation with the archaeological consultant to submit a quinquennial report on works which he considers should be carried out and on their priority. Otherwise, the role and duties of the architect are the subject of advisory guidelines drawn up by the Cathedral Architects' Association, and similar guidelines are in preparation for archaeological consultants.

The scope of the advice by the cathedral architect and archaeological consultant should, and normally does, cover matters relating to the conservation of sculpture and other historic works of art. However, the architect may be expected to base any detailed advice upon the further opinion of a qualified conservator or conservators. In at least one case the administrative body of a cathedral has appointed a consultant conservator to give regular advice on conservation matters and this is a welcome development.

I will here acknowledge, but not explore, the controversial question of the relationship between the consultant and the executant in conservation projects. I will only state that in my view the roles of consultant conservator, of supervising conservator, and of executant conservator are distinct and should not be allowed to become confused.

The Cathedral Works Department
The second important extension of an administrative body's role in relation to the fabric exists where it maintains a direct labour organization. Such an organization may be headed by a clerk of the works whose employer will be the chief administrative officer of the administrative body, but who in many if not most matters relating to the repair of the fabric (as distinct from routine maintenance) should take his instructions from the cathedral architect. Direct labour organizations at cathedrals will generally be qualified to deal with major repairs to stonework, carpentry, glazing and leadwork: however, work in these areas may soon impinge upon conservation issues. I do not wish to discuss this area in detail, but I would say that I do not believe it is helpful to maintain too rigid a division between direct labour organizations and professional conservators. The consequence of division can be that a cathedral works department having no internal conservation skills may regard the outside conservators with jealousy and seek to exclude them on the grounds that they themselves can tackle a particular task quite satisfactorily: but their skills may be inappropriate and the end product will then be thoroughly unsatisfactory. It is much better to have within the works department a general range of conservation experience which knows its own limitations and is willing to call in more specialist help to tackle the really difficult problems. In only a few cases will it be appropriate for an administrative body to set up a specialist conservation workshop in house.

By now I think I have gone about as far as I should in discussing the responsibilities for the fabric of the administrative body and its employees; it is time to turn to the area of external advice and regulation which restrain the administrative body's freedom. Again I would like to set out some of the historical background before dealing with the practical detail.

The Public Interest in Cathedrals
Cathedrals have always in a sense been public buildings, despite the fact that responsibility for their maintenance has been the specific responsibility of precisely defined legal bodies. The medieval cathedrals were built as the mother churches of the territorial dioceses into which the country was divided, and each served within its area the whole religious community - not yet divided by doctrinal disagreements. They were built with the wealth of the community and by craftsmen from the community. At the time of their original building they were the finest artistic expression of their day and they have remained unsurpassed in their inspired exploration of the

creative possibilities of stone, timber and glass. Through the centuries many layers have been added to the fabric of the cathedrals and their contents, so that they have become an important shrine of the nation's historical self-consciousness.

A recognition of the importance of the cathedrals to the national heritage goes back at least to the seventeenth century when, faced with the dissolution of the cathedrals under the Commonwealth and the threat of their going the same way as the monastic houses a century before, Sir William Dugdale undertook his great survey of the history of the cathedrals and monasteries, published in his *Monasticon Anglicanum* in 1655. Thereafter, the study of ecclesiastical antiquities developed through the eighteenth and nineteenth centuries and their style came to influence once again that of contemporary architects, sculptors and artists as they moved into the historicising Victorian period.

But the Victorian period brought with it also a fashion for the 'restoration' of ancient buildings, succeeded by the response of the first conservationists who attempted to save authentic antiquities from misjudged restoration and falsification. So came the prophetic voices of John Ruskin and William Morris, who called into being the Society for the Protection of Ancient Buildings. But the perception that the national heritage needed to be protected and conserved was not confined to prophets and pressure groups: it was taken up also within the establishment, especially by Lord Curzon, leading to the first parliamentary legislation to protect ancient monuments.

When the *Ancient Monuments Act 1913* was being debated in Parliament there were those who thought that the ancient cathedrals should be included within its schedule. But Archbishop Davidson resisted this proposal, arguing that the Church should be free from secular interference in using its own buildings for worship - particularly since the Church hitherto had always looked after its historic heritage responsibly. From that time until now there has been an understanding between Parliament and the Church of England that in the interests of freedom of religion the Church should be able to look after its churches without secular control, provided that the Church maintains its own system of control, meeting no less than an equivalent standard to that laid down in parliamentary legislation relating to conservation. Parliamentary legislation has of course grown and developed through this century, and the Church of England's system has grown in parallel.

The Care of Cathedrals Measure 1990
It was as part of this developing process that in the 1980s an examination was put in hand of bringing the fabric of cathedral churches under a system of control that made the administrative bodies of the cathedrals more accountable to a public opinion that was increasingly conservation minded. The result of this was a new piece of legislation, *The Care of Cathedrals Measure 1990*, which replaced a previously informal and advisory system with new streamlined and mandatory procedures.[6]

The key provision of the new system is that before they implement any proposed work which might materially affect the architectural, archaeological, artistic or historic character of the cathedral church (or certain other categories of proposed works), the administrative body must now have a formal written approval, granted by one of two bodies to which application must be made. Certain major matters are reserved to the national Cathedrals Fabric Commission for England; all other matters are dealt with by a local but independent Fabric Advisory Committee appointed at

[6] On the background to the legislation, see *The Continuing Care of Churches and Cathedrals: Report of the Faculty Jurisdiction Commission*, London, Church Information Office, 1984. The legislation comprises: the *Care of Cathedrals Measure 1990*; the *Care of Cathedrals Rules 1990* (Statutory Instruments 1990, No 2335); the *Care of Cathedrals (Supplementary Provisions) Measure* now provides enforcement procedures.

each cathedral.

In addition to their functions as authorizing bodies, both the Commission and the Committees have an advisory role: that is, they will help the administrative body to formulate proposals by providing informed advice at a preliminary stage; and they will often monitor the implementation of proposals after they have been approved and put in hand. The Commission and Advisory Committees will include within their membership expertise in some (though not all) areas of conservation: this, however, is no substitute for the advice that should be provided to the administrative body by a conservator retained by them as a consultant, supervisor or executant.

Proceeding Under the Measure

I should now like to go through the stages in which a conservation project will need to be organized in relation to the statutory requirements. These stages fall into three main divisions: the preliminary discussion and formulation of proposals; the obtaining of statutory approval; and the implementation of work.

The *first stage* will begin when the cathedral architect recognizes that there is a conservation issue that needs addressing and obtains the agreement of the administrative body to investigate it further. The architect may next seek informal advice from the Advisory Committee (or specialist sub-committee thereof) or from the Commission and will then approach a conservator to make an inspection and report. This may lead immediately to clear recommendations or, more likely, will lead to a further period of investigation, analysis and environmental monitoring. From this process a number of options may emerge and these should be shared with the Advisory Committee (and in appropriate cases with the Commission) before any definitive proposals are drawn up. If the work is likely to be the subject of grant aid from English Heritage, then the options should be shared also with that body at this stage. Having taken account of the preliminary opinions of these bodies, the cathedral architect and the conservator will need to draw up a definite proposal which they will recommend to the administrative body.

The *second stage* begins when the administrative body decides that it wishes to proceed with the proposals and makes a formal application for approval to either the Advisory Committee or the Commission as the case may be. In any complex case (which includes most conservation projects) this application should never be made without the prior informal consultation recommended in the first stage. The application will need to be supported by detailed information, which must include a method statement and a general schedule of the proposed work. Except in the most straightforward cases it may be inadvisable to link the formal application to a detailed specification as such, because variations from a specification may be required when work proceeds. The Advisory Committee or the Commission has three options in determining an application: it may approve or reject it outright; or it may approve it subject to conditions. A standard way in relation to a conservation project might be to approve the method statement and schedule of work on the condition that their detailed implementation be subject to periodic reports back to the Committee, or a nominated group from it, for discussion and agreement.

The *third stage* is the implementation of the proposal in accordance with the formal approval. As I have indicated already, it is no good suddenly realizing at this stage that variations may be required to the approved programme. The architect and conservator must face this issue before submitting the proposal for approval, and must build into the programme a mechanism for responding to changing circumstances. Sometimes the Commission and always the Advisory Committee will continue to be involved in a project right through to completion. Sometimes the administrative body and Advisory Committee may decide that this is best achieved with a specialist

sub-committee: but such sub-committees should always be answerable to the statutory Fabric Advisory Committee itself.

Quinquennial Reports and Cathedral Inventories

Before leaving the subject of the 1990 Measure I should like to draw attention to one or two other aspects of it which have conservation implications. The first is that it is now a requirement for the cathedral architect and archaeological consultant to prepare a quinquennial report recommending what work should be carried out to the fabric and in what order of priority. This report should certainly cover the conservation needs of all items that form part of the fabric itself: sculpture and monuments, stained glass, tile pavements, wooden fixtures and so forth. In the preparation of this quinquennial report the architect may well need to call on the advice of a conservator.

The second aspect relates to items of architectural, archaeological, artistic or historic interest owned by the cathedral chapter, which include moveables. It is now required that a complete inventory of these be produced. There is also control introduced over their possible sale, loan or disposal, which may not happen without the formal approval of the Advisory Committee or the Commission. Here the Church of England has gone considerably further than has Parliament in trying to safeguard the contents of historic buildings.

Conclusion

In conclusion I would return to the question posed by the title of this conference. Does the system of statutory control over cathedrals promote the preservation of sculpture or merely interfere? While any bureaucratic system can lead to interference for its own sake, I do believe that a certain level of interference is essential to secure responsible conservation. The scale and complexity of the problems involved in the conservation of such great sculptural programmes as those at Wells and Exeter, or Lincoln and York, are so great that they cannot be handled without a carefully tiered advisory system, and a judicious measure of external control, to support the administrative bodies who bear the burden of responsibility.

CHAPTER 2

SCULPTURE CONSERVATION IN ENGLAND AND WALES: AN ARCHITECT'S VIEW

M.B. Caroe

Introduction

This paper describes the current system for the control and financing of conservation of works of art in all media, discusses the changes that have occurred over the last twenty years, as seen from the point of view of a conservation architect, and comments on developing relationships in these difficult times between the architectural and conservation professions.

Control and Finance of Conservation in England and Wales

Ecclesiastical: Churches

As so often occurs in this country, the Church of England has been the first organisation in the field to control and eventually provide finance for conservation. Since the early Middle Ages a licence known as a *Faculty* has had to be obtained for all significant alterations to church buildings. From early days bishops delegated their power to grant the faculty to their legal officer, the Diocesan Chancellor. The system has frequently been honoured in the breach, but was revived in the nineteenth century and significantly strengthened by the Church in 1913 in response to representations being made in Parliament that the State should exercise control over ecclesiastical buildings. An advisory committee was appointed under Sir Lewis Dibden, Dean of the Court of Arches, which recommended the appointment in every diocese of an expert body known as the Diocesan Advisory Committee (DAC) to give advice to the Chancellor, but also to parishes, on the architectural, archaeological, artistic and historic character of the buildings. This phase is now written into the Measures which control work both in parish churches and cathedrals. The majority of dioceses had such committees sitting by the early 1920s.

Following on discussions between Church and State in 1979, the Church appointed a commission under the Chairmanship of the Bishop of Chichester to review the Faculty Jurisdiction system and

> to consider how and in what ways the Church of England should monitor and, where appropriate, control in the interests both of the Church and of the wider community, the process of maintaining, altering and adapting churches in use for worship, taking account of the ecclesiastical exemption and the making available of State Aid towards the cost of repair and maintenance of churches of historic and architectural interest.[1]

The primary recommendations of the review have now largely passed into legislation and include:

[1] *The Continuing Care of Churches and Cathedrals* (Church Information Office) London, 1984.

- The desirability of greater experience on the DAC. It should be noted that even today few DACs have conservators amongst their number.
- The widening of accountability, by increasing publicity and access to the system, to those not actually resident in the parish.
- A simplification of procedures.
- The provision of a new mandatory system of control over cathedrals.
- Improvements to enforcement procedures should buildings suffer through illegal action.

The Faculty Jurisdiction is the law of the land, passed by Measure and vetted and approved by Parliament. In general the somewhat trite phrase the *Ecclesiastical Exemption* is a misnomer. The exemption applies only from listed building control (ecclesiastical buildings themselves cannot be scheduled) and, where working properly, the ecclesiastical system, extending as it does to repair and conservation as well as to alterations, is a far tighter method of control than that exercised by the state through listed building consent.

The situation in the disestablished Church in Wales is somewhat similar. Notwithstanding the existence of non-statutory legislation, procedures within the dioceses have until recently varied wildly. One, at least, provides exemplary control with DAC members visiting virtually every church before recommending a Faculty. Elsewhere control has been applied only to alterations: repairs and conservation have thus taken place without any technical oversight.

The Church of England has forty-three dioceses each with a DAC co-ordinated by the Council for the Care of Churches (CCC) at All Hallows, London Wall.[2] Since the late 1950s the Council has received block grants from the Pilgrim and other Trusts, and distributed these towards the conservation of works of art and important non-structural furnishings in church buildings. In that such a system does not operate in Wales, parishes there may make direct application to these Trusts, whilst in England only the cathedrals retain this privilege.

Grants are awarded by four specialist sub-committees:

- Mechanical Furnishings Group (bells, clocks, organs).
- Painted Surfaces Group (stained glass, paintings).
- Sculptural and Furnishings Group (monuments, metal work, timber work).
- Fragile Furnishings Group (books, manuscripts, textiles).

Sub-committees are composed of experts, conservators, art historians and, where appropriate, architects, with a strong representation from the major museums. Their role is to evaluate the historic and artistic importance of the objects and approve specifications. In general committees meet only once a year, but Chairman's action in the interval is possible.

In 1993 the Council had some £150,000 block funds from several bodies such as the Pilgrim Trust, Baring Foundation and the John & Paul Getty Charitable Trust, to award. Sub-committees are serviced by the Conservation Officer and his assistant, part of whose role is to secure additional funding for specific projects from such other bodies as the Radcliffe Trust, National Heritage Memorial Fund, the Francis Coales Charity, St. Andrew's Trust etc. In addition, the officers visit to inspect work in progress, check specifications and approve and file conservation records.

[2] Recently moved to Fielden House, 10 Little College Street, London, SW1P 3SH.

Ecclesiastical: Cathedrals

As Dr Gem explains elsewhere in this volume, control over the English cathedrals is exercised by the Cathedrals Fabric Commission (CFCE) which also has offices in All Hallows, London Wall, but shares its task with local Fabric Advisory Committees jointly appointed to each cathedral by the Commission and the cathedral itself. It is illegal for Chapters to carry out any significant works without permission from one or other of these bodies. The Commission has access to the advice of the CCC Conservation Team. Fabric Advisory Committees can command considerable expertise. That at Rochester Cathedral is chaired by a retired cathedral architect and has as members:

- – The President of the Royal Academy.
- – The Chairman of the Kent Planning Committee.
- – The Director of the Crafts Council.
- – An officer of the Royal Commission for Historic Monuments of England.
- – A retired Keeper of the Victoria & Albert Museum who also chairs the CCC Monuments Committee and is a member of the DAC.
- – The Surveyor for Conservation of the National Trust.
- – A retired Historic Buildings representative from the National Trust.

Members of the Chapter with their surveyor and archaeologist will be in attendance.
This Committee meets three times annually, tours the building and is consulted on all proposals, at all stages, as well as inspecting work in progress.

Secular

The State - as represented by English Heritage - is a much more recent entry into the field, funding only having been made available for *fixtures* (as opposed to the structural repair of buildings) in the last few years. Kate Foley's paper below sets out the new role of her department in providing conservation expertise. The integration of the scientists and conservators of the original Ancient Monuments Laboratory into the field of policy is, I believe, a development of the utmost importance and augurs well for future standards in the UK. Equally important is the decision of English Heritage to set up a joint conservation committee with the Church of England to discuss standards and oversee current developments and to which difficult cases can be sent for advice. English Heritage at present offers some £350,000 annually in grants towards fixtures, both secular and ecclesiastical, so it is profoundly encouraging to find the statutory body with a preponderance of funds prepared to co-operate with its long-standing predecessor.

English Heritage is only empowered to provide grants to scheduled monuments, buildings in conservation areas, and buildings judged to be of outstanding architectural and historic importance, which in practice means buildings listed Grade I and Grade II*. Grants can be offered towards *fixtures*: thus while bell frames are covered, bells and organs are not, and movables are totally excluded. To that extent the Church system remains more flexible. Grants are, of course, only made where specifications are approved and owing to the shortage of money are subject to stringent means-testing. In the building field the test is so severe that no grants are made to buildings in beneficial use, such as a home or office, unless the value of the building once the work is completed is less than the market value! The State is thus at present relying on the market to solve financial problems, the only exception being when a sale would have the effect of separating an outstanding collection of furnishings from the building with which it has been historically associated. It is encouraging that such a stringent means-test is *not* placed on the conservation of

'non-beneficial' objects such as wall paintings or fixed sculpture and this is specifically referred to in the advisory notes for potential applicants.

In the secular field control is exercised merely by the need to obtain listed building consent for any works that would affect the character of a building 'as one of architectural or historical importance'. Such control is exercised merely over fixtures: there is no control whatsoever on moveables, except over the overseas sale of items of particular national importance. In general, technical control can only apply where grant-aid has been obtained. The rules as to what is a fixture are somewhat uncertain and are governed by case law - witness the recent controversy over the *Three Graces* at Woburn. Usually control extends only to the removal or alteration of the specific work. It is rare for the test of 'affecting the character' to be applied to repair or conservation of objects, though in theory attempts might be made to control major and controversial interventions.

The State has taken powers to abolish the exemption from listed building consent for all denominations that fail to meet a new standard of accountability, expertise and enforcement. Some denominations will inevitably fail this test, thus it is possible that listed building consent may in future be required for the conservation of structural objects and surfaces in their buildings.

Assessment of Recent Practice

As seen by an architect, a one time member of the Monuments Sub-Committee of the CCC, and now a Trustee of the St. Andrew's Trust, the development in the role of the 'field' conservator, as opposed to colleagues in the museum world or practising as restorers of objects that are normally bought and sold, has been astounding. Conservators know that the final appearance of an object after cleaning and conservation is not always predictable - witness the 'blue' windows of Chartres. It could certainly be argued that such changes 'affect the character' of the building. Conservators should therefore be aware of the risk of public controversy and the possibility of attempts to exercise control by planning authorities, lacking experience in this field, over conservation projects in buildings subject to Listed Building Control.

When I first became aware that such skills existed I found conservators' work and techniques to be wholly mysterious. Other than a small band of wall painting and painting-on-wood conservators - mostly in a very small way of business and mostly female - such work was normally carried out by restorers or museum conservators commissioned on a one-off-basis, their names specially recommended by the CCC. I can recall roof angels at Blythborough, early polychromed organ pipes at Framlingham and Stamford-on-Avon, and an angel Gabriel (now suffering from its dose of unrecorded soluble nylon).

Lack of resources was the root of the trouble. Inadequate funding for work led to immense competition between conservators for inadequate grants, inadequate renumeration and quite frequently somewhat acrimonious professional rivalry. This inevitably led to diminished career prospects and was thus partially responsible for the lack of training in this field of work. Lack of funding also gave rise to the temptation to use the latest, cheapest and most recently qualified student, reinforcing pressure on those already in practice.

The tide seemed to turn in the 1970s. Society clearly changed its attitude to the importance of the buildings and objects in care. In 1975 work started on the west front of Wells Cathedral leading to the employment of an evolving team of seven to ten conservators who worked each year on the sculptures. Before that date, as far as I am aware, only three external limestone figures had been conserved in the UK (two on Merton College Chapel, Oxford, and figure 387, the southern figure of the lowest tier of the west front of Wells). The Victoria & Albert Museum, in the shape of John Larson, intervened and saved the struggling Croydon course on the conservation of sculpture whilst later training developments included the new wall painting course at the Courtauld and a very

interesting course at Weymouth that is providing students with the skills to work on stone in close association with the building industry.

As a result of this course of work at Croydon and work at Wells a number of small independent conservation studios were founded. Originally trained, or partially trained, in entirely different techniques, it did not take long before their professionalism resulted in a healthy exchange of knowledge. Some of the best presented lime-base repairs have been carried out for me by a Croydon-trained conservator, whilst a well-known West Country firm originally steeped in 'muck and magic' have carried out some prestigious contracts on eighteenth-century marble.

A number of problems commonly affected the Church system of grant-aid. These included:

- Delay in decision-making.
- An over-emphasis on the appointment of art historians as committee members and an under-emphasis on the appointment of members with technical knowledge.
- Where complex problems arose, the difficulty of arranging site visits before decision-making.
- Officers were over-worked, committee members were busy but invariably volunteers.
- Failure to inspect works regularly on completion and thus to obtain feedback.
- Failure to apply the pressure of grant-aid to develop both simple and fair business relationships between building owners and conservators, and clear guides on standards of documentation.

This failure should be compared with an almost obsessive interest - sometimes interference - in the technical content of the work. The application of such pressure would have been in the interest of the conservators as well as the objects for which they care. Virtually all these difficulties arose from lack of resources and many have been subsequently tackled and largely overcome.

There is, of course, never sufficient money but these problems should not arise to the same extent with English Heritage's involvement with 'fixtures', if only because it will be possible to appoint an officer to oversee each grant. I suspect that at present there are insufficient officers with the necessary experience within English Heritage to oversee grant-aided conservation work but this is a relatively new scheme, skills will develop, and the Commission has the option - which it already exercises with its grants for building repair - of appointing an appropriate professional person, in this case a conservator, to oversee the quality of the work.

A further difficulty affecting the scene in the 1960s and 1970s was an over reliance on advice from great national museums. It is essential to acknowledge the generosity with which such free advice was given, but too often it was given by historians and conservators who had little working experience of the appalling conditions that exist within so many under-used or partially heated historic buildings, let alone the effect of the British climate on external surfaces. Such blind reliance on the 'experts' was common, particularly in the National Trust, but is now a thing of the past. Work by the National Trust to provide good house-keeping - day-to-day conservation - has been immensely important, while their work on the control of the internal environment by low-energy heating services backed by sophisticated controls and monitoring appears likely to be of fundamental importance.

When I lectured abroad on work at Wells, I discovered a contrast between the well-established professional-led decision making on conservation in the UK and the level of scientific pre-investigation that appears to be common elsewhere. Notwithstanding that so many of such conferences - I include APT (Association for Preservation Technology) in Toronto and IIC

(International Institute of Conservators) in Bologna - focused on the reaction to past mistakes, I found our current inability to commission and fund such prior investigations and monitoring an unacceptable feature of British practice. Here things are changing, very largely due to greater awareness by the Church, English Heritage and of course the National Trust.

At St. Helen's, Abingdon, the environment was monitored for some four years prior to the recent works by Anna Hulbert and Hugh Harrison. Monitoring continues under the direction of Bill Bordass and Bob Hayes. The sheer complexity of the modern scene is illustrated by the introduction into the team of Gavin Simpson of Nottingham University as dendrochronologist, Caroline Babington of English Heritage to analyse pigment, and Jerry Sampson of our office to write the co-ordinated conservation record which includes a study of the conservation process of the timber, all pieces examined having been 150 years old before felling and obtained from Scandinavia or the Baltic.

In 1995 we hope to start work on the thirteenth-century crypt at Rochester where vault paintings need cleaning and stone must be cleaned and consolidated. Monitoring of the crypt by Plowden & Smith will start this year, while Dr Clifford Price is examining the make-up of the salts in the walls with the hope that the new heating system can keep the relative humidity away from those levels where salts go in and out of solution. The significance of these investigations is that they are being assisted by a generous 40 per cent grant from English Heritage. I find this to be exciting.

Current Developments

Kate Foley in her paper has spoken of the commissioning of conservation work for English Heritage by competitive tender. The commission has already laid down that there shall be a presumption of competition when grant-aiding buildings, but in my experience has been sensible and flexible in exercising the presumption. I am advised that similar requirements are likely to be imposed in future on the funding of the conservation of *fixtures*. Such a requirement will inevitably lead to changes in the manner in which much future conservation is commissioned. Other bodies under government pressure have taken an even more inflexible line: the Royal Palaces Agency have to take competitive tenders for all work valued over some £500!

Too often in the past commissioning procedures have been appalling, with enquiries sent out - often by architects working to the rules of the public sector - which have exploited conservators. The conservator is a fellow professional and thus deserves payment for professional opinion. Too often in the past a conservator has been asked to report without payment and subsequently the report, with some changes, has been issued to others for competitive tendering. Alternatively an officer has consulted two or three independent conservators for an opinion and estimate and has subsequently recommended acceptance of the lowest estimate, probably thus putting the object at risk.

It is always difficult in the building industry for organisations that both give professional advice and work to a price. The uncertain terms of reference for the beetle and rot eradicators are a typical example. Like them the conservators wear two hats, both those of the professional and of the executant. It is important that the hats are kept distinct, that proper fees are offered and paid for professional advice, but not for tendering to a specification produced by others.

I suspect in the future there are likely to be three scenarios:

(a) A direct approach to a conservator of experience, payment for the report and subsequent commissioning without competition.

This continues current practice and could well remain the norm for at least the smaller projects.

(b) Appointment of a consultant conservator with a brief to examine the object, carry out tests as necessary, prepare a specification and subsequently to obtain competitive tenders.

It could be possible under such a scenario for the consultant to be invited to tender, in which case the administration of the contract would remain with a third party, presumably an architect. Depending on the skills and techniques involved on some projects the latter could be appropriate, on others entirely inappropriate, leaving the consultant solely responsible for the oversight of the work of the successful tenderer.

(c) Preparation - in appropriate circumstances - of the specification by an architect either for a single tender action or competition, often after tests by a conservator for which full and proper payment has already been made.

There are many disciplines where such action would be inappropriate, but it is on occasion a valid option. The document must be of sufficient technical weight to enable proper and fair pricing, must respect the professionalism of the contracting conservator and thus, as indicated in Kate Foley's paper, allow for the submission and justification of alternative costed proposals. It is essential that the document gives a clear idea of the strategy that is to be followed, whilst also allowing the conservator to develop minor changes in approach as the project progresses and new findings emerge. It should also lay a duty on the conservator to stop and consult if procedures are not working, damage is being caused, or a change of technique is required.

The building industry has developed a convention that if materials, quantities and methods are clearly defined a fair competitive price can be calculated. Building industry specifications are prescriptive. There is rarely, if ever, an option for the contractor to vary what he has been instructed to do. However, a form of documentation originally developed to instruct the craftsman, and possibly to control the dishonest, is not appropriate for conservation by professionals where frequently a number of options are both possible and proper. In addition there is often a problem of scale: it is impossible to describe and quantify, let alone separately estimate for, the removal of innumerable small flecks of cement from a weathered old limestone surface. I doubt that the word 'specification' is the correct title for works of conservation. I prefer to use the phrase 'Technical Proposals' to avoid confusion with the practices of the building industry, and to give some hint of flexibility.

There is little doubt that as the number of conservators grows, increased funding comes from central sources and building owners seek ever better value-for-money, a greater volume of conservation will be carried out after competitive tendering.

Present methods of commissioning work are often inadequate, frequently exploit the conservator and leave the contractual relationship between the conservator and building owner extremely vague. The tendency for the architectural profession to assume that a conservator is merely an expert craftsman further complicates the situation whilst the subjection of the conservation process - with all its uncertainties - to the harsh discipline of the large building contract (a subjection which is generally to be avoided but on occasions is essential) can make matters even worse. Standards are rising partly due to the increased collaboration between building professionals and conservators. Methods of commissioning are changing, perhaps becoming harsher, more business-like. I believe it to be of great importance for conservators, associated professions and the larger owners of important historic buildings to consider current practice, to study how it might be improved and to publish recommendations.

I hope such an examination could include a study of recently prepared 'specifications' or 'technical proposals' with a view to learning from past mistakes, improving working relationships between conservators, consultant conservators and architects, clarifying the brief for recording and documentation and to advise on sensible and fair contractual relationships between building owners, the conservators they employ and those who finance the project.

I fear that unless such a study is put in hand it will be the conservators - and the objects for

which they care - that will suffer. Such an outcome would be unacceptable.

Acknowledgements
The writer would like to acknowledge past collaboration and assistance given by the following individuals and companies: Professor Robert Baker, Anne Ballantyne, Deborah Carthy, Officers for the Council of the Care of Churches, Nicholas Durnan and colleagues, Harrison and Hill, Anna Hulbert, Katkov and Oldenbourg, John Larson, Perry Lithgow Partnership, Nimbus Conservation Ltd, Plowden and Smith, Dr Clifford Price, Herbert Read Ltd, Trustees of St. Andrew's Conservation Trust, Taylor Pearce Restoration Services Ltd, Wells Conservation Ltd.

Postscript
Since this paper was presented, the Faculty system of the church in Wales has been entirely overhauled and mandatory control extended over the Welsh Cathedrals. The very recent development of funding through the Lottery Boards cannot be discussed here though the partnership between the Heritage Lottery Fund and English Heritage over funding for churches is to be greatly welcomed for its reduction in the requirement for professional involvement before the result of the application is determined.

CHAPTER 3

THE BUREAUCRATIC TENDENCY: POLEMIC REFLECTIONS ON THE CONTROL OF CONSERVATION WORK, WITH REFERENCE TO THE ROMANESQUE FRIEZE AT LINCOLN CATHEDRAL

J. Baily

In the 1993 Annual Report of an English public school the headmaster, describing the current dispute with central government concerning assessment within the National Curriculum, writes:

> the twin forces of legislation and social trend are, as ever, providing the greatest challenges with which we must wrestle. Legislation in its broadest intentions is usually beneficial as it originates from some perceived need that has not previously been addressed, or must be tackled afresh. Nevertheless, in its minutest requirements legislation tends to overstate its demands and threaten many established good practices... the needless emphasis on assessment suffocates initiative and swallows staff time...

It is not just a coincidence that this could also describe the situation created by the *Care of Cathedrals Measure* operated by the Cathedrals Fabric Commission of England. Or the cathedral grants scheme operated by English Heritage, for legislation generally tends to follow this pattern. It also operates on two fronts, firstly to draw to the centre the reins of power and secondly to decentralise the practical implementation. These may appear contradictory, but may be used by the centre to imply that what goes well is caused by central control and what goes wrong lies with local error. This is particularly marked in legislation that includes elements of interpretation.

Those who have experienced variations in the application of the VAT regulations on listed buildings, or the insistence on the retention of unfortunate previous repairs, or the use of a certain 'approved' mortar mix, will recognise this circumstance. The use of a 'little red book' in place of the consideration of local circumstances and skills is not a good thing. What would William Morris, let alone William of Sens, have thought of our present practices? William of Sens - or any other medieval master mason - would be at a complete loss to understand our fear of creativity (unless he spoke to some of our clerics, who may well express a strong desire to pull down and start again). 'Given the choice', writes Jane Fawcett, 'between conservation and replacement, most architects have chosen to rebuild.[1]' (And quite right too). William Morris, despite being overtaken by SPAB doctrines, would surely have had something pungent to say on the shift away from craft skills and local variations as the basis of judgement to centralised administrative procedures.

The Lady Chatterley trial confirmed that it is unwise to legislate on taste, style or opinion. Certainly legislation on good practice is possible where factual data is used, but as soon as an interpretative clause is inserted it is the taste, style or opinion of the Inspector that is dominant, for

[1] J. Fawcett 'Introduction', in J. Fawcett (ed.), *The Future of the Past: Attitudes to Conservation 1174-1974*, London, 1976, p.8.

the applicant is invariably anxious about time delays and costs and is under pressure to yield in order to obtain an approval.

The *Care of Cathedrals Measure* is written in a very particular way. First and foremost it is concerned with a strict process of control and makes rigid assumptions as to the process of decision making employed in the care of cathedrals and the sculpture and other objects associated with them. Unfortunately those who drafted the legislation assumed a process more associated with new commissions. This begins with the dean and chapter, or administrative body, taking a decision to undertake a certain project, which then requires a series of approvals; first from their architect and archaeologist, next from the Cathedral Fabric Advisory Committee, and then the Cathedrals Fabric Commission for England, together with views taken from English Heritage, the local authority and SPAB. New commissions are rare, for ninety-nine per cent of the work concerns the repair or conservation of some part of the cathedral, or carved works upon it. This need is usually identified by the craftsmen working in that area, or by the architect or clerk of works during an inspection. The proposal is worked out and the dean and chapter asked to support it via their treasurer. This can best be described in a 'balloon' diagram (figure 3.1). The traditional system kept the decision making close to those with local knowledge and specific craft skills, with the Architect providing an overview and a liaison with the cratfsmen and the Treasurer. The new system (figure 3.3) divorces the decision making from craft knowledge, and introduces so many detached elements into the decision making, that influential votes can easily be cast by people in other disciplines in distant places.

Secondly, the *Measure* operates a truly comprehensive interpretative clause, namely that:

> a cathedral church shall not implement any proposal for carrying out works on, above or below land... being works which would materially affect... the architectural, archaeological, artistic or historic character of the cathedral church... unless the proposal has been approved under this Measure.

Strictly interpreted this means that before any stone in the building can be touched, a formal application - that can easily take nine months to determine - is required. All agree that this is clearly a nonsense, but what is the alternative? What is one person's 'run of the mill' repair is somebody else's desecration. Who determines where the boundaries are, and when they have been crossed? This uncertainty will almost certainly lead to test cases and the unwanted polarisation between those who do and those who administer. It will slow down creative development, enforce inappropriate treatment and dissipate the enthusiasm of on-site conservators whose views and skills are not always considered by those who make the decisions.

Thirdly, the *Measure* is written to stop bad things happening, not to encourage good things, in spite of a call to give advice, and assist in educational and research projects. This creates a negative response to the legislation locally, and will be frustrating to the adminstrators in London as they will know of projects being discussed and developed locally, but can have no input until such time as the dean and chapter make an application. As written the *Measure* is more about the process of control than the quality of intentions. At worst its administration could slide into a form of cultural policing.

The condition of the Romanesque frieze panels at Lincoln provide a good example of the problems we face in formulating a practical policy. As Professor Lasko has pointed out, 'history will not provide us with the answer', but history certainly has an influence.[2] When Browne Willis wrote his *Survey of Lincoln* in 1730 he did not even mention the frieze, and it is likely that James

[2] D. Kahn (ed.), *The Romanesque Frieze and its Spectator*, London, 1992, p.162.

Essex referred to it in 1786 not out of any particular interest, but because he replaced a panel that presumably had fallen out at that time. During the nineteenth century the frieze was thought to be Anglo-Saxon, and Deborah Kahn has pointed out that 'the need to understand it historically has gone hand in hand with the concern to preserve it for posterity'.[3] Indeed, the influence of the historian and the archaeologist has complicated the development of a conservation policy through a reluctance to adjust historical judgements or to recognise the inevitability of progressive decay.

At the conference in 1988 (now published as D. Kahn (ed.), *The Romanesque Frieze and its Spectator,* London, 1992) the verbal violence of the nineteenth-century debates on restoration was an unseen presence, perhaps as the calm after the storm. No one, I hope, would nowadays follow Pugin and write: 'I rushed to the cathedral: but horror! dismay! the villain Baily had been there', or when I am no more refer to me in print as 'the happily dead dog' as Morris did of Scott. But Morris and the SPAB can be detected in Professor Sauerländer's observation that 'the wisest and the most respectful way to conserve Romanesque sculptures is to leave them in their original architectural context'.[4] Professor Lasko takes a more pragmatic view, recognising that replacement is an inevitability and 'it is the ethics of such a solution, among others, that are bound to be raised now, when we are faced with the serious and constantly accelerating decay of the magnificent Romanesque Frieze'.[5] He raises all the options - allow it to remain and be destroyed by the weather, removing it and replacing with modern works, or pastiche, or casts. He finishes not with any advice to those locally charged with formulating a proposal, but by bleakly observing that the decision to be taken 'will be ours alone, and will be judged harshly'.[6] Dr Price is even more gloomy: 'However good our stewardship of the stonework in our care, it is going to deteriorate and eventually be lost'.[7]

Since the symposium, a good deal of progress has been made, by understanding the actual condition of the stone. This has been achieved by the removal of four panels from the west front for examination in the Cathedral's conservation workshop. Two of the panels came out in over forty individual fragments. These panels have been carefully cleaned and meticulously reassembled, one on a slate bed for stability. The structural condition of the panels, and the weakness of the repairs, makes it unthinkable that they can be refixed outside in a hostile climate. The surface condition of others is so delicate and friable that it is quite impossible to make a moulded copy. Some panels are so securely fixed in that it may not be possible to remove them. The structural condition of the ashlar wall in which they are set, makes it essential that only one or two at a time can safely be removed and examined, inhibiting a comprehensive view of the condition of the frieze as a whole.

In a factual and logical manner, the data and experience gained by the conservators, the architect and the other consultants should evolve into a self-evident solution. But at what point in this evolving procedure can the formal process required by the *Measure* and by English Heritage be started? At the beginning, a mature and considered programme of work cannot be described, for there are too many unknowns, and when the knowledge is at hand it is really too late as work has already been undertaken. If the cathedral conservation staff, the many consultants and Fabric Advisory Committee have carefully gone through the learning process, will the Cathedrals Fabric

[3] *Ibid.,* p.10.
[4] *Ibid.,* p.43.
[5] *Ibid.,* p.161.
[6] *Ibid.,* p.162.
[7] *Ibid.,* p.182.

Commission or English Heritage, without this intimate, hands-on knowledge of the problems, be able to offer a more considered alternative?

Out of this process some general observations can be made. The bureaucratic systems we are experiencing inevitably shift control from local knowledge, skills, enthusiasm (and no doubt eccentricities) to distant desk administration. The wider the gap the less intimate the solution, or if you like, the more standardised is the result. The identity and personality of highly individual carvings and buildings may suffer. The development of local skills in the treatment of the frieze panels and other carvings is the most valuable aspect of our work at Lincoln, and the retention of this corpus of skill as a local tradition is what the job of a cathedral architect is all about. It is this core of knowledge that should be the dominant constituent in the decision making on future work.

Earlier, the application of the *Measure* was described as 'cultural policing', which may sound somewhat hostile, but one definition of culture in the *Oxford English Dictionary* is 'improvement or refinement by education and training'. Had the *Measure* been drafted with this positive and creative aim in mind what potential could have been released! The profession of the conservator is young, with even the language of its myriad parts still developing as well as its techniques. What could be achieved with encouragement and support in setting up local conservation workshops, as at Lincoln, in which to train more skilled conservators? What if the rigid 'process of control' were replaced by an encouragement to develop? What if the Cathedrals Fabric Commission and English Heritage were to exercise control through the validation and licensing of local craft people and workshops rather than by imposing standardised approaches and lengthy application procedures in order to say Yes or No? Is it too late to make some changes, and move from a bureaucratic driven system to a craft skills methodology? 'A State without the means of some change', wrote Edmund Burke, 'is without the means of its conservation.'

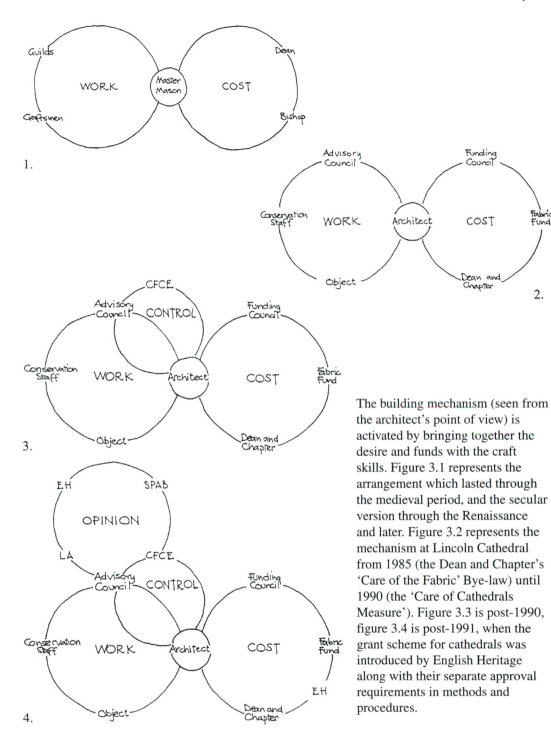

The building mechanism (seen from the architect's point of view) is activated by bringing together the desire and funds with the craft skills. Figure 3.1 represents the arrangement which lasted through the medieval period, and the secular version through the Renaissance and later. Figure 3.2 represents the mechanism at Lincoln Cathedral from 1985 (the Dean and Chapter's 'Care of the Fabric' Bye-law) until 1990 (the 'Care of Cathedrals Measure'). Figure 3.3 is post-1990, figure 3.4 is post-1991, when the grant scheme for cathedrals was introduced by English Heritage along with their separate approval requirements in methods and procedures.

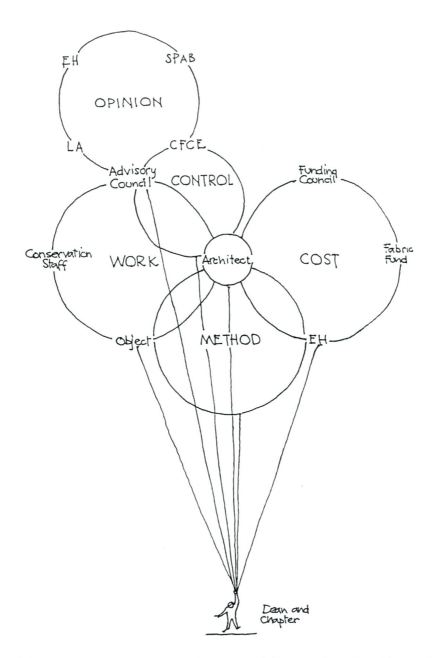

Figure 3.5 The poor chair - in this case the Dean and Chapter - finds himself not only increasingly marginalised by the developing bureaucracy, but having to keep a whole array of balloons in the air, and at considerable cost. There is yet another balloon about to rise, that of the 'Project Supervisor' as required by the Health and Safety Executive under the Construction (Design and Management) Regulations 1994.

CHAPTER 4

THE HISTORIC MONUMENTS OF FRANCE AND THEIR FATE: WHO MAKES THE DECISIONS?

I. Pallot-Frossard

The Department of Historic Monuments (now part of the Ministry of Culture) is a long-established administration which has taken decisions about conservation for the last one hundred and sixty years. This is one of the reasons for its complexity, which at times seems impenetrable to the uninitiated.

All the decisions affecting a particular monument stem from as many consultations as are found necessary to ensure that a suitable programme of conservation is followed. In effect, since the mid-nineteenth century all work undertaken on a monument is the result of discussions between the technical supervisor and the art historian or archaeologist. Consultation between these officials takes place on site or at the High Commission of Historic Monuments where any complex technical or ethical problem is considered.

We will follow through the different stages in the procedure, from diagnosis, through the proposed programme of work, to the hoped-for cure. In the first instance the *Architect en chef* (chief architect), appointed by competitive examination, is in charge. He is a specialist both in well-proven conservation techniques and in architectural history. He directs the restoration of all listed monuments. Most chief architects, who have been trained at the Centre for Advanced Studies of History and Conservation of Historic Monuments, are in charge of one or more Departments (administrative geographical areas).

In order to establish his diagnosis, within the framework of a preliminary study carried out by the master of works (the regional conservator of historic monuments), the chief architect takes the advice of various specialists: the historians who have studied the archives, the scientists from the laboratory for the research of historic monuments or other laboratories which try to find out what has caused the changes and suggest the appropriate remedy. If necessary, the advice of engineers specialising in specific problems such as stabilisation, as in the case of Beauvais Cathedral, can be obtained. This collaboration results in a preliminary study in which the chief architect synthesises the various contributions and proposes solutions, which may be purely technical, or ethical, or again formal. This report is backed up by detailed studies and photographic evidence and sometimes also by a photogrammetric study. The report sometimes suggests several possible courses of action from which a choice has to be made.

The dossier is passed to two civil servants who have to give their advice to the master of works:

1. The Inspector of Historic Monuments is by training an art historian, recruited by competitive examination. He supervises at a regional or inter-regional level and is responsible for going through the dossiers presented by the architects in charge of the historic monuments. His advice does not deal with technical matters, as these are not within his field of expertise, but with historical and ethical matters. It is up to him or her to give an opinion on how compatible the project is with the history of the monument, while naturally at the same time taking into account its function and appearance. His advice is especially important when it comes to monumental

decorative schemes, mural paintings, sculpture, large altarpieces and stained glass, for which he has specialist knowledge. The Inspector of Historic Monuments is also in charge of overseeing the restoration of ecclesiastical furnishings in his or her region, for the techniques involved are similar to those used in large decorative schemes.

2. The Inspector General of Historic Monuments, a senior architect with several years experience, is in overall control and will in turn go over the report and give his opinion on the technical proposals as well as on the appraisal made by the chief architect of Historic Monuments.

Sometimes a second opinion is sought from another Inspector General, specialising in the subject area, to substantiate the advice given by the Inspector of Historic Monuments. When a consensus is finally obtained between architect, inspector and one or more of the general inspectors, the master of works (the regional conservator of historic monuments) can go ahead and ask for an architectural and technical study from the chief architect. This will entail a comprehensive and detailed study of the projected course of work and of all the necessary paperwork for the conclusion of the project. The report is usually subjected to the same scrutiny as the preliminary study.

If no agreement is reached between the various officials as to how to proceed, or if a serious technical or ethical problem arises, the report is then passed on to the High Commission for Historic Monuments. The Commission, comprising architects, historians, archaeologists and representatives of the various different officials responsible for the management of historic monuments, was created in 1837. At the Commission, presided over by the *Directeur du Patrimoine* (Director of Heritage), a lively debate sometimes ensues which can result in disagreement between the architects and historians and a delegation visiting the site. These discussions end up with a proposal being sent to the Minister of Culture (see figure 4.1; figure 4.2 shows the process for an object).

Once the decision to restore is taken a large proportion of the cost comes from the annual budget (in the case of listed monuments it is about 50 per cent). The decision is made after negotiations with the owner of the monument, who also contributes a sizeable sum, be it a public body, such as a Municipality or Department, or a private individual. To lessen the expense to the Municipalities most Departments (General Councils) contribute a sum which is sometimes topped up by the Regional Council. Each scheme is the outcome of an agreement between at least three parties. When the question of finance has been resolved the Regional Conservator can go ahead with the schedule of work. Sometimes he has to make difficult decisions, prioritising the urgency for restoration of the various monuments within his region, without neglecting the assessment of their value, as this is important to make the public appreciate their heritage.

It is therefore abundantly evident that all the resulting decisions stem from negotiations, sometimes difficult, sometimes harmonious, between the architect, the historian, the administrators and the owners. However, even if the administrative procedures and the areas of individual responsibility are clearly set out in the documentation, in reality things often turn out rather differently: the differences of opinion are difficult to arbitrate, especially when individuals move out of their own particular areas of expertise: the technician into archaeology, the historian into technique, the conservator into architecture. The financial and operational considerations of the different proposals for restoration bring their own problems and have to be agreed upon by those financing the project.

At this stage discussion rather than arbitration is required, with individual strengths contributing to a balanced picture and a resultant compromise. It is vital not to get bogged down in tiny details, possibly resulting in a poor decision, but if necessary to call on strong arbitration so as to adopt a bold solution. The role of arbitrator is taken on by the High Commission and the Heritage Director.

Having to resolve disagreements and conflicting ideas, the Department of Historic Monuments has tried to establish some ground rules; not rigid rules, but rules which have evolved and changed over the years through experience. This can be perfectly illustrated by the case of Rheims Cathedral, an outstanding Gothic building, particularly noteworthy for its sculpture.

The Example of Rheims

The first half of the nineteenth century in France saw the beginnings of archaeology as a discipline and a growing interest in the Middle Ages, and guiding principles were laid down by Prosper Mérimée and a group of diocesan architects interested in their heritage. Gradually finding out about old methods, they acted with caution when it came to reconstruction, replacing stones only where necessary. They left sculpture *in situ*, grafting on new stone or mortar to restore it to its original state. With time these modest restorations often came to be seen as being of poor quality (plates 6-7).

As knowledge of history and archaeology developed, with the emergence of important architectural archaeologists, such as Eugène Viollet-le Duc, a freer approach to reconstruction was adopted. Missing sculptural details were completed (plate 7), but above all parts of the monument which had completely disappeared were rebuilt on the basis of comparisons with similar monuments and with a sense of stylistic congruity informed by an understanding of architectural typology. The removal of seventeenth- and eighteenth-century restorations in order to achieve stylistic unity continued until the early part of the twentieth century.

After the very serious damage to the cathedral's structure and decoration during the First World War, efforts were concentrated on repairing the fabric of the building. Where the sculpture was concerned, every tiny fragment was collected, sorted and stored for future restoration. Nothing was replaced, apart from two or three sculptures in the upper part (a king, an angel, *Ecclesia*) (plate 8). It was only after the Second World War that the appalling state of the stonework and sculpture was fully appreciated. The Chief Architect, Henri Huignard, raised the alarm and the condition of the sculptures was documented. Those in the worst state were removed and replaced with stone copies. In cases where the original sculptures were severely damaged, the copies were stylistically very free, showing the hand of the individual artist. The copies of less decayed pieces were truer to the original sculpture, though they still possessed a certain contemporary feeling.

Today, as the process of disintegration accelerates, original sculptures which are high up and difficult to reach have been taken down, while those in more accessible positions which can be monitored, such as on portals, have been stabilised and wherever possible kept *in situ*. Where the originals are in a suitable state of preservation, their replacements are made from casts in reconstituted stone (plate 9). When, due to deterioration, this cannot be done, a faithful stone copy is made, based on photographs, even though it is but a pale shadow of the original.

In order to support the decision-making process and amplify the debate at Rheims, the *Direction du Patrimoine* (Department of Heritage) established in 1988 an International Scientific Committee of historians, scientists and technicians who meet twice a year to discuss the various technical and ethical questions concerning the restoration of the sculpture. This example has been followed for about a dozen other important monuments in France, such as the Abbey of Cluny, the church of Notre Dame la Grande at Poitiers, Rouen Cathedral, etc. When buildings face severe and recurring technical or ethical difficulties a panel of experts is asked to oversee the work and advise the officials of the department of Historic Monuments.

Acknowledgement
I am grateful to Mr Nicholas Watkins for assisting in the translation of this essay

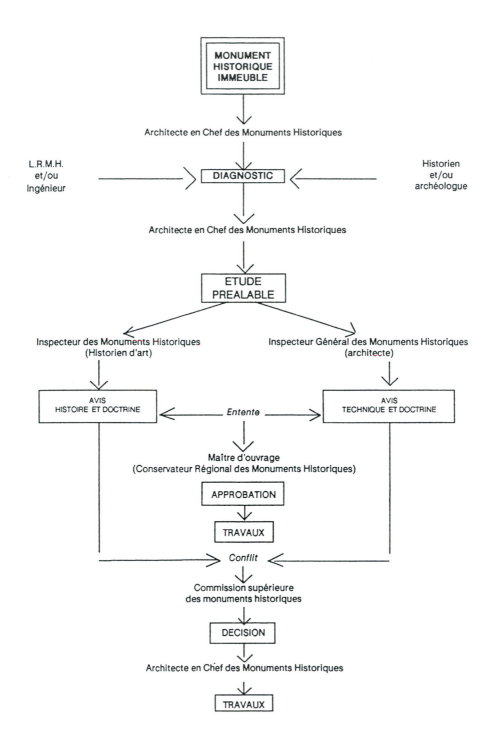

Figure 4.1 Flow Chart showing the process of decision-making for a Site

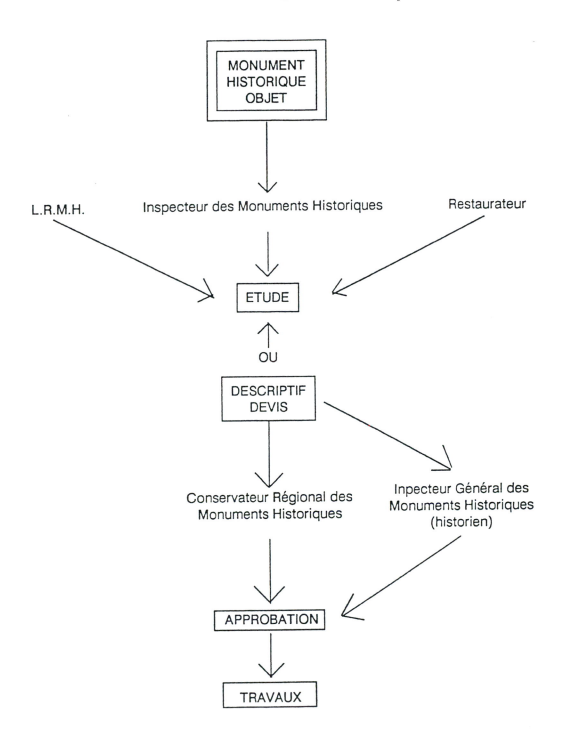

Figure 4.2 Flow Chart showing the process of decision-making for an Object

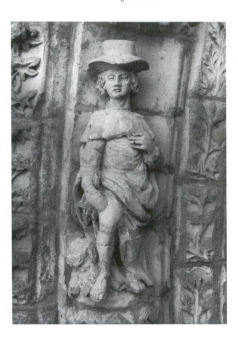

Plate 6 Cathedral of Rheims (Marne), *St Roch,* element of voussoir of central portal of the west façade, restored in the eighteenth and nineteenth centuries in the style of that period.

Plate 7 Sculpted element of the northern gable, replaced in the nineteenth century in Gothic Revival style.

Plate 8 Statue of *Ecclesia,* from the southern transept arm, broken during the First World War and replaced by a copy in the course of work by Henri Deneux (1937). In the background is the broken original; to the right is the plaster model and on the left the stone copy.

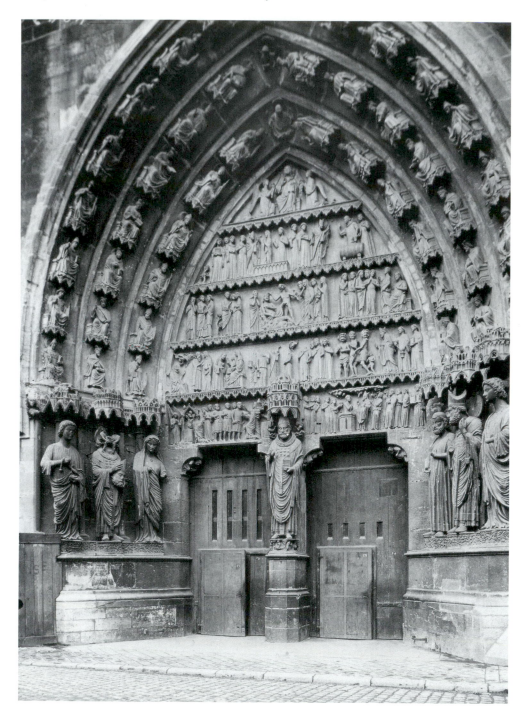

Plate 9 The *Saint Calixtus* portal, north transept façade, state at the end of the nineteenth century.

CHAPTER 5

CONSERVATION: A DIRECT ROUTE TO THE PROTECTION AND STUDY OF MONUMENTS

R. Nardi

Introduction

Conservation of cultural heritage is a sophisticated and complex process that must take into account the dual nature - material and cultural message - that characterizes works of art. The material must be revitalized and brought back to a point where ordinary maintenance is possible. The cultural message must be highlighted and transmitted through data and interpretation. A conservation project must accomplish all this: the alchemy of the process may vary, but the result should not change.

In this paper, we describe the experience of a private group of conservators working on public commissions in the sphere of monument and stone preservation. Three case studies of treatments performed from 1982-1992 are presented. In describing this experience, carried out in a very limited geographical area, we discuss the structure of the group, its strategy (ethical and commercial), the commissioning agencies and the way work is assigned. We also examine the types of professionals who contributed to implementing the projects, in respect of their technical-scientific training and their institutional positions.

Case Studies

This paper describes the experience of a private group of conservators - the CCA (*Centro di Conservazione Archeologica*) - working on public commissions in the sphere of monument and stone conservation.[1] Three case studies are presented of work carried out in Rome in the decade between 1982 and 1992: the Arch of Septimius Severus in the Roman Forum (for the Archaeological Superintendency of Rome) (plates 10-12), the epigraphic collection of the Capitoline Museums, and the structure and Roman sculpture collection of the atrium of the Capitoline Museum (commissioned by the city of Rome) (plates 13-15).[2]

Before discussing the principles by which the conservation projects are managed and implemented, it may be useful to describe the group involved in these projects: how it is organized; who its members are; on what basis ethical and business choices are made; and how assignments are received - a healthy dose of bureaucracy to begin with. It is important to state now that what follows is based exclusively on personal experience directly related to the activity of the group in question, and that it reflects the situation in Italy, and Rome in particular, because Rome is where the group primarily works. Thus, it is not our intention to provide an overview of all the laws and

[1] Centro di Conservazione Archeologica, Via del Gambero, 19, 00187, Rome, Italy, Fax 00396-6-6780786.

[2] R. Nardi, 'The Arch of Septimius Severus in the Roman Forum', in *Proceedings of the ICOM Triennial Meeting*, Sydney, 1987, 493-501; S. Pancera, *La Collezione Epigrafica dei Musei Capitolini*, Ed. di storia e Letteratura, Rome, 1987; R. Nardi, 'Il restauro delle lapidi capitoline,' *Il Museo Epigrafico, Colloquio AIEGL - Borghesi Epigrafia e Antichita*, 7 (1984), 542-50. A video on the conservation of the atrium of the Capitoline Museum has been produced by the CCA.

mechanisms that regulate the composition of conservation groups, the assignment of work and the procedures by which the work is finally accomplished. Neither do we wish to judge the experience of others, because we could easily be mistaken without first-hand knowledge.

First, we should provide some general remarks on the composition of the group. To do this, we must first consider the issue of training for conservators/restorers. The institution officially established for this purpose in Italy is the *Istituto Centrale del Restauro* in Rome (ICR), founded by Cesare Brandi in 1939 and later joined by the *Opificio delle Pietre Dure* in Florence. Both institutions have a strictly limited student intake (eighteen a year), with a three-tier entrance examination; they offer a three-year course in restoration of paintings or archaeological objects, followed by a fourth year of specialization in stone conservation. These two institutions are the only ones in Italy officially permitted to produce qualified restoration professionals. Consequently, only their diplomas should provide guarantees for public agencies hiring staff members for their own administrations or contracting outside conservation firms through public tender. We say 'should' because this was the case for many years, but then, there not being any legislation on the subject, freedom of choice has now enlarged the field out of all recognition, giving the administrators a latitude that has sometimes led to procedures dictated by much wider - and sometimes questionable - interests. The situation has led to a proliferation of schools and private institutions which can, in exchange for hefty tuition fees, turn out an army of restorers in a few months and release them into the market.

A solution will occur when parliament passes legislation defining and regulating the profession, including approval of a professional roster. For the present, a useful contribution came in the 1980s with the creation of an association that unites all conservators/restorers with four years of training, such as that given by the two institutions in Rome and Florence. The association - *Associazione Restauratori d'Italia* (ARI)[3] - now has some 400 members and is actively working to obtain parliamentary approval of a law establishing a professional register. Currently, however, the criterion for judging the qualifications of operators when hiring members of a group or assigning restoration or conservation work is determined by the head of the group itself or even by the administrators in charge of the monument. This system can work very well if managed with honesty and scientific rigour; it can work extremely badly if exploited for other purposes or even simply for an 'apparent saving.'

To return to personal experience, we must go back to 1982, when the author decided to start a group including a certain number of conservators with a common educational background - the four years of the ICR. Today, the group comprises eight ICR conservators, two ICR student interns and a worksite foreman. Some of the conservators also have a university education in the humanities. The group has a single administrator and the restorers are bound by contracts either as employees or as independent associated firms (on fixed-term contracts, connected with a specific project). The field of work is exclusively that of public commissions because, by Italian law, the built archaeological heritage belongs to the state.

In the case of a private group, an important choice is made in defining the principal objective of its work: this can be either financial, or purely scientific (research), or a combination of the two. We chose the third option because, while we maintain a strong interest in the scientific side of the profession, the very nature of private firms also requires some attention to the budget. This focus is not merely due to personal considerations, for only with a healthy balance-sheet can one satisfy all the technical requirements of operation and research.

[3] Associazione Restauratori d'Italia, Viale Manzoni, 26, 00185, Roma, Fax 00396-6-70495277.

How is this result obtained? The method is to establish an annual budget ceiling beyond which one foregoes or postpones projects. This approach means that one can select a limited number of projects and choose the most interesting and satisfying ones. When planning a budget, special attention must be paid to the costs that, although related to operations of fundamental importance, are often not covered in the contract - e.g. historical research, publications, or video documentation. These (and this better explains the group's ethics) must be considered as an integral part of the operation, even though apparently not funded. We say 'apparently', because in reality there is always an important return in image and professional gratification.

Indeed, it is the image, understood in the positive sense of the term as a reflection of professional quality, that becomes important when contracts are being let out. Here, we must introduce a second theme, the mechanism by which work is assigned. It can be non-competitive (direct assignment) or competitive (on a scientific basis, economic basis, or both). We should say immediately that, among the three examples presented below, there are no cases of contracts assigned on a purely economic basis. As a matter of principle, we feel that our profession must be founded on a search for maximum specialization and the best scientific product, not on simple financial savings. Naturally, however, legitimate costs and the convenience for the government must always be taken into consideration.

Three cases are described below. The first (Capitoline epigraphs) involved direct assignment by the administration to the group, with a cost estimate drawn up by the latter (and judged appropriate by the former) and with full freedom of operation. The second (Arch of Septimius Severus) was a case of direct assignment with some conditions (operating and economic) established by the administration. The third assignment (Atrium of Capitoline Museum) was allocated upon competitive selection on an economic and scientific basis.

The first example involved the restoration of the epigraphic collection of the Capitoline Museums, with 1,450 Roman epigraphs from the underground gallery joining the two museums. The project was proposed by the city of Rome and directed by a staff archaeologist. Its scope was not only to conserve the collection but also to focus on important archaeological and documentary aspects, in that the epigraphs required a scientific re-reading and computerized cataloguing. For this, the approach of the city of Rome was to choose, among the groups available, one that could also guarantee archaeological competence. The group was asked to draft an operational project and a cost estimate. The project was then examined by the administration and felt to meet the requirements; the cost estimate was compared with others submitted by other groups and judged to be appropriate, and the work was then assigned.

The second example concerns the restoration of the Arch of Septimius Severus in the Roman Forum, carried out in the context of a global plan for five of the large stone monuments of Rome, financed in 1981 by a special law. The Archaeological Superintendency of Rome was responsible for directing the works and decided to manage the project with the scientific assistance of the ICR and with the use of groups of ICR-trained restorers (in temporary business associations) according to instructions supplied by the Superintendency itself. The Superintendency identified the groups to be put in charge of each monument, and then added other conservators to these teams. Coordination among the associations thus formed was managed through weekly meetings, which allowed for a continuous exchange of the technical and scientific information necessary to guarantee a uniform approach to treatments. The general methodological lines were indicated by the ICR, which also supervised the works, whereas the economic criteria were drawn up by the technical offices of the Superintendency.

The third and last example concerns the restoration of the Atrium of the Capitoline Museum, on commission for the city of Rome. This was a conservation treatment of the building planned by

Michelangelo which houses the museum's Roman statuary collection, as well as the collection itself (25 statues, 300 epigraphs, etc.): a single project for a collection and for the historic building in which it is housed. This was an excellent premise for obtaining a uniform treatment capable of dealing with an historic museum building (constructed in 1633 on Michelangelo's plans and inaugurated as a museum a few years later) and of treating it as a monument with a history of its own, not simply as 'container' and 'contents.'

To assign the work, the city superintendency used a mixed and highly unusual form of public tender. A first selection on the basis of credentials (carried out by the superintendency itself) produced a short list of five conservation groups, all trained by the ICR and with experience very similar to the outlined project. At the same time, ICR technicians were asked to draft a detailed proposal defining the methodologies appropriate for the treatment and specifying the costs. This top-secret plan was drawn up by a committee of ICR archaeologists and conservators and given to the city superintendency. Meanwhile, a similar request was made to the conservation groups, who also produced their project proposals. When the work came to be assigned, the group whose project most closely resembled that of the ICR in methodology and costs was given the job.

This method might appear complex, but in practice it led to interesting results. Almost all of the five proposals were very close to the methodology defined by the ICR, confirming the existence of a well-established approach, and, as further confirmation, the costs were not too dissimilar either. Our winning proposal was just 0.5 per cent less than the pre-established sum, followed by that of another firm, also widely experienced in this field, which produced an estimate about 0.8 per cent higher. The other offers were also quite close on average.

Following this lengthy bureaucratic preamble, we will look at what happens in practice in the conservation treatments. As we have seen, the project involves two distinct entities: a private one (conservators) and a public one (civil servants). Good results will depend on the way in which these two bodies are able to interact and complement each other to achieve a sole objective - implementation of the conservation treatment. Leaving aside the purely financial aspect, which is handled by the agency contracting out the work, let us see how the conservation team manages to conserve, interpret, and collate data on each project in cooperation with the civil servants. The conservation project must accomplish this; otherwise, one risks losing an opportunity for study and information. In the absence of such cooperation, conservation becomes mere 'cleaning' or, worse still, 'transformation' (from ancient deteriorated object to modern supersolidified product).

These are the criteria by which the group decides to accept a project. When the contracting agency is not disposed (either by will or cultural capacity) to undertake a conservation treatment with these methodological premises, the group's policy is automatically to refuse the project. Painful decisions are sometimes involved - in view, perhaps, of the quality of the monument or economic attractions - but experience has shown that such sacrifices are ultimately worthwhile, as they enable us to maintain a lower level of business but with higher qualitative standards.

For this reason, the few experiences we relate here were fully satisfactory, from the viewpoint of work management and final product. This was due neither to luck nor to any particular ability of the conservators, but simply to a strict selection process guiding the choices made. On one hand, we find a team of conservators engaged with the material of which the monuments are composed, as well as all the signs of time - natural and artificial - that are registered on it in some way. The task of this team is to resolve the strictly technical problems linked to the restoration of the material (cleaning, consolidation, protection, etc.) and to discover, document and understand all the signs present on the monument's surface. On the other hand is another team, the civil servants - archaeologists, art historians, architects - who are able to tap into information of an archaeological, art-historical or archival nature. Such information is a vital complement to the interpretation of the

data discovered by the conservator on the monument. Thus, the full implementation of the project will be the fruit of the integration of these two teams, who must be able to cooperate and communicate at the highest level to produce the final result, represented by the publication and interpretation of all the data collected on the monument and in the archives. All this material must be brought together in one of the many media available: books, videos, or other didactic material.

These criteria were fulfilled in different forms in the three examples described above. The forms were different because the combinations of people involved were also different. The conservation of the Capitoline epigraphs, which should be completed by 1997 for the occasion of the International Epigraphic Conference in Rome, involves cooperation between the conservators and the archaeologist directing the work for the city superintendency, as well as some epigraphic specialists appointed by the city itself. This collaboration produced the following results:

- standardization of the technical conservation methodology;
- conservation of 750 epigraphs out of 1,400;
- design of a registration form for computerized cataloguing of the Capitoline epigraphic collection;
- revision of the entire epigraphic catalogue;
- graphic and photographic documentation of the entire collection;
- a short written article on the conservation, published (and signed) by the conservator (R. Nardi);
- a paper on the epigraphic review of the texts following the restoration, published by the director of the works (M. Mattei);
- a video on the whole project produced by the group of conservators (CCA, with script by A. Costanzi Cobau);
- a study of the ancient carving techniques for epigraphs, and
- a review of the epigraphic texts, to be presented at the termination of the project by the archaeologist in charge (M. Mattei) and the conservator (R. Nardi).

The restoration of the Arch of Septimius Severus (plates 10-12), now also half completed, has a committee composed of architects of the superintendency and technicians of the *Istituto Centrale del Restauro* to support the conservation team, providing technical direction of the works. For the conservator, this group proved to be an extremely important instrument for consultation, to compare work with what was happening in Rome at the same time on similar monuments. This committee had access to the information discovered by the conservators, to the historical data collected by scholars and to the results of analyses performed by scientists. The result of this collaboration was the production of a series of technical suggestions of fundamental importance for the implementation of the conservation treatment. This work was followed by a number of articles published by the conservator. With regard to a monographic publication of an archaeological nature, the conservator (R. Nardi), who has a university degree in archaeology, obtained a brief from the superintendency to do a graphic survey and analysis of the monument. A complete publication will be presented when the other half of the arch is available for study.

We come, finally, to the conservation of the Atrium of the Capitoline museum (plates 13-15). The work, which is still going on, involves treatment of marble sculpture as well as structures in travertine and plaster, which have had numerous restoration and maintenance treatments in their history and have frequently changed appearance as a result. For example, over the centuries the plasters have become green, red, and yellow instead of light blue; the sculpture has become a

veritable repertory of the history of restoration over the past five centuries. Thus, the work offered an important occasion for study of archaeological fragments and, principally, the history of collecting and restoration.

For this purpose, a mixed working group was organized, composed of conservators, scholars of stoneworking techniques, a certain number of archaeologists and art historians from the museum, technicians of the ICR for analysis of pigments, and technicians of the British Museum for analysis of the marble. Apart from the strictly technical tasks, the project was divided in this way because the conservators could focus on the treatment of the monument and the survey and documentation of all the historic traces present on the surfaces, while the archaeologists and historians could initiate archival research that would be helpful in interpreting the data gathered by the conservators. The resolution of technical conservation problems, as well as the final presentation of the sculpture, was entrusted to the conservators. A final publication will, it is hoped, collect the results of the work in a single monograph, and will be the best yardstick to measure the efficiency of the working group and the success of the project.

In conclusion, we will attempt to answer the key question that exemplifies by itself the 'power balance' on a worksite between conservators and civil servants: who has the last word in case of technical-scientific controversies? From a strictly legal standpoint, the contracts speak clearly: 'the works must be performed according to professional standards, with appropriate personnel and materials and in conformity with the orders given by the Directorate of the Works, which reserves the option of acceptance or rejection.' From the practical standpoint, however, we have always seen the conservator delegated to resolve the everyday problems and - probably owing to good sense on both sides - the more complex decisions are postponed for common discussion. In any event, given a possible positive influence in the way the group chooses projects, we find it hard to imagine conservators and civil servants attempting to 'force' the others to do anything that goes against their own convictions.

From what has been said to this point, it seems clear that the crux of the theme in question is the human factor, but this factor is also the weakest and most variable. Whereas a professional approach ought to overcome weakness of character, it can mutate into individualistic behaviour, which certainly does not contribute to the success of a project. Nevertheless, we would like to conclude on a note of optimism. Although convinced that the human factor will always be an unpredictable and capricious variable, we also consider it highly important to codify the methodological premises which, at least in theory, should always provide guidelines for correct treatment.

Plate 10 Arch of Septimius Severus in the Roman Forum. South.

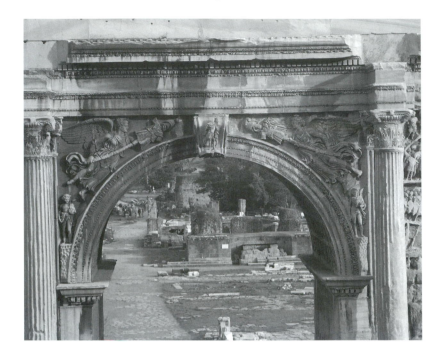

Plate 11 Arch of Septimius Severus in the Roman Forum. North, central arch.

Plate 12 Arch of Septimius Severus in the Roman Forum. North, central arch.

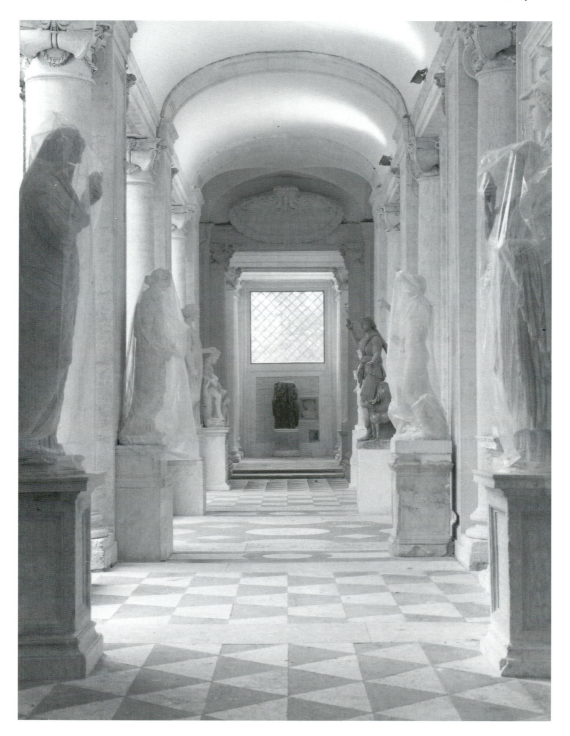

Plate 13 Atrium of the Capitoline Museum. General view.

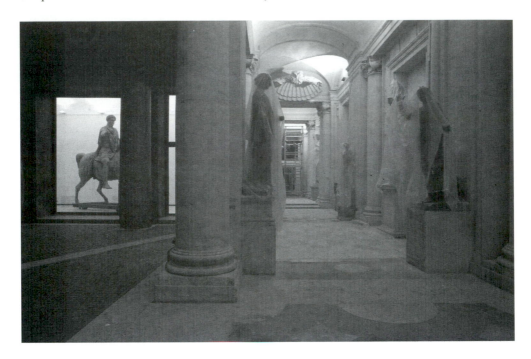

Plate 14 Atrium of the Capitoline Museum. General view during conservation work.

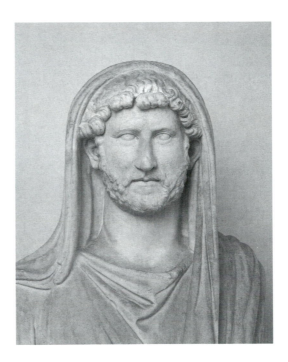

Plate 15 Atrium of the Capitoline Museum. Hadrian.

CHAPTER 6

SCULPTURE IN ACTIVE SERVICE

J. Farnsworth

Introduction

In employing the title 'Sculpture in active service' I am attempting to differentiate between sculpture within a museum environment, and those sculptures in use and often still in the possession of the church for which they were created. The latter can be subdivided into two other groups. The first still guards the graves of the patrons or flanks dusty epitaphs; or waits patiently on their altarpieces or lofty corbels and brackets on windy facades; or stands in warm and dusty interiors waiting to be discovered with the aid of binoculars. The second group of sculptures, those which I mean to discuss, are images which are touched, carried and actively take part in visually realising parts of the Bible. The thought that part of a museum's sculpture collection could be simply removed from the museum by completely unqualified persons, carried around the city and afterwards 'dusted down' and put back into the collection, is probably a nightmare for any museum curator.

There are, however, many examples of sculptures that have survived such 'unqualified handling' in Europe.[1] This type of sculpture 'in active service' has been in service for hundreds of years, and some images have been specially built for the purpose: for instance, crucifixes with swivelling arms. Others have become members of this category because of their miraculous healing powers. They have been in this environment for many years and - unlike museum objects - have a defined frame of reference (because of their function) in which all conservation and restoration actions are to be made. These actions are quite different from those taken in a museum where sculpture does not have any sacral or original purpose anymore. Naturally the aims of a museum are of a pedagogical nature and the optimal use of the current ethics of conservation and restoration can be applied. Objects in museums and private collections have in the past been victims of contemporary taste and conservation ethics. Sometimes this results in problems in the interpretation of a sculpture.[2] With objects in their original or intended environment, decisions are easier to make with respect to conservation because the sculpture often belongs to a decorative scheme, or has a particular function within its environment. In a museum with ideal working and better climatic conditions than objects on site, objects can be taken from display and put into storage until a suitable conservation solution can be found. The treatment of objects *in situ* is often influenced by many other factors which do not always lead to the optimal conservation of objects: for instance, the time pressure from architects, contractors, or politicians and the worst type of self-generated

[1] J. Taubert, *Farbige Skulpturen, Bedeutung, Fassung, Restaurierung,* Callwey, Munich, 1978, pp.38ff, 'Mittelalterliche Kruzifixe mit schwenkbaren Armen'. The author has a catalogue of forty examples of crosses in Europe with swivel-mounted arms. Medieval crosses with swivel-mounts were intended to be taken from the cross at Whitsuntide, the arms crossed over the body and the figure laid in the grave or laid in state under a baldachin. The cross is then draped with a shroud. On Good Friday, the Resurrection is visually enacted (the author has seen this practised in Siena Cathedral).

[2] Taubert, *op. cit.*; many sculptures which were transformable crucifixes with swivel arms have been fixed with dowels and the joints filled such that they appear as 'normal crucifixes'.

pressure. A current example is the 'clay figure army' from the Qin Shihuanghi Emperor (246-210BC). Seven thousand clay soldiers require urgent consolidation treatment which can be practically applied on site. This makes it difficult to apply current conservation ethics. It must be common knowledge that salt efflorescence would occur, so why have so many been uncovered? Would it not have been easier to have left most of the figures underground and slowly develop a reasonable conservation approach? The urgency with which we have to act causes us to make mistakes, but often sites develop their own dynamic, and ambition and the desire for fame lead to a sudden rush to uncover the past which often has bitter consequences for the objects. In Germany religious requirements have priority and can override the laws of protection. Fortunately this rarely occurs as the Catholic and Protestant church authorities have their own advisers, usually art historians with practical experience in working together with conservators and restorers, but more often than not compromises must be made.

Sculptures 'in active service' are used to visualise the rituals of the church: they are intended to be touched and carried and are a form of humanisation of the bible. This process started in the middle ages and reached its peak in the baroque period where it attained theatrical proportions.[3] This is a very special group of sculptures in which the primary goal for conservators must be to keep them in active service and the secondary goal is to apply the current ethics of conservation as far as possible. The fact that the sculptures are in use contradicts many basic premises of the contemporary ethics of conservators and restorers alike.

1. The Telgte Madonna

A typical example is the life-sized Madonna, dated 1370, in the small town of Telgte near the city of Münster, Westfalia. The first written evidence of the image's existence dates from 1455, when minor repairs were paid for by a gift of money.[4] The Telgte *Gnadenbild* was the focus of a pilgrimage in Münsterland. The practice of pilgrimage to Telgte was revived after the upheavals of the Thirty Years War which were ended with the Peace of Westphalia in 1648. The Prince-bishop Christoph von Galen (1650-1678) built the Chapel of Holy Mary to house the *Gnadenbild* in the hope of reviving the religious faith of a people exhausted by war. With the decretal of 27 June 1651, which declared that a pilgrimage procession was to be made each year to Telgte, the way was paved for an annual festival. The chapel's foundation stone was laid on 1 June 1654, a key date for the following years of restoration on the *Gnadenbild*, which always followed the 50th and 100th jubilees. A detailed report of the festival is given in 1754 by the curate of Telgte, C.P. Nitschen.[5]

[3] In Marienfeld, Kreis Warendorf, under the organ gallery there is a small theatre built up in different levels, like a pop-up paper picture. The stage is on wheels and allows various stages of the life of Mary to be shown. Many churches have altar pictures which can be changed with complicated pulley systems and illustrate the life of Christ (Marienfeld, Badwörishofen). Altar pillars can be made of alabaster, hollow, with a scaffold for candles within. In the Pieta by Ignaz Günther, dating from 1758, the glass eyes and hollowed-out head are illuminated from behind (Kircheiselfing, Pfarrkirche St Georg), illustrated in 'Der Altar des 18. Jahrhunderts' in the series *Forschung und Berichte der Bau- und Kunstdenkmalpflege in Baden-Württemberg* from F. Buchenrieder, *Rokokofigur und Rokokoaltar*, 1979, pp.154-55, pls.26a, 26b, 27.

[4] Church archive in Telgte. Gerd Walgarding gave a certain sum of money to repair a madonna in the cemetery 'to deme geluchte unser lewen frouwen up deme Kerchhove to Telgte' in 1455. Many more endowments were recorded during the fifteenth and seventeenth centuries.

[5] C.P. Nitschen, *Beschreibung des fünfzehntägigen Grossen Jubel-Festes. Welches zu Eheren Gottes und Seiner Allerseeligsten zu Telgte besonders Wunderthätigen Schmerzhafften Mutter MARIA Schutz-Patronin des Hoch-Stifts Münster*, Münster, 1754, printed by the court printer Wittib Nagel. The book describes the

After the end of the French occupation in 1815, the jubilee was especially celebrated; this jubilee witnessed the first major changes to the *Gnadenbild*, changes which raised some of the conservation problems to be discussed below. The figure was completely repainted in the neogothic style and the posture of the right arm of Christ, which originally hung down vertically, thus exposing the wound from the lance in His side, was changed and laid on His thigh (plate 16). The reason was that because of the ritual of touching (*Berührungsbrauch*) the arm of the *Gnadenbild* had been weakened. Over the many years of pilgrimage to Telgte the *Gnadenbild* must have been touched millions of times. In the year of the 1854 jubilee, there were 20,000-30,000 pilgrims a day. The tradition of carrying the *Gnadenbild* through the town of Telgte by the bakers' guild is over 200 years old. The *Gnadenbild* was always clothed for the festivities and had a large wardrobe of clothes which were given to it over the years (plate 17). Two particularly valuable robes, decorated with precious stones and gold brocade,[6] and fifteen other robes were counted in the inventory in 1789. There were seven bridal crowns (*Brautkronen*) and five crowns of thorns.[7]

The 250th jubilee was in 1904 when the Telgte *Gnadenbild* was officially attested by Pope Pius X as a miraculous image of the Virgin Mary. The numerous historical etchings and engravings illustrate the various robes and crowns which were worn by her over the years, and those after 1854 show the changed position of Christ's right arm. A painting of the image in a small way-side chapel was recently restored and examination revealed the original posture of the arm under the over painting (which showed Christ's right arm on His thigh).

Over the last ten years the studio of the *Denkmalpflege* has been involved in conservation work. My predecessor had the sculpture in the workshop for thorough examination and concluded that the wooden core of the *Gnadenbild* should be thoroughly consolidated. He recommended injecting consolidating material into the wooden core to stabilise it. Secondly he argued that the image should not be carried through the streets of Telgte again or even from the Chapel of Holy Mary into the church of St. Clement opposite, thus breaking a 350 year old tradition. Naturally, there was immediate passive resistance to this recommendation and stalemate ensued. The whole idea of conservation slipped into the background. In my first year in office I was called to inspect the *Gnadenbild*, unaware at first of the potential conflict I was about to enter. The paint layers were not only flaking but much of the surface appeared to be hollow, to such an extent that it appeared that there were several papier-mâché Pietas, imposed over one another (rather like Russian dolls).

The investigation had to follow a tight schedule between Christmas and the start of the pilgrim season just before Easter. The first meeting was attended by the Dean; the church council; the local office for the protection of historic buildings (*Untere Denkmalpflege*); the art historian from the Bishops General Vicariate; and the *Denkmalpflege* in my person (this is the usual combination when the first decisions are made). The most obvious solution at first appeared to be to make a copy for the pilgrims' procession and to keep the original in the chapel. The original position of

festivities in detail. The court architect and artillery officer Conrad Schlaun was ordered to design an Obelisk with the symbols of Mary and the church for the market place. It was seventy-three feet high. On one day over 40,000 pilgrims came to Telgte. The catholic priests were called from the surrounding villages to cope with the confessions of the pilgrims. Many gifts from the villages, some over a day's march away, were in the form of decorative candles, weighing up to seventy pounds. The festivities lasted for fifteen days.

[6] K. H. Engemann, 'Das Kronenbrauchtum beim Telgte Gnadenbild' in E. Ahlmer (ed.), *Marienwallfahrt Telgte*, in the series *Quellen und Forschung zur Geschichte des Kreises Warendorf*, pp.73ff.

[7] H. Gruber, *Brautschmuck der Kurfürstin Therese Kunigunde*, in the catalogue *Kurfürst Max Emanuel, Bayern und Europa um 1700*, Bd.II, Munich, 1976. Cat. No. 619, pp. 269-270, with four illustrations of the jewelled wedding dress which was given to the Holy Mother of God in Telgte.

Christ's arm could be restored, thus making it easy for pilgrims to distinguish between the original and the copy. This work would have been paid for by the local museum which would have displayed the copy with its original decoration restored, between the processions. This solution was strictly opposed by the bishop himself. Thus no copy was allowed, but there was an urgent need to act. How could the 550-year-old tradition of pilgrimage be saved? Even the most recent tradition of the bakers' guild, nearly 250 years old, was still being forcefully defended by the guild and the local community. The registered pilgrims (large groups and bus-loads of people requesting a small church service) reach around 200,000 each year, not counting the daily visits of pilgrims and tourists. The one thing that they all have in common is that they light a candle as an offering. This leads to tons of stearin wax being burnt annually in the chapel. Extractor fans have been installed and the chapel now only needs to be redecorated every three to five years. The once brightly coloured neo-gothic overpaint of 1854 presents itself as an almost black layer of dirt on the sculpture. The various repairs and retouchings over the last 140 years have slowly been toned in, darker and darker, to match the ever darkening appearance of the sculpture.[8] The question of a restoration was considered but quickly rejected for several reasons: the restoration of the 1854 decoration would only lead to its darkening once more within ten to twenty years and thus initiate a restoration cycle; there were dangers in wanting to go further and reveal the baroque, renaissance or even the original gothic decoration.

The only hope was to reassess the situation and concentrate on the state of preservation of the wooden core. The primary aim of the investigation in the studios of the *Westfälisches Amt für Denkmalpflege* was to gain as much information as possible about the wooden core using non-destructive methods of investigation. An obvious solution was the use of X-ray photography but applied to sculpture this often results in attractive and fascinating pictures which however offer little useful information. Even if two exposures are made in two perpendicular planes, the general problem of linear addition of all absorption coefficients of the different materials and the overlay of all information into one plane, the film, often makes interpretation difficult. Because X-rays are emitted from a point source and widen out to a cone, the virtual positions of all parts of the object that are not axial to the source are distorted by the projection onto the X-ray film.[9] Thus images such as iron nails can appear to go into the wood when they have been driven in from the back of the sculpture. When objects have components with large differences in X-ray absorption coefficients, or many layers which cumulatively cause high absorption, several exposures may be necessary for each area which needs to be studied (plate 18). Dr. Cromme[10] has been experimenting with a relatively new method of making X-ray recordings, the digital exposure technique. The principle is quite simple: instead of an X-ray sensitive film emulsion being used to record the remaining X-rays after the selective absorption from the object, the information is immediately transformed into digital information in the cassette. The 'exposed' cassette, with magnetically stored information, is then transferred over the interface into a computer and can be

[8] This is quite common in Germany in churches where many candles are lit. The so-called 'schwarze Herr Gott' (the black Lord God) is not to be found anywhere in the cathedral in Münster where the crucifix hung for many years. It is now clean! All literature before the sixties refers to the 'schwarze Herr Gott' and now it is just a crucifix.

[9] The phenomenon is light (X-rays) being emitted from a point source and not the usual parallel rays: compare the use of condensers in slide projectors.

[10] The Raphaelsklinik belongs to the Clements Schwester, an order of nuns which was founded in 1730 to look after patients in the Clement Hospital. My special thanks to Schwesteroberin Anette and Chefröntgenarzt Dr. Cromme without whose kind cooperation it would not have been possible to make the comparison of the X-ray techniques.

electronically manipulated on the monitor screen. The transfer erases the information from the digital cassette which can be reused many more times for further exposures. Different exposures can be experimented with in the computer without submitting the patient to further X-ray exposure. The exposure can be seen on the monitor and the optimal exposure can be 'printed' on a normal X-ray film format (plate 19). This way it is possible to achieve different contrasts and penetration. The technique is approximately ten times more sensitive to X-rays than conventional X-ray films and thus exposes the patient to a lower dosage of X-rays (for the conventional X-ray exposures we occupied the X-ray unit for several hours, whereas the new technique only required one exposure from each area). The disadvantages at the moment are the fact that the technique requires huge computer support (costing around 1.5 million DM) and that the information in exposed digital cassettes must be transferred to the computer memory within twenty-four hours as the digital cassette is highly sensitive to all stray radiation.

Another possibility is the use of computer tomography. The technique today uses a rapidly rotating X-ray tube which generates a thin beam of X-rays with a receiver opposite orbiting around the object. The information is then transformed into a picture by computer software. The advantage is that the image is not a three-dimensional image projected on a two-dimensional plane; instead, the information is recorded slice for slice as the object is moved into the measuring field. The movement into the field is usually automatic and distance between tomograms can be adjusted. The only disadvantage is that the opening is made for humans in a recumbent posture and is only 70cm across, thus physically limiting the size of object that can be examined. The images can be manipulated before they are 'printed' on a normal X-ray film and can also be magnetically stored for a later date. (This technique is still largely theoretical, as the computer memory is limited and it is primarily intended for hospital patients). It is also possible to use this technique to enlarge parts of the picture taken on the screen although the resolution and increase in detail depends on the individual performance system being used. This system runs with the automatic exposure meters which are, of course, optimised for bone and muscles. The computer tomography had technical problems with borders between materials with large differences in X-ray absorption, e.g. metal/wood or air/paint layers with high absorption because of the oblique angle of the X-rays hitting the surface. This caused refracting patterns on exposure which usually radiated around the areas of high absorption. This technique can make relative measurements of the absorption to enable the content of the cavity to be defined as bone compared to other objects with a lower density e.g. parchment (plate 20). Further, a reconstruction can be made of a chosen plane perpendicular to the measurements. A perpendicular plane was chosen through the reliquary cavity in the head of the Virgin. It revealed bone splinters or a tooth, and smaller unidentified objects. The results were interesting with respect to the state of preservation of the wooden core. In addition to the repairs to the core, bored cavities containing relics were discovered in the heads of Mary and Christ, and the changed position of Christ's right arm - in which parts of the original arm were reused - was revealed. The legs of Christ had been renewed just below the knees and the throne had been completely renewed in 1854. The shrouded covering of the throat was also found to be an addition of the mid nineteenth century. To complete the examination, the iron handles on the figure were removed and through the bolt holes an endoscopic examination was carried out. This not only confirmed the results of the computer tomography but the extent of the repairs could be observed and photographically recorded. The replacement of Christ's legs had not been documented but by comparing stratigraphy of the paint layers using an operation microscope it was found to be a repair from 1854. (None of the above-mentioned techniques gave any information about the paint layers. Unfortunately the resolution was too low and the lead white content caused further contrast problems because of its high absorption characteristics).

The examination confirmed that the wooden core was in a relatively good state of conservation: there was minor degradation from woodworm attack. The head of Christ had been broken off and reattached using a pine dowelling (this was indicated by a fine crack in the paint layers under the chin). The Pieta was made out of poplar and not lime wood and the carved back was made out of pine (the species were later positively identified by the forestry department of the University of Göttigen). The flaking had previously been consolidated with wax which hindered further consolidation with fish glue. Luckily, larger areas had been only temporarily consolidated by sticking over the many flaking hollow areas a very fine black silk net with very little wax. Thus lacunae were successfully camouflaged and secured for the final consolidation work.

To gain more information about the paint layers and gesso grounds, old areas which had been opened in the previous examination and skilfully camouflaged by the black silk netting were reopened and the edges of flaked areas were examined. There were three layers of fine canvas covered with what appeared to be a very fine brownish plaster with white particles in it, which was confirmed by scientific examination to be fine sand mixed with lime. This was the preparation for the repaint of 1854 and served as an 'exoskeleton'. The adhesion to the paint layers below is very weak but the layers of canvas and fine lime plaster covered the whole figure like a shroud. There were more layers of canvas to be found on the carved wooden cover on the back of the figure; this is a very old and common technique to cover joins and wooden knots to prevent cracking in the gesso. The consolidants which it had originally been proposed to inject into the wooden core, to stabilise it, would have been absorbed by the porous lime plaster and canvas and would have joined them irreversibly with the older paint layers.

Although the Pieta has been 'mishandled' over the last 500 years, parts of the original decoration have survived. Especially worth mentioning is the border manufactured by pressing or stamping a flexible putty into a form which later hardens.[11] The pressed or stamped material was found to be mixture of red lead, quartz sand and linseed oil. Examples of this decorative technique have rarely survived over the years, even on objects which have been in museums or in the care of collections. Sometimes the contemporary methods of conservation have caused more damage to unusual types of applications and decorative objects than those which have remained untreated. During the examination it was possible to establish the colours of the first decoration: hair: gold, shroud: white with a golden pressed border and blue on the inside, plinth: green, and shoes: black.

Conclusion

The wooden core was found to be stable and the gesso support as a whole was also stable. It was decided to do no consolidation work on the ground because of absorption of consolidants in the very porous lime plaster. Flaking paint was consolidated where necessary with a fish glue. The alternative preferred to a massive conservation campaign and the use of large amounts of consolidants was that of careful observation. The Pieta is thoroughly examined twice a year and checked over before and after the procession. The new flaking areas are recorded on a transparent

[11] F. Buchenrieder, *Gefasste Bildwerke*, in the series *Arbeitshefte des Bayerischen Landesamt für Denkmalpflege*. Compare the mid-fourteenth-century Pieta in the Cathedral of Wetzlar. The nearest pressed border in size and style is that of the Pieta in the Rheinisches Landesmuseum in Bonn, from the earlier Roettgen collection, dating around 1300. The best illustrations are in the paper by M. Frinta, 'On the Relief Adornment in the Klarenaltar and other paintings in Cologne', in the *Vor Stefan Lochner: Die Kölner Maler von 1300-1400: Ergebnisse der Ausstellung und des Colloquiums* in the Kölner Berichte zur Kunstgeschichte Begleithefte zum Wallraf-Richartz Jahrbuch 1977 Band 1, p. 131. Examples of pressed or stamped borders can also be found on the Pietas in Dieberg, Fritzlar, Eschweiler, Münstereifel and Wetzlar.

OHP-sheet in Din-4 size over black and white photographs in each examination. Thus the development of damage can be chronologically charted and perhaps only the problem areas treated in the future instead of a 'blanket treatment' of the whole sculpture with consolidants. The baldachin is in use once more to protect the Pieta from sun and rain. A new carrying platform has been built to accommodate all sizes of bakers! The bakers were always invited to attend the discussions as were the church council. The studio was always open to them and they were confronted with the problems and the amount of work required to care for an object that looked the same before and after treatment. I am convinced after working for many years here that the best treatment is no treatment and that people should be encouraged to be directly involved with 'their' objects.

2. The Crucifix from Billerbeck

This crucifix belonged to the church of St John in Billerbeck and once stood on the Holy Cross altar. It was sold with the figures of Mary and John on 7th August 1843 to a farmer named Kemper.[12] In 1954 it changed hands once more; this time the St John's parish gave Kemper's descendant a more recent stone image in exchange for the old cross and figures which had been sold to his family generations before. The group was repainted in a stone colour. The crucifix is made of wood and the two sculptures (St John and Mary Magdalen) are stone. The crucifix is life-size and dates from the first half of the fifteenth century; the stone figures, on the other hand, are dated around 1600. The group was hung in the Ludgerus Brunnenkapelle in Billerbeck between 1959 and 1986. When the chapel was restored and the chapel redecorated, the crucifix was 'rediscovered'. It was then identified as carved from wood and not stone as had always been thought. After a preliminary investigation it was found that the paint layers, fifteen in all, had been shrinking and caused a surface tension which caused the paint to flake off down to the wooden support (plate 21). Consolidation was difficult owing first to the thickness of the paint layers, and secondly to the dead 'thunderflies'[13] under the flaking areas. This biomass of chitin proved to be the equivalent of a perfect non-stick layer.

As the crucifix and the stone figures had now become 'homeless' because of the new decoration in the chapel the problem arose of what to do with the crucifix once it had been conserved and who was to pay for the conservation. A suggestion was made to return it to the church of St John and hang it in the choir arch in the church. For this was at least the historical location of the crucifix, which once stood on the Altar of the Holy Cross directly under the choir arch.

After extensive examination, the decision was made to thin down the layers of over-painting, (the first eleven being monochrome sandstone coloured, and the last three carnation overpaintings). No one wanted a stone coloured crucifix and since the church committee was prepared to pay for a crucifix with polychromy, the final decision was to remove the over-paintings down to the first carnation paint layer. A conservation and restoration proposal was submitted and approved by the church committee; the Bishops General Vicariate; the *Untere Denkmalpflege* (and the *Denkmalpflege* in my person). Costs were to be split into three: Church; General Vicariate; and the

[12] *Verzeichnis des Pfarrers Henneweg über die zur Reparatur und Verzierung der Kirche in Billerbeck eingenommenen Gelder* (a list compiled by Pastor Henneweg in 1856 about the money received for repairs and refurbishing in Billerbeck; money was raised by selling altars, sculptures and fittings). The first item mentioned in the list is 'Vom Zeller Kemper auf der Beerlage für ihm verkaufte alte Kruzifix mit den beiden Figuren 18 Rthlr.' The old crucifix and two figures were thus sold to Zeller Kemper in Beerlage.

[13] 'Gewitterfliegen' or 'Thunderflies' belong to the family of Thysanoptera and swarm out on hot summer evenings often before thunderstorms.

Denkmalpflege. The next step, which must be made before any work or movement on or near a protected object can begin, is the *Benehmensherstellung*, where written permission is applied for and the plans are submitted for approval. If the plans require expertise or the *Untere Denkmalpflege* has doubts, then our office is asked for advice. Nevertheless, written approval must come from the *Untere Denkmalpflege*. When approval is given, the date when work is to start must be given and all deviations from the plans or in the restoration work itself must be approved once more. It was then possible to conserve and restore, to find a suitable hanging place, and to finance work on the object.

During the restoration work the figure of Christ was X-rayed and a computer tomogram was made in the Raphaelsklinik, once more with the kind help of Dr. Cromme. In the middle of the chest a cross shaped depository for a reliquary was rediscovered. It had been originally closed by a small window of horn which was fixed with fifteen nails with gilded heads. The window had been broken and the original contents, most certainly of great religious but most probably of no monetary value, were lost or simply thrown away. Stone fragments and bones embedded in a mass of window putty served as a filler. The figure had not been hollowed out, which is unusual for a figure of this size and the long cracks did not correspond to the expected radial cracking of the wooden core. The pith of the tree trunk used was almost carved away on the upper surfaces and in the stomach area. A hollowing of the figure would have weakened the structure and caused it to break into long segments. An attempt is in progress to carry out a dendrochronological dating on the growth rings that can be well defined by computer tomography. The X-rays revealed the over-large sockets for the arms which were fixed with wooden dowels. The figure of Christ was removed from the cross and remains of the first decoration were found, azurite in a binding of animal glue. This had survived the wind and weather for over 150 years (plate 22). The crucifix is being prepared for the exhibition 'Imagination des Unsichtbaren' in the Landesmuseum in Münster as part of the city's 1200th Jubilee.[14]

[14] 'Das Unsichtbare an ihm wird ja als Begreifbares seit Weltschöpfung an den Werken gesehen.' (For the invisible things of him from the creation of the world are clearly seen) Romans 1,20.

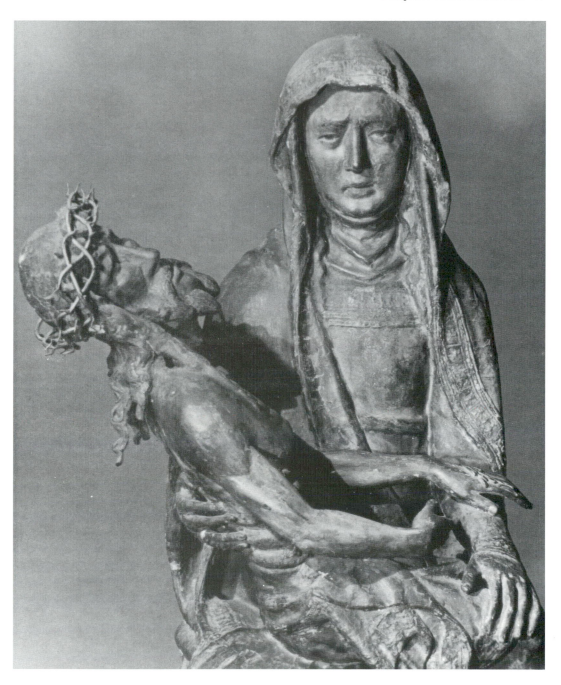

Plate 16 Telgte Pieta, Kreis Warendorf.

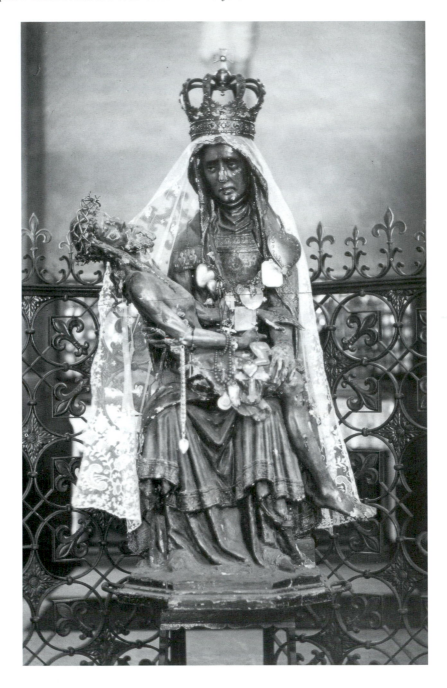

Plate 17 Photograph of c.1890, showing the gifts of gold and silver hung round her neck as thanks for her thaumaturgical powers. Often valuable jewellery was offered or hammered silver sheets in the form of the limb or organ which had been healed. Christ has a crown of thorns and the Virgin a golden crown.

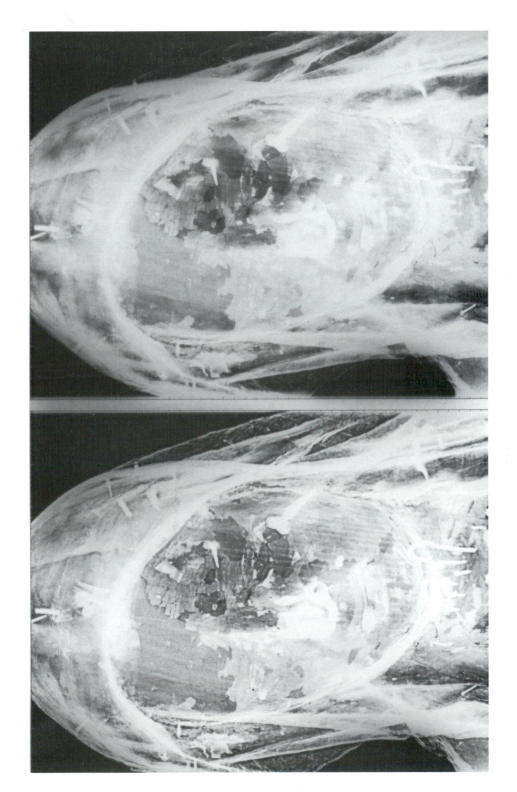

Plate 18 Telgte Madonna's head, X-ray photographs.

49

Plate 19 A digital X-ray positive can be manipulated with the aid of a computer: here the absorption of the X-rays is shown in black.

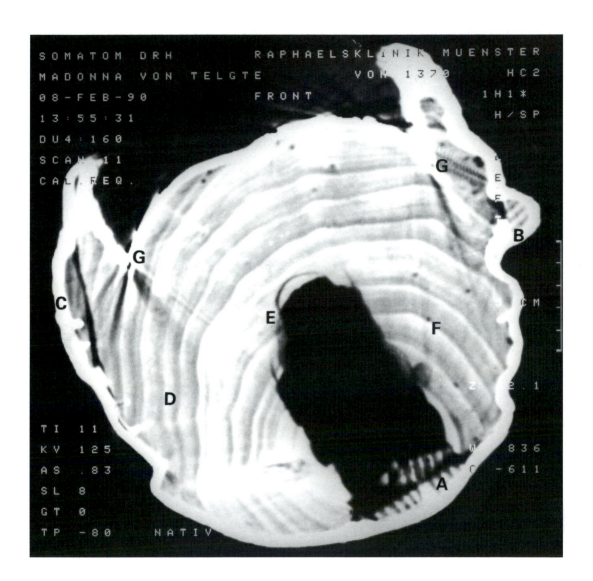

Plate 20 Computer Tomogram representing a cross-section of the Virgin's head at eye level.
Different types of wood can clearly be seen. A the pine wood cover plate which has been split by a
fixing nail. B a pine wood repair on the right-hand side of the neck shroud. C a repair on the left of
the shroud attached with nails. D the distinctive graining of the poplar. E the tooling marks of a
gouge within the cavity. F worm holes as black dots. G the diffraction patterning caused by the
X-rays hitting the much denser paint layers.

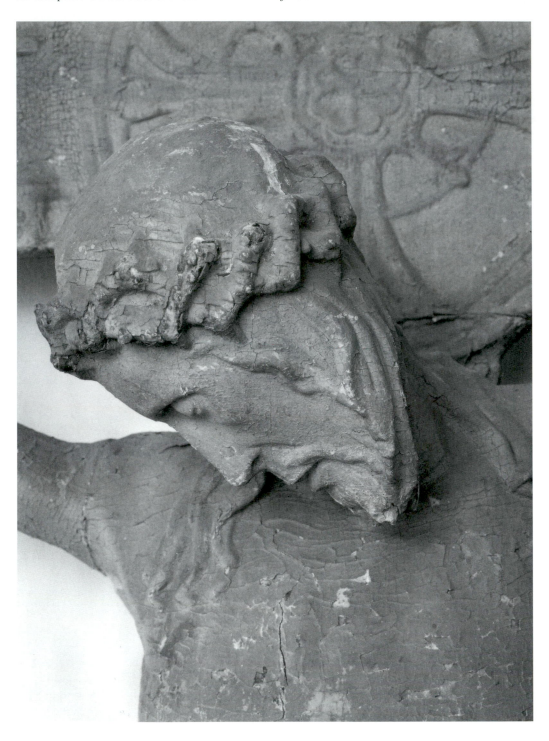

Plate 21 Detail of the Head of Christ, before conservation, showing paint layers flaking.

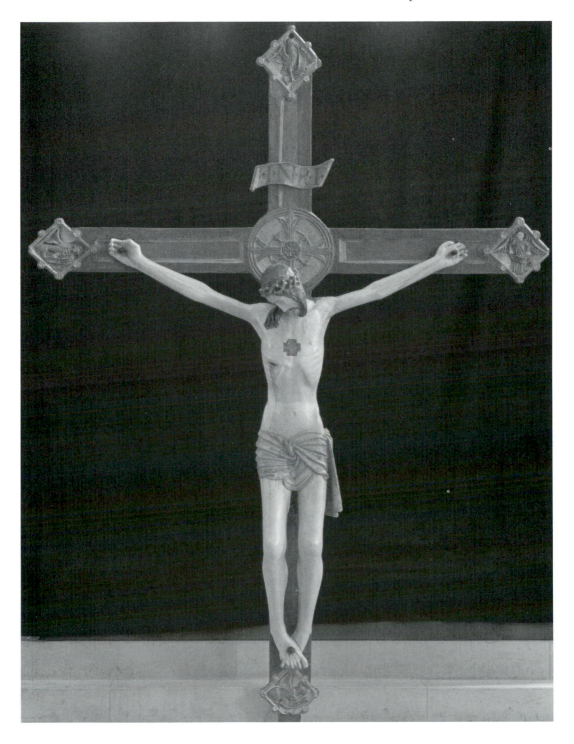

Plate 22 Billerbeck Crucifix, after conservation.

CHAPTER 7

PRESERVATION OR DESECRATION? THE LEGAL POSITION OF THE RESTORER

R. Fry

There are some problems and a lot of concerns. What about the artist who intentionally makes a work of art knowing that it is going to fall apart, and taking delight in that fact? What do you do with a work of art like that once it is old and has this incredible dollar figure put on it? These things are passed on to conservators because people are in a panic about stopping the deterioration. Who do you honour as a conservator? Do you honour the artist, the owner or the art market.[1]

From Leonardo da Vinci to Sir Joshua Reynolds, artists have continued to feel an urgent need to experiment - striving to reach that particular meeting point of their imagination and the reality of the materials to hand. In the last fifty years, there has been an acceleration, not only in the materials ostensibly available for artists, but also in the parameters of what forms are acceptable as 'art'. In this period there has also been an irresistible desire to reflect varied images of a society seen by many as ephemeral and in transition. These factors have led many modern artists to disregard established methods and traditional modes of representation in order to use materials which are themselves experimental and ephemeral. In time, however, problems[2] have beset the physical condition of many works of artists as varied as Naum Gabo, Marc Rothko and Marcel Duchamp.[3] Some artists have gone further and included change and deterioration as an important - and in some cases essential - element of their work. Josef Beuys was particularly pleased with the oily and rancid state which his *Fat Battery* (plate 23) (made of felt, margarine, wood and cardboard) had reached by 1984, twenty years after its making. The Tate Gallery's notes on this piece (T 03919) refer to the importance of fat: 'a material never used in sculpture before...Through the reversionary consistency of fat one can observe the changing of substance back to the formless state'.[4] Damien Hirst, known to art journals and tabloids alike as the man with the eight foot shark, can hardly avoid deterioration in his work. *One Thousand Years* showed a rotting cow's head being consumed by bluebottles. Whatever its message, it is not one addressed to conservators schooled in traditional techniques. In the face of such inadvertent - or obvious and insistent - change it is apparent that standard views and techniques of conservation may be irrelevant and, indeed, ineffective.

Decisions have to be made: should the work be restored to its original state at the time of making - or should it be frozen in its existing state in order to prevent further change? Or in some other, intermediate stage believed to be typical or representative of the true nature of the work?

[1] Suzanne Penn interviewed in *The Journal of Art,* 1/2 (January 1989).
[2] See for instance R. Perry and S. Hackney 'The ageing of modern painting materials: A survey of conservation problems - and some approaches' *Apollo,* (July 1992), 30-34.
[3] R. Perry, 'Conserving Change : Conservation and Modern Art', *Art Monthly,* (September 1990), 5-7, and E. Gibson, 'The Other Rothko Scandal', *The New Criterion,* (October 1988), 85-88.
[4] G. Adriani, W. Konnertz and K.Thomas, *Josef Beuys Life and Works,* New York, 1979.

The choices are necessarily subjective and restorers presented with a problematic or damaged work may turn initially to their own professional standards and guidelines - but these give little assistance other than to confirm the conservators' view that the primary obligation is to preserve, with as little interference as possible. However, with certain works, preservation is interference - interference with a process that has been dictated (or tacitly accepted) by the artist. Hard decisions therefore remain.

It might be anticipated that in the context of preservation there would be an obvious consensus between the views of the owner and that of the conservator. But the catalogue of works wilfully destroyed or damaged by their owners makes a fascinating article[5] and clearly restorers cannot justify their actions simply by referring the decision back to the owner - who may be a temporary, and even negligent, custodian of an artwork. John Ruskin, for instance, disgusted with a portfolio of erotic drawings which turned up after Turner's death in 1851 took his duties as executor seriously: 'Suddenly it flashed on me that perhaps I had been selected as the one man capable of coming in this matter to a great decision. I took the hundreds of scrofulous sketches and paintings and burnt them where they were, burnt all of them'.[6] But destruction is one thing; it is tampering with an artist's work that evidently leaves an artist outraged. For example, David Smith, an American sculptor, created a work entitled *Seventeen H's* carefully layered with six coats of cadmium red and aluminium powder. The owner felt it needed some improvement and, preferring the work to be cleared of all surface decoration, had it stripped back to the original metal. The protests of the horrified artist were here of little relevance to a determined owner, convinced of his own aesthetic judgement.[7] Public opinion may also be in opposition to the working of a restorer: the row over the restoration of Barnet Newman's *Who's afraid of Red Yellow and Blue III*[8] has aroused considerable public debate and precipitated a writ for libel issued by the restorer, Daniel Goldreyer.

There is one person who can claim to speak for the integrity and wishes of the artist, and that is the artist himself. Should he or she always be consulted? For anyone wishing to be seen to be even handed and fair, however, the process of consultation may lead to a moral commitment to accept what advice may be given - and this advice may be at odds with the prudent and, by definition, conservative techniques of the conservator. Some artists are totally uninterested in any form of conservation or are opposed to any meddling in what they have fashioned as a protean image. Even Whistler maintained: 'Tampering with the work of an artist no matter how obscure is held to be in what might be called the international laws of the whole art world ... a villainous ... offence'.[9] This particular outburst related to the important matter of the repainting by the Royal Society of British Artists of a signboard for its meeting room.

Finally, there is another more potent restraint. These are the legal rights which are always vested in persons other than the museum, dealer or collector who may be in control of an artwork.

[5] A. Berman, 'Art Destroyed: Sixteen shocking case histories', *Connoisseur,* (July 1989), 74-81.

[6] Frank Harris, quoted in 'Art Destroyed', *supra.*

[7] (1960) 59 (Summer) Art News 6 referred to in S. Simpson, *The Visual Artist and the Law,* 2nd edn., Law Book Company Limited, 1989.

[8] See *The Art Newspaper*, 13 (December 1991) and (February 1992) and 'Restoration ruins ceiling': *The Independent,* 20 March 1991.

[9] Whistler. Degas was reported to have said 'What do I want? I want them not to restore the paintings ... A man who touches a picture should be deported.'

Berne Convention

Throughout the territories of the signatories to the Berne Convention for the Protection of Literary and Artistic Works (over ninety countries including the USA, the UK and all EC countries) there is established certain minimum protection for artists in terms of copyright. The Convention does not use the word 'copyright' but the principal elements of the protection required by the Convention are:

i. that copyright subsists in every original artistic work - without the need for any registration or other formality,[10]
ii. that the rights are first given to the author[11] and
iii. that the protection period continues to subsist until at least fifty years after the death of the artist.[12]

It follows therefore that there may remain copyright protection in respect of works of art created even at the turn of the century (e.g. early works of Picasso) and, accordingly, a legal framework of rights and restrictions remains in place for many artists who may have died many years ago and, of course, all living artists. In certain countries (such as France and Germany) the period can be greater. In France, for instance, the period of protection for copyright was extended in certain cases by reason of the interruption in the war years; accordingly, Claude Monet (1880 - 1926) remains in copyright there. Even in Britain where there is the minimum period of copyright protection, artists such as Matisse, Utrillo, Kandinsky and Leger still remain in copyright. The term of copyright is in any case to be extended to seventy years *post mortem auctoris* in the EC in respect of many classes of works.[13]

Copyright does not give any specific positive rights to the holder; the system is primarily based on the right to prevent others from copying or from carrying out any of the 'restricted acts' - any person so doing is declared to be in infringement of copyright. Apart from the economic basis of copyright the Convention also includes so-called moral rights; of particular relevance is Article 6.

> Independently of the author's economic rights, and even after the transfer of the said rights, the author shall have the right to claim authorship of the work and to object to any distortion, mutilation or other modification of, or other derogatory action in relation to, the said work, which would be prejudicial to his honour or reputation.

This continues:

> The rights granted to the author ... shall, after his death, be maintained, at least until the expiry of the economic rights...

There are two particular moral rights which are of critical importance to restorers:

i. False attribution: A person has the right not to have an artistic work falsely attributed to him where either the work was not created by that artist or where the work is dealt with in the course of business as an unaltered work, where it has been altered since it left the hands of the artist.

[10] Art 5 (2) *Berne Convention for the Protection of Literary and Artistic Works,* Paris Act, 24 July 1971.
[11] Art 2 (6) *ibid.*
[12] Art 7 *ibid.*
[13] See now the *EC Directive on Copyright Protection* (Term of Copyright) No: 93/98 (ISBN 011-912-5781[1290]).

It therefore follows that a person dealing with 'the work' (and this will include a restorer) may infringe the artist's right if the work undergoes 'alteration' and, subsequently, the artist (or his estate) claims that the authenticity has been lost. In other words the work can be disowned - with perhaps a consequent collapse in value.

ii. Derogatory Treatment: The artist can bring an action as a breach of statutory duty to prevent such treatment of his work.

> If it amounts to distortion or mutilation of the work or is otherwise prejudicial to the honour or reputation of the author...[14]

The right extends not only to preventing the treatment but also any exhibition of either the work or a photograph of it. Restorers must therefore be aware of the specific legal boundaries - beyond which they step at their peril.

The relevant legislation in the UK only came into effect in 1989[15] and accordingly reported cases are few. France has, however, always accorded great regard in its laws to creative works and traditional French copyright doctrine views any work of the mind as bearing the imprint of its author's personality.[16] It follows that French law maintains that it is right and proper that the author should have certain prerogatives regarding exhibition, attribution of authorship and, more generally, respect for the integrity of the work. The American painter Whistler, for instance, when living in Paris had been commissioned by Lord Eden to make a portrait of his wife. Whistler completed the picture and even allowed it to be shown briefly at the Salon du Champ de Mars. It was, apparently, received very favourably but there then ensued a bitter dispute concerning the commission price. In a fit of pique, Whistler painted out the subject's head; legal action followed. The Cour de Cassation (Chambre Civile) acknowledged that Whistler had been in breach of contract but refused to make any order that Whistler restore the painting reasoning that 'the author alone has the right to divulge his work'.[17] In another case,[18] Georges Roualt had signed a gallery agreement with Ambroise Vollard under which he passed over his entire output in return for a yearly retainer. It was specifically confirmed that works would only be classified as finished when they had been signed by the artist. Vollard died in 1939 and over 800 canvasses by Roualt were found in the gallery, all unsigned. The Cour d'Appel (Paris) heard that the practice had been that Roualt would attend at the gallery from time to time working intermittently on various of the pictures and, only when he was completely happy with them, would he sign them and effectively give delivery in the legal sense to Vollard.

Vollard's heirs naturally claimed ownership to this valuable cache but this was barred by the Court on the basis that Roualt alone had the moral right to determine when the work was complete - and in those circumstances he could prevent the distribution into the art market of these incomplete canvasses.

There are limits however: Salvador Dali asserted his right to integrity for his work because he claimed that theatre costumes he had designed were not satisfactory. The Cour d'Appel in Paris

[14] It is not clear whether the word 'otherwise' is intended to qualify the 'distortion or mutilation' or to any such treatment which is demonstrated also to be prejudicial.

[15] *The Copyright Designs and Patents Act 1988* came into force on 1 August 1989. See Chapter IV (SS>77-89) for Moral Rights.

[16] *International Copyright Law and Practice,* Nimmer and Geller (Mathew Bender) FRA -

[17] Cass civ. 14 March 1900; *Dalloz Periodique 1900* (1) 497 referred to in Geller (*supra*) at FRA-95.

[18] Desbois, Gaz. Pal 1947, I, 184; Paris 19 March 1947 D(1949) 20 and Simpson pp. 127-128.

acknowledged[19] that, in principle, the artist has the right to modification or correction which might alter the character of the work but here concluded that the additions were minor and did not 'result in an inaccurate portrayal of the work'. This decision was, however, criticised as the court's supplanting of the artist as the final arbiter of the integrity of an artist's work. Bernard Buffet obtained an injunction[20] to prevent the disassembling and subsequent sale of one of his works - a series of refrigerator panels - by a purchaser who had bought the panels at a charity auction. Buffet was able to maintain that the work had to remain intact.

More recently there has been considerable activity regarding 'the colourisation' of old black and white films. John Huston, the film director, obtained in France a preliminary injunction[21] against the televising of a newly coloured version of 'The Asphalt Jungle'; this had originally been produced in black and white in the United States. What was of particular relevance was that the director John Huston did not own the copyright in the film (this was owned by the production company). There may be seen here parallels with the rebronzing or patination of sculptures or even the cleaning of marble sculptures such as the *Ilaria del Carretto* by Jacopo della Quercia.

Position in the USA

Not surprisingly it is the USA, and California in particular, which has the most wide-ranging laws to entrap an ambitious but unwary restorer. It is generally understood that federal law does not include the *droit moral* but nevertheless a number of states have either extended state law to cover these areas or have expanded notions of traditional common law in order to protect the interests of what are recognised elsewhere in the world as moral rights.

'Mutilation' of an artwork accompanied by public display or distribution may be actionable. In one case[22] this was held not only to be a form of copyright infringement but also a violation of the relevant federal trademark statute.[23] New York State law prohibits the unauthorised reproduction, public display, or publication in New York of

> a work of fine art ... in an altered, defaced or mutilated form if the work is displayed, published or reproduced as being the work of the artist or under circumstances under which it would be reasonably regarded as being the work of the artist and damage to the artist's reputation is reasonably likely to result therefrom.[24]

The State of California goes further:

> The legislature hereby finds and declares that the physical alteration or destruction of fine art which is an expression of the artist's personality is detrimental to the artist's reputation, and artists therefore have an interest in protecting their works of fine art against such alteration or destruction; and that there is also a public interest in preserving the integrity of cultural and artistic creation.

The California Art Preservation Act (from which the above declaration[25] is taken) continues:

[19] Paris, 1e ch. 30 May 1962, D. 1962, 570 (Geller *supra*).
[20] Paris, 1e ch. 11 May 1965, D.S. 1967, 555, Note Francon (referred to in Geller *supra*).
[21] Paris, 1e ch. 25 June 1988, R.I.D.A. 1989, No. 138, 309 (Geller *supra*).
[22] *Gilliam -v- American Broadcasting Cos.* 538 F.2d 14 (2d Cir. 1976).
[23] *The Lanham Act* 15 U.S.C. Sec 1125(a).
[24] *Artist's Authorship Rights Act 1983* (New York) Sec. 14.03.
[25] *California Civil Code* S.987 (a) (a).

> No person, except an artist who owns and possesses a work of fine art which the artist has created, shall intentionally commit or authorise the intentional commission of, any physical defacement, mutilation, alteration or destruction of a work of fine art.[26]

Until now, restorers might feel confident that none of the laws quoted could possibly be of relevance to them. However, the Act confirms its essential protection of the interests of artists by stating:

> No person who frames, conserves or restores a work of fine art shall commit, or authorise the commission of, any physical defacement, mutilation, alteration or destruction of a work of fine art by any Act constituting gross negligence.[27]

'Gross negligence' may not be such an unusual occurrence; there is a legal presumption in favour of this having been established if there was, simply, so slight a degree of care as to justify the belief that there was 'indifference to the particular work of fine art'.[28]

As outlined earlier, such rights do not die with the artist; the Californian moral rights continue for fifty years after the date of death and are then exercised by the heirs, legatees or personal representatives of the artist. Words such as 'distortion' and 'mutilation' are not usually part of a restorer's vocabulary, but the words may readily be used by artists incensed in circumstances where they see a gross interference with their work but where a restorer sees only a sensible course of preservation initiated in order to save a fast deteriorating work of art. The acute sensitivity of some artists in relation to how their work is treated (and the readiness of some courts to accept their declarations) is now coupled with the increasingly litigious systems within which professionals now operate in many countries. This points to an increase in legal proceedings in respect of conservation or restoration.

Restorers and conservators should therefore take certain steps: standard terms and conditions should be introduced and the proposed course of restoration - and its likely results - must be in writing and agreed in advance. Further, it may in the future be prudent to require that the owner, or person who has authorised the restoration, give an indemnity to the conservator which indemnifies them from any legal claims and proceedings in respect of the agreed course of restoration. The restorer should also consider suitable insurance - not only against physical damage or loss to artworks but also extended cover in respect of negligence claims, particularly where the restoration of the relevant artworks has a close connection with any of the jurisdictions outlined in this essay.

[26] S. (c) (1) *ibid.*
[27] S. (c) (2) *ibid.*
[28] S.1. (1987) (c) (2) *ibid.*

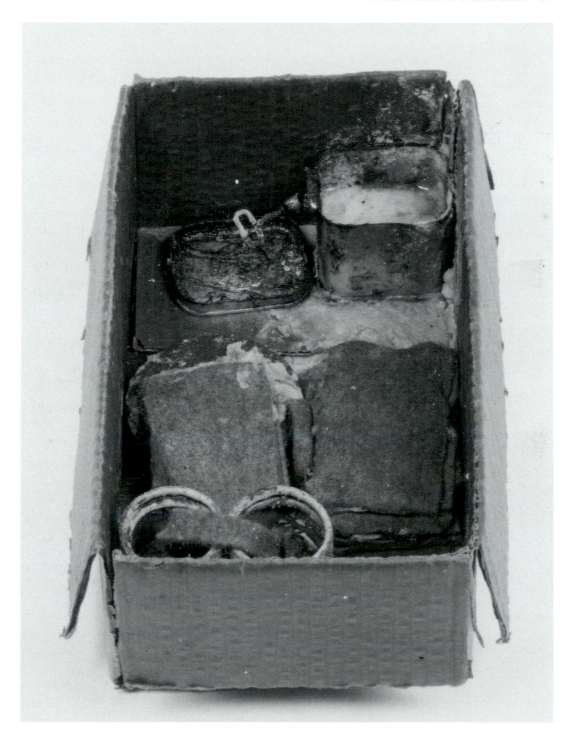

Plate 23 Joseph Beuys, *Fat Battery*.

The Conservation Group, based in four regional teams, is responsible for advising the Secretary of State for Heritage on listing historic buildings and scheduling ancient monuments. It liaises closely with planning authorities. It is also empowered to offer grants in aid to preserve monuments or buildings that are of national importance under Section 24 of the 1979 Ancient Monuments Act;[2] or Section 3A of the 1953 Historic Buildings and Ancient Monuments Act[3] and the 1990 Planning Act (Sections 77 and 79)[4], which empowers grants to buildings in conservation areas. From this provision comes the opportunity to conserve 'fixtures' interpreted as important non-structural elements of a building or monument which add to its historic or architectural importance. In addition, the Conservation Group administers the Church Grant and also the Cathedrals Repair Grant, initiated in 1991 and the recipient of £11.5m from central government so far. A considerable amount of conservation work to be carried out on fixtures is identified during the inspection carried out prior to the award of grant-in-aid. It may also come into consideration when permission is requested to repair or alter listed buildings or to intervene in any way with a scheduled Ancient Monument.

English Heritage's Historic Properties Group has in its care around 400 buildings and monuments. Some, like the World Heritage sites of Hadrian's Wall and Stonehenge, are of international importance, as well as being foci of national interest and occasional controversy. Some are ruins, or earthworks representative of a particular period; others are roofed castles, like Dover, attracting many visitors; or historic houses, such as Kenwood, transferred to the ownership of English Heritage from the Greater London Council (GLC); or Audley End, now in the guardianship of English Heritage.

In the curatorship of Historic Properties Group, collections and objects amounting to an estimated five million items are stored or displayed in historic houses or at twenty-five site museums. Their care requires a substantial input of conservation time, some of which may be provided in-house, but much of which must be commissioned from the wider field.

Newly named, the *Research and Professional Services Group* (RPS) was formed to create a research environment for professionals (architects, engineers), scientists and conservators to work together on the active task of preserving the heritage. Within the Group three branches practise, respectively, the conservation of architectural material: painted surfaces (on canvas, panel, or wall); artefacts, fresh from excavations or as a part of English Heritage's collections; and the collections themselves. All three branches are involved in the process of audit, disaster mitigation, standard setting, research, outreach, and - increasingly - education. In a climate where resources are stretched, the Group tries to focus its efforts so as always to secure maximum benefit from each conservation task. For example, through upgrading the commissioning and evaluation procedures for buying in conservation from outside, it seeks to influence professional standards.

Much conservation commissioned on behalf of English Heritage is engendered through the 'fixtures' route, where grant-in-aid is offered for the repair of an outstanding building or monument, and, usually as a subsidiary part of the programme, an important fixture is also included. It is a policy that the repair of the building comes first. Although a very important fixture may be considered for grant aid in isolation, approval should never be given unless the building and its environment are sound. English Heritage's curatorial team also commissions a considerable amount of conservation, and the Artefact Conservation team, which provides for the bulk of archaeological conservation carried out nationally, through its six contract conservators, may also commission

[2] The Ancient Monuments Act (1979).
[3] The Historic Buildings and Ancient Monuments Act (1953).
[4] The Planning (Listed Buildings and Conservation Areas) Act (1990).

CHAPTER 8

A STANDARD FOR CARE: THE ROLE OF ENGLISH HERITAGE IN THE PROVISION OF CONSERVATION EXPERTISE

K. Foley

The statue of Eros in Piccadilly is a Grade I listed building. An excellent piece of garden statuary may be listed in the same way; but a sculptural alabaster tomb within a church is likely to be a 'fixture' in a building of outstanding importance, like the stained glass, or the rood screen; and a buried, waterlogged site might be a scheduled Ancient Monument, as is the obviously sculptural lead lion of Alnwick Bridge.

These apparently arcane designations reflect the remit of the Historic Buildings and Monuments Commission (now known as English Heritage) and created in 1983 by the National Heritage Act.[1] Its brief is to secure the preservation and to increase the public's knowledge and understanding of heritage. Its responsibility to advise the Secretary of State for Heritage on the listing of historic buildings and the scheduling of ancient monuments, and its other powers, are a potent instrument in ensuring the preservation of the built environment and those other items of our national heritage which need protection.

However, the examples listed above, which are protected by statutory means, also demonstrate something of the wide range of building materials and artefacts that English Heritage may be responsible for, and through its grant-aid programmes and statutory advice, must ensure that any necessary conservation is carried out to the highest standard.

For professional conservators, practising their discipline on specific materials and categories of objects, it is often rather difficult to trace the connection from the broad, national remit of English Heritage to the point of focus where they may be commissioned to carry out a piece of work in the workshop or studio. How do English Heritage's statutory obligations impinge on them? What effects, if any, do English Heritage's own team of practising conservators have on standards to be adopted for commissioned conservation? This paper, by taking as a model the path adopted for the conservation of 'fixtures' (defined below), will show how the in-house conservation team attempts to influence standards in collaboration with others in the field. It will also show how English Heritage endeavours to gain maximum effect on standards by the research it funds, and also by the education and training it supports.

The structure of English Heritage reflects the three broad areas of work undertaken by the organisation. Three groups - Conservation, Historic Properties, and Research and Professional Services - reflect, respectively, English Heritage's listing, scheduling, advisory, planning and grant-aiding activities; its stewardship for historic properties in care; and the scientific, technical and practical tasks it undertakes. It liaises closely with planning authorities in operating the Town and Country planning system as it relates to conservation, particularly through the listed building and scheduled monument consent processes.

[1] The National Heritage Act (1983).

specific additional work on a project, or on behalf of the collections. However, since this paper is considering primarily methods of influencing standards in the widest sense, the 'fixtures' conservation route is the best exemplar.

One of the problems facing private conservators is that unless they belong to a firm with considerable resources they are unlikely to have analytical and technical backup. They are often in a better position than those of us working for public institutions to gain experience both wide and deep in their chosen field but unless they have the resources to keep abreast of technical innovations they may fall increasingly behind. Conversely, those who develop innovatory techniques may not necessarily have the field expertise to try them in a really testing casework environment. We have sought to create a link between our own capacity to buy or provide analytical services and the invaluable practical field experience of conservators, by including an evaluation stage in our procedures for securing the conservation of fixtures, and providing support for the best analytical, recording and reporting practice on grant-aided-projects.

The steps towards the completion of a Fixtures Project are as follows:

Definition of the Project: when the value or outstanding nature of the fixture is justified and the need for conservation established.

Evaluation: a full condition report is prepared and any additional analytical documentary or environmental monitoring is proposed and carried out - e.g. analysis of structural problems, salt determination, the effects of relative humidity (RH), temperature, light, and biological problems; paint and media studies.

A subset of evaluation is:

- Specification: the outcome of full evaluation is specification, where the methods, approaches, and potential risks are fully defined.
- Tendering: a list of tenderers, which may include the specifier, will be drawn up from suitably qualified conservators, who may if they choose propose alternative strategies, but must justify them fully. Tenderers will be asked to cost the job fully on the basis of the specification. They may indicate the costs of any variations they consider appropriate and they must supply a staged project proposal.
- Practical Conservation: to be fully and appropriately recorded. If at this stage major new work comes to light English Heritage will re-evaluate the project.
- Report Preparation: a summary report will be produced at the end of each major phase of conservation. On completion, a full report, incorporating the evaluation findings, will be prepared for the archive.
- Dissemination: English Heritage is prepared to fund report preparation, when appropriate, to publication stage.[5]

This scheme affords English Heritage several opportunities to influence the standards of major fixtures work, while it does not interfere with the right of the grant recipient to appoint a conservator of choice. The evaluation stage is a major step forward in ensuring that all works are carried out on the basis of sound scientific investigation and that no work takes place where the soundness of the building and good environmental conditions are not secure. Proper specification obviously affects the choice of methods and ensures a good standard of recording; and investment in report writing cannot but increase the breadth and depth of the conservation pool of knowledge.

[5] M. Corfield, 'Commissioning Conservation', 1993 (unpublished internal paper).

One telling example of the value of commissioning analytical study relates to the very important painted screen of 1512 at St Mary's Church, Worstead, Norfolk (colour plate I). Much excellent and meticulous work had been carried out in a first conservation campaign and the parish was asking for a further large sum to complete the work. At this point (and at the request of the original conservator) we commissioned a paint analysis of the Victorian overpaint and varnish, and a solvent gel development programme from Curteis Paine Associates.[6] We hope the study will have provided a sensitive and rather shorter route to the cleaning of the screen, with the reassurance of detailed investigation to back up conservation. It also provided insights into the techniques and materials used to create this important object. In this particular case, the parish commissioned the conservator's practical work, while the in-house conservation team commissioned the study on behalf of Conservation Group.

The Research and Professional Services Group, as its name implies, sees research as an essential factor in the development of conservation methodology and standards. We aim to target research in areas where our extensive field expertise suggests there are important gaps in knowledge. For example, rather than use the total package of c. £11 million government funding for cathedrals on problems specific to individual cathedrals, we have opted to spend a percentage of the money on strategic research, which will benefit all cathedrals and many other categories of historic buildings.[7] The £350,000 Cathedrals Research Programme includes: research into fire prevention, undertaken on our behalf by the Warrington Fire Research Centre; polishable limestone decay and conservation; moisture ingress and structural timber decay; masonry cleaning; tile pavement decay and floor wear studies.

To take but one of these studies, of particular interest to this conference, masonry cleaning is bedevilled by a polarised approach. Either the friable surface of the building is dealt with as part of the contracted works and cleaned with varying amounts of water, without knowledge of the substrate; or it is subjected to the panic measure of oversensitive laboratory processes, unsuitable for large scale cleaning. In order to raise awareness of English Heritage's reservations on current cleaning practice in the wider construction industry, we asked the Stone Cleaning and Surface Repair Committee of the British Standards Institute to lobby for a revision of British Standard 6270. We also requested the Department of the Heritage's Air Quality Division to retrieve unpublished data on pollution effects and have now been asked to participate in setting the Department of the Heritage's air quality research priorities.

Other projects which support the Cathedrals Research Programme, while also being of wider value, are the Smeaton Mortars Project, a study of how material practice affects the parameters of a conservation mortar; underside lead corrosion (which, as a spin-off, will also effect our work on lead statuary); and masonry consolidants research, a review of the long-term performance of alkoxysilanes on our estate and on cathedrals.

Because our own estate is large, and our experience of conservation problems through grant-aiding listed buildings and monuments is thoroughly comprehensive, we have been able to devise and fund programmes of research to meet well-defined needs. We see ourselves working in partnership with universities, research institutes, government departments, the construction industry and conservators, in order to gain maximum leverage from each increment of knowledge gained. More important still, because it increases the root stock of competence in conservation, is the incorporation of new knowledge into teaching practice. Our Fort Brockhurst Training Centre will

[6] Curteis Paine Associates, 'Analytical Examination and Solvent Gel Development for the Sixteenth-Century Rood Screen at St Mary's Church Worstead', 1993 (unpublished, commissioned by English Heritage).

[7] J. Fidler, 'Strategic Technical Research on the Cathedrals Grant Scheme' 1993 (unpublished internal paper).

offer building professionals and tradespeople (including our teams of specialist craftsmen) the chance to benefit from direct, structured tuition on problem 'monuments' erected in-house to exemplify the range of problems that live-site instructors do not always have conveniently to hand for demonstration purposes. English Heritage has other commitments to conservation education. It undertakes to provide practical on-site experience for students from the Courtauld Wall Painting programme and from the University of Durham's post-graduate conservation degree, and for a range of interns from other programmes. It is closely identified with the attempt to establish effective competency testing and NVQs.

No organisation, even one with a national remit, can raise standards single-handedly. It is essential that we at English Heritage see ourselves as partners, working in close collaboration with others in the broad conservation field. We aim to exert leverage at the points where we can reasonably expect the greatest gain. These points of leverage may be summarised as better supported, more closely controlled commissioning procedures, strategic research, and our commitment to the process of conservation education.

Postscript
Since this paper was written, English Heritage has undergone an internal reorganisation; however, its research programmes and methods of commissioning conservation work remain the same.

CHAPTER 9

SCULPTURE CONSERVATION: TREATMENT OR REINTERPRETATION?

J. Larson

It is a common experience amongst conservators that when they clean or treat a well-known work of art, the changes their intervention brings about are bound to upset somebody. There are those who believe that a sculpture can only be viewed properly when it is scrubbed clean. Others consider the acquisition of dirt to be a crucial component of an object's aesthetic personality. My personal view has always been that it is the original intention of the artist that is paramount, and the task of the conservator and the art historian is to uncover this by means of careful technical examination and the scrutiny of documentary evidence. If in the course of this investigation one uncovers intentions that do not coincide with current values or accepted critical theory, then one must be prepared to argue the case with well-founded technical arguments. There are always historians and critics who are convinced that they alone understand how Rodin or Michelangelo wished their sculptures to appear. Such opinions are rarely founded on convincing technical evidence and usually stem from personal aesthetic prejudice or values established during early academic training.

An example of the way in which strong aesthetic prejudices have altered our perception of a period of sculpture is represented by a remarkably life-like portrait bust from Windsor Castle (colour plate II). The sculpture is of polychromed terracotta, and represents a laughing child of about six years of age, dressed in sumptuous Renaissance costume. The quality of manufacture, and astute psychological perception displayed in the rendering of the facial features, suggest that it is a work by the great realist sculptor of the fifteenth century, Guido Mazzoni. Some historians have also agreed that this bust may well be a portrait of the young Henry VIII as a child.[1] Apart from its extraordinary artistic quality, the important thing about this bust is that its original polychromy is almost completely intact. A careful campaign of conservation revealed an almost complete scheme of polychromy beneath several successive layers of re-paint (colour plate III) and a crude early nineteenth century redecoration (colour plate IV). How rare a survival this bust is can be seen if we look at terracotta and stucco busts of a similar date that were acquired by North American and European museums during the late nineteenth and early twentieth centuries. Many of the busts now on display in Paris, New York, Washington and London are only crude reflections of what the Renaissance workshops produced. The Mazzoni has survived because it has remained in a private collection and although the surface has been 'refreshed' from time to time, it has never been stripped of its original layers.

In museums in North America and Northern Europe it was a common practice (even until the early 1960s) to strip terracotta sculpture of its paint. This may now seem an appalling act but when I was first studying art history in the 1950s I was told by my tutors that great sculpture looked better without paint. Paint was something that was associated with crude religious images,

[1] J. Larson, 'A polychrome terracotta bust of a laughing child at Windsor castle', *Burlington Magazine*, 131 (1989), 618-624.

fairgrounds and waxwork museums. The application of paint disguised the true intention of the sculptor and was associated with deception and trickery. These views grew out of a late-nineteenth-century tradition that associated artistic truth with the honest use of materials. People such as William Morris and Roger Fry advanced the ideas that artistic truth could only be fully demonstrated in the honest use of materials: therefore, the beauty of stone, marble, bronze and terracotta should all be clearly demonstrated by the artist and not hidden by cosmetic trickery. An interesting anecdote regarding Rodin's reaction to the Greek sculpture at the British Museum is quite revealing. Sir Gerald Kelly (who was with Rodin) recorded that the curators wished to point out traces of pigment on the sculpture that showed how the Greeks had painted their sculpture. He says,

> I translated to Rodin all about the painting and Rodin said, 'They weren't painted' and he said, 'Who is this imbecile?' but the curator persisted, showing Rodin traces of some of the paint still clinging to the back of one of the horses' heads - and Rodin looked at it and said 'Oui en effet en effet'![2]

It is clear, if one looks at Rodin's sculpture, that the translucency of white marble that is used to such great effect to imitate the qualities of flesh would be completely obliterated by paint. What is interesting, however, was that he was incapable of understanding why it was that the Greeks wished to paint their marbles and it is this lack of sympathy that is so often echoed in early twentieth-century art criticism.

If one examines John Pope-Hennessey's *Catalogue of the Italian Sculpture in the Victoria and Albert Museum*[3] one finds some interesting comments on how various sculptures have been affected by restoration after their acquisition by the museum. The earlier catalogue of the sculpture compiled by Maclagan and Longhurst in 1932[4] was reviewed by Pope-Hennessey in his work of 1964 and he details interesting changes to some of the Renaissance terracotta busts. In entry 198 he notes:

> Traces of a gesso ground for painting noted by Maclagan and Longhurst are no longer visible.

Of 199 he says:

> The whole surface of the bust was presumably pigmented, but has suffered from drastic cleaning, and no traces of colour or priming survive.

Again in entry 200 he observes:

> Traces of colour noted by Maclagan and Longhurst are no longer visible.

These observations continue through a number of entries and clearly demonstrate that a campaign of ruthless cleaning was undertaken between 1932 and 1964.

Clear evidence of the losses that have occurred in our understanding of Renaissance portrait sculpture are demonstrated by two photographs of the bust of *Sir Gilbert Talbot* acquired in 1947. Two black and white photographs show its condition on acquisition and its present condition

[2] F. Grunfeld, *Rodin: A Biography*, Oxford, 1989, p.432.

[3] J. Pope-Hennessey, *Catalogue of Italian Sculpture in the Victoria and Albert Museum*, HMSO, London, 1964.

[4] E.R.D. Maclagan and M.H. Longhurst, *Catalogue of Italian Sculpture*, Victoria and Albert Museum, London, 1932, 2 vols.

(plates 24-25). Even without the aid of colour photographs one can see that the surface of the bust was painted before it came into the museum collections. The pupils of the eyes were clearly defined and one can see the different garments were painted with a number of colours. Such wholesale paint removal has sadly altered our understanding of the whole tradition of Renaissance portrait sculpture and we are unable fully to appreciate its range. The *Sir Gilbert Talbot* was never a great work of art like the Windsor bust, but it was an example of the type of routine portrait bust that was produced in Italy and Northern Europe during the late-fifteenth and early-sixteenth centuries. Detailed investigation of sculpture of this period has shown that the polychromy was more highly prized than the sculpture. In fact, presenting stripped terracotta of this type as a finished work of art is rather like presenting a painting where all the paint has been removed and only the under-drawing and canvas are left. Masterpieces such as the bust of *Niccolo Da Uzzano* by Donatello[5] and the bust of a laughing child from Windsor demonstrate how lively such portraits can be when the quality of painting and modelling are at their best. The more humdrum busts like the *Sir Gilbert Talbot* would have relied heavily on the application of gold and surface decoration. Raised decoration of wax, gesso and paper was often applied to sculpture at this time and one can imagine that such busts were 'enlivened' by similar treatment to give them a sense of realism that was not present in the modelling.

It is interesting to note that in her dissertation on *Florentine Busts*[6] Schuyler spends a considerable amount of time describing how life and death masks were used to give veracity to these portraits. She does not, however, say much about the painting of these busts and thereby misses the whole purpose of the genre which was to produce highly realistic portraits of powerful people that would impress their individual character on the society of the time. It was for these reasons that great Italian portrait sculptors of the fifteenth and early-sixteenth century were brought to Northern Europe: Mazzoni to France to make the royal tomb of Charles VIII at St Denis; and Torrigiano to make that of Henry VII at Westminster Abbey. It was clear that what was required in both these cases was realism. The portraits were intended to demonstrate the individual identity of the king and not merely to celebrate the impersonal ideal of kingship. It is a pity that we have lost the royal tombs at St Denis for they, rather more than those at Westminster Abbey, would have shown how important the painted sculpture portrait was in late fifteenth-century European art.

When we consider the problem of cleaning monochromatic sculpture the most important question is what constitutes dirt and what is patination. The word 'patina' has often been used by those aesthetes and connoisseurs who would wish to distinguish themselves by their aesthetic sensibility. The accretion of dirt and hand grease that often obscures the surface of sculptures is usually considered an integral part of the beauty of an object and its removal often causes considerable anguish. If we again look at the work of Rodin we find a strange dichotomy. The sculptor, we know, had many antique works in his sculpture collection and loved the strong colours and patination that age produced on his Greek marbles. But his attitude to his own sculpture was different. He liked his own marbles to remain clean and in a letter to the collector Dr. Max Linde he says:

> It will be necessary to clean (the Eve) with pure water and a sponge and a very clean paint brush with no dye on the string around the brush.[7]

[5] J. Pope-Hennessey, *Donatello Sculptor*, Abbeyville Press, 1993.

[6] J. Schuyler, *Florentine Busts: Sculpted Portraiture in the Fifteenth Century*, Garland Publishing, New York, 1976, p.127.

[7] Grunfeld, *Rodin*, p.436.

Rodin laboured hard to produce the most delicate textures in his marble sculptures and to allow dirt to accumulate on them would completely destroy his intentions. Many of those who praise the concept of 'patina' on marble do not consider what it does to the formal values of a sculpture. When dirt gathers on the surface of a head, for instance, it is the most prominent features that become dirty first (plate 26). The tip of the nose, the chin and the forehead all become dirty before the hollows around the eyes and the indent beneath the lower lip and the prominence of the chin. This gradually turns the bust into a negative of the original, for the sculptor would have rendered the prominent forms as white and the recessed ones as dark.

The development of lasers for cleaning has allowed the conservator to distinguish more precisely between the various layers that constitute black pollution crusts on marble.[8] The recent examination and cleaning of a large marble sculpture of *Huskisson* by John Gibson (colour plate V) has demonstrated that it is possible for a Neodymium YAG laser in Q-switched mode to remove pollution encrustations very delicately, allowing the conservators to decide whether they wish to clean back to the damaged white marble surface, or, leave a 'patinated' appearance. Close inspection of the surface by microscopy (colour plates VI-VII) has shown that the black layer on the *Huskisson* was complex. It consisted of three distinct strata:

i. The black crust that covered the sculpture when seen in cross-section was composed of a transparent layer of calcium sulphate in which large black particles of unburnt hydrocarbons and fly ash were present.

ii. Below this was a transparent layer of calcium sulphate, very consistent in character and distinct from that above.

iii. The eroded and jagged calcite crystals of the original marble.

Trials using steam cleaning had dissolved both the upper layers which are soluble in water and had left the calcite exposed. The eroded surface of the marble felt very rough to the touch and it is clear that the sculpture had been over-cleaned by this method. The laser, by comparison, vaporised the black layer but was reflected by the pure calcium sulphate layer beneath. After laser cleaning the surface of the marble had a light honey colour that felt smooth to the touch and did not disfigure the formal characteristics of the original carving.

Although modern technology is extremely seductive and there is a temptation to adopt it wholeheartedly, there is always a time when more traditional techniques offer a more appropriate solution. When asked by the Royal Academy to clean the Michelangelo Tondo, I decided to use techniques that had been in use at the Victoria and Albert Museum for thirty years.[9]

The tondo had been subjected to moulding processes in the past which meant that the surface would have been coated with parting agents such as soft soap and oil. Subsequent attempts to clean the surface with soft soap had contributed to the build-up of a thick discoloured skin on the tondo. A finger rubbed across the surface of the marble would roll off a thin layer of soap and dirt. This is a problem which occurred many times at the Victoria and Albert Museum and I decided to use well-proven techniques for degreasing the surface and removing the dirt. Nitromors (dichloromethane in a gel paste) was applied to the surface with cotton wool swabs and left to react for about twenty seconds. It was then removed and neutralised with acetone. Once the whole surface of the sculpture had been treated in this way a poultice of Sepiolite clay (magnesium silicate) and de-ionised water was applied to a thickness of about 1cm (colour plate VIII). As the clay dried it drew out the remaining dirt in the marble and formed a distinct craquelure. It was then

[8] M.I. Cooper, 'Laser Cleaning of Stone Sculpture', (unpublished PhD thesis, Loughborough University, 1994).

[9] J. Larson, 'The Cleaning of Michelangelo's Taddei Tondo', *Burlington Magazine*, 131 (1991), 844-6.

easy to remove the dry clay and the residue was cleaned from the surface with white bristle brushes and de-ionised water. This classic cleaning technique is not only gentle, but it imparts a lovely even glow to the marble, restoring the sense of translucency that is lost when the marble is dirty (colour plate IX). The sculpture is, of course, an unfinished piece and therefore left in its natural cleaned state. To wax it or apply any form of protective varnish would have destroyed the freshness of its cleaned surface.

So far, the problems of sculpture held in museum collections have been discussed. We have noted that there have been some problems in the past, but it is in the national museums during the past three decades that scientific standards for the treatment of sculpure have been established. Sadly this is not true of outdoor sculpture, and in particular our medieval sculpture has been subjected to a crudeness of treatment that results from both a lack of real interest amongst more influential art historians and a concern from heritage bodies to be seen to be acting. If one turns to the study by Prior and Gardner earlier this century their words of concern seem appallingly apt today:

> External sculpture has no doubt been exposed to careless and wilful damage, as well as to the natural decay of exposed stonework. Medieval figure work is now often broken, headless and limbless, left to us as mere blocks and fragments. Still, as long as what is left is allowed to tell its story, that story is one of genuine art. But when attempts are made to tidy up our ancient pieces, when the fancies of a *restoration* are let loose upon them, then they are destroyed completely as medieval examples.

Even more pertinent is the following passage:

> But while modern art should be warned off meddling with the great sculpture of the past, modern science could even now, if it wished, do much for the more efficient preservation of it. Very little in this direction has at present been attempted by the authorities in charge. Many thousands of pounds have been and are now being spent on the restorations making stage scenery of our ancient cathedrals and abbey churches.[10]

How little things have changed in eighty years! 'Modern science' has attempted to do something about the state of our medieval sculpture but its intervention has generally been reviled by those who consider its proposals unnatural. Since the early 1970s there has been a strong movement in this country towards the principles enshrined in the articles of the Society for the Protection of Ancient Buildings. This society was formed on principles propounded by William Morris as a reaction against the crude restorations carried out by late Victorian architects on medieval English churches. At that time, the ideas of Morris looked very sound and one can only applaud his motives. Unfortunately, as in most faiths, the disciples become more doctrinaire than the teacher. Morris was a principal mover in establishing the conservation movement in this country and I think that he would have been pleased to see how strong that movement is today. I also think that in the current climate he would have been excited to see how science has worked so hard to establish precise methods for recording decay and also devising techniques for arresting it. Sadly many of those who follow Morris's teachings today are wholly dogmatic and indulge in a form of pseudo-medieval revisionism that has now buried most of our important medieval sculpture beneath layers of lime wash.

Those who uphold the so-called 'lime method' would claim that they are not restoring the sculpture and that their technique is quintessentially medieval. Restoration is a difficult term but I

[10] E.S. Prior and A. Gardner, *An Account of Medieval Figure-sculpture in England*, Cambridge, 1912, p.19.

would argue that covering the surface of a decayed sculpture with paint or lime is an act of restoration. The lime method requires the coating of weathered sculpture with a layer of lime, stonedust and sometimes casein. This effectively buries the sculpture under a thick layer of stonepaint, blurring the form and disguising what is left of the original. This treatment has been applied with a crude consistency to the major groups of sculpture at Wells, Exeter and Rochester and imparts a depressing uniformity to all our sculpture regardless of date or the geological characteristics of its stone. One begins to feel that in some heritage department somewhere there is a British Standard for the colour of medieval sculpture, for whether it is made of Doulting, Beer or Caen stone it all looks the same creamy colour and has a similar texture.

In the case of Exeter, photographs exist before the application of the lime coatings (colour plates X-XI) and they clearly show that much of the polychromy that could be seen before the restoration was covered over after treatment. In fact, if it were not for the intervention of a conservator who worked on the project, we would have no record of the polychromy that has now disappeared. Contrary to instructions, she collected samples of the remaining polychromy secretly and worked on these, finally publishing them in 1991 in *Medieval Art and Architecture at Exeter Cathedral*,[11] published by the British Archaeological Association. Strangely the publication makes no mention of these particular occurrences, but as so often happens, these problems tend to be glossed over or avoided in official publications. It is clear that if this treatment had been meted out to a famous Italian work of art or cathedral there would have been letters of outrage in *The Times*. The English, however, rarely take their own art seriously and do not think it worthy of the same consideration as Italian art.

There is little doubt that during the past two decades the word conservation has become very respectable whilst restoration has almost become a term of abuse. The divisions between the two approaches have become somewhat distorted by dogmatism. It is clear to those who regularly deal with problems of stone decay outdoors that there are many sculptures that are now so deteriorated that they must be moved indoors if they are not to become meaningless. In England there is a strong resistance to this idea amongst official heritage bodies. This belief is based upon the idea propounded by William Morris that the work of art only retains any meaning if it is kept in its original position. Of course, everyone would agree with the principle of keeping sculptures in the situation for which they were designed. However, if this means that they will lose all their sculptural value (and this usually resides in the surface detail that the sculptor so painstakingly carves in the stone) then it is unacceptable to anyone who is genuinely interested in the study of sculpture.

There is a strong contast between English attitudes and French or Italian views on this subject. The French have recently decided to move all their most important marble sculptures indoors to new galleries in the Louvre. In Italy many important sculptures have been moved indoors to be replaced with copies. Lovers of sculpture can only be grateful that Michelangelo's *David* was moved indoors to the Accademia in 1873. In England the case is very different. Sculpture is not a highly regarded art form and people are used to considering external sculpture as mere background, not to be taken seriously. For those of us who wish to study the history and stylistic development of sculpture this is an irritatingly whimsical view. Most of our sculpture is poorly recorded and if it were allowed to decay we should have very little record of it for further study.

[11] E. Sinclair, 'The West Front II. The West Front Polychromy,' *British Archaeological Association Conference Transactions*, 1985, XI, F. Kelly (Ed.), *Medieval art and architecture at Exeter Cathedral*, Leeds, 1991, pp.116-33.

A recent case in Liverpool has highlighted this problem. The huge marble figure representing *Liverpool* that has sat on the roof of the Walker Art Gallery since 1877 is now so severely decayed that it has become dangerous (plate 27). The Carrara marble of which it is made has been so attacked by a combination of pollution and salt from the maritime environment that it has turned to sugar and has little structural strength. The sculpture weighs some twelve tons and several substantial lumps had fallen off it during the past few years. Clearly for a public institution to leave a sculpture in such condition would be unacceptable and the National Museums and Galleries on Merseyside decided that a detailed examination of *Liverpool* should take place and a programme of treatment be formulated. Concern about the condition of the sculpture had been voiced as early as 1920 even though photographs taken in 1925 show much of the detail still visible. By 1981 the decay of the marble was so advanced that the County Analyst's Department was asked to define the cause of decay. Their chemical analysis states that 'A significant amount of chloride was present which may have been responsible for the damage.'[12] The inspection in 1992 by the present Sculpture Conservation Section of the NMGM reached the conclusion that the decay was so far advanced that any attempt to halt the decay *in-situ* would be impractical. During the past thirty years much research has been done on stone decay. Numerous treatments (usually based on the application of synthetic resins either by brush, vacuum or spraying) have been proposed but none has produced a long-term solution to the problem. In this case, where the environment was so aggressive, to spend many thousands of pounds on a treatment that might only last for five years, or less, seemed unwise. It was decided that the best course of action was to take the sculpture down and replace it with a copy.

The idea of making a copy raised many problems. The English Heritage inspector stated that in principle he was against the idea of putting original sculptures indoors and replacing them with copies. His view was essentially philosophical and remote; ours had to be pragmatic and practical. Finally it was agreed that the sculpture was so damaged that it should come down for reasons of public safety but no agreement as to the installation of a replica had been reached. We felt that a replica was necessary because the three large marble sculptures carved by John Warrington Wood for the Walker Art Gallery are such an important feature of the architectural ensemble. Many people who were asked to comment on the problem suggested that a replica should be made in fibreglass. This, however, posed several difficulties. The surface of the original was so fragile that to put a mould on it would risk further damage. A replica made of fibreglass would be so light that it would be blown off the roof by the strong winds that afflict Liverpool, unless it were filled with concrete. Also fibreglass does not have a great record for durability and a sculpture made of this material would probably decay within the next decade.

The only answer that seemed to make sense was to make a copy in marble. The problem here was cost. A block weighing some forty tons was required in order to carve the large figure and to buy this from Carrara (even if the Italian authorities would allow such a large block of the precious material out of the country) would be impossibly expensive. Fortunately, we were able to reach an agreement with a company who were importing high-quality white marble from China and they agreed to produce the replica for a much more affordable sum. Meanwhile, we had removed the decayed marble from the roof and had placed it in a large store. The surface was treated with a five per cent solution of Paraloid B.72 in acetone as a sealant. It was decided that the damaged surface of the sculpture should be recreated on top of the marble using white plasticine. To guide our restoration work we used photographs from 1925 when the sculpture was still in reasonable

[12] Merseyside County Council, County analyst's department report on sample of stone from statue, Walker Art Gallery. Unpublished letter 17 October 1981.

condition. The careful remodelling of the features demonstrated how much of the original had been lost (plate 28). The work took some six months and when it was complete, a detailed photographic survey of the sculpture was made (plate 29). Along with numerous measurements, this information has now been forwarded to China where the block has been quarried and is now being roughed out. The original sculpture has been moved to NMGM's new Conservation Centre in Liverpool where it will dominate a gallery devoted to the exhibition of displays on conservation.

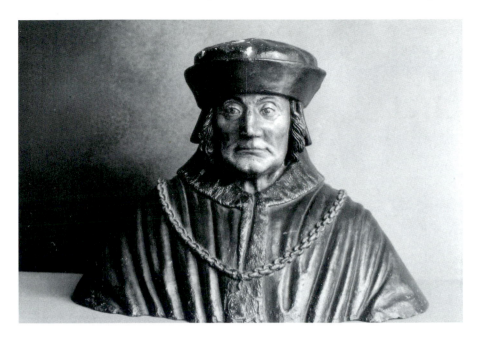

Plate 24 Bust of *Sir Gilbert Talbot,* photographed on acquisition by the Victoria and Albert Museum, clearly showing full polychromy.

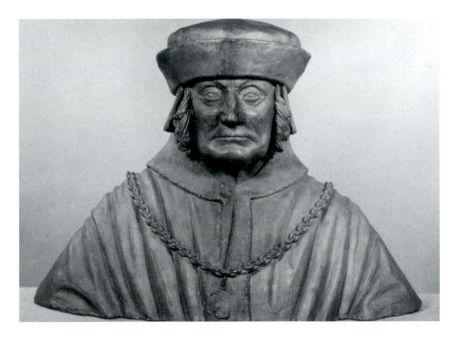

Plate 25 Bust of *Sir Gilbert Talbot* as it now appears, with polychromy completely removed, presumably in the nineteenth century.

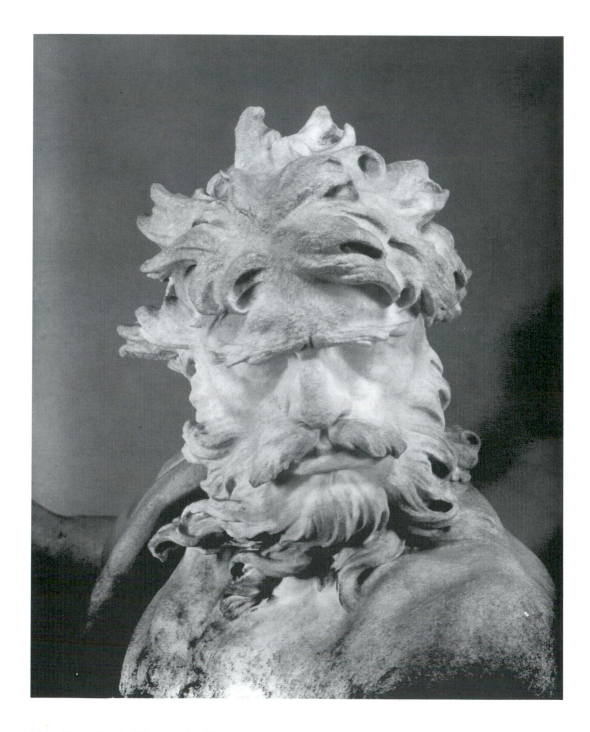

Plate 26 Head of *Neptune* by Gianlorenzo Bernini, before cleaning.

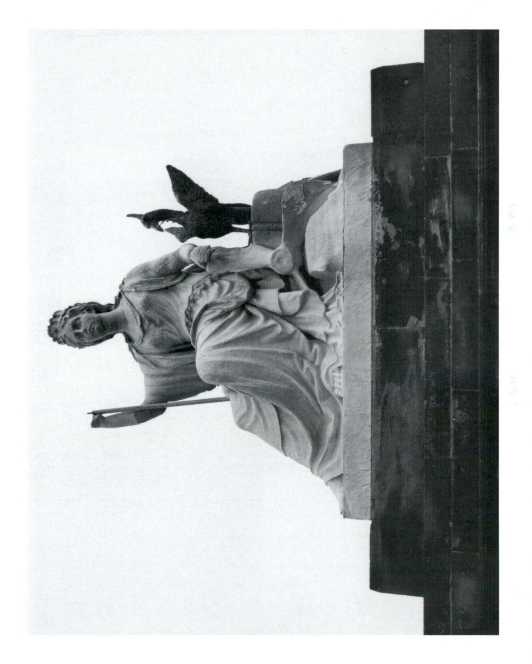

Plate 27 Gigantic marble statue of *Liverpool* by John Warrington Wood (1877), on the roof of the Walker Art Gallery, in severely deteriorated condition.

79

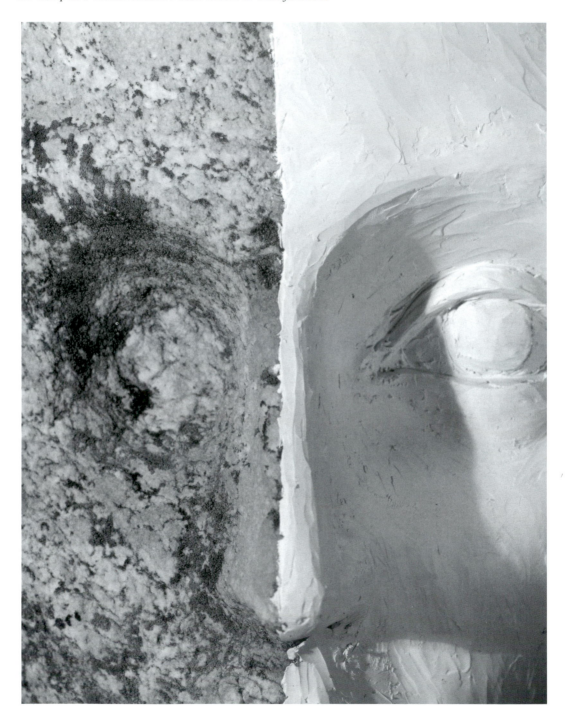

Plate 28 Detail of *Liverpool* showing the early stages of the remodelling of the surface with white plasticene.

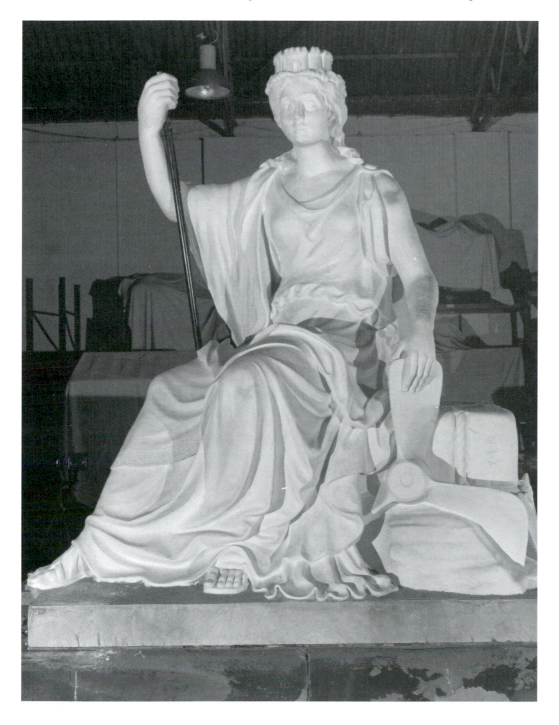

Plate 29 Sculpture of *Liverpool* after complete remodelling of the surface with plasticine.

CHAPTER 10

AN ASSESSMENT OF THE 'LIME METHOD' OF CONSERVATION OF EXTERIOR LIMESTONE SCULPTURE

N. Durnan

Introduction

As I have been treating limestone sculpture with the 'lime method' for the past eleven years, I felt this would be a good opportunity to look back at work I have done during that time and assess, where possible, the changes in condition and appearance that these treatments have made to the sculpture.

To obtain as broad and informative a view as possible I have generally selected sculpture that I have been involved with from the initial survey stage through to the final treatment and any subsequent monitoring. Although my examples only deal with two limestone types, Caen and Doulting, I have endeavoured to illustrate a good cross section of different conditions and treatments to provide a meaningful survey of lime treatments and allied techniques. At the end of the paper I will discuss whether the conclusions from this assessment corroborate the suggestion of Dr Clifford Price that:

> the dramatic change that can be achieved in the condition of friable limestone may be attributable not to lime *per se* but to the meticulous skill of the conservator and the use of carefully designed mortars to secure flakes and to fill cracks.[1]

For assessment I have chosen the conservation of a twelfth-century tympanum at Rochester Cathedral as a recent project, completed in 1990; a series of sculpted capitals at Canterbury Cathedral, on which work was finished in 1988; and finally the conservation of a figure from the west front of Wells Cathedral, completed in 1984.

Rochester Cathedral: The Tympanum of the Dorter Doorway in the East Walk of the Cloisters

The tympanum (colour plate XII) which probably dates from the mid-twelfth century[2] is set above the original daystair entrance of the monks' dorter (dormitory), of which only the lower part of the west wall survives. The dorter was one of many monastic buildings grouped around the cloister which fell into a ruinous state soon after 1550.

The repair history of the tympanum starts about 1558 when the dorter doorway was blocked up. No work appears to have been carried out until 1937-39 when this blocking wall was dismantled and set back some 600mm as part of restoration work to the east walk. A protective slate inset was probably inserted in the east wall at this time. Further restoration work is known to have been carried out to the garth walls in 1949-52; this was followed by cleaning and repointing in 1962.

[1] C.A. Price, 'A further appraisal of the 'Lime technique' for limestone consolidation using a radioactive tracer', *Studies in Conservation*, 33 (1988), 178-186.

[2] T. Tatton-Brown, 'The East Range of the Cloisters', *Friends of Rochester Cathedral Report for 1988*, pp. 4-8.

The carving depicts the biblical scene of the sacrifice of Isaac (Genesis 22). The sculpture is severely weathered but the figures and a small section of lettering which reads *ARIES PER CORNVA* (ram by the horns) are still legible (colour plate XIII). The tympanum and doorway are of Caen limestone with the exception of two flanking shafts which are of Tournai marble, and some rectangular tufa blocks behind the tympanum. The tympanum is constructed of six rectangular stones set upon a corbelled lintel. Little original surface survives but early twentieth-century photographs show much more detail than at present; a good deal was probably lost during the cleaning work of 1962.

The condition in 1989 was as follows:

- a large crack ran vertically from the apex of the arch down through the tympanum panels into the centre of the lintel. It was caused by corrosion of a twelfth-century vertical tension bar which carried the load of the tympanum and lintel from the apex stones of the arch.
- large pieces of stone were loose or dislodged at the apex of the arch.
- soot crusts had collected on sheltered and undercut areas of the tympanum and adjacent arch stones.
- numerous small blisters and exfoliating edges occurred on the tympanum and adjacent stones.
- hard Portland cement mortar had been applied to large voids and some joints.

The Conservation Programme[3]

After some trial work with lime treatments by Wells Conservation Centre on a bay of the adjacent twelfth-century chapter house in 1984, a full programme for the conservation of the monastic remains was devised by Martin Caroe, the cathedral surveyor. The programme began in 1989 when the lower level of the chapter house was treated. Conservation work to the dorter doorway was phase 2 of the programme and was carried out in 1990.

After temporary structural support to the tympanum had been erected, the soot crusts were removed by application of 2.5 per cent w/v ammonium carbonate solution held in an Arbocel (cellulose fibre) and Sepiolite (magnesium silicate 100 mesh) poultice. The poultice was applied to a thickness of 12-25mm, left uncovered and removed after 24 hours. Approximately fifty per cent of the soot crust came away with the poultice, the remainder being first dry-brushed and then rinsed off with water from the surface. The surface was rinsed a second time after it had dried out. A second application was required for thicker crusts.

Cement-based fills were removed. Cracks, blisters, voids and joints were filled and packed with lime mortar using the same application technique and formulation as used at Canterbury Cathedral (see below and Appendix). Sheltercoat was applied to all stone surfaces, except the back of the doorway and tympanum and the Tournai marble shafts, again to the same formulation and technique as at Canterbury (colour plate XIV). The slate inset was seen to provide good protection from rainwater and thus retained.

Parallel to the surface treatments of the tympanum, the structural problems were attended to. First, a twelfth-century tufa wall built immediately behind the tympanum panels, to function as a lightweight cladding and to hide the back of the tympanum stones and the vertical iron tension bar, was dismantled. The ingeniously designed bar was removed in one piece and replaced with a much

[3] N. Durnan, 'Conservator's Report on the Conservation of the Dorter Doorway at Rochester Cathedral', (1991), MS in Cathedral Library.

simpler removable horizontal stainless steel angle lintel which transferred the load directly onto the door jambs. The tufa cladding was then rebuilt upon the new steel lintel. The wall behind the doorway was partially dismantled during the work and then rebuilt further back. The wall was lime plastered and limewashed to improve the contrast between the blocking wall and the doorway.

Assessment

No formal assessment of the effect of the treatment has been carried out but annual conservation work at the cathedral has enabled informal monitoring. After two years the sheltercoat was surviving well and likewise the repairs and stone remained sound with one exception. A large mortar repair close to Abraham's head developed a crack around its perimeter. It was decided to remove this and replace it. The cause of the problem was the feather edges which had been created while the repair was being modelled. Feather edges tend not to cause a problem on coarser limestones like Doulting but are prone to failure on fine-grained limestones such as Caen. The 1990 repair was easily removed using dental picks without damage to adjacent stone and replaced with a coarser mortar which was modelled to ensure an edge with a minimum thickness of 3-4mm. The removal of the failed mortar repair was facilitated by wetting which enabled clear differentiation between mortar and stone.

Attitudes to the Conservation Treatment

Tim Tatton-Brown, the cathedral consultant archaeologist, approves of the shelter-coated appearance so long as it is not so thickly applied as to obscure fine detail. He prefers the sheltercoat appearance after two-three years when it has toned down, and I think most observers feel this way. There is general agreement that if it is done well, it provides an architectural and sculptural unity to a treated area that cleaning and repair alone cannot do. The rendering and limewashing of the blocking wall was generally approved.

Canterbury Cathedral: The Romanesque Arcade

Of the arcade that runs around the exterior of the choir only four bays - three on the south-east transept and one on the north-east transept - contain capitals carved with figurative sculpture. The rest of the capitals are either plain or of simple foliage design. The arcade dates from soon after 1100 and originally formed part of an earlier choir which was damaged by fire in 1174. The present choir, built between 1175 and 1184, incorporated some of the earlier work into the lower portions of the walls. The sculpture collection comprises twenty-one arcade capitals each carved on three sides and twelve ornamented shafts. These accomplished carvings depict a variety of subjects: lively hunting scenes, fantastic scenes of battling men and monsters, elegantly dressed musicians, and large expressive masks (plate 30). All the sculpture is carved in Caen limestone, a creamy yellow, fine grained, easily workable stone, imported from Normandy.

The Conservation Programme

After an art historical survey(1982-4) of the sculpture by Dr Kahn,[4] I was asked to survey the sculpture in 1985 and recommend conservation treatment. It was decided to treat the sculpture *in situ* and protect the conserved stonework by redesigning the temporary shelters erected soon after Dr Kahn had completed her survey. Due to the successes of treating exterior limestone sculpture at

[4] D. Kahn, 'A record of the Romanesque arcade on the choir exterior at Christ Church Cathedral Canterbury', (June 1985), MS in Cathedral Library.

Wells Cathedral, the 'lime method' was chosen for the programme. The programme lasted three seasons, commencing in April 1986 and ending in July 1988.[5]

The typical condition of a capital was for the front panel to be rainwater eroded to the point where it was sometimes difficult to identify the carving. The side panels had invariably collected a soot crust ranging from 2-25mm in thickness. Only the vaguest outline of the sculpture could be seen on many of them. At the interface between rainwashed and soot encrusted surfaces, blisters and exfoliation were common. Hard nineteenth-century Portland cement-based mortar in adjacent joints was leading to stone breakdown at the cement's perimeter. Although some nineteenth-century Portland stone replacement had been carried out to some impost stones above the capitals, there was no visible or documentary evidence to suggest that the capitals themselves had ever been cleaned.

After initial cleaning experiments with lime and Sepiolite poultices, and timed nebulous sprays, micro-airbrasive cleaning using aluminium oxide abrasive (29 micron) was selected as the safest method for the sculpture (plate 31). Adjacent architectural detail was cleaned to a limited extent to identify stone types and assess its condition using either timed nebulous sprays or ammonium carbonate poultices.

Cement pointing adjacent to the capitals was removed and replaced with a lime mortar matching the colour and texture of the original twelfth-century type. The replacement mortar consisted of a 1:2½ Totternhoe lime: coarse sand aggregate mixture. Cracks, exfoliating skins and friable surfaces were repaired using a mortar based on a 1:2½ Totternhoe lime: graded Caen stone aggregate with the addition of ten per cent yellow brick powder to act as a pozzolanic additive and colourant. Repairs were always placed on a sound, well-prepared substrate which was coated with an adhesive slurry prior to mortar application. Loose fragments were re-adhered with Totternhoe lime/fine aggregate adhesive. Mortars and adhesives were kept damp after application for seventy-two hours before being allowed to dry naturally. Once dry the repairs were periodically wetted to improve carbonation. All surfaces received forty applications of limewater which 'tightened up' semi-friable surfaces on some of the capitals.

All exposed and weathered surfaces were treated with one application of sheltercoat based on a 1:3 Totternhoe lime: fine aggregate mix pigmented with Hornton brown stonedust and thinned to single cream consistency with a 50/50 solution of skimmed milk/tap water. It was applied to damp stone left to 'cure' until matt in appearance and worked into the stone surface using soft bristle brushes. The treated area was covered with polythene for 24 hours and then allowed to dry naturally. Any excess in areas of fine detail was removed by further brushing. Sheltered areas which displayed original surface and toolmarks - mainly the side panels - were not treated with sheltercoat because they were not felt to be at risk from further weathering. The temporary shelters were replaced in 1989 with small lean-to shelters made of elm, designed by Peter Marsh, the then cathedral architect, to provide a reversible weather protection (plate 32).

A programme of monitoring every five years was suggested. The first survey took place in 1993 although I have regularly visited the site since 1988.

Condition Survey 1993
There were some differences in the overall appearance of the treated area since 1988. Firstly the elm boarding of the lean-to shelters had weathered to a darker colour and had started to warp. Secondly the sheltercoated and repointed areas had toned down and were less prominent. The

[5] N. Durnan, *Conservators Report on the Conservation of the Romanesque Arcade Sculpture at Canterbury Cathedral*, 1988, MS in Cathedral Library.

carved capitals and shafts were inspected from a ladder, attention being directed to the condition of stone, mortar repairs and the sheltercoat layer.

The condition of all the carved capitals and shafts was sound with no sign of any further surface breakdown. The sheltercoat layer was still in place on the capitals but had started to weather away on the shafts; it was becoming powdery on some capitals. The unsheltercoated panels of the capitals were in an identical condition to that in which they had been left in 1988. Capitals on the south wall of the south-east transept had started to collect a thin rippled grey powdery layer in undercut areas: this was assumed to be the very early stages of a new soot crust.

It is hard to pin down the exact cause of the stability of the stone and whether it is primarily the roofs which are keeping the stonework much drier than before or the cleaning and lime treatments. I suspect it is a combination of both.

My recommendations following this survey were as follows:

- Retain the lean-to roofs in their present form except the one on the north wall of the north transept which requires redesigning to allow visitors a clearer view of the capitals.
- Replace sheltercoats where these have weathered away on capitals and shafts.
- The unsheltercoated side panels of the capitals do not at present require any further treatment.
- Replace the damaged mortar repair on capital S31.
- Carry out trial cleaning of adjacent architectural stonework with Jos vortex piccolo cleaning system.
- Survey the arcade again in 1998.

Attitudes to the Conservation Treatment

Dr Kahn's original survey had suggested that certain capitals be removed from the arcade to be treated and displayed in a museum. She was pleasantly surprised by the stability of the cleaned and repaired capitals and by the amount of detail surviving under the thick soot crusts and is now in favour of their retention *in situ*.

The lean-to roofs, however, do provoke different reactions. Tim Tatton-Brown, former consultant archaeologist at the cathedral, would prefer a less obtrusive means of protecting the arcade sculpture, a feeling that is shared by the present architect John Burton. The cathedral conservators and I find their appearance acceptable and improving as the timber weathers. The subtle visual differences between sheltercoated and unsheltercoated areas of the arcade is acceptable to all, but less visually acceptable is the different level of cleaning between sculpted capitals and shafts and adjacent architectural detail and ashlar.

One interesting discovery during conservation work regarding lime treatments was the way the twelfth-century builders had dealt with a mistake in the working of two capitals. The ashlar stops had been cut back approximately 12mm too far and these had been rendered over with construction mortar to bring them flush to the wall line. Although the repairs themselves were in a very friable state the stone surface beneath them was in a pristine state. The lime mortar capping had protected this surface for 850 years.

Wells Cathedral, West Front: Seated King, figure no. 151

The figure is a large seated king (2.49m in height) carved from a single block of Doulting stone

(plate 33).[6] He is seated on a bench-throne carved in fake perspective with his dexter foot on a footstool. The arms are placed in the awkward position common among the Wells School seated kings: hands on knees and elbows turned outwards. His tunic is clasped near the neck with a very large penannular brooch and is belted. Beneath the sinister hand, though held only by the tips of the finger and thumb, are the heavily repaired remains of a document or charter.

Repair history
The figure is damaged but has been repaired in at least two phases when numerous cement repairs and copper fixings were applied. In 1854 major repairs were made in a brown cement to the dexter arm, which has a totally rebuilt forearm, the sinister foot and hand, and many areas of drapery. Five copper restraining cramps were also fixed at this time. In 1925-31 Portland cement repairs were made to the lower central chest and numerous other areas.

Condition in 1982
Serious loss or damage was as follows:

- On the head, the front, sinister and front sinister fleurons are all broken off, and the nose has been rebuilt in cement.
- The lower half of the upper torso above belt level, particularly on the sinister side, is a large hollow area where a hard skin is in the process of lifting off.
- Both arms have been repaired heavily in brown cement - the dexter forearm and sinister hand especially, the shoulders are hollow and bursting.
- The dexter knee and shin have been refixed with strong Portland cement and copper dowels in lead and the lower drapery has been rebuilt in brown cement, as has the charter.
- The front of the dexter foot and footstool is gone.
- Cages of wire surround the dexter knee and the sinister arm; some of the latter, together with some modern emergency repairs, date from 1977.

Carbon deposition was restricted to the head, crown and shoulders, the sides of the figure throughout its height, the undersides and backs of the arms, the lower drapery, ankles and vertical front face of the bench-throne between them. Lichen growth was prevalent in the area stretching from the belt to the blackened lower drapery, and on the base of the bench-throne. The orange surface colouration was present only on the sides of the head.

Conservation Treatment 1983-84
The figure was cleaned by application of a hot lime poultice left in position for three weeks. This was removed and the figure water washed by timed nebulous sprays. Cement repairs were prepared for removal by cutting a narrow channel around them with the micro airbrasive. A gentle tap then freed the cement repair without damage to adjacent stone. Cleaning and cement removal revealed the figure had a crack running across the torso: it was therefore decided to insert two 25mm round section phosphor bronze restraining dowels, one for each half of the cracked figure, holding it to the niche back. The dowels were secured in the holes with adhesive lime mortar. The most obtrusive copper cramps were removed from the shoulders and upper torso.

[6] J. Sampson, 'Pre-conservation condition report of Figure 151', copy in Wells Cathedral west front archive stored at the Cathedral.

It was decided to retain the restored brown cement dexter arm as its removal would have damaged some very friable areas of stone adjacent to it. Also, although this repair was probably conjectural, it was felt that its removal would do more harm than good to the appearance of the figure.

The figure required very extensive mortar repair to the sinister arm and hand, the dexter arm, the lower torso, many areas of drapery and the footstool. The hard surface skin of the lower torso was found to be lifting off and this area required packing to provide a new backing support for this skin. The figure was given forty coats of limewater during mortar repair. After the repairs had fully dried out and started to carbonate the figure was sheltercoated.

Re-Survey 1987[7]
The figure was inspected from an hydraulic hoist in April 1987 as part of the regular three-yearly assessments designed to ensure each figure on the west front is inspected every six years. Its condition was found to be good with no mortar or stone breakdown. It is due to be inspected again in 1994.

I recently inspected the figure (June 1993) from the ground with the aid of binoculars. All the visible mortar repairs appear sound as does the stone. Much of the sheltercoat has been lost and some of the repairs have become a little darker than adjacent stone (plate 34). It is heartening that the very extensive repairs are sound after nine years on a figure in such an exposed position. I look foward to the closer inspection next year.

Attitudes to the Conservation Treatment
Jerry Sampson, archaeologist and the Wells Cathedral west front archivist (1980-87) has clear views about removal of sculpture and the visual effect of mortar repairs and sheltercoat.

In the case of figure 151, for example, both the deep cracks and the concrete which had been poured behind the figure meant that any attempt at removal would have severely damaged the figure. The additional cost of conservation, museum display and of having a replica carved in stone would be very high, not to mention the problems of displaying a sculpture that was designed to be viewed high up on the building.

Regarding mortar repair and reconstruction Mr Sampson's view is that minimum intervention is best and rebuilding to a weathered surface always the most successful. Remodelling of lost detail, no matter how well done, can often harm the appearance of a piece of medieval sculpture and the imagination is a better reconstructor than the hand. But he is in no doubt that lime mortar repairs are the single most important conservation treatment applied to the sculpture.

Having seen many sculptures subjected to sheltercoat treatment Mr Sampson has much experience of its benefits and drawbacks. Careful choice of colour is essential as without this care forms can disappear. Sheltercoat can visually unify mortar repairs and stone, especially on very decayed figures where repairs are extensive. It can also help sculptures which are positioned high up on the front to be 'read' more clearly. The initial dramatic change to the sculpture's appearance soon tones down.

Conclusion
Observing the condition of sculpture I have treated at Rochester, Canterbury and Wells some years after conservation has led me to conclude that although much of the behaviour of limestone and

[7] M.B. Caroe, 'Wells Cathedral, West Front: Re-Survey of Figure Sculpture', *Association for Studies in the Conservation of Historic Buildings Transactions*, 11 (1986), 71-73.

applied lime treatments is predictable, there are always occurrences which are not. Unexpected behaviour both in terms of rapid failures and exceptional durability is almost certainly due to the fact that there are so many variables in the stone, the environment and the treatment itself. Only through regular inspection can the behaviour of exterior sculpture be understood and changes in condition acted upon as required.

The condition of the treated sculpture I have discussed above clearly supports Dr Price's suggestion quoted in the introduction. I find myself in complete agreement with it and one only has to read Hebe Alexander's description of the lime mortar application process[8] to realise how meticulous and important this aspect of lime treatment is. I would add that this dramatic change of condition can only be maintained by understanding lime treatments of exterior sculpture not as one-off treatments, but as a treatment where regular monitoring, assessment and adjustment are equally - if not more - important than the initial conservation work. The advantage of such regular inspection is that small adjustments made every five years are much gentler on the stone than a major retreatment every twenty-five or more years. This course of action will lead not only to a reduction of interference but to an increase in the preservation of exterior limestone sculpture.

[8] H. Alexander, 'Lime Mortar Repairs', *Conservation News*, 34, November 1987.

APPENDIX

Mortar and sheltercoat formulations used at Canterbury (Romanesque Arcade) and Rochester Cathedral (Dorter Tympanum) for the conservation of Caen stone.

Repair Mortar

Totternhoe lime putty	4 parts
Caen stone 10-20 mesh	1 part
Caen stone 20-40 mesh	3 parts
Caen stone 40-80 mesh	3 parts
Yellow brick 80 mesh	2 parts
Silver sand 60 mesh	1 part

Crack filling and adhesive mortar

Totternhoe lime putty	1 part
Caen stone 60 mesh	2 parts
Hornton brown 60 mesh	1/4 part

Sheltercoat

Totternhoe lime putty	1 part
Caen stone 80 mesh	2 parts
Hornton brown 80 mesh	adjusted to match stone colour

Mortar and sheltercoat formulations used at Wells Cathedral for the conservation of figure 151, Doulting stone

Repair Mortar

Buxton lime putty	3 parts
Doulting 10-20 mesh	11/2 parts
Doulting 20-40 mesh	2 parts
Hornton brown 40 mesh	1/2 part
Hornton blue* 40 mesh	1/2 part
Yellow sand 20 mesh	1 part
H.T.I. 80 mesh	1/2 part

Crack filling and adhesive mortar (all ingredients passed through a 60 mesh sieve)

Buxton lime putty	3 parts
Guiting	1 part
Hornton brown	1 part
Hornton blue*	1/2 part
H.T.I.	1 part

Sheltercoat (all ingredients passed through an 80 mesh sieve)

Buxton lime putty	3 parts
Guiting	2 parts
Hornton brown	2 parts

| Hornton blue* | 3 parts |
| Yellow sand | 1 part |

*Since 1984 Hornton blue has been replaced by slate because of its unstable nature, which could lead to colour changes.

H.T.I. = high temperature insulation, a white fired clay used as a pozzolanic addditive.

10-20 mesh means the material has passed through a sieve with 10 holes per inch but retained on a sieve with 20 holes per inch. The closest metric equivalent would be sieves with hole sizes of 2.36 mm and 1.18mm.

Acknowledgements
I am grateful to Tim Tatton-Brown, Jerry Sampson and Hebe Alexander for the help they have given me in the preparation of this paper.

Plate 30 Canterbury Cathedral: the south bay of the south-east transept in 1986, before conservation.

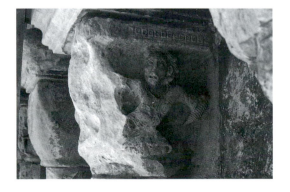

Plate 31 Canterbury Cathedral: detail of capital after cleaning.

Plate 32 Canterbury Cathedral: redesigned shelters soon after erection in 1989.

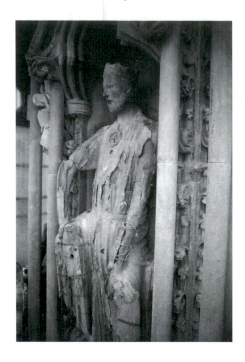

Plate 33 Wells Cathedral: figure 151 in 1979, before conservation.

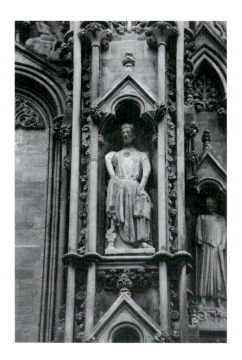

Plate 34 Wells Cathedral: figure 151 in 1993, nine years after treatment

CHAPTER 11

TREATMENT AND PROTECTION OF PUBLIC MONUMENTAL STONE SCULPTURE IN BRITAIN: THE ROLE OF THE SCULPTURE CONSERVATOR

J. Porter

Introduction

Britain's sculptural stone heritage is at risk of destruction from cleaning. Recent research has identified the acceleration of decay and irreversible long-term damage which is now being caused to its fabrics by the general systems of cleaning and treatment currently employed throughout the UK. These systems are being applied without sufficient research and monitoring data. Nor is there a national code of practice for exposed monumental sculpture which provides professional conservation procedures for its research and treatment. Both are required to ensure treatment which encourages long-term preservation and avoids accelerating decay.[1]

It has become clear that there is an urgent need for a greater understanding, not only of exposed stone structures and the complexities involved in their pattern of deterioration, but also of the effects of treatment on this weathering pattern, in both the short and long term. Nowhere is this more apparent than in the approach to treatment of our national public sculptures and sculptural monuments. Due to their specific structure and design, they provide the greatest complexity in patterns of decay and consequently they require the greatest sensitivity in analysis and treatment. To date they have been too freely classified as 'building fabric' and treated by the building industry with insufficiently trained operators and methods totally inappropriate both to their condition and the requirements for their preservation. This treatment has had particularly drastic effects on sculptures and sculptural reliefs where they are associated with a building structure, and little or no, differentiation has been made in terms of their treatment.

It may be further recognised that conservators with specialist training both within and outside the museum profession in the UK are not fully aware of the complex and accelerated decay mechanisms of sculptural stone exposed to a wet and polluted environment. Consequently insufficient attention has been paid by the conservation profession to the current threat of damage and loss from either injudicious methods of treatment, or simply neglect.

It appears that much of our public exterior sculpture - which forms a major part of British sculptural heritage from the middle ages to the twentieth century - does not receive the same degree

[1] B.J. Bluck and J. Porter, 'Sandstone Buildings and Cleaning Problems', *Stone Industries*, 2 (1991), 21-7; B.J. Bluck and J. Porter, 'Aims and Methods of Sandstone Cleaning', *Stone Industries*, 3 (1991), 21-8; J. Porter, 'Stonecleaning', *UKIC Conservation News*, 1991, 16-20; B.J. Bluck and J. Porter, 'Glasgow Research Programme on Stonecleaning: Areas of Study', English Heritage/BRE Workshop Preprints, 17 February 1992; B.J. Bluck, 'The Composition and Weathering of Sandstone in Relation to Cleaning', in R. Webster (ed.), *Stonecleaning, Proceedings of International Conference*, Edinburgh, April 1992, Historic Scotland and RGIT, 1992. pp.125-7; RGIT Masonry Conservation Research Group, 'Research Commission Investigating the Effects of Cleaning Sandstone, April 1991, *Historic Scotland, Scottish Enterprise, Robert Gordon Institute of Technology*, 1992, pp.18, 22, and 28.

of specialist conservation as that presently devoted to the housed collections. It is equally clear that its rapidly deteriorating condition and vulnerable situation mean that it needs such attention even more urgently if both carved surfaces and interior structures are to be saved.

This paper outlines the reasons for the complex and extensive decay associated with public monumental sculpture; it also highlights the specialist considerations prerequisite to suitable treatment. These points will be demonstrated by the evaluation of approaches to the treatment of two central city monuments in Glasgow and Edinburgh. A proposal for the increased use of specialist conservation expertise within the organisational framework responsible for the care of public monuments will be made and the extended role of the conservator within that framework discussed.

Weathering

The basic aim of any conservation treatment is to prolong the life of the object with minimum interference to its surface and structure. Thus the suitability of any treatment may be gauged by the degree to which it inhibits decay rather than accelerates it. An understanding of the weathering of exposed porous sandstone is vital to achieve this goal. It has become clear that the passage of water throughout sandstone structures is the principal factor determining their degree of soiling, patina formation and decay mechanisms. Sculpture and sculptural monuments will suffer a greater degree of water ingress than buildings due to their structural design. Consequently their degree of soiling and deterioration will be greater and their treatment more problematical and complex.

Water Ingress and Structural Design

Generally the shape of a sculpture may be described as pyramidal. This is particularly true of traditional figure sculpture but if one looks at sculptural monuments, a similar outline may be traced, starting from a central apex and sloping downwards and outwards to a broader base. Such an unroofed porous structure will encourage the inward transmission of water, as opposed to outward shedding. Moisture will dwell longer on its sloping sides, particularly where the surface is roughened or scored by carved work. The longer dwell-time and the larger surface-area-to-volume ratio will allow water to ingress more readily and more abundantly (figure 11.1).

Where more definite horizontals are created by indenting of the sculptural outline or the addition of sculptural detail, catchment areas will form, which retain pools of water. The extended retention time in this instance will exceed the rate of evaporation with the result that much of the water will ingress.

Many sculptural monuments are tiered structures so that architectural features may form major water catchments: this applies to the parapets/platforms of the Scott Monument or the water basins of the Stewart Memorial Fountain (figure 11.2). Hooded mouldings, string courses and plinths for sculpture may also act as catchments or wicks to direct water inwards. Fine sculptural detail added to a sculptural body whose core diameter is already narrow will significantly enhance water ingress by the large overall increase of surface area to volume.

Water Transmission and Decay

The amount of water ingressed into sandstone will depend on its porosity and permeability, particularly at its surface. Equally the degree to which water is transmitted and retained will depend on the size of its pore space and the way in which these are interconnected. The composition of the sandstone, i.e. the nature of the cement-matrix of secondary materials binding the primary sand grains, will affect the rate of water transmission between the pores. The way in which these cement-matrix materials react to water will determine the pattern and degree of decay caused by

water transmission. These processes of deterioration may be directly related to the rate at which water leaves the stone. This is termed the ingress-egress cycle and the decay mechanisms it stimulates are described below.

Ingress-Egress Cycle and Patina Formation

The constant ingress-egress of water through a stone will cause minerals to dissolve and reprecipitate at areas of evaporation within it. These areas form a series of genetically interrelated zones which we term the patination profile (figure 11.3).

In general, minerals are dissolved to a specific depth within a stone according to its permeability and the degree of water penetration this permits - a depth of 7-8mm has been recorded in porous Scottish sandstones. These minerals are subsequently drawn out towards the drying surface and deposited on a gradient culminating in heavy concentration just below the surface. The deepest zone (zone 4) will gradually become depleted and structurally weakened through mineral loss, and the evaporative areas below the surface (zones 2/3) will become more impermeable from mineral enrichment. Where transmitted minerals contain iron, discoloration and surface staining will result. Other dissolved constituents and pollutants may combine and reprecipitate as new mineral phases. Should these be deposited below the surface, the resultant mineral growth (salt crystallisation) may cause structural breakdown; at the surface efflorescence results. Where heavy concentrations of iron, clay and carbonates are deposited, the surface may become impermeable.

Surface clay will attract inorganic soiling (as in Edinburgh), but where heavy rainfall occurs (as in Glasgow) retained water and high mineral concentrations will initially stimulate algal growth and bacterial activity. The green to blackish soiling crust will be a combination of organic and inorganic pollution which is intimately related with internally dissolved minerals reprecipitated at the surface (zone 1/2). The original carved surface of the stone will be a weathered band 1-2mm wide contained within zone 1/2. A conservator's aim - to find and follow that surface - would require strict controls within the cleaning method.

It is clear that on heavily weathered sandstone, where the cycle of ingress-egress is high, a thick impermeable patina will form, entrapping moisture and salts below the surface. An increase in volume from precipitated salts and hydrated clays will cause surface spalling, often revealing a depleted zone 4.

Fine sculpture or sculptural detail will develop thick soiling crusts in this instance due to their narrow core diameter and their higher ratio of surface area to volume (figure 11.4). The patination profile of these structures has often been found to span the complete internal diameter of the core. This suggests that the interior of the sculpture may be weakened from depletion and that its hardened outer crust may be acting as a protective barrier against breakdown from further weathering. Cleaning in this instance may well be injudicious except if a carefully controlled method permitted sufficient reduction of the soiling to allow evaporation of trapped moisture. Any exposure of decayed zones 3/4 or an increase in surface porosity and water ingress would rapidly accelerate structural decay. Cleaning tests on the sculptural detail of the Scott Monument suggest that its soiling crust inhibits the ingress of cleaning solutions and therefore must be considered protective against greater water ingress.

Water Retention and Structural Breakdown

Decisions on the method and degree of cleaning - or indeed on the desirability of cleaning at all - must therefore be based on a balance between permitting the evaporation of trapped or retained water and protecting the surface from greater water ingress. An understanding of what happens to the water during its transmission through the stone is vital to this consideration. It is clear from

figure 11.5 that water enters the stone as fluid or vapour but that it may only egress as vapour; this indicates that a large amount of moisture may enter a stone surface and subsequently be retained for long periods due to the slow process of evaporation.

Current research in Scotland has established that water retention is the main cause of sandstone deterioration in wet northern climates because it will stimulate:

a) algal colonisation and bacterial activity (the extent and nature of damage from these organic pollutants is currently being reassessed by research groups in Aberdeen and Glasgow);

b) conversion of feldspar to clay - this is the principal geological factor in the long-term reversion of sandstone to sand within the earth's crust;

c) swelling of natural clays creating internal pressure;

d) hydration of sulphate salts creating crystallisation pressure;

e) oxidation of iron oxide to iron hydroxide creating surface staining and discoloration.

It is clear from figure 11.2 that sculptural monuments will suffer more serious decay from this problem than other structures.

Salt Transmission and Structural Breakdown

The transmission of rainwater through stone, particularly if polluted, will deposit within the stone dissolved minerals such as sodium chloride or anions from dissolved sulphur, nitrogen, and carbon gases such as sulphates, nitrates and carbonates. Depending on extremes in pH, the water may also dissolve compounds within the cement-matrix which release harmful cations, such as sodium and calcium. Salts will reform to produce minerals which expand on hydration with a sufficient force of crystallisation to cause structural breakdown. *Thenardite*, anhydrous sodium sulphate, is the most damaging agent of such decay, particularly when high concentrates are deposited by chemical cleaning systems.[2] Salts which effloresce onto the surface will cause less harm than those which crystallise sub-surface.

Examination of the patination profile and path of the ingress-egress water cycle indicates that salts may also be transmitted by capillary action deep within the stone and that drying action will deposit them at evaporative zones generally just below the outer stone surface, but in some cases at a point within the depth of the stone. The location of salt deposition across the patination profile will partly depend on the area of greatest drying action (figure 11.6).

Patterns of salt efflorescence on the stone surface give a good indication of salt concentrations down the stone structure, usually occurring below water catchment and retention sites, such as parapets and string courses, or at its base (colour plate XVI).

The force of gravity plays a major role in concentrating salts at the base of structures. There the salts may threaten the structural stability of the stone by causing severe decay, particularly if this takes place at the base of sculptural features such as pillars and columns. This particular feature has been recorded on buildings which have been chemically cleaned, where residual salts originally deposited at low concentrations over the surface have been subsequently transmitted downwards by gravity to form a high concentration at the base.

Current practice towards sculptural monuments

It is clear from the complex weathering and soiling patterns of exposed sandstone structures that

[2] Porter, 'Stonecleaning', 16-20; R.J. Schaffer, 'The Weathering of Natural Building Stones', *Building Research Special Report 18*, HMSO, 1932, p.94.

water - its ingress, transmission and retention - is the main agent of decay. Where cleaning treatments introduce water and chemical solutions, these will follow the path of water movement throughout the structure and may dramatically accelerate the processes of decay. Current cleaning practice in Scotland has particularly favoured water-based and chemical treatments for all exposed stone structures. The harmful long-term effects of such treatments have been initially recorded by university research groups in both Glasgow and Aberdeen. The specific problems arising from the current approach to two city monuments will now be used to demonstrate the additional complexity of treating sculptural structures in this way and the urgent need for more specialised, controlled methods and procedures to ensure long-term preservation.

A: The Scott Monument, Edinburgh

Designed by William Kemp in 1846 as a memorial to Sir Walter Scott, Scottish poet and novelist, this monument contains sixty-four individual narrative figure sculptures derived from Scott's work, and represents one of the most important Gothic Revival groups in Britain (colour plate XV).

Centrally located in Edinburgh's main thoroughfare, it has developed a black overall industrial soiling which heavily encrusts the sculptures and architectural detail, particularly on its wet northern face. More variable soiling, surface staining, efflorescence and loss are found on the drying surfaces facing the sea-blown winds from the north-east and the sunny winds from the south-west.

The City's desire to clean and revitalise the darkened profile of Scotland's first national monument is commendable and their architectural team adhered strictly to the standard procedures currently practised for treatment of stone buildings, giving much time to examination and analysis prior to presenting a proposal for cleaning. Due to recent concern over the long-term effects of current cleaning methods, however, their proposal became the subject of a Public Inquiry.[3] In the light of this Inquiry, the City's approach is now reviewed.

Nature and Condition of the Monument

In order to examine the City's proposal in relation to a thorough understanding of the monument, scientists presented evidence which combined to establish the nature and current condition of the monument. This concluded that:

- The design of the monument and its abundant sculptural detail will stimulate a high ingress and retention of water, as demonstrated by the patination profile of its ashlar surface (figures 11.2 and 11.7).
- The principal fabric is a porous Binney sandstone with iron, clays and a minor oil component; much of this material has been drawn to the surface by water transmission.
- When exposed to water, the iron within the profile oxidises to various states of iron hydroxide, staining the outer surface bright orange beneath its soiling crust (colour plate XVI).
- The clay attached to the outer grains of the surface traps the incoming inorganic carbon pollutant.

[3] City of Edinburgh District Council/ Historic Scotland, 'Report of a Public Local Inquiry into an Appeal by the City of Edinburgh District Council against the Refusal of Listed Building Consent for Stone Cleaning of the Scott Monument, Princes Street Gardens, Edinburgh, June-November 1992, 18 January 1993. File Ref: HGG/A/LA/3732.

- From ingressed pollution, there is a notable presence of calcium sulphate, nitrate, sodium chloride, potassium and phosphorous.
- Any increase in sodium will dramatically accelerate decay by i) creating thenardite (sodium sulphate) salts, ii) releasing iron from natural iron carbonates, and iii) replacing water in the clay matrix increasing its expansion.
- The soiling crust on sculptural detail appears to act as a protective barrier; where earlier water ingress has been trapped behind it, however, expansion pressure from crystallised salts and hydrated clays will result in spalling and exposure of a weak depleted layer (colour plate XVII).
- Cross sections of sculptural detail were found to be weathered right through their core diameter constituting a thoroughly changed but weakened interior structure with high iron concentration and thick soiling patina at the surface (figs. 11.2c-d, colour plate XVII); this was considered an indicator for the condition of all sculptural detail and sculpture on the monument.

The City's Proposal: Examination, Method and Specification

a) Examination: Two phases of testing within a ten-month period examined three chemical cleaning processes and two air-abrasive trials. Test panels were made in sheltered areas of ashlar and cored for analysis six months after the first phase; further tests within this period were cored and analysed immediately after cleaning. Geological analysis - using thin-section petrography and scanning electron microscopy - determined the effectiveness of the methods in removing the soiling and the degree to which the immediate surface was physically altered after cleaning, i.e. colour change, grain and matrix loss. This short-term surface analysis concluded that the 'gentlest' method, while providing a 'good clean', only appeared to affect the surface to a depth of 1-3 grains, i.e. 1-2mm. Subsequently, 'data from preliminary tests were issued to the stonecleaning specialists [i.e. chemical manufacturers] to enable them to tailor their products to the particular stone and soiling'.

b) Method: on the above basis the final proposal for the whole monument was submitted: it favoured a combination of chemical cleaning procedures as outlined in Appendix A. The principal method was the use of a sodium hydroxide poultice sealed over a 6-24 hour dwell-time, 'neutralised' with an hydrofluoric or acetic acid afterwash. High pressure hosing would be used throughout.

c) Specification: Prior to chemical cleaning, all mortar joints would be restored with fresh lime putty mortars. The process would be carried out by a team of contractors under the supervision of the architects and trained by representatives of the chemical company providing the cleaning reagents. Cleaning would be initiated in sections from the top downwards with polythene and tac-pro-peel film as surface protection from wash waters below the cleaning area. In order to achieve an even clean, the strength of the poultice and its dwell-time would have to be continuously changed to suit the variably soiled surface, so that simultaneous testing would need to proceed in line with the cleaning and supervised by the chemical manufacturers. The sculptures would be cleaned *in situ*.

Assessment of the Proposal from Inquiry Evidence

On examination of the City's proposals it became clear that:

1. Their examination had not included:
 a) establishment of the Binney patination profile

b) testing for long-term effects

c) testing on exposed, variable or heavily weathered areas, i.e. sculptural detail

d) testing for presence of residual chemicals beyond the immediate surface

e) any consideration or examination of the figure sculpture.

2. Their choice of method and specification did not consider:

a) the intricate design of the monument and the abundant inward transmission of water through its porous structure; this in turn might permit pathways for fluid chemical solutions to travel far beyond the immediate surface, risking attack not only of the stone composition but also, on transmission downwards, the multiple mortar joints and metal dowels of the sculptural structure;

b) the potential increase in strength of the chemical solution as it disperses throughout the stone and the inevitable deposition of salts beyond the washing surface; in these sites, salts could take years to weather out, possibly concentrating at load-bearing areas;

c) the possibility of washing procedures encouraging greater ingress and retention of chemical solutions deeper into the stone (protection of the outer surface below any cleaning area would only serve to inhibit evaporation and encourage longer retention of solutions that had travelled downwards within the stone from the cleaning area);

d) the potential dangers of the chemicals themselves including

- the formation and deposition of harmful soluble salts
- attack of stone (quartz, feldspar, clay, iron, carbonates)
- attack of structural or ornamental metals (iron, copper, lead)
- attack of lime mortars (to which acetic acid is particularly harmful)
- disturbance of natural pollutants;

e) the variability of the surface and the inherent lack of control of the poultice method; this is not able to confine its action to the surface, nor to adapt its effects flexibly in response to the differing degrees of soiling within a single area;

f) the highly deteriorated nature of the sculptural detail and problems of removing the soiling without losing the carved surface or without exposing the weakened interior structure to accelerated water and chemical weathering by increasing surface porosity;

g) the importance of the figure sculpture and its prime importance for preliminary testing not only to determine specialist conservation methods but as an important indicator as to the feasibility of cleaning the monument as a whole - it is clear that, should the sculpture prove too deteriorated to clean without damage, the whole project of cleaning the monument would be questionable;

h) the problems associated with the treatment of heavily deteriorated figure sculpture and the impossibility of carrying out a detailed and sensitive examination and treatment *in situ*.

Further Testing Required by the Inquiry

The City's architectural team provided more comprehensive data to support their proposal, resulting from extensive analysis using High Performance Gas Liquid Chromatography in order to determine chemical deposition and transmission at depths up to 20mm into the stone. Over eighty visible cores, approx. 3-5mm wide and 12-20mm long (colour plate XVIII) with corresponding panels, were taken from diverse areas over the monument on both ashlar and sculptural detail.[4]

[4] It became evident during the Inquiry that many of the City's cores for analysis were taken from areas unrepresentative of the weathering and cleaning process and were therefore unable to provide meaningful data.

One sculpture, 'Dirk Hatteraik' (figure 11.2c), was removed and tested using its entire surface area; the sealed 24 hour sodium hydroxide poultice was applied, with one half of the sculpture 'neutralised' by hydrofluoric acid and the other by acetic acid. High-pressure jetting completed the test and sizeable cores were taken from each area of the buttocks.

The short-term results from this analysis indicated that:
1. On ashlar and sculptural detail
a) The effects of the poultice will:
- cause deeper infiltration of chemicals, the more liquid the poultice and the longer the dwell time; increase sodium levels to twelve times normal base rate from 300 ppm to 3500 ppm, concentrating in 1-7mm saturation zone and ingressing in a flattened downward curve to 20mm depth; this was well beyond the surface wash-out area and the 1-2mm affected surface originally claimed.
- dissolve ions from surface pollutants SO_4, NO_3, Cl and cause them to infiltrate deeper within the stone to a saturation peak beyond sodium at 12mm; following the poultice 3000 ppm sulphate ions were found to be dissolved at the surface and flushed to a saturation peak at 6mm within the stone - on drying 20,000 ppm sulphate ions were recorded at 1mm below the surface.
b) On heavily weathered porous structures such as crockets, pinnacles and sculpture, fluid chemical infiltration exceeded 20mm (in comparison to 6mm on fresh unweathered stone) and a higher concentration of salts will be deposited at 1mm below surface; iron mobilisation from 20mm will be greatest in these structures.
c) The thicker pollutant layer on sculptural stone will inhibit penetration to 3mm, compared to 12mm on exposed surfaces - this demonstrates the protective nature of the soiling crust.
d) Pre-wetting will stimulate greater infiltration of chemicals.
e) Washing will remove soiled grains from the outer surface giving the false impression of 'good cleaning action'; it will also remove pollutants from 1-2mm of the surface, reduce them at 3-4mm, and leave salts untouched at a deeper level, permitting them to diffuse further in.
f) Drying will draw a percentage of ingressed soluble salts towards the surface, depositing the majority at specific saturation peaks within the profile - the forces of evaporation being counterbalanced by capillary forces in towards a drier zone.
g) The effects of air-abrasive cleaning using 150 grit (Jackson-Cox) will achieve a partial clean and preserve detail; it was rejected for cleaning ashlar surfaces due to 'shadowing' but considered by the City as acceptable for sculpture.
2. On the sculpture
The poultice clean caused immediate patchy iron staining and revealed the stone to be different from Binney, with structural fissures throughout its structure caused by large iron sulphide concretions within its composition which had expanded on weathering; further attack by water, oxygen and residual chemicals from cleaning would inevitably exacerbate this expansion process and risk further liberation of iron from the pyrites and the formation of sodium sulphate. No results from coring were noted.

On the basis of these results, the City team proposed:
i) adapting the poultice in such a way that the level of sodium could be reduced on the monument by using shorter wash times; and ii) the sculpture should be abrasively cleaned which would partially retain soiling as a protective coating; this process to be left to conservation specialists. No connection was made between treatment for the sculpture and treatment for the monument.

Conclusions from Inquiry Findings[5]

Conclusions from the Inquiry may be summarised as follows:

1. Complete removal of soiling from the monument would
 a) increase its porosity and degree of water ingress, estimated at over seven times its present intake, thus accelerating its natural pattern of decay;
 b) reveal a surface already variably stained bright orange, particularly in the areas of sculptural detail; this discoloration would be intensified by fresh exposure to water ingress.

2. The use of chemical cleaning solutions including the poultice would contribute to the dramatic acceleration of decay by:
 a) increasing porosity and water ingress through attack and dissolution of the stone structure (the removal of impermeable clays from the outer surface, which possibly contributed to the protective nature of the soiling crust, would facilitate such water ingress and the deep infiltration fronts recorded from chemical treatments clearly demonstrates this form of attack);
 b) forming and depositing harmful salts and pollutants deep within the stone, beyond the wash-out zone;
 c) lacking sufficient control to retain cleaning action to the surface and adapt it sensitively to variable soiling across the surface.

A professional conservation assessment might further conclude: i) cleaning the monument at all may not be desirable either from a visual or conservation point of view and that any acceptable method should still be the subject of further research using the feasibility of cleaning and protecting the figure sculpture as the prime indicator for treatment of the whole monument; ii) any cleaning method should avoid wet treatments; iii) the City's approach to methods of examination not only caused damage to the Monument and sculpture but was insufficient to establish the harmful nature of the method they initially proposed; the use of a single sculpture as an experimental multi-test area broke all conservation ethics and demonstrated a lack of sensitivity to fine figure sculpture of national importance; iv) the City's final proposal, despite various adaptations, demonstrated a lack of understanding of sculptural monuments exposed to long-term weathering and the requirement for a method which would protect the surface and inhibit accelerating decay. Although they insisted on chemical methods known to form salts and risk inevitable deposition within the stone, they made no provision for salt removal or long-term monitoring following cleaning.

B: The Stewart Memorial Fountain, Glasgow

Built in 1872 to commemorate the bringing of fresh water to the city, this sculptural monument contains finely sculpted surface relief and individual sculpture representing flora and fauna from Sir Walter Scott's poem 'The Lady of the Lake'. Additional decorative features include a series of enamel roundels set into the fabric, bronze sculpture and relief plaques, pilasters of variously coloured and veined polished Portsoy 'marble' (viz. serpentinite) and an outer water basin of granite. The main fabric of the carved central structure is a blonde Giffnock Liver Rock with

[5] Although the Public Inquiry has not yet been published, the *Glasgow Herald* of 7 April 1994 recorded that 'consent to clean...has been refused on the grounds that the stonecleaning process would do more harm than good', and that Ian Lang, the Scottish Secretary of State, had, 'accepted the conclusion of the Reporter, Mr John Grainger, that the risk of harm to a monument of national importance outweighed the potential benefits of cleaning. The Binney stone used in the Scott Monument was known to have poor resistance to crystalline sodium sulphate and the introduction of sodium in the proposed cleaning technique led to the conclusion that the process could be potentially damaging to the stonework.'

components of iron, clay and some carbonate.

Set in the centre of Kelvingrove Park and long since disused as a fountain, the monument became disfigured with dark patches of soiling and discoloration over the surface and with loss from continuous attacks of vandalism. The incentive to treat the Fountain was provided by Glasgow's Garden Festival 1988 and the decision to restore it to full working condition was commendably promoted by the Glasgow Building Preservation Trust, whose main aim was to protect it from further vandalism by providing a continuous flow of water over its surface.

Despite the professional and conscientious approach taken by the Trust and a leading firm of city architects supervising the treatment, the decision to reinstate a full water flow to the Fountain clearly demonstrated a lack of awareness of the long-term weathering problems associated with water on a deteriorated porous stone structure of such intricate design and complex material. Unlike the drier situation of the Scott Monument in Edinburgh, this factor would be more critical in Glasgow due to the heavier rainfall and higher incidence of algal growth.

This problem was further exacerbated by the lack of specialist advice in the early stages which would have ensured a more specific investigation upon which to base the best choice of treatment for long-term preservation. Insufficient examination subsequently led to an inadvisable treatment, with serious long-term consequences for the Fountain. With the support of both the Trust and the architects, the consequences of both the choice and the method of treatment will be outlined below, as a useful form of guidance to those responsible for similar city sculptures elsewhere.

Analysis and Treatment
The procedures for analysis and treatment are outlined in date order in Appendix B. This demonstrates that the choice of treatment was based on the visual results of a three-day test panel using a fluid multi-chemical treatment principally composed of alkali sodium hydroxide, hydrochloric acid and hydrofluoric acid. High-pressure rinsing was used throughout. This was followed by a simple geological identification, noting absence of carbonate.

Subsequent cleaning of the whole Fountain revealed patches of heavy iron staining juxtaposed with dark grey uncleaned areas (colour plate XIX). These poor results stimulated a visual examination of the stone's profile which suggested the presence of residual traces of an original water-repellent coating in the surface and explained the patchy cleaning result. It was evident that due to the porosity of the stone chosen for the carved structure, its surface had to be sealed so it could be used as a working fountain.

Prior to a scientific identification of the coating as paraffin wax and boiled linseed oil, steam cleaning was tested unsuccessfully to reduce this coating. Had scientific data been available prior to cleaning, conservators would have been able to advise against trying to dissolve these hydro-carbon materials with steam.

The third attempt to clean using a multi-chemical detergent dissolved in hot water also failed, risking further deposition of new chemicals and water through the porous surface of areas free of the oil-wax coating. This treatment was immediately followed by a biocide application. Within weeks, owing to financial pressure and the approaching opening date, there was no option but to reseal the sandstone surface with a paraffin wax in order to permit restoration of the full water flow.

Projected Damage
It is evident that resealing the surface so soon after the wet treatments risked entrapping a great deal of water with the deposited chemicals which had not had time to evaporate from the saturated

stone. A conservation assessment of the projected effects of treatment on the surface profiles is given in figure 11.8.

Apart from the disfiguring and uneven effects of cleaning, the potential dangers of this treatment hold the following serious implications for the long-term preservation of the Fountain:

Water Retention and Microbiological Attack: Research in Glasgow and elsewhere has established that water saturation and retention is responsible for the heavy growth of algae in sandstone buildings and forms their principal soiling content. Current microbiological research is further examining extensive stone decay from bacterial activity which depends on water and the presence of algae to support its life-systems.[6] The added stimulation of specific minerals and pollutants such as iron, sodium, sulphate and nitrate is further being examined, and early research into the effects of synthetic hydro-carbon polymers on bacterial activity has recently been published.[7] It is clear that an abundance of all three stimulants of organic pollution, i.e. water, minerals and synthetic polymers, was applied to the Fountain.

Chemical Attack: Apart from physical attack, the alkali/acid treatment risked excess deposition of sodium and the formation of sodium chloride. The dangers of sodium within sandstone have already been noted; the dangers of sodium chloride will lie primarily in its ability to retain water and to attack iron, copper and bronze, i.e. dowels, piping, nozzles and sculpture. The crystallisation of sodium chloride is known in archaeological conservation to break up iron. Hydrofluoric acid is known to pit and etch silica. General attack by the acids would dissolve whatever mortar/synthetic material is present and the matrix material binding the silica.

Should the dangers above materialise, two fundamental problems would occur with the future maintenance of the Fountain:

Continuous Water Flow: this would wash any residual chemicals and dissolved silica down the outgoing pipes, risking abrasion and corrosion of the metal; the abundance of water would accelerate organic growth, and degraded material would be washed down the pipes risking clogging, internal pressures and cracking.

Switching Off the Flow: this would cause drying out and salt crystallisation, particularly where water could evaporate through degraded mortar joints. Having entrapped chemicals behind the surface, there would be a serious risk of salt crystallisation and structural decay, particularly from the sodium input, should the Fountain be allowed to dry out. The original insistence by the Trust and architects for maintaining a continuous water flow over the Fountain now became more critical: to avoid structural decay as well as vandalism, it was imperative that the Fountain as treated should never now be switched off.

Post-Cleaning Effects
Some of the potential dangers discussed above appear to be borne out by the post-cleaning effects

[6] W. Krumbein *et al.*, 'Microbial Interactions with Building Stones with special reference to various cleaning and restoration techniques, in Webster (ed.), *Stonecleaning*, pp.237-8.

[7] M. Wilimzig, W. Sand and E. Bock, 'The Impact of Stonecleaning on Micro-organisms and Microbially-Influenced Corrosion' in Webster (ed), *Stonecleaning*, pp.235-6; R. Palmer Jr., 'Microbial Damage to Building Stone, Analysis and Intervention', in *ibid.*, pp.239-45; K. Petersen, Ch. Peyn and W. Krumbein, 'Degradation of Synthetic Consolidants used in Mural Painting by Micro-organisms, *Conference Proceedings: Peintures Murales, Journees d'Etudes de la SFIIC*, 1993, SFIIC, 29 Rue de Paris, 77420, Champs-sur-Marne.

(colour plates XX-XXI). Since November 1988, the visual effects on the Fountain may be identified as follows:

Immediate:
- increased porosity (unsealed areas)
- etched marble pillars and granite basin
- accelerated iron staining efflorescence

Short/Long Term:
- very heavy iron staining (colour plate XXI)
- accelerated organic growth (algal/lichen/plant) (colour plate XXII)

The most disturbing effect to date, however, was the discoloration and clogging of the water flow by degraded plant/organic material and a 'heavy coliform bacterial contamination'. This occurred within a year of opening and by 1990 the Fountain was switched off for a few months for sludge removal and nozzle cleaning. During this period the Fountain was vandalised by graffiti and sculpture removed. This year the Fountain has been dried out for a second period due to a collapse in the piping system and is now boarded up against vandalism (colour plate XXIII).

Specialist Conservation Alternatives
With hindsight, and the knowledge derived from current research and monitoring, it would appear that reinstatement of the Fountain to full working condition contained risks for its long-term damage which were not considered at the time the decision was made.

Had specialist conservation advice been sought at this stage, these risks could have been better clarified and a proper procedure for full pre-treatment analysis and testing carried out. This would have identified the irreversible presence of a wax-oil coating, the porous degraded nature of the stone, and the added complexities of multi-media materials. Thus, the inadvisability of both general wet cleaning (especially chemical) and reinstating a continuous water flow would have been clearly established, and a selective conservation treatment proposed, advocating:

1. Controlled selective dry abrasive cleaning on all carved sandstone surfaces, to be carried out by trained staff under specialist supervision.
2. Algal removal using biocide treatment and dry brushing.
3. Specialist conservation treatment for individual sculpture and associated materials: enamels, metals, polished granite and 'marbles'.
4. Protective (ornamental) structure to inhibit vandalism and weathering.

Long-term Damage from Current Practice
In examining the complex structure and decay of two city monuments, one exposed to normal weathering conditions and the other to saturated conditions, it is clear that the current treatment and procedures fall far short of addressing the problems and providing an acceptable treatment for long-term preservation. Each approach appears to have lacked an understanding of materials, the specialist knowledge and procedures required to assess them, and sensitivity to the carved surfaces and sculpture.

Neither approach demonstrated awareness of i) the ability of degraded stone structures to decay from exposure to water ingress and pollution and the acceleration of this decay caused by use of chemical treatments; ii) the inability of chemical treatments to confine their action to the surface and clean variably soiled surfaces evenly. The most serious effect of the methods of analysis and

the treatment employed is the physical damage currently suffered by both monuments and the conservation question of whether the damage may be corrected - a question which appears not to have been considered prior to treatment.

It is hoped that in examining these two examples, a new awareness may be generated of the problems with sculptural monuments which will guide those responsible for major city monuments at present awaiting treatment.

The Specialist Conservator within Architectural Conservation

To date, the use of the specialist conservator and the full extent of his/her expertise has been highly restricted within architectural conservation. It is proposed that a more defined and extended role for the specialist conservator might prove beneficial to those responsible for the care of exposed monumental sculpture and the complex problems they pose for long-term preservation.

Fully qualified specialist conservators with training which combines scientific understanding with practical hands-on experience of deteriorated multi-media materials should be in the best position to assess these complex problems. Their materials science training includes an understanding not simply of stone but all associated materials involved in sculptural structures, e.g. mortars, metal dowels and sculptural ornament, synthetics etc. and the effects of treatment on them. Their practical training and experience in assessing the effects of treatment, however, must be considered their most valuable asset.

Such combined skills form an essential link between theory and application which enables them to consider all aspects of the problem.[8] From such assessment, they should be able to draw up a fully comprehensive specification which details:

a) the most relevant type of research and analysis required;
b) the most suitable choice of treatment, based on the analysis;
c) the correct procedures and timing required for a. and b;
d) risks of treatment in future weathering and requirements for post-treatment monitoring and protection.

The dual theoretical/practical role of a specialist conservator within conservation may be compared to a surgeon within the medical world - a professional whose choice and application of treatment is based on research and consultation with many specialists, but who retains the ultimate responsibility for choice, application, and after-effects of treatment. Such responsibility fundamentally requires that the surgeon plays a key role in asking the questions, directing the research, assessing the results and deciding on treatment. A good surgeon should be respectful of his consultants and should be constantly reassessing his techniques in the light of new research.

In the architectural world, the full responsibility for choice and application of treatment lies wholly with the architect who has a theoretical and practical knowledge of structures but does not possess a combined scientific understanding and working experience of materials on site. He will not himself practically apply the treatment he has specified; he cannot therefore have first-hand experience of the effects and problems involved as they arise across the surface. This he must leave to his manual workforce who, if they lack the expertise of specialist conservators, will not be able to interpret fully the on-site problems in relation to the treatment and thereby initiate correct alternatives. This leaves an area in which unintentional but severe long-term damage may occur.

[8] J. Porter, 'A Conservator's Approach to Architectural Stonework', in Webster (ed.), *Stonecleaning,* pp.121-4.

For monumental sculpture and sculptural monuments requiring specialist expertise, it is proposed that the gap between the architect's expertise and the material effects of treatment be filled with the practical expertise of the specialist conservator and that he/she is brought in on the overall project from the earliest stages of planning, with joint professional responsibility for decisions on analysis and choice of treatment. On this basis, the position of the specialist conservator within the organisation currently responsible for the care of sculptural monuments is proposed as outlined in figure 11.9.

National Code of Practice for Treatment of Sculptural Monuments

It is further proposed that architectural conservation initiates a national code of practice for the treatment of architectural sculpture and sculptural monuments based on the standards and procedures of specialist conservation expertise. Section 1 would outline criteria required for theoretical determination of the efficacy of treatment for long-term preservation, and Section 2 would outline basic procedures and standards required to be built into any contract under the major headings of Pre-Treatment Testing, Practical Application, and Post-Treatment Monitoring. Appendix C outlines this proposal in relation to cleaning.

Acknowledgements

This article could not have been produced without the advice and direction of Professor Brian Bluck and the constant, patient cooperation of his technical staff: Miss Sheila Hall (draughtsperson); and Mr Douglas Maclean (photographer) of Glasgow University Geology Department. Deep gratitude is extended to them. My warm thanks also is extended to Mr Ingval Maxwell, Head of Conservation, Historic Scotland for his generous support and loan of slides; to Miss Liz Davidson of the Glasgow Building Preservation Trust and Mr Brian Park for support and data on the Stewart Memorial Fountain; to my conservation colleagues in Glasgow Museum for their support and encouragement.

APPENDIX A

Original Cleaning Proposal submitted to Public Inquiry by City of Edinburgh

The Report concludes 'it may be worthwhile to consider a cleaning programme utilising all three processes for different situations' (Final clause, p.106). The processes under consideration were:

A. PROSOCO T-1217 STRONG ALKALINE POULTICE

- Applied to dry stone (@ ?pH 14)
1 application of sodium hydroxide mixed with inert powder (magnesium silicate) to form a paste 6mm thick sealed 6-24 hours.
- High pressure rinse/jetting off
2 applications of acid afterwash (HF or *weak acid solution)
- High pressure rinse

B. NEOLITH ALKALI/ACID CLEANING SYSTEM

- Applied to 'pre-wetted' stone
- 2-4 applications of HDL (sodium hydroxide) gel @ 2-3 hours dwell.
- High pressure rinse
- 1 application of a) 625SS (HF Acid) neutraliser @ ?pH 1.8 OR
b) * weaker acid Neolith 907 (?sulphuric acid)
 OR
c) *organic acid afterwash (?acetic acid)
- High pressure rinse
* not specified

C. REMMERS 'ALKUTEX'

- Applied to dry stone @ pH 5-6
1st application of ammonium hydrogen fluoride @ 30 min. dwell time
2nd booster application of ammonium hydrogen fluoride @ 30 min. dwell time- Rinsed off

A and B chosen as the two preferred options

STEWART MEMORIAL FOUNTAIN - TREATMENT PROCEDURE

1988		ANALYSIS	RESULTS
April	PRECLEAN	3-DAY TEST PANEL - Chemical Acid/Gel Solution	Uneven, inhibited by residual coating
May	"	GEOLOGICAL ID (Commercial Analysis)	Carboniferous sandstone + little carbonate
August	INTERMEDIATE & POST-CLEAN	COATING ID (Commercial Analysis)	Paraffin Wax + Boiled Linseed Oil
"	NO POST-CLEAN ANALYSIS TO DETERMINE RESIDUAL SALTS	discounted by Manufacturer's Chemist due to lack of visible surface efflorescence at time of inspection	
		CLEANING	**RESULTS**
June	a) CHEMICAL CLEAN	i. Sodium Hydroxide Soln. @ pH14) Pre-wetting + High / ii. Hydrochloric Acid Soln. upto 20%) Pressure Jet Washing	Uneven clean, Surface etching, Algal growth, Iron Staining, Efflorescence
July	b) TEST STEAM CLEAN	To reduce old residual coating	Little Change
August	c) HOT WATER DETERGENT CLEAN	Chemalux 24: Polyetylene Glycol, Butoxyethanol, Potassium Hydroxide, Nitrite	Little Change
August	RESTORATION: STONE, SPRAY NOZZLES, MISSING SCULPTURE		
	PREVENTION / PROTECTION		
August	a) BIOCIDE TREATMENT		
September	b) PROTECTIVE COATING	Paraffin Wax heated in with blow torch	
November	RESTORATION OF WORKING FOUNTAIN WITH FULL WATER FLOW		

CONSERVATION CODE OF PRACTICE

I THEORY: Criteria to Determine Efficacy of cleaning

1. RESEARCH AND ANALYSIS

Understanding Nature of stone: *weathering and soiling patterns*

Understanding method and materials: *short and long-term effects*

(+reference to general scientific data from testing and monitoring elsewhere)

2. PRACTICAL CRITERIA

a) aim of cleaning method

b) degree of level of cleaning required

c) degree of control of method

d) degree of risk of method

e) degree of provision for correction of damage

⎫
⎬
⎭
CHOICE OF METHOD FOR

LONG-TERM PRESERVATION

OR

DECISION NOT TO CLEAN

II APPLICATION: Criteria and Procedures for Treatment

1. PRE-CLEAN TESTING *(short and long-term)*

choice and use of testing methods *(panels, cores, others)*

nature and format of scientific reports

2. PRACTICAL APPLICATION *(senior specialist conservator)*

informed supervision

skilled workforce *(conservation trained)*

3. POST-CLEAN MONITORING *(built into contract)*

nature and format of documentation

⎫
⎬
⎭
LOGGED IN A

CENTRAL DATA

SYSTEM

WEATHERING & STRUCTURAL DESIGN

STRUCTURES

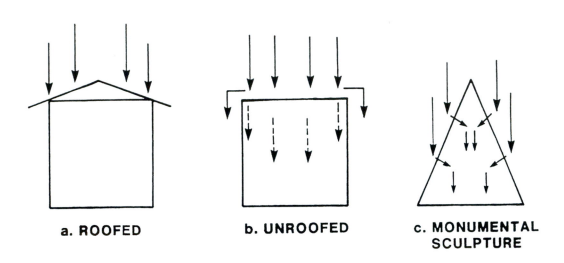

WATER INGRESS

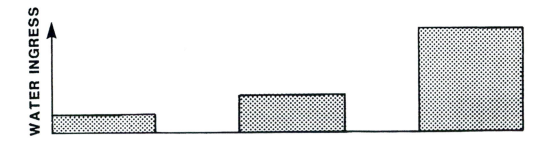

Figure 11.1 Distribution of rainwater on variously shaped structures. Arrows representing rainfall and water flow demonstrate greater inward transmission of pyramidal monumental sculpture. A diagrammatic illustration of possible water ingress is also presented.

WATER INGRESS - CATCHMENT AREAS

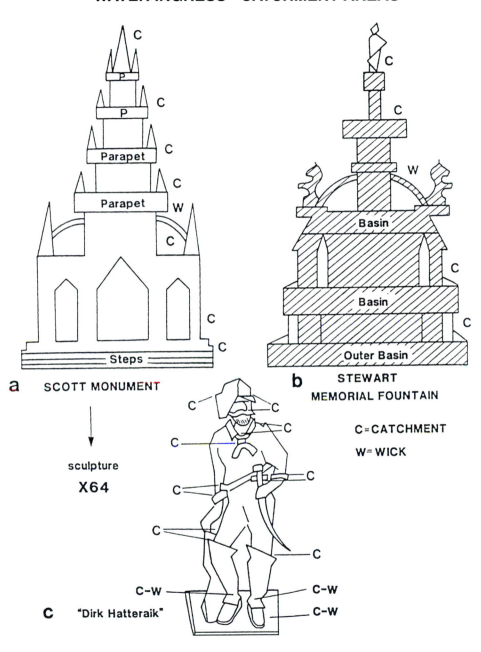

Figure 11.2 Water ingress pattern on two sculptural monuments of pyramidal form. The intricate design and architectural detail results in a greater surface area exposed to fluids and provides catchment areas for the greater retention of water. Additional figure sculpture will increase ingress (x 64 on Scott Monument).

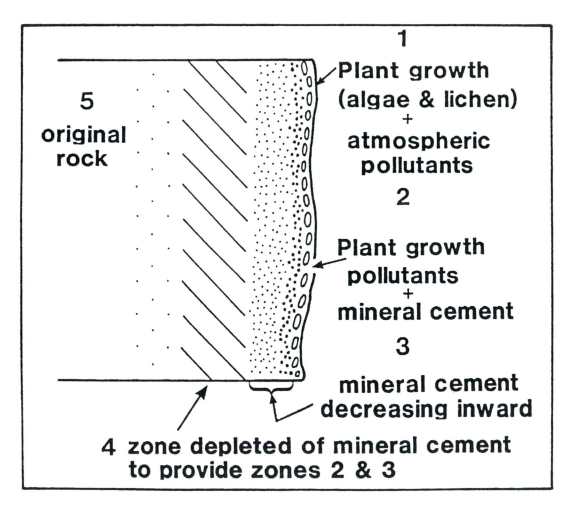

Figure 11.3 Mature patination profile from weathering on a porous sandstone, ranging from mm. to cm. and illustrating integration of exterior pollution with internal minerals redeposited below the surface and leaving weakened zone (4) vulnerable to spalling.

CORE WEATHERING

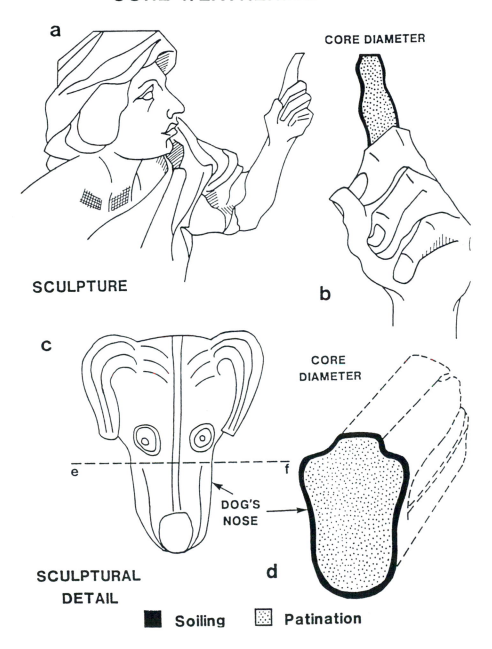

Figure 11.4 Diagrammatic illustration of patination across complete core of sculptural detail:
a. & b. exposed red sandstone sculpture (1900, Glasgow City Art Gallery); c. & d. exposed blonde
sandstone sculptural detail (1846, Edinburgh Scott Monument); e-f. section of dog's nose broken
during maintenance.

INGRESS-EGRESS: WATER STATES
DURING TRANSMISSION

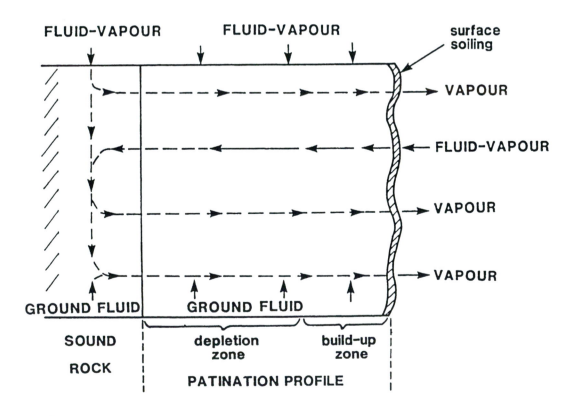

Figure 11.5 Water states during transmission illustrating the ready ingress and slower egress of moisture leading to greater water retention.

FORCES OF FLUID TRANSMISSION & SALT BUILD UP

CAPILLARY & GRAVITY ACTION

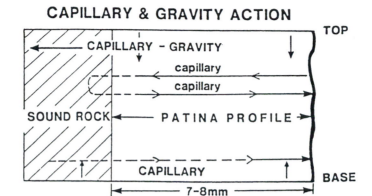

DIFFUSION ACTION & EVAPORATIVE ZONES

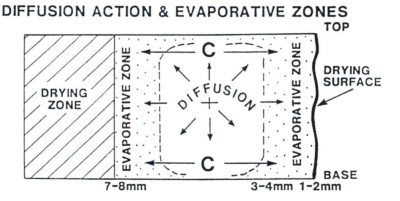

SATURATION ZONES & SALT BUILD UP

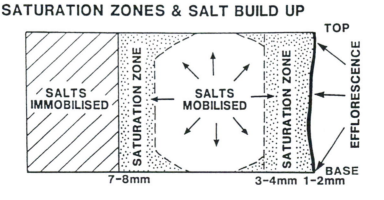

Figure 11.6 Diagrammatic illustration of forces governing movement of fluids (capillary & gravity action); locations of drying (diffusion action & evaporative zones); and the resultant zones of saturation and salt build-up.

SCOTT MONUMENT : WEATHERING PROFILE

	QUARTZ 90%		CLAY-RICH ZONE	SOILING:
	FELDSPAR	IRON RICH ZONE + RETAINED H_2O		Rock dust & 20%
			Kaolinite	Carbon (Diesel)
		α-FeOOH	Illite	&
	CLAYS			S
	FeO	IRON HYDROXIDE (Goethite)		
	IRON OXIDE			NO_3
	Kaolinite	γ-FeO (OH)	Clay film on outer	
	Illite		grain surface	Na
	Smectite	$FeCo_3$	attracts	
		IRON HYDROXIDE (Lepidocrocite)	pollutant	Cl
	Oil-clay	IRON CARBONATE (siderite)		
				PO
	SIDERITE	expansion of		
		illite-Smecrite		
	Fe oxide	CLAYS		(no organic)

PATINATION PROFILE

mineral mobilisation & hydration

| 4–8mm | 1–3 grains | 1–4mm | 0·5–1mm |

POLLUTANT SOILING : Variable , thickest in grain clefts where
 kaolinite present. Some areas impermeable

Figure 11.7 Diagrammatic illustration of Scott Monument Weathering Profile, based on research data from Public Inquiry.

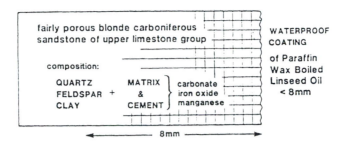

a. ON CONSTRUCTION, 1872

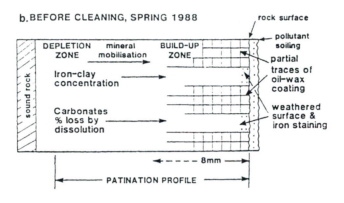

b. BEFORE CLEANING, SPRING 1988

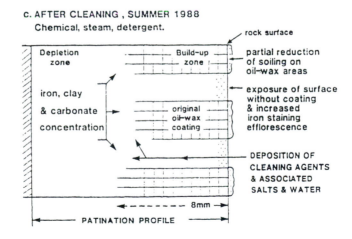

c. AFTER CLEANING, SUMMER 1988
Chemical, steam, detergent.

Figure 11.8 Stewart Memorial Fountain: diagrammatic illustrations of projected surface profiles: a) On construction in 1872 showing application of original waterproof coating; b) Before cleaning, Spring 1988, showing residual traces of oil-wax coating and weathering effects; c) After cleaning, Summer 1988, showing uneven clean inhibited by oil-wax coating, decay of exposed uncoated surface areas, and deposition of cleaning agents within the structure.

PRACTICAL CRITERIA FOR TREATMENT --- WHO DECIDES ?

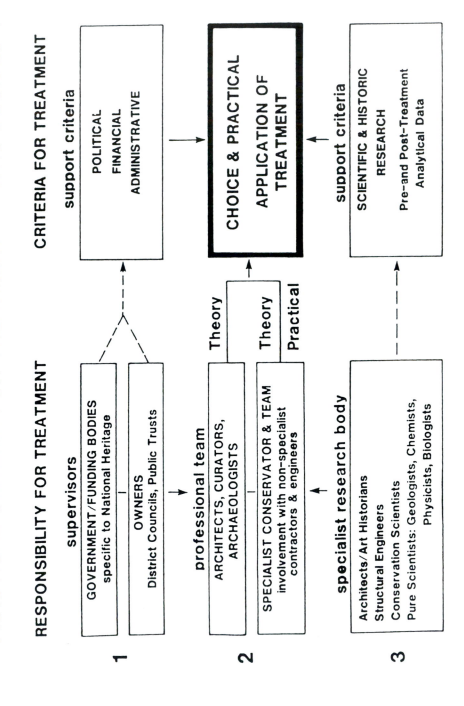

Figure 11.9 Flow Chart indicating the effective position and role of the specialist conservator within the organisation treating sculptural monuments.

CHAPTER 12

PERSPECTIVES ON THE REPATINATION OF OUTDOOR BRONZE SCULPTURES

J. Heuman

Introduction

Patination, the artificial colouring of metal sculptures, has been practised since antiquity. In this paper I shall consider some practical implications of the changes which patinas on nineteenth and twentieth-century outdoor bronzes have undergone, and the factors involved in deciding when a sculpture should be repatinated. The surface of a bronze is usually chased or polished after casting and then patinated by the foundry or the artist. Patination techniques have altered historically; by the nineteenth century chemical patination was widely practised. With chemical patination, acids and mineral salts are applied to a bronze surface to produce chemical compounds of various colours. The original patina is considered an integral part of the sculpture's aesthetic history.

As patinas change with exposure to the atmosphere, original colours are forgotten. The 'natural' green patina found on many ancient works, usually a mixture of sulphates, sulphides, oxides, carbonates and chlorides, has come to be valued despite evidence that many ancient sculptures were originally a highly polished gold colour or polychromed. 'A patina of age that authenticates or preserves antiquity is apt to be thought aesthetic'.[1] Why is it unacceptable to restore an ancient bronze to its original gold colour, when the repatination of nineteenth and twentieth-century sculptures has become accepted practice? The 'art historical' reason is that if the original surface of an ancient bronze is tampered with, valuable information about the history of the work may be lost. This is complemented by a positive appreciation of an antique appearance. 'It is not that we prefer time-worn reliefs ... as such, but the sense of life they impart, from evidence of their struggle with time'.[2]

Artist's Intention

When nineteenth- and twentieth-century works are conserved, our views are focused not so much on the passage of time but on the ideas and techniques which the artist used to create the work originally. The artist's original intent is rarely mentioned when conserving ancient works.

One art historian offers the criticism that:

> much conservation, although certainly not all, is based upon the premise that the artist's original vision of an artefact represents the most true and authentic appearance of that artefact, as if artists and makers were not themselves aware that they were launching an object into a long and complex journey in which it might be changed in both physical appearance and in meaning. The life-cycle of an artefact is its most important property. It is a species of contemporary arrogance which regards it as possible to reverse the

[1] D. Lowenthal, *The Past is a Foreign Country*, Cambridge, 1985, p.155.
[2] Lowenthal, p. 172. Also see A. Malraux, *Voices of Silence*, Princeton, 1978, p.635.

process of history and return the artefact's appearance to exactly how it was when it popped out of its maker's hands.[3]

Certainly, whatever is done to conserve an object, physical change is inevitable. Neither is the present audience and context identical with that of the past. When the artist's wishes and intentions are known, they are taken into account when deciding on a treatment. Yet with outdoor sculptures, the treatment can involve chemical repatination which is not a reversible process. The patina can only be removed by losing some of the metal surface. More reversible methods - such as pigmented waxes and lacquers - have been used successfully to alter colours on bronzes although with outdoor exposure frequent applications are necessary.

Changing Patinas of Nineteenth and Early Twentieth-Century Bronzes

In the Victorian period, large numbers of outdoor commemorative sculptures were erected in London and other cities. There is little information about their original colours or patination techniques. Many London sculptures now have a black patina as a result of the annual application of a lanolin/beeswax mixture.[4] The patination techniques used on these sculptures were usually not documented but it is known that the original colours were not always black or brown. Chantrey's figure of *William Pitt* (1831, in Hanover Square) (plate 35) and that of Westmacott's *George Canning*, (1832, in Parliament Square) were originally described as 'olive-green'[5] and 'pea green',[6] respectively. Interestingly, the Westmacott statue has been maintained and is now black, while the Chantrey sculpture has obviously suffered neglect and is pale green, perhaps ironically closer to its original colour.

Green was not the only colour chosen by nineteenth-century artists for outdoor sculpture. We have become so accustomed to seeing London statues with black patinas that it would be hard to imagine Wyatt's sculpture of *George III* (1836 in Cockspur Street) (colour plate XXIV) as it was described at the unveiling 'of a gorgeous gold colour varnished to resist the effects of the weather.'[7] Perhaps, beneath the black wax coating, remains of the original gold still exist with clues about the patinators' techniques.

The Tate Gallery's sculpture by Lawes-Witterronge, *The Death of Dirce* (1889) (plate 36) originally had subtle colours and tones. Reviewed for the Franco-British Exhibition in 1908 it was described as 'one of the most daring and complicated things ever attempted in this country... in order to prevent complexity becoming confusion, the sculptor has artificially greyed the body of the bull, and the ground, with excellent effect'.[8] A 1908 photograph illustrates how the original tonal modulation added a contrast to the overall composition. Although it is owned by the Tate Gallery, it had been maintained by the Property Service Agency for at least fifty years while it was displayed outdoors, resulting in the ubiquitous black London patina.

Artists who originally patinated their sculptures green, gold, brown or toned probably did not intend their works to turn black or be disfigured with green and black streaks. Should we therefore

[3] C. Saumarez Smith, 'Museums Artefacts, and Meanings', in P. Vergo (ed.), *The New Museology*, London, 1989. p.20.

[4] J. Jack, 'The Cleaning and Preservation of Bronze Statues', *The Museums Journal*, 50 (January 1951), 231-6.

[5] *The Gentleman's Magazine*, London, September 1836.

[6] J. Blackwood, *London's Immortals*, London, 1989, p.178.

[7] *The Times*, London, 4 August 1836; *The Gentleman's Magazine*, NS 6 (1836), 307, has 'of golden hue, and varnished to resist the effects of the weather'.

[8] F.G. Dumas (ed.), *The Franco-British Exhibition*, London, 1908, p.95.

try to retrieve lost patinas? One outdoor sculpture at the Tate Gallery, Henry Fehr's *Rescue of Andromeda* (1894) (plate 37), had its black wax coating removed to examine the underlying surface. Beneath the coating, corrosion was found (colour plate XXV) (antlerite and atacamite identified by EDX) in the more protected areas. A rich chestnut brown colour which was possibly original patina was also revealed beneath the wax (colour plate XXVI), but because no information on original colour was available and the bronze was not disfigured, repatination was not considered an option. The sculpture was cleaned with pressurised steam and a synthetic wax applied over the existing browns and greens.

Repatination has, however, been done on other sculptures of this period. Some art historians argue that an untouched patina, although changed by exposure, is still the 'natural' patina and should not be repatinated even if original colours were documented. As one curator comments,

> while conservation of outdoor public monuments is absolutely essential, we need to be careful not to distort the original artistic intention... Patination of sculpture is one of the most important artistic qualities that a sculptor will give to his work of art, it should not be randomly reapplied by the academic and conservation community.[9]

Yet the fact that this same curator supported the regilding of a major work, Saint-Gaudens' *General Sherman and Victory*, emphasises the need to assess each case on its own merits.

Repatination of the Sherman Memorial

It is impossible to predict how public and professionals will respond to a dramatic repatination. The regilding of Saint-Gaudens' statue of *General Sherman and Victory* (colour plate XXVII) (1903, in Manhattan's Grand Army Plaza) is a project that was well researched with conservators and art historians represented on the board of the Art Commission of New York. Colour was an important component on Saint-Gaudens' sculptures. He paid for the gilding of the Sherman Memorial himself because he did not want his sculptures 'looking like old stove pipes'.[10] The Art Commission agreed that the statue should be regilded to match the original as closely as possible. The regilding was done in 1990 and was followed by a controversy reported in the New York Times. Richard Schwartz, the president of the foundation which funded the restoration, claims that originally

> there was a patina applied to [the gilding] to make the color more appealing. The statue as it stands without being toned down, looks garish and vulgar and not at all like the great work of art it is, to many of the untutored as well as to scholars and professionals. But regardless of aesthetic evaluations, the restoration in its present unfinished state is irrefutably historically inaccurate.[11]

There have also been comments from the public describing the gold sculpture as 'gaudy, tacky and a symbol of excessive opulence in an era of municipal austerity'.[12] This reaction contrasts with that of 1903 when it was described by one critic as the sculpture that 'glitters in the sunlight,

[9] S. Sharp, Director of Denver Art Museum; personal communication on the unpublished talk he gave at the 'Dialogue/89' Conference in Baltimore on the conservation of outdoor bronze sculptures.
[10] J. Dryfhout, *Augustus Saint-Gaudens*, in J. Wasserman (ed.) *Dialogue/89: The Conservation of Bronze Sculpture in the Outdoor Environment*, Cambridge, Mass., 1975, p.183.
[11] *New York Times*, 20 July 1990.
[12] *New York Times*, 7 June 1990.

sumptuous and splendid.'[13]

Would the public today have felt any differently if the regilding had been toned down? Perhaps we have grown so accustomed to seeing outdoor sculptures with muted colours, especially in cities, that *any* gilded sculpture would look gaudy and 'in bad taste'. The experience and expectations of the audience will always be influenced by current trends.

Twentieth-Century Sculptures

With the change from traditional academic representationalism to non-representational forms of 'modern art' has come a renewed interest in the use of colour on sculptural forms. Changes to patinas on more recent sculptures by artists such as Barbara Hepworth and Henry Moore illustrate the conservator's dilemmas even more acutely.

Moore is often quoted as having liked the changes that happened 'naturally' to some of his unlacquered bronzes when they were put outdoors. In 1964 he discussed adjusting his patinating chemicals to take into consideration the environmental changes that will happen so that he could 'get to the ultimate appearance he had in mind'.[14] This indicated that in 1964 he had some ideas as to how his sculptures would change. What he could not know was that the increase in pollution would cause the bronzes to corrode at a much faster rate than in previous centuries. The weathered look of an unprotected bronze in twenty years' time reflects the erosion rate to the surface of five to fifteen microns a year. The subtle changes in colour and surface detail that Moore may have witnessed during his lifetime will not remain indefinitely. In fifty years' time, conservators may consider returning a black streaked Henry Moore back to the artist's original intention, quoting him as saying 'bronze naturally in the open air (particularly near the sea) will turn with time and the action of the atmosphere to a beautiful green.'

Hepworth's attitude to the ageing of her own work was not as clear. The colour change to the patination on her sculpture *Two Forms (Divided Circle)* (1969) (colour plates XXVIII-XXIX), for instance, alters not only the audience's perception of the form, but also modifies the outcome of the artist's original choice of colours. The sculpture originally had a polished gold interior with a chemically patinated greenish colour on the outside. The colour used by the artist represents part of her total conception of form. 'Colour acquired a function in relation to the form, not to the material to which it bore only an indirect relation'.[15]

This sculpture was displayed outdoors in the garden of the Barbara Hepworth Museum and over the passage of time the colours have altered considerably. The interior is now a brownish colour while the exterior has darkened and lost much of the applied green (colour plate XXIX). The changes to the interior and exterior have dramatically reduced the contrast between the two.

The sculpture has been well maintained and the bronze is in good condition. The question is whether we should intervene to change the 'natural' patina which has developed on outdoor exposure and attempt to bring the sculpture closer to what the artist originally intended. Before a decision could be made, it was necessary to undertake a technical examination of the sculpture, consult with art historians about the artist's intentions, and consider the implications to the sculpture if it were repatinated.

According to Hepworth's assistant, the gold interior had tarnished while the artist was alive and the inside had been repolished using wet/dry abrasive paper and varnished.[16] The interior has again

[13] B. Wilkinson, *Uncommon Clay, The Life and Works of Augustus Saint-Gaudens*, Florida, 1985, p.325.

[14] Henry Moore, 'Sculpture Against the Sky', *Studio International*, May, 1964, p.179.

[15] A.M. Hammacher, *Barbara Hepworth*, London, 1987, p.90.

[16] Personal communication with George Wilkinson.

oxidised to a brown colour with remaining traces of gold. There was also evidence of brush strokes where the lacquer had broken down. Microscopic analysis revealed a synthetic resin and a yellow ochre pigment with traces of cadmium yellow. This suggests that the lacquer with added pigment was used perhaps to tone the polished bronze. The outer sides of the bronze have weathered to a much browner colour than the original greenish patina.

Barbara Hepworth had been experimenting with colour on her sculptures since the late 1930s. Colour was very important to her, as she said in 1960:

> I find it necessary to work with a foundry that has an artistic understanding of the qualities of finish and of colour that I want to obtain in the bronze... Look at the colour of that bronze... The blue-grey quality of the shadows, on the interior surfaces, is exactly what I wanted, though I had never seen it before in any bronze.[17]

The use of the contrasting colours can be seen as a theme she explored with other works in different media. Fascinated by the relationship of inner and outer form, she described her use of colour as follows, 'I have often used colour within forms, and concavities, to create another dimension of light and depth which would give a contrapuntal emphasis....'[18]

Locals in St Ives suggest she would not have liked the way nature has aged this sculpture; rather than becoming more contrasted, as has happened on other works, the colours on this sculpture are merging and perhaps will eventually lose all contrast. If the interior were repatinated to resemble its original gold appearance, would this recreate the artist's intention or would it create a new relationship with the aged exterior surface that would be a manifestation of the conservator/curator's reinterpretation? If the sculpture is to be repatinated, it should be done in the near future while traces of the original gold colour remain and those familiar with the original colours can give guidance. In consultation with the curator, it was decided that repatination should take place and tests are underway to find the most appropriate treatment.

Future Problems

Modern technology is already altering the relationship between artists' and audiences' expectations of the ageing of sculptures. Rusted sculptures have usually been thought unappealing but this is becoming an outdated fashion with the introduction of Cor-ten, a weathering steel that was developed to provide a stabilised rusted surface on outdoor exposure. As many artists are using such materials, contemporary taste is being altered. Interpreting the artist's original intent may be even more difficult in the future, unless a special effort is made to record it at the time the work is being created.

Conclusions

As Gerry Hedley pointed out with regard to paintings, 'we cannot return to the artist's original intentions and so we must construct a new relationship between the original intention, the present state of the work and the passage of time'.[19] Repatination, like other major conservation treatments, requires a consultative process involving art historians and conservation scientists. More research and documentation on original and existing patination is necessary for all outdoor sculptures. There

[17] E. Roditi, *Dialogues on Art*, Bristol, 1960, p.94.

[18] Barbara Hepworth, British Council Lecture, 'The Sculptor Speaks', 23 March 1970, Tate Archive.

[19] G. Hedley, 'Long Lost Relations and New Found Relativities: Issues in the Cleaning of Paintings', *Shared Responsibilities*, National Gallery of Canada 1990, p.159.

are not and probably never will be absolutely correct solutions to such dilemmas; conservators and curators can only collaborate in trying to find appropriate solutions for each case.

Acknowledgements
I am grateful to Joyce Townsend, Conservation Scientist at the Tate Gallery, for microscopic analysis. Also thanks to Derek Pullen and Brian Durrans for their comments.

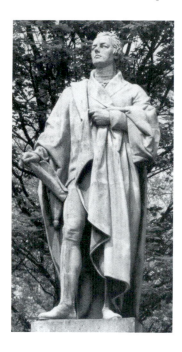

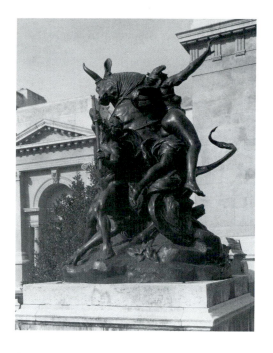

Plate 35 Sir Francis Chantrey, *William Pitt* (1831).

Plate 36 Charles Lawes-Witterronge, *The Death of Dirce* (1889).

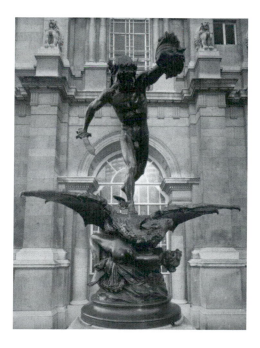

Plate 37 Henry Fehr, *Rescue of Andromeda* (1894).

CHAPTER 13

THE MONUMENT TO GEORGE HOME, 1ST EARL OF DUNBAR, BY MAXIMILIAN COLT, C.1611, IN DUNBAR PARISH CHURCH

K. Taylor

Introduction

The Parish Church of Dunbar in East Lothian was severely damaged by fire in January 1987. All that remained of the building were the four outer walls and the tower. The monument to the 1st Earl of Dunbar, built against the west wall of the north aisle, was extensively damaged (plate 38) and only survived because firemen directed water onto it through a tracery window during the fire. The monument (7.9m in height and 3.65m wide) was constructed in alabaster with decorative panels of Belgian Black and a Rosso type marble. It is almost identical, in detailing and materials used, to the monument to the 1st Viscount of Stormont in Scone Palace (c.1618). There is documentary evidence attributing the Scone monument to Maximilian Colt, who was also responsible for Elizabeth I's tomb in Westminster Abbey. Fortunately, immediately after the fire, the monument was protected by boxing in with a foam-lined and roofed construction and the rubble in the immediate vicinity of the monument was placed inside the temporary cover. This was fortunate because, at the time, the parish had no idea of who to contact regarding the possibilities of conserving the monument. It was almost two years later, following an inspection by Malcolm Baker and John Larson on behalf of the National Heritage Memorial Fund, that I was asked to prepare a report and specification for the conservation of the monument. Prior to the inspection by Malcolm Baker and John Larson, the parish had obtained a report from an Italian conservator who proposed to treat the monument *in situ*. This approach was felt by all concerned to be inadequate, given the serious structural damage to the architectural elements and fixings of the construction.

Initial Inspection and Specification

On my first inspection, my immediate impressions were also that, because of the severe thermal fracturing of the large blocks and structural elements, the only approach would be to completely dismantle the sections of the monument, consolidate, repair and strengthen them, and then rebuild them on new stainless-steel fixings and ties to the wall, even though safely handling and dismantling such a badly damaged and friable monument would be extremely difficult. There were severe fractures running right through the blocks of stone and in some cases large pieces had become detached and had fallen (plate 39). There were also obvious major fractures in the architectural elements, which seemed to correspond to probable enclosed metal cramps and fixings. It was later confirmed that the fixings had expanded in the heat and caused the blocks to split. There were many detached fragments, either blown off the monument during the fire and hosing down by the fire brigade, or broken off by falling debris from the building. It also appeared, on checking, using a photograph taken shortly after the fire, that some elements had fallen since the boxing in, confirming the instability of the structure.

In order to assess what remained of the detached and damaged areas, the rubble within the

enclosure was sorted (plate 40) and the fragments identified and labelled, before being wrapped and packed in plastazote high-density foam-lined cartons.

It became clear that one of the major problems in dismantling would be how to handle, lift and move safely elements weighing up to three quarters of a ton, with serious structural fractures, without the damaged blocks collapsing under their own weight, and how to protect the fragile surface enough even to handle the smaller blocks and panels.

A consolidant of high adhesive strength would obviously be needed to secure the fractures and the viscosity of the consolidant would need to be variable to deal with penetration of deep and hairline fissuring, as well as bridging wider fractures, especially in the large blocks. The consolidant would also have to be reversible, because of the need to separate the fractured pieces later in order to carry out a satisfactory repair, using dowels and pins to strengthen the blocks. A facing tissue seemed to be the only solution to protecting the fragile surface. Following tests on some of the smaller details, it was decided that Paraloid B72, an acrylic resin, dissolved to varying viscosities in acetone, would be suitable in terms of adhesive strength for both the consolidation of fractures and the binding of the facing tissue. The acrylic appeared to dissolve again readily in acetone, allowing the tissue to be removed and the fractures to be flushed out and separated. A specification with cost estimates was prepared for the architects.

Dismantling

An enclosed scaffold with a lifting area and ramp to move the larger pieces to level ground was erected and the consolidant was injected into fine and hairline cracks. A less viscose mix was run into larger cracks using pipettes. Elthelene tissue was then applied to face over fragile surface areas. As is normal practice, dismantling began at the top, each element being carefully removed after cutting through enclosed fixings and removing bedding and jointing material. For the larger elements it was felt that, in addition to the consolidation and facing, a stronger binding was necessary to hold the block together during moving. Hessian bandages adhered with Polyvinyl Acetate emulsion were used. The kneeling figure of the Earl was the first large element to be removed and this was achieved by carefully sliding the figure on oak slides, inserted into the joint under the figure, onto a pre-constructed packing case base. The case sides were then erected around the figure and secure padded bracing employed to hold it in position. The case could then be moved safely to ground level without touching or placing any stress on the actual figure (plate 41). The two large knights were moved in a similar way with additional timber splints bound on to the back of the blocks to allow them to be laid over on to travelling bases. All the sections of the monument (362 in all) were successfully dismantled and placed on pallets and travelling bases in the remains of the church (plate 42). The monument was loaded on three trucks for transport to London. The architectural elements were loaded on to two flat bed trucks by crane and the larger sculptural elements were carefully loaded on an air suspension truck by means of a tail lift.

Conservation

Once safely back in the studio, the Polyvinyl Acetate bound hessian was removed with scalpels (plate 43) and solvents and the facing tissue was slowly removed by dissolving in acetone. Some local reconsolidation was carried out on the surfaces during this operation, before cleaning of the smoke-damaged surface began, using solvents and micro-air-abrasive (plate 44).

Where fissuring of the blocks had not caused complete breaks, e.g. the small lion head details, the fissures were consolidated and filled with Paraloid, aggregates and pigments to match the cleaned surfaces (plates 45-47). Where the fracturing had caused breaks, the breaks were taken apart by dissolving the consolidant and repaired by inserting stainless-steel dowels, set in resin

adhesive, as necessary (plates 48-50). Some of the larger elements (e.g. the heraldic device from the top of the monument and the large coloured marble panels) were further reinforced by inserting stainless-steel angle bars into the backs of the panels.

In places, the surface of the alabaster had lost translucency and had the appearance of plaster. In some areas it was very powdery when the consolidant was dissolved and it was necessary to reconsolidate these areas. The surface generally responded well to several coats of thinned cosmolloid wax which readily soaked into the dry surfaces. This treatment restored some of the translucent qualities of the surfaces. The wax would also provide a buffer against any condensation of atmospheric moisture in the church.

After repair, certain badly damaged features were thought to be key visual elements in the overall design of the monument. The central visual element in the monument is obviously the figure of the Earl, set in the niche against the dark coloured marble background, with the previously gilded inscription panel above. After discussions with all concerned it was decided to carry out restoration of detailing to return these elements to their condition before the fire. It was hoped that restoration of the harsh physical damage in these elements would allow the viewer's eye to travel over the key areas of the monument and unify the design as a whole. The restoration of detail on the figure of the Earl involved refixing surviving fragments and then remodelling larger missing sections of, for instance, drapery, in plasticine on the figure. The plasticine was then removed and the details were recast in a matching resin/aggregate mix, which was then attached to the figure. Moulds were taken from surviving details of lace, etc., cast and pieced in as necessary (plate 51).

The badly fissured and blistered inscription panel was cleaned with acetone and reconsolidated with Paraloid. The blistering was support-filled and some of the surface was filled to level, before the (still legible) lettering of the inscription was regilded.

Rebuilding

The figure of the Earl and the two smaller figures of Justice and Peace returned to Scotland to be included in the exhibition 'Virtue and Vision, Sculpture and Scotland', at the Royal Scottish Academy, organised by National Galleries of Scotland. The remaining 359 sections were transported to Dunbar on air-suspension trucks and the rebuilding of the monument was started in the autumn of 1991, following the completion of the extensive reconstruction of the church.

The monument was rebuilt in its previous position, on new sandstone foundation blocks over an integral damp proof membrane included in the reconstruction of the church. The first course of the monument was set out and fixed, and the new supporting core for the lower section was built up, using stainless-steel ties set in resin adhesives (plate 52). Once the first supporting section - the base, two plinths for the knights and the central sarcophagus - was completed (plate 53), the back supporting cores for the knights were built up (plate 54). These columns would be the springing point for the arch above and when the niche was re-clad with the large coloured marble and alabaster panels, all tied back to the supporting core with stainless-steel fixings, the arch was reconstructed over a timber former (plate 55). The remaining sections of the monument were refixed in this way, until all the architectural elements were securely refixed. Finally, the two allegorical figures were repositioned and the figure of the Earl was replaced in the niche, five years after surviving the fire (colour plate XXX).

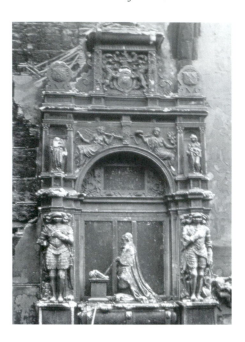

Plate 38 The *George Home, First Earl of Dunbar* monument, Dunbar parish church, shortly after fire in 1987.

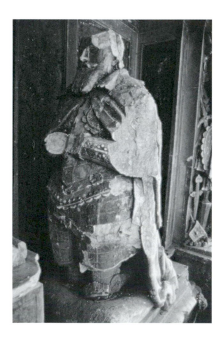

Plate 39 The *George Home* monument; figure of the Earl, showing the effects of fracturing of the large blocks.

Plate 40 Surviving fragments being sorted.

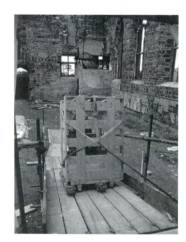

Plate 41 The cased figure being lowered to ground level.

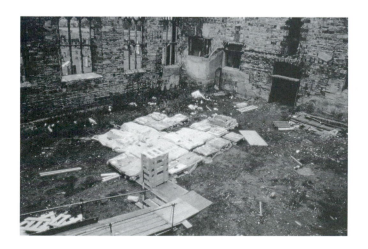

Plate 42 Sections of tomb dismantled and packed for transport.

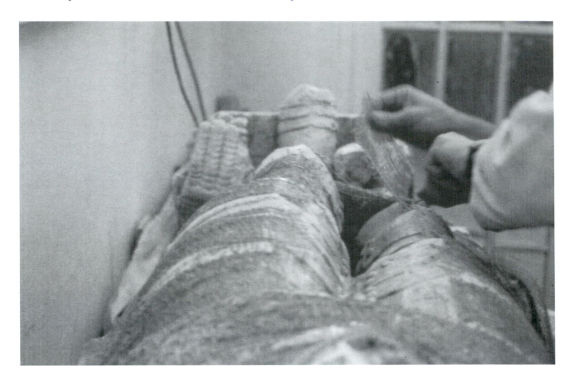

Plate 43 Removal of the hessian binding.

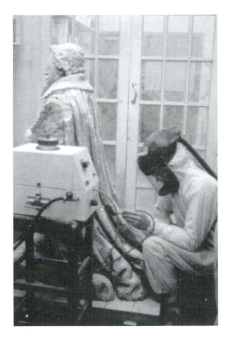

Plate 44 Cleaning using air abrasive.

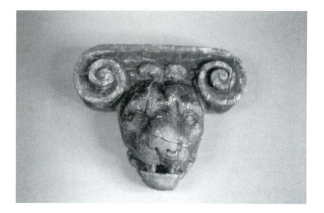

Plate 45 Lion's head detail before conservation.

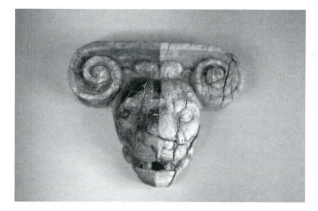

Plate 46 Lion's head, half cleaned.

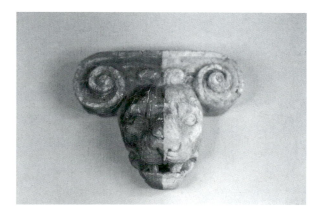

Plate 47 Lion's head, half consolidated and filled.

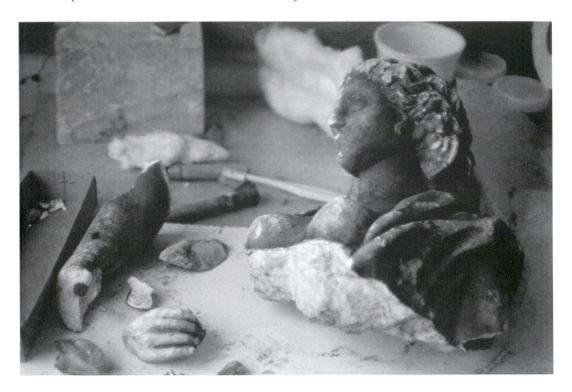

Plate 48 Fragment of allegorical figure.

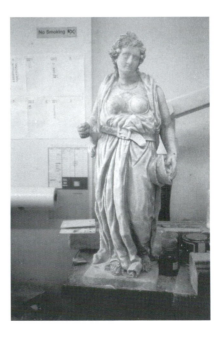

Plate 49 Fragmentary allegorical figure. Plate 50 Figure reconstructed and completed.

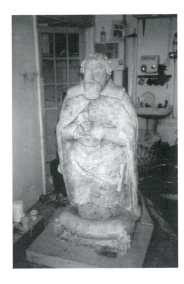

Plate 51 Figure of the Earl completed.

Plate 52 Rebuilding: first course
of stone in position.

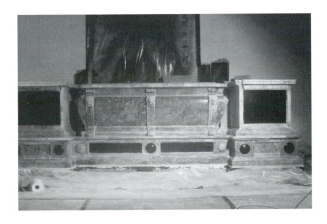

Plate 53 Rebuilding: first stage
completed.

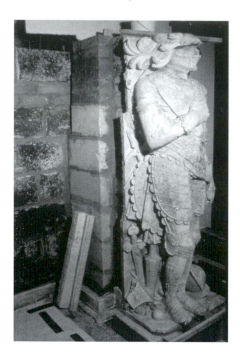

Plate 54 Supporting core for knights in place.

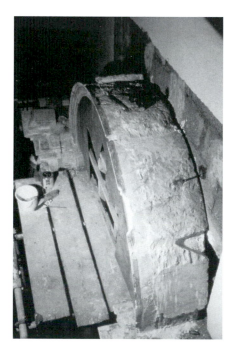

Plate 55 Rebuilding of the arch.

CHAPTER 14

VASARI'S THEORY ON THE ORIGINS OF OIL PAINTING AND ITS INFLUENCE ON CLEANING METHODS: THE RUINED POLYCHROMY OF THE EARLY THIRTEENTH CENTURY CRUCIFIX FROM HAUG, NORWAY

K. Kollandsrud

Introduction

This article will discuss the crucifix from Haug and its conservation history. The background for the misinterpretation of medieval paint as based on egg-tempera, belying the characteristic oil paint appearance, will be discussed. Combined with a lack of understanding for painterly effects on sculpture, this led to the use of conventional paint stripper for the removal of secondary oil-based paint in the 1930s. This treatment, and the consequences for the sculpture, are situated in the context of the overall development of conservation and art history. The work presented was part of the author's painting-conservator diploma, carried out at Universitetets Oldsaksamling (University Museum of National Antiquities) in Oslo in 1992.[1]

The Haug Crucifix

The polychrome wooden crucifix from Haug church, Ringerike in Buskerud, Norway, dates from the first half of the thirteenth century and measures 235.5 x 146.5 cm. The figure and evangelist symbols are carved in alder and the cross in pine.[2] The crowned Christ with wide open eyes is represented standing upright with outstretched arms. The sculpture was incorporated in the collection of the Universitetets Oldsaksamling in 1864. It was at that point completely covered with a crude overpaint based mainly on grey and brown-red colours, probably in imitation of stone. The original paint bears the characteristics of oil paint with its smooth, even surfaces, wet-in-wet modelling and glazes. The colours have been put on in separate layers in clearly defined areas. A variety of metal techniques have been applied to the surfaces of the carved figure and evangelist symbols, as opposed to the mouldings of the cross in green, yellow, blue and red colours. Imitation gold, accomplished by glazing highly polished water-silvering with a yellow glaze,[3] has been used on the outside of the crown and loincloth. The crown is embellished with painted imitations of precious stones in red and green glazes outlined in black. Gold leaf has been applied in a matt oil gilding technique on hair and beard. These metal techniques are a common phenomenon on our

[1] K. Kollandsrud, *Krusifiks fra Haug kirke i Buskerud. Undersøkelser og behandling*, (Varia 27), Universitetets Oldsaksamling, Oslo, 1994, (178 pp).

[2] Wood analysis has been carried out by Kari Henningsmoen, University of Oslo, on samples taken by Martin Blindheim in 1978.

[3] These glazes can be resinous, based on drying oil or combinations of these. Solubility tests of the glaze used on Haug indicates drying oil, possibly with resin added to it. U.Plahter, 'Líkneskjusmíð: 14th-century instructions for painting from Iceland', *Norwegian altar frontals and related material*, ACTA (XI), Roma, 1995, pp.157-172. The application of yellow glaze on silver is described in this manuscript.

medieval sculptures of this period. A distinctive feature in this particular sculpture is an orange underpaint, consisting of red lead mixed with lead white and vermilion, used on all the parts of the figure except where imitation gold has been applied. The orange colour contributes to the cool pink flesh colour achieved through the use of lead white and vermilion. The loincloth has a red inner side. Here the orange underpaint is painted with a thin layer of vermilion. The border between the interior and outside of the loincloth is marked with a double black line. With its materials and technique, the sculpture is part of the European medieval tradition.[4]

We have known for a long time that the binding medium for medieval paints are drying oils; gas chromatography (GC) analysis indicates a basis of linseed oil, but small amounts of additives, to adjust the performance of the media in relation to the specific pigments, are also suggested.[5]

It has been common belief that, despite their characteristic oil paint appearance, medieval painted altar frontals and polychrome sculptures in Norway were painted in egg-tempera. This erroneous assessment of the painting technique, together with a lack of understanding of painterly effects on sculpture, led to the use of conventional paint stripper to remove secondary oil-based paint from the medieval paint layers. The method was common practice within the Universitetets Oldsaksamling in the 1930s. The work was carried out by the technician at the museum, supported by the head of the medieval department who was both an art historian and archaeologist.

An article from 1931 written by the then head of the medieval department at the museum, Eivind Engelstad, describes how and why the paint stripper 'Reprin' was used.[6] In the search for a medium that could remove the oil overpaint and yet be harmless to the original medieval 'tempera' colours, a chemist was consulted. Having analysed the paint stripper 'Reprin' (mainly consisting of benzole and alcohol) and found it harmless to tempera, the chemist recommended it.[7] Unfortunately, the scientific answer was based on the wrong question. They had analysed 'Reprin', but it would be another thirty years before the medieval paint was analysed.[8]

[4] See further description in appendix.

[5] L.E. Plahter, E. Skaug and U. Plahter, *Gothic painted altar frontals from the church of Tingelstad: Materials/Technique/Restoration*, Oslo, 1974, p.95. Analyses of the binding media of the three altar frontals from Tingelstad indicates vegetable drying oil with additions of proteins, possibly egg. The relation between egg and oil is varying. GC analysis of the Norwegian medieval material by Raymond White, National Gallery in London, shows a broad variation in the use of binding media: basically linseed oil, but also walnut oil and proteins are found: R. White, 'Analyses of Norwegian medieval paint media. A preliminary report, *Norwegian altar frontals and related material*, XI (ACTA), Roma, 1995, pp.127-36; and U.Plahter, 'Colours and Pigments used in Norwegian Altar Frontals', *Norwegian altar frontals and related material*. XI (ACTA), Roma, 1995, pp.111-26. Practical tests carried out by Svein Wiik and the author in connection with the reconstruction of the Madonna from Hedalen, dated 1250, show that it is necessary to adjust the binding medium to the different pigments because of their diverse behaviour towards the medium in order to get a good paint without the use of conventional solvents and diluents. See also L. Kockaert et M. Verrier, 'Application des colorations à l'identification des liants de van Eyck', *Bulletin de l'Institut Royal du Patrimoine Artistique*, 17 (1978/79), 122-27. Analysis by staining has been undertaken on three works by Van Eyck. The results show that the binder is variable from one colour to another, although it is normally of the oily emulsion type containing more or less protein. Some blues, however, are pure tempera whereas glazes like copper resinate are found to be fatty.

[6] E.S. Engelstad, 'Avdekningen av de, i nyere tid, overmalte kunstverker fra middelalderen', *Universitetets Oldsaksamling, Årbok 1930*, (1932), 133-39.

[7] Engelstad, *op cit.*, p.134. 'Et preparat som fjernet oljeovermalingene men lot tempera farvene uskadt'.

[8] B. Kaland and K. Michelsen, 'A Medieval Panel Painting at the University of Bergen: Preliminary Report', *Bulletin de l'Institut Royal du Patrimoine Artistique*, 5 (1962), 195-205. Kaland and Michelsen began early with wet chemical tests on the objects in the Bergen Museum (University Museum of Bergen) in Bergen,

What lies behind the misconception that medieval paint is based on egg-tempera?[9]

It is a tenacious belief that the art of oil painting was an early fifteenth-century invention by the Van Eyck brothers. R.E. Raspe was one of the first to question this. He pointed out that the idea originated with Vasari.[10] In the late eighteenth century, the librarian at Wolfenbüttel, Lessing, discovered the manuscript of Theophilus, book III.[11] To his surprise it described the use of oil as a paint medium at a time long before Vasari's description of its discovery by the Van Eycks. As a result Lessing wrote the work *Vom Alter der Oelmalerei aus Theophilus Presbyter*, published in 1774.[12] In 1781 Raspe, inspired by his friend Lessing, published *A critical essay on oil painting, proving that the art of painting in oil was known before the pretended discovery of John and Hubert van Eyck*,[13] to which were added a translation of the manuscripts of Theophilus and Eraclius. These texts are both dateable to the twelfth century and as stated above describe the use of oil as binding medium for pigment.

A growing interest in the history of paint technology and the written sources connected with it can be noted in the nineteenth century. Sir Charles Eastlake published his *Materials for a History of Oil Painting* in 1847.[14] He notes the amount of documents and bills giving evidence that huge amounts of painters' oil were bought in connection with room decoration in thirteenth-century England. Eastlake states that

> Whatever may have been the purposes for which it was considered fit, it is clear from the foregoing statements that oil painting was sometimes employed in Germany, France, and Italy, during the fourteenth century, if not before. That it has also been practised in England at the same periods, there is abundant proof. The only question, as regards its early use, both in this country and elsewhere, is, to what kinds of decoration it was applied.[15]

Mary Merrifield had already translated Cennini's *Il Libro dell'Arte* into English in 1844.[16]

Norway. The binding medium of the painting from the church of Fet was found to be based on a drying oil. See also Plahter, Skaug and Plahter, *op cit.,* pp.91-5 and U. Plahter and S.A. Wiik, 'The Virgin and Child from the Church of Dal. Examination and restoration', *Studies in Conservation*, 15 (1970), 311-18. In 1965 Unn Plahter at the Universitetets Oldsaksamling in Oslo found it necessary to prove the use of oil scientifically. She performed tests by means of gas chromatography on samples from the Dal madonna and the altarfrontal Tingelstad I. The tests indicate that the binding medium is mainly based on a drying vegetable oil, probably linseed oil, with proteins, probably egg, added to it.

[9] This discussion is based on lectures given by Unn Plahter on the history of oil painting before the brothers Van Eyck and the importance of Vasari's long enduring misconception on this matter.

[10] G. Vasari, *Vasari on Technique,* translated by Louisa S. Maclehose, J.M. Dent & Company (1907), (Dover reprint New York, 1960).

[11] A. Raft, 'Nogle iakttagelser angående 'De diversis Artibus'', *Meddelelser om konservering*, 7 (1983), 263-77.

[12] E. Lessing, *Vom Alter der Oelmalerei aus Theophilus Presbyter,* Braunschweig, 1774.

[13] R.E. Raspe. *A critical essay on oil painting; proving that the art of painting in oil was known before the pretended discovery of John and Hubert van Eyck, to which are added: Theophilus de arte pingendi, Eraclius de Artibus Romanum and a review of Farinator's lumen animae,* London, 1781.

[14] C.L. Eastlake, *Materials for a History of Oil Painting,* 2 vols, London, 1847-1869 (reprinted as *Methods & Materials of Painting of the Great Schools & Masters* by Dover Publications, 1960).

[15] Eastlake, *op cit.*, p.48.

[16] *A treatise on Painting written by Cennino Cennini in the year 1437* [Thompson notes in his later translation that this date is an error]; *and first published in Italian in 1821, with an introduction and notes, by Signor Tambroni: containing practical directions for painting in fresco, secco, oil, and distemper, with the*

Merrifield's and Eastlake's works reflect a new attitude towards the study of historical paint techniques. They replace the eighteenth century's stumbling search for the old masters' secrets with scientific studies of primary sources.

Vasari's *Lives of the Artists* was translated and published in English by the turn of the nineteenth century. In the translation of 'Vasari on Technique' in 1907, Professor Brown stated in the notes to the text[17] that the history of oil painting began a long time before the Van Eyck brothers, and that Vasari was wrong. He pointed out that if we ask what is the truth about this 'invention' by Van Eyck the first answer of anyone who knew both the earlier history of the oil medium and Vasari's anecdotal predilections would be that 'there was no invention at all'. The drying properties of linseed and nut oil, and the ways to increase these, had been known for hundreds of years. 'Hence we may credit the Van Eycks with certain technical improvements on traditional practices of oil painting, though these can hardly be called the "invention of oil painting"'. Thompson and Laurie, who both published their works about paint technique in the early twentieth century,[18] were also aware of this, but as long as they did not have concrete examples to illustrate the fact, it did not gain credence outside this limited area of technical expertise. As a result Vasari's erroneous hypothesis continued to live on. It is also possible that art historians' special interest in Italian fourteenth-century tempera painting has contributed to distort the normal interpretation of how medieval paint technique developed elsewhere in Europe, in accordance with Vasari. Considering these points, it is interesting to note that oil painting had already been identified in 1878 on an early Norwegian frontal. The archaeologist Ingvald Undset at that time referred to the Danish artist and Professor Magnus Petersen from Copenhagen in the newspaper *Ny Illustrert Tidende*[19]: having examined the frontal from Trondheim, dated to the first half of the fourteenth century, Petersen had declared that the surface was painted in oil colours. However, in the article describing the treatment with paint stripper,[20] Engelstad when describing the paint technique instead refers to the German art historian and conservator Hubert Wilm. Wilm wrote in 1923 the book *Die gotische Holzfigur, ihr Wesen und ihre Technik.*[21] He describes medieval paint as water-based: the artist prepares a thick paste of pigment and water to which is added a binding medium consisting of either egg, rubber or glue tempera. Wilm remarks that in the oldest edition of Theophilus the wide use of linseed oil is notable, but that Vasari's story about the Van Eyck brothers is the commonly accepted one.

How did the treatment with paint stripper affect the sculpture?

The damage caused by the solvent treatment is extensive to the original polychromy on the crucifix from Haug. It has led to abrasion of the surface, the loss of original paint layers and the chemical alteration of the paint film. As a result, the general impression of the polychromy after the treatment is confusing. The result depends mainly on how the paint stripper was applied and in

art of gilding and illuminating manuscripts adopted by the old Italian Masters. Translated by Mrs. Mary Philadelphia Merrifield, with an introductory preface, copious notes, and illustrations in outline from celebrated pictures, London, 1844.

[17] Vasari, *op. cit.*, (n.10), pp.295-6.

[18] D.V. Thompson, *The Materials and Techniques of Medieval painting* (Dover reprint, 1956). A large part of this book is based upon a course of lectures, 'The techniques of Medieval Art', given in the autumn of 1935 at the Courtauld Institute of Art in the University of London. See also A.P. Laurie, *The Painter's Methods and Materials*, 1910 (Dover reprint, 1968).

[19] I. Undset, 'Et gammelt Antependiums-Maleri fra Trondhjem', *Ny Illustrert Tidende,* (1878).

[20] Engelstad, *op. cit.*, (n.6).

[21] H. Wilm, *Die gotische Holzfigur, ihr Wesen und ihre Technik*, Leipzig, 1923.

what way the different materials responded to it. As described by Engelstad,[22] the paint stripper was put on with a cotton swab. When swelling, the layers of overpaint curled up and could be removed one by one. Some colours were more difficult to remove than others, and several applications, sometimes five or six, were necessary to remove the layers successfully. Examination of the paint film shows that the original surfaces before the treatment were, apart from expected ageing, healthy and almost preserved intact beneath the overpaint.

The flesh areas have a stepwise damage pattern mainly following the network of age craquelure (figure 14.1 and colour plate XXXIII). This can be caused by a combination of two phenomena at once. Solvents diffuse through cracks and lead to a higher concentration of solvent and more effective swelling in this area. The paint surface is slightly deformed by cupping, so the raised edges of each 'cup' (that is, the border of the craquelure) is where the paint is most fragile and the overpaint is thinnest. When the swollen paint was removed with a big cloth or something similar, it not only tore the overpaint off, but also abraded these vulnerable edges, especially on the highest surfaces of the three-dimensional forms. As the different levels of damage are visible, the result is a broken-up impression of a surface which is difficult to interpret; overpaint, flesh colour, orange underpaint, ground colour and the wooden surface. The overpaint on the crucifix from Haug is particularly resistant to solvents, which made the work difficult. Islands of overpaint which were not removed still remain on the surface. These are especially confined to less accessible areas.

Among the most serious damage is the loss of the yellow glaze on the gold-imitation water-silvering. This common medieval technique is used on the crown and the loincloth. Most of the imitation precious stones, outlined with black contours and coloured glazes on top of this golden imitation have disappeared together with the glaze. As a result the crucifix has lost its golden aspect and its symbolic message.

Work has recently been carried out to make the sculpture more presentable (colour plates XXXI-XXXII, XXXIV-XXXVI). The remaining secondary paint was removed mechanically with a scalpel under a microscope. Apart from an expected ageing of the original paint, it was preserved almost intact beneath these remains. It is therefore likely that the original polychromy, and also the imitation gold, was in a very good state before the former uncovering with paint stripper. Retouchings[23] have been performed in order to improve the effects of the original polychromy. It was mainly the damage caused by the former uncovering that has been toned down. The object's 'documentary' and age value were at the same time retained by keeping the interference to a minimum. By suppressing the most intrusive damage, the effect of the original polychromy and the volumes of the forms were enhanced.

What was the background to the use of paint stripper?

When we look at this treatment today it is easy to condemn it as rough and as having had catastrophic results for the original polychrome treatment. We ask ourselves: how could they do this? In order to try to understand the background for this treatment, we have to look at the development of conservation in general. Who did it, what kind of qualifications did they have and to whom did they turn with their enquiries?

The development of conservation as a profession has been, and still is, going through a violent process of change that has rapidly accelerated in this century. Organized education has contributed to research on materials, their degradation and chemistry, how and why damage occurs,

[22] Engelstad, *op. cit.*, (n.6).

[23] Different levels of integrated retouchings were carried out in aquarelles and gouache with small additions of oxgall.

conservation methods and the history of technology. In Norway a regularized education of painting conservators was first established in the 1960s. The general trend has gone from quantitative to a more qualitative and individual treatment of the works of art.

The Universitetets Oldsaksamling still has the short original written reports on the treatments undertaken with paint stripper. The way the colours are listed is characteristic. The descriptions are restricted to describing the colours, and neither painterly effects - such as modelling, transparent or opaque, impasted or smooth, matt or reflecting surfaces and so on - nor materials and binding media are discussed. The reports were written a generation before an interest and understanding of polychrome effects on sculpture developed. At least they show an interest in the colours. Elsewere in Europe at the same date, it was not unusual to remove damaged paint layers altogether, in favour of the material effect of the wooden core.

It took a long time for art historical research to take the polychromy of medieval sculpture seriously. Andreas Aubert,[24] in an article written in 1900, pointed out that the value of colour has been suppressed by historical research and that what he defined as 'art archaeology' as a science has not risen above the varying artistic tastes of the times. He showed that the extensive and universal 'fear of colour' is rooted in a delusion of earlier art historians, and their lack of knowledge of polychromy in earlier cultures, especially the Greek. The Norwegian discussion was based on an evaluation of the three-dimensional form as presented by the wooden core. The classicist opinion that 'colour is alien to form' contributed to this view. The admiration for materials and their effect has a long history. Indeed, the dominant aesthetic interest in the eighteenth century - when a methodology for analysing sculpture was first being developed - tended towards monochromatic sculptures, and their specific sculptural forms. The methods of style criticism are still based on the registration of stylistic criteria and how these are joined together as a whole. Plasticity, line and texture have been important for the dating and grouping of works of art, whilst iconographic method registers the occurrence of what are assumed to be meaningful elements.

When Harry Fett in 1908 published his work *Billedhuggerkunsten i Norge under Sverreaetten,* the sculptures were presented in black and white photographs: there was no mention of the sculptures having been painted.[25] This was typical of art historical research during the years between the world wars.[26] In Norway, Anders Bugge discussed the sculptures' role as church art.[27] Eivind Engelstad's great work *Die Hanseatische Kunst in Norwegen* from 1933 is directed towards dating and attributions.[28] An interest in paint work can be traced, though. In 1910 Bendixen published the altarpiece from St. Mary's church in Bergen, containing sculptures, with a description of the colours.[29] Frederik B. Wallem in his *Iconographia Sancti Olavi,* dating from

[24] A. Aubert, 'Lidt om polykromien i vore middelalderlige stavkirkers træskjaererkunst', *Foreningen til Norske Fortidsminnesmærkers Bevaring, Aarsberetning for 1900* (1901), 209-14.

[25] H. Fett, *Billedhuggerkunsten i Norge under Sverreætten,* Kristiania, 1908.

[26] The following list is mainly based on: E.B. Hohler, 'Middelalderens kunst som forskningsmateriale', in *Kirkekunsten lider,* M. Stein, G. Gundhus og N.H. Johannesen (eds), (Riksantikvarens rapporter 14), Øvre Ervik, 1984, pp.48-50.

[27] A. Bugge, 'Kunsten langs leden i nord', *Foreningen til Norske Fortidsminnesmerkers Bevaring, Årsberetning for 1932* (1933), 1-53.

[28] E. Engelstad, *Die Hanseatische Kunst in Norwegen,* (Det Norske Videnskaps Akademi Skrifter), Oslo, 1933.

[29] B.E. Bendixen, 'Alterskapet i Mariakirken i Bergen', *Den Norske Forening til Fortidsmindesmærkers Bevaring, Aarsberetning for 1910* (1911), 65-96.

1930[30], describes the colours and their function: he also mentions technique and state of conservation when describing the objects. Aron Andersson brought in a description of the colours in the footnotes in his Swedish work *English influence in Norwegian and Swedish figuresculpture in wood 1220-1270* of 1950.[31] A new approach was brought in with Martin Blindheim's work on thirteenth-century sculpture in 1952 when he added a chapter on technique.[32] In Germany art historian and conservator Hubert Wilm's work *Die Gotische Holzfigur; ihr Wesen und ihre Technik* was first published in 1923. Here he praises the medieval painters' skill and technique. In the introduction, Wilm writes that his work is based on 'jahrelange Erfahrungen, die ich beim Studium, beim Sammeln und bei der Restaurierung gotischer Skulpturen habe'. His interpretation of the medieval technique is long-winded, extensive, and in some places described with a lively imagination, but this was one of the first attempts to take polychromy on medieval sculpture seriously.

Medieval sculptures and altar frontals in Norway were acquired by archaeological museums. In the period when these treatments were performed, the Universitetets Oldsaksamling had one conservation studio with one technician, who was responsible for the treatment of the whole collection, ranging from archaeological material to art objects. He also joined archaeological excavations and was a recognized photographer. The technician had no background in painting and, unlike the painter Magnus Petersen,[33] was unable to make correct assessments about the painting technique. It is tempting to ask whether the art value of these objects would have led to their being treated differently if an art museum had undertaken their treatment.

Our own conservation treatments will - even though it is difficult for each of us to see ourselves in the light of time - be coloured by the state of knowledge our research has reached and the time we live in. Our best guard against misconceptions and imposing the taste of our own time is knowledge about the objects. The study of materials and technique in addition to stylistic and iconographic criteria gives us a wealth of information that will give future research a broader platform for grouping and dating. At the moment we are still in the infancy of understanding these medieval sculptures. Future research will require a continuous dialogue between art historians, conservators and scientists in their interpretation of these works, so that mutual correction and inspiration will permit deeper comprehension of the objects. In order to understand them we must study the work of art as the primary source.

Acknowledgements
The author would like to thank her tutors Svein Wiik and Unn Plahter at the Conservation Department, Universitetets Oldsaksamling, who have willingly shared their work and ideas. Especially thanks to Unn Plahter for allowing the author to use her unpublished material. Riksantikvaren in Oslo supported the work with four months' funding.

[30] F.B. Wallem and B. Irgens Larsen, *Iconographia Sancti Olavi. Olavsfremstillinger i middelaldersk kunst*, (Det Kgl. Norske Videnskabers Selskabs Skrifter), Nidaros, 1930.
[31] A. Andersson, *English influence in Norwegian and Swedish figuresculpture in wood 1220-1270*, (Kungl. Vitterhets Historie och Antikvitetsakademien), Stockholm, 1950.
[32] M. Blindheim, *Main Trends of East-Norwegian Wooden Figure Sculpture in the second half of the thirteenth Century*, (Skrifter utgitt av Det Norske Vitenskaps-Akademi i Oslo 3), Oslo, 1952.
[33] Undset, *op. cit.*, (n.19).

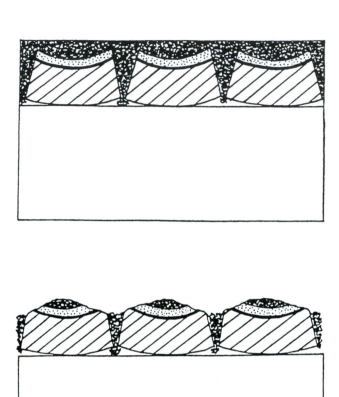

Secondary paint layer

Original light pink carnation

Orange underpaint

Ground

Wood

Figure 14.1 Schematic drawing of cross-section of the flesh colour, with age craquelure and cupping. a) Before treatment with paint stripper in 1930s; b) After treatment with paint stripper in 1930s.

APPENDIX

Crucifix from Haug Church, Ringerike in Buskerud, Norway. C. nr. 3604
Construction and original polychromy

Christ figure: 109.0 x 92,5 x 20.0 cm
Cross: 235.5 x 146.5 cm

The Christ figure and evangelist symbols are carved in alder and the cross in pine. The nipples are probably oak.[34]

Construction

The Christ figure has been constructed of three main pieces. Body, head and crown are cut in one piece. The arms are carved separately and joined to the body with elongated rectangular tenons halved into the back, probably with wooden pegs.[35] The nipples are carved separately as wooden nails with conical shaped heads. The head and legs are fully carved. The arms and the rest of the body and loincloth are flattened at the back. The main part of the body and the loincloth are hollowed out at the back. The relief effect of the figure's head is notable. It is consciously carved for frontal viewing. The beard has on the left side two rows of curls, while the right side, which is slightly foreshortened, has one only. The figure is secured with three iron nails to the cross; one through each hand and one through the feet.

The evangelist symbols are carved separately. They are placed in the three-foliated ends of the cross.

The cross is made of two boards halved together and secured with four iron nails. The boards are tangentially cut from the bole. The cross stem has been painted on the bark side, while the arms have been painted on the marrow side.

Tool marks

The wooden surfaces of the figure and the cross are detailed and smoothly finished. Tracks with a width up to 9mm indicate that flat and slightly rounded chisels or a sharp iron scraping tool have been used on the front of the figure. A knife may also have been used. Parallel tracks that may have been caused by the action of a sharp iron blade are found on the wooden surface of the cross and on the surface of the ground on the loincloth.

The hollowing at the back is even and finely worked with a slightly rounded gouge or chisel. The hollowing is rounded towards the lowest part of the loincloth.

The back of the cross has marks caused by the action of an axe and traces up to 3cm wide from a slightly rounded iron scraping tool.

Ground

The ground is a white chalk ground bound in animal glue. The thickness is approximately 1mm. Coccolith analyses of the chalk[36] shows CC 26 after Sissingh,[37] indicating that chalk from the late

[34] *Op. cit.*, (n.2).
[35] The figure has not been detached from the cross.
[36] Carried out by Dr Katharina von Salis Perch-Nielsen in December 1991.
[37] W. Sissingh, 'Biostratigraphy of Cretaceous Nannoplankton', *Geol Minjbouw*, (1977), 37-65.

Maastricht age has been used. This type of chalk was classified by Perch-Nielsen and Plahter[38] as continental chalk and agrees with the type of chalk identified on art ascribed to the eastern parts of Norway as opposed to the western part where chalk for painting purposes normally derives from the English Channel area.

Solubility tests[39] indicate a general isolation layer, probably egg white, on top of the ground.

Original polychromy
Pigments used

Blue	: Azurite
Green	: Verdigris
Yellow	: Orpiment and yellow ochre
Red	: Red lead, vermilion and organic lake
Brown	: Iron oxide (not analysed)
Black	: Charcoal black
White	: Lead white and chalk

Binding media
The binding media are mainly based on a drying oil. Solubility tests[40] indicate additions of tempera to the blue colour on the cross. The yellow orpiment on the cross may have been based mainly on tempera.

Metal techniques
Three different types of metal leaf have been used. Two different techniques are used to attach the leaf:

a. Outside of crown and loincloth:
 Silver foil adhered directly on the chalk ground in a water-silvering technique with a yellow glaze[41] applied to it, imitating gold.

b. Hair and beard:
 The gilding is performed in an oil-gilding technique. The mordant is a mix of yellow ochre and lead white bound in a drying oil. Analyses of the gold leaf[42] showed that two types have been used; pure gold leaf, and an alloy of gold and silver, which has been applied to less visible areas and repairs.

Colours
Christ figure:

Blue (probably azurite): iris.

Green (probably verdigris): used as a glaze in the green precious stones on the imitation gold on the crown.

[38] K. Perch-Nielsen and U. Plahter, 'Analyses of fossil coccoliths in chalk grounds of medieval art in Norway', *Norwegian altar frontals and related material*, XI (ACTA), Roma, 1995, pp. 145-57

[39] Very simple solubility tests on binding media have been carried out by the author on small samples, observing the reactions under a light microscope with water, alcohol and 10% KOH.

[40] *Op. cit.*, (n.39).

[41] *Op. cit.*, (n.3).

[42] Analysis of cross-sections have been carried out by the author using scanning electron microscope (SEM Jeol 840) in combination with energy dispersive X-ray analyses (EDX Link AN10000).

Orange (probably red lead): the inner side of the crown.

Red organic glaze has been applied as a glaze for the red precious stones on the imitation gold on the outside of the crown. Vermilion has been applied on the orange underpaint (red lead mixed with vermilion and lead white) on the inner side of the loincloth. The traces of blood and the lips are probably vermilion.

Brown (probably hematite with additions of red lead and lead white): applied for the pupils, the drawing of the eyes and as small brush strokes outlining the beard.

Black: charcoal black with additions of red lead and white lead has been applied on outlines of painted precious stones on the crown and the imitation gold of the loincloth.

Carnation (white lead with addition of vermilion): Darker shading is made by adding more vermilion to the lead white.

Cross:

Blue (azurite mixed with lead white): bevelled inner side between the yellow roll and the red flat outer border.

Green (verdigris mixed with lead white): applied on the slightly bevelled center of the cross and three-foils.

Yellow (orpiment): used on the roll between the red outlines and the blue.

Red organic glaze has been applied on an orange underpaint (red lead mixed with lead white) on the flat outer borders.

White (probably pure white lead): applied as double lines on the inner side of the red flat outer border.

CHAPTER 15

PROBLEMS IN THE CLEANING OF POLYCHROMED WOOD SCULPTURE

B. Schleicher

When a conservator's intervention has gone too far, controversy often results. Usually, such interventions happen through insensitivity and lack of humility with respect to the work of art. Among the results of such controversial interventions are over-cleaning, whether it be a painting, a sculpture, a building or any other kind of artefact. An awareness that something is not 'right' with a treated work can also be caused by too much, or unsatisfactory, integration. However, such interventions are of a kind that can be removed or redone with greater taste or sensitivity on another occasion. But the damage caused by too drastic cleaning is irrevocable and irreversible.

For these reasons cleaning problems assume a major role in the kind of conservation with which I am concerned. I would like to discuss my concept of cleaning via several examples of polychromed sculpture that I treated on behalf of the superintendencies of Florence, Arezzo and Siena. As a preliminary, I should say something about my status: I belong to a group of independent non-salaried restorers with a studio in the Pitti Palace in Florence. We work by contract for each work of art. Every commission is carried out under the supervision of an official of the superintendency, usually a trained art historian responsible for the territory from which the work comes.

The difference between a piece of sculpture and a painting is that the sculpture generally retains at least its shape no matter what the condition of the surface may be, and therefore something of its original character remains even though the polychromy or the surface may be in very poor condition. With polychrome sculpture, the paint is the epidermis of the piece and this is especially clear in cases where the carved form is finished with layers of stucco, cloth and hemp fibres.[1] Even in cases where the form has been entirely created by carving, the polychromy, though consisting only of a veil of material, nevertheless has the function of emphasising details and giving finish to the surface.

Today either cleaning or the removal of repainting without damage to the original should be an obvious goal. The restoration of a polychromed surface on a piece of sculpture should be done with the same care as with a panel painting. But until quite recently this was not the case. It is significant that restorers of sculpture were often themselves sculptors, very capable of remaking sections, but with no particular expertise for dealing with painted surfaces. All too frequently, polychromed sculpture was washed with strong agents such as caustic soda, and repaints were scraped away, often skinning the original polychromy beneath. This was still the situation in Tuscany during the post-war period until the end of the 1960s and unfortunately, in certain quarters, this approach persists even today. An example is Francesco di Giorgio's *St John the Baptist* from the Opera del

[1] For example Michelozzo's crucifix in S. Niccolo in Florence in P. Stiberc, 'Polychrome Holzskulptur der Florentiner Renaissance, Beobachtungen zur bildhauerischen Technik', *Mitteilungen des Kunsthistorischen Instituts in Florenz*, 33 (1989), 217-218.

Duomo di Siena, which was restored in the 1970s.[2] The surface is very abraded as can be seen from a detail of the arm (colour plate XXXVII): the damage occurred during removal of a hard white overpaint, when the original surface was literally skinned. One of the reasons for such pitiful results is that a conscientious cleaning is generally a very slow, difficult business and it is therefore expensive to carry out.

An ideal restoration should not at first glance be evident. The work should appear in good order, legible in all its parts, but showing also its age. A balanced and careful cleaning has the fundamental purpose of achieving this. Here, of course, reintegration and varnish also have their parts to play. But these processes, I believe, should be limited to essentials. In this respect, one has recently seen excesses where the reintegration has been done to such extremes that in some cases the figures look fit for a merry-go-round.[3]

A restoration cannot recreate the object's appearance as it left the artist's studio. Some colours change with time in varying degrees according to the type of pigment and media used. This change is due to centuries of exposure to light and other factors, as can be seen in a detail from an altarpiece by Cecco di Pietro where the behaviour of different pigments can be observed with respect to light exposure (colour plate XXXVIII). In this case a colonette of the frame passed across bands of different colours. The green and red pigments above remained almost undamaged whether protected by the colonette or exposed, whereas the red lake, below, faded with exposure to light. Perhaps only in certain illuminated manuscripts can one still admire the original freshness and harmony of intact colours. So, generally, cleaning with the intention of retrieving the original vivacity of colours only brings out the dissonances that time created.

It is rare to encounter old polychrome sculpture that has never been repainted nor cleaned. Such cases must be considered as virtual miracles. In Florence several wooden crucifixes exist which have been blackened only by dust, soot and candle grease. An example is Giuliano da Sangallo's *Christ* from San Domenico in Fiesole (colour plate XXXIX).[4] The polychromy before cleaning was blackened by soot and dust. Earlier interventions were limited to the reconstruction of fingers and the stuccoing of a few losses.

In such felicitous cases it should be the absolute rule that the polychromed surface is left intact with its own patina which as part of a venerable surface has not only an aesthetic importance but testifies to its integrity (colour plate XL). However, cases of overcleaning in the past have been rendered less offensive thanks to a veil of further accumulated dust and soot. An example of this is Francesco di Valdambrino's *St Stephen* in the Collegiata of Empoli (colour plate XLI),[5] which in the sixty years since its drastic cleaning has acquired a generally pleasant appearance which is also due to the fact that the work had not been dimmed by a false patina.

To illustrate the importance of a partial cleaning I could give the example of a late fifteenth-century *Madonna in Adoration* from the Marches, now in the Bargello (colour plate XLII). The problem in this case was that the complexion had a final layer that was opaque, very hard and permeated by dust and soot. This layer absolutely had to be preserved because all the finishing touches - the drawing of the eyes, the brows and the curls which frame the face - were incorporated in this stratum and would have been severely damaged had its grey surface been removed. One is

[2] A. Bagnoli, in L. Bellosi (ed.) *Francesco di Giorgio e il Rinascimento a Siena 1450-1500*, exhibition catalogue, 1993, pp.192-195.

[3] J. Pope-Hennessy, 'Painted Sculpture in Siena' *Apollo*, 126 (1987), 430-432.

[4] M. Lisner *Holzkruzifixe in Florenz und in der Toskana*, 1970, pp. 65-6.

[5] A. Natali in L. Berti and A. Paolucci (eds), *L'età di Masaccio, il primo Quattrocento a Firenze*, exhibition catalogue, 1990, pp.74-5.

faced with the same problem in pictures varnished with egg white that have become grey: too often one can see how paint surfaces have been lacerated in attempts to rid pictures of their dark tone. It may well be that the grey surface of the complexion of the Bargello *Madonna* also consists of egg white varnish just as in many contemporary panel paintings. Unfortunately, no test was made to establish this point. In any case, the polychromy was carried out with great delicacy and adorned with details done with shellgold and fine punchwork in the gilded areas. All this must have been the work of a panel painter. Here, the Madonna's face is partly cleaned on the right (colour plate XLII): a characteristic deposit of soot is visible, giving the appearance of a photographic negative so that the lightest areas are to be found in the deepest part of the carving. In the cleaning, we limited ourselves to removing the superficial grime and to taking away the dark greasy accumulations on the highest parts of the carving, leaving intact the light grey layer that closes the surface which, happily, is here so well preserved. The head thereby reacquires its volume and the legibility of the colour is enhanced as with the rosy cheeks visible through the grey. After restoration the entire figure is in order without, it is to be hoped, making us too aware of the conservator's intervention (colour plate XLIII).

The conservation of the patina to just the right degree is a decision dependent upon how far one wants to clean. This is therefore a critical decision which cannot be entirely objective since it involves the conservator's experience, sensitivity and skill. The important thing is not to lose sight of the goal: to conserve the work of art in its age and dignity. Beyond this one cannot make any rules. Naturally, also, it is possible to recover well preserved patina or original varnishes often applied only to particular colours - such as the complexion - beneath repaint. This is the case with Jacopo della Quercia's *Anghiari Madonna* (colour plate XLIV).[6] After removal of the overpaints, the figure now exhibits the original polychromy with the original varnish applied to the complexion and to the white veil. This varnish has slightly yellowed with time and thereby has attenuated the unevenness in the generally well preserved polychromy, with the exception of the mantle of which, generally, only the dark grey preparation survives. Not only has the colour gone from this dark mass but also the delicacy of the opaque azurite surface with its glue medium, in contrast to the shiny enamels of the other colours such as the dark red lake and the green copper resinate.

There are many different problems involved with repainted sculpture. Each piece presents a special case with issues such as the quality and quantity of the repaints, the condition of the original polychromy to be recovered, and the various degrees of difficulty in removing the superimposed layers. In extreme cases, the repainting can reduce the image to a grotesque mask where one can only guess what the quality of the work might be (colour plate XLV). In the detail of the face of a small Christ from Massa Marittima Cathedral[7] before restoration, one sees an irregular crust of six layers of repaint riddled with losses filled by successive layers. Underneath all this was a work by Giovanni Pisano as can be seen from a detail of the face after cleaning (colour plate XLVI).

Usually repaints do not alter the appearance quite so dramatically. But even a veil of repaint can make a sculpture cruder by dulling the magic vitality of original polychromy. This can be seen in the face of the Romanesque *Madonna* from Arezzo Cathedral at the mid-point of cleaning (colour plate XLVII). The repaints consisted of only two thin layers of colour but they were dull in tone and saw changes in the drawing of the eyes and the mouth. In the cleaned area the luminous vivacity of the medieval painting emerges.

[6] A.M. Maetzke, in *Maestri di Legname e Pittori a Siena, 1250-1450*, exhibition catalogue, 1987, pp.158-160.

[7] M. Seidel, 'Un "Crocifisso" di Giovanni Pisano a Massa Marittima', *Prospettiva*, 62 (1991), 67-77.

The initial approach to complex conservation problems, such as repainted wooden carving, is to make a thorough examination of the piece so as to determine the quantity and nature of the layers of overpaint, the existence and state of conservation of the original polychromy and the condition of the wooden structure, thereby to determine if removal of the paint is justified or not. It can be very useful to have scientific help such as taking samples of the various layers, analyses of the colours and media, x-rays etc, in order to clarify the problems that visual observation alone cannot provide, as well as to confirm the results obtained. Such preliminary examination provides guidelines for how conservation is to be carried out. But experience suggests that it is always advisable to leave room for unexpected difficulties that may arise when work is in progress.

Today restorations of what the Italian critic, Roberto Longhi, termed the *rivelazione* - recovery - category, are much disputed. The question arises as to the utility of removing repaints which have their own historical value. Also, an original polychromy protected by layers of repaint is analogous to buried treasure: concealed from visual enjoyment but safe from vandalism, neglect and such agents as light, soot, humidity and, let it be said, the intrusion of inexpert restorers. From this point of view, perhaps it is a luxury to make a work of art aesthetically enjoyable again through cleaning. But beyond the aesthetic gain careful conservation can contribute a good deal to an understanding of the piece: its artistic quality, the nature of its technique and also its history.

In this context I would like to conclude by discussing plates taken during the conservation of the monumental *Volto Santo* of San Sepolcro, which is a perfect example of results of this kind (colour plate XLVIII). The figure is 2.71 metres tall, the extent of the arms is 2.9 metres across and with the exception of the arms, it was carved from a single trunk of walnut, hollowed out at the back. Historians hitherto believed that this *Volto Santo* was a thirteenth- or fourteenth-century copy of the one in Lucca that in turn was supposed to be a copy of a lost original going back to the eighth century.[8] The first surprise was the discovery of a beautiful, almost completely intact, Romanesque polychromy found beneath three layers of repaint. The photograph shows the face during the removal of the dark overpaints: on the left side Romanesque polychromy appears, complete with its old golden varnish. Among the further surprises that this Romanesque polychromy disclosed was the thick gesso and cloth preparation that covered old injuries and repairs to the wooden support, among them the substitution of the left arm. Extremely interesting is the discovery that here and there are fragments of three further layers of polychromy beneath the Romanesque one, which were carried out directly on the wood. This data and other stylistic elements suggested a date much earlier than hitherto suspected. In fact, Carbon 14 testing indicated that the figure was made between the end of the seventh and the beginning of the ninth century. The information collected is the result of a fruitful collaboration among specialists in various fields: art historians, wood technologists, scientists and conservators. It is hoped that such interdisciplinary dialogue will become even more frequent.

I hope I have been able to render an idea of our approach to works of art which means giving them the maximum respect and putting oneself entirely in their service. The greatest compliment one can pay to a conservator is to say that one can now admire the beauty of the work without thinking that it was a pity it was restored.

[8] A.M. Maetzke (ed.), *Il Volto Santo di San Sepolcro, un grande capolavoro medievale rivelato dal restauro*, 1994.

CHAPTER 16

PIETRO TORRIGIANO'S TOMB OF DR YONGE IN THE PUBLIC RECORD OFFICE: CONSERVATION DISCOVERIES AND DECISIONS

C. Galvin and P. Lindley

Pietro Torrigiano's monument to Dr John Yonge (d.1516), Master of the Rolls, is the first tomb in England - outside Westminster Abbey - to show Italian Renaissance conception and detailing (colour plates XLIX and L). The Yonge monument's whole-hearted 'Italianicity' - proof that Torrigiano designed as well as executed it - gives it a particular significance in the story of the penetration of Renaissance ideas into an artistic ambience in which the formal vocabulary was still late Gothic.[1] The tomb's combination of materials was as revolutionary in the English sphere as its style. The effigy, of polychromed terracotta, reclines on a Caen stone sarcophagus and base, backing onto a wall and enclosed within a blind semi-circular arch. A white marble panel with a gilded inscription is positioned in the middle of the base. Inset into the lunette above the effigy are three polychromed terracotta heads, a central head of Christ flanked by two seraphs or cherubs.

Since its construction in 1516, Dr Yonge's tomb has undergone a number of fundamental changes, both in structure and in appearance. It appears that the original site of the tomb was in the chancel of the Rolls Chapel, from which position it was moved when the chancel was demolished in the mid- or later-seventeenth century. The tomb was re-erected on the north wall at the east end of the nave, at which time its overall proportions may have been reduced to accommodate it to its new site.[2] Even in the eighteenth century, concern was expressed about the poor state of the Rolls Chapel and its dampness.[3] The position of the tomb on an external wall would have exposed it to the ingress of moisture and salt contamination, which would have initiated deterioration. The first evidence of concern about the condition of Yonge's monument was expressed in a letter by Sir Francis Palgrave in 1858, in which he drew attention to the decayed state of the terracotta effigy in particular.[4] He recommended a consolidation treatment be applied 'as was done in the case of the ancient Royal Tombs in the Abbey [a reference to the experimental consolidation treatments - using waterglass or shellac - employed by Sir George Gilbert Scott, in treating the monuments at Westminster Abbey] ...But with the full understanding that, whilst whatever process be followed as may be needful for preserving the memorial from further decay, the Master of the Rolls does not

[1] This paper is a version, abbreviated and revised to concentrate on conservation issues, of an essay by the same authors, 'The Tomb of Dr John Yonge in the Public Record Office: Pietro Torrigiano's methods and models', in P. Lindley, *From Gothic to Renaissance: Essays on Sculpture in England*, Stamford, 1995, pp.188-206. By using the terms 'Renaissance' and 'Late Gothic', we do not mean, of course, to reify the styles, but merely to deploy them as convenient shorthand.

[2] H.C. Maxwell-Lyte, *The Fifty-seventh Annual Report by the Deputy Keeper of Records*, Appendix, pp.22-23.

[3] Maxwell-Lyte, *Annual Report*, Appendix, p.26.

[4] Public Record Office, Work 12/67/2, XCO252, 20 July 1858.

desire that any *restoration* should be attempted'.[5] In response, a report was prepared by Mr Szerelmey, in which he identified the body of the effigy and the three heads in the lunette as being of fired clay. He attributed their advanced state of decay 'to the great quantity of carbonic acid and moisture which this soft porous material has absorbed in the course of centuries' and secondly to the clay being strongly impregnated with iron (oxide).[6] Szerelmey described the consolidants used in the Abbey as '*silicate of potassa*, (waterglass)' and noted that the treatment 'already exhibits symptoms of fresh decay'. He proposed to use a separate 'secret' consolidation process, but the Master of the Rolls instead opted for the same process as had been used in the Abbey. Consolidation treatment was duly carried out on the Yonge tomb late in 1858; however, this treatment also proved to have only temporarily beneficial effects and the monument required retreatment by 1884.[7]

The medieval Rolls Chapel was demolished in 1895 to make way for the new Public Records Office building, which incorporated a new chapel, in which the Yonge monument was rebuilt. Black and white photographs showing the appearance of the monument before and after its reconstruction survive (plates 56-57). They clearly illustrate the deteriorating state of the effigy, particularly the leg section, and of the lower part of the cherub on the left side. The drier environment within the new chapel could have accelerated the deterioration of the terracotta and stonework as they rapidly dried out. The effigy was in such a poor state of repair by 1932 that some of its surface was remodelled in plaster of Paris, and the whole effigy repainted; by 1956 deterioration of the stone sarcophagus was sufficiently serious to warrant consolidation treatment and 'extensive cleaning and restoration of colour' by the Ministry of Works.[8] It is not known which resin was used for this treatment, but it resulted in the darkening of the stone, a disfigurement which was hidden by the painting and gilding of the sarcophagus. The effigy and three heads were also repainted at this time (the 1932 repaint was not fully removed but a terracotta-coloured paint was applied as a new ground over it, prior to repainting) (colour plate XLIX).

In 1988, a general condition report was commissioned from Carol Galvin by the PRO. Stonework on the lower panels of the monument was spalling badly, and was generally in a friable condition (plate 58). The feet of the effigy, which had been entirely reconstructed from plaster, had fallen off, because the body of the terracotta to which they had been joined was so friable that it was not possible to achieve a satisfactory bond. This gave an indication of the condition of the effigy below the layers of overpaint and repairs. At the time, the Rolls Chapel was being used as an exhibition area with public access, thus posing a further potential hazard to the monument. A total of thirty paint samples was taken from the monument for examination in the conservation laboratory of the Victoria and Albert Museum, where cross-sections were prepared and examined microscopically. Analytical work on the pigments and paint layers was carried out by Josephine Darrah. Almost all of the samples, with the exception of those taken from the sarcophagus, showed at least three distinct layers of decoration. The earliest decoration consisted of a ground or sealant, an underpaint and a final paint layer, and samples taken from the cloak of the effigy revealed a fourth layer of glaze. The two further layers of decoration represented later overpaintings, in 1932

[5] The emphasis is Palgrave's.

[6] See the letter of Szerelmey of 31 July 1858 on waterglass at Westminster (PRO, Work 12/67/2, XCO 252).

[7] See the letter from John Romilly of 6 November 1858, and the draft reply noting that 'the same process which was found successful in Westminster Abbey' would be used. See also the memorandum of 11 June 1884 that 'the monument has been put in a thorough state of repair' (both documents in PRO, Work 12/67/2, XCO 252).

[8] *The Museum of the Public Record Office: a Short Catalogue*, London, 1956, p.2.

and 1956 (only a single layer of decoration - that dating to 1956 - was found on the sarcophagus). Simple staining tests were carried out on the samples to identify the type of media employed. The results were not conclusive but indicated that the sealant applied to the porous terracotta was probably an oil-protein mixture, whilst an egg-tempera was used for the paint medium (with the exception of the copper resinate paint which was in an oil medium, as was usual at that date). The combination of pigments used in the earliest decoration, and their method of application, were very much in keeping with the early sixteenth-century polychromy of Torrigiano's terracotta portrait bust of Henry VII.[9] The recommendations of the report were that the monument should be dismantled and conserved, and after consulation between English Heritage and senior staff from the PRO it was agreed that work should proceed as recommended. The contract for the project was awarded to the specialist sculpture conservation firm Harrison-Hill Ltd., the work being funded by the Property Services Agency.

The monument was dismantled in May 1989 and the stonework conserved by Harrison-Hill.[10] The conservation of the terracotta elements from the tomb - the effigy, the head of Christ and two cherubs - were subcontracted to Carol Galvin, a private conservator, who had previously undertaken technical research on Torrigiano's terracotta portrait bust of King Henry VII in the Victoria and Albert Museum, and had co-ordinated comparative analysis of the paint layers from the Dr Yonge tomb.[11] Dr Phillip Lindley was invited to act as art-historical adviser to this part of the project and it was agreed that both he and Dr Hallam-Smith, the Keeper of the PRO Museum, were to be consulted and invited to view and advise on the conservation of the terracottas as work progressed.

The Effigy
The effigy was bedded onto the sarcophagus in a thick layer of white, nineteenth-century plaster, which had been modelled and painted to form a mattress: the layer was particularly thick beneath the cushions under the effigy head. 9cm of the effigy's maximum width of fifty-three cm was inset into the adjacent, cement-rendered wall: traces of original polychromy survived on the surface of the embedded terracotta, so the whole monument must once have stood forward from the wall by another 10-15cm when it was originally constructed. When removed, the effigy was found to be a hollow cast, assembled from three sections: head and shoulders; torso (plate 59); and legs. A gap between each of the sections had been filled with cotton wadding and white plaster and overpainted. The effigy's walls were of relatively even thickness, averaging about 20mm overall. The thin-walled construction was intended to minimise shrinkage and distortion as the clay dried, and to reduce firing damage from pockets of trapped air and moisture. The sectional assembly was doubtless intended to facilitate handling and, since it appears that this effigy, like the portrait bust of Henry VII, was fired in a domestic pottery kiln, it may have been necessitated by the size of the furnace.[12]

[9] C. Galvin and P. Lindley, 'Pietro Torrigiano's Portrait Bust of King Henry VII', *Burlington Magazine*, 130 (1988), 892-902, reprinted in revised form in Lindley, *Gothic to Renaissance*, pp.170-187.

[10] When the sarcophagus was removed, the remains of a carved angel was found on the reverse of one of the stones. It was closely comparable with two other fragments of angel carving identifiable as reject sculptures from Henry VII's Chapel at Westminster. Alfred Higgins, in a letter to Maxwell Lyte dated 21 July 1896, confirmed that the fragment to which the head of Christ had been fixed was from the Henry VII Chapel, Westminster Abbey (PRO 8/32).

[11] For details, see Galvin and Lindley, 'Tomb of Dr John Yonge', 190.

[12] Galvin and Lindley, 'Torrigiano's Portrait Bust of Henry VII', in *Gothic to Renaissance*, p.175.

When the head and shoulder section of the effigy was removed, the head separated from the cushion along an old break following the contour of the head (plate 60). Another joint, evident where the base of the neck tapered to fit the neck aperture above the shoulders, suggests that the head of the effigy was made separately. The face of the effigy is almost certainly directly based on a cast taken from a death mask. The features have barely been modified from the appearance of the corpse, save for the slight opening of the eyes. The procedure employed by the sculptor to make the head has been reconstructed. First, a positive cast from the face of Yonge's corpse was made; it would have required very minor remodelling and the addition of the hair and hat. A negative mould would then have been taken from this cast, and a clay pressing made (plate 61). The cushions were probably produced separately and seem to have been modelled rather than cast, judging by finger and spatula marks left in the clay. A coarse pink plaster remained on the opened joint between head and cushion: it can be identified as contemporary from the fact that it appears elsewhere on the effigy and sometimes has the original polychromy painted over it (as occurs in a break on the left shoulder). The edge of the neck had been tapered to fit the body aperture, the smooth surface left by a modelling tool still being visible on the right side of the neck edge, whilst the left side has the irregular surface of a break. This suggests that the head was fitted to the cushions and shoulders while the clay was still damp. During firing, these joints reopened and the plaster was intended to mask this damage. Torrigiano first cast the body, minus the head, in a single piece, by pressing wet clay into a plaster negative mould: the drag marks left by his fingers are visible here just as they are on the inside of his bust of Henry VII. When the clay had dried to the leather-hard stage, the head and cushions were added to the body, the joint surfaces being either wetted or coated with clay slip. The effigy was then cut into three sections using a wire. Internal ribs of clay were added to strengthen the structure. The clay body is a rich red-brown in colour, very porous and soft, indicating that it was fired at a low temperature. This was probably intentional, to minimise the clay shrinkage. The effigy actually suffered some damage during firing, particularly to the structurally weak central section, which broke into a number of pieces and also sagged, as a result of which the profiles no longer fit together comfortably. The inside surface is covered with a layer of contemporary pink plaster to cover the small firing cracks. It seems evident from this examination that the effigy was transported from the site of the firing to the Rolls Chapel, pieced together, repaired with plaster and painted *in situ*.

Of the nine paint samples taken from the effigy, seven indicated the presence of the original polychromy. In addition to this information, there was the evidence of Alfred Higgins's photograph published in 1894, showing the condition of the effigy before the monument's removal to the new building. After liaising with the clients at the PRO, it was agreed that exploratory windows should be opened through the overpaint layers in a number of selected areas, to reveal the extent and condition of the polychromy, and to assess the condition of the terracotta surface. As expected, much plaster modelling was found on the leg section but, alarmingly, the terracotta beneath the plaster was found to be laminating and in a poor and weak condition. The other two sections of the effigy had small areas of white nineteenth-century plaster repair, but were generally in a much sounder condition, with large areas of surviving polychromy. Similar windows were opened on the terracotta heads of Christ and the cherubs. Based on this information, a decision had to be made as to whether the overpaint and restorations should be retained or totally removed. The clients and conservator agreed together on removal to permit consolidation treatment and to reveal the original polychromy and surface modelling of the sculpture. The date of the two overpaint layers was documented as 1932 and 1956; they were only loosely based on the original polychromy and lacked subtlety or historical significance, so it was decided that the recovery of the important original paintwork should be accorded a higher priority than their preservation.

Plaster repairs were first removed and the friable terracotta consolidated with a 2 per cent solution of Paraloid B72 in methyl-trimethoxy silane (Dow Corning Z-6070 silane). This consolidation system was chosen as it allowed maximum penetration of consolidant with minimum colour and texture change. The presence of salts in the terracotta did not inhibit the curing of the consolidant. Loose fragments of polychromy were refixed with Paraloid B44 acrylic in toluene. Using the report from the pigment cross-sections as a guide, the overpaint layers were removed. Operating with a stereo microscope working at between x10 and x20 magnification, the paint layers were gradually removed mechanically with a scalpel; although a slow process it allowed maximum control in the separation of paint layers. As identified in the cross-sections, the red cloak was built up in three layers over the sealed terracotta surface: red lead, vermilion and a rich crimson glaze. The glaze was not applied as a flat colour but with a tonal range which enhanced the modelled form. The visual effect achieved was very subtle and rich, qualities which could obviously not be detected from the paint cross-sections or after the Ministry of Works repaint. Enough of the green cloak lining also survives to illustrate the subtle translucent quality of the copper resinate paint. Large areas of the original polychromy survive on the hands and face, particularly on the side of the face next to the wall. The pigment, basically lead white tinted with carbon black and lead-tin yellow, is very pale and must have been intended to represent the flesh of a corpse. Most of the original pigment of the hair survives but only small areas of the original charcoal black paint of the hat. Both of the cushions beneath the effigy head retain much of their gilding which was originally decorated with a red glaze floral pattern.

The problem of supporting the structurally weak sections of the effigy was solved by the Victorian rebuilders of the tomb by the insertion of vertical walls of 5cm thick Caen stone slabs. These were cut to follow the internal contours of the terracotta and fixed in place with generous amounts of plaster of Paris. The tremendous weight they added to each of the sections left the latter very vulnerable to damage in handling and they were therefore removed. As an alternative means of support for the effigy, it was decided to reconstruct the effigy on a base of Welsh blue slate. The base and break-edges of the effigy were sealed with polyvinyl alcohol before it was pieced together and bedded onto the slate. Polyfilla with polyvinyl acetate emulsion added to increase its strength and adhesive properties was used as bedding material. This was sufficiently strong to secure the effigy but could be easily removed with minimum risk to the terracotta.

The Head of Christ
When removed from the lunette, the head of Christ was still mounted on a block of Caen stone, obviously an original fixing as the terracotta head extended only as far as the base of the neck band, the remaining garment, clouds and halo being directly carved into the stone (figure 16.1).[13] The head was in good condition, the loss of the tip of the nose and several curls of the beard being the result of mechanical damage at some stage before the 1932 restoration. The head of Christ is approximately life-size but in contrast to the effigy head is based on a modelled form rather than a life or death mask. X-rays clearly showed the head to be cast with walls no more than 1cm thick in places, and that it was fixed into place with three metal cramps leaded into the stone (plate 62). The joint between the neck band and stone carving is no more than 2mm wide but in this gap is the same distinctive pink plaster which was on the effigy. A series of small holes on the side of the head is also visible; they were probably made prior to firing to allow moisture to escape.

[13] For the relationship of this head to the marble bust by Pietro Torrigiano in the Wallace Collection, see Galvin and Lindley, 'The tomb of Dr John Yonge', in *Gothic to Renaissance*, pp.203-4.

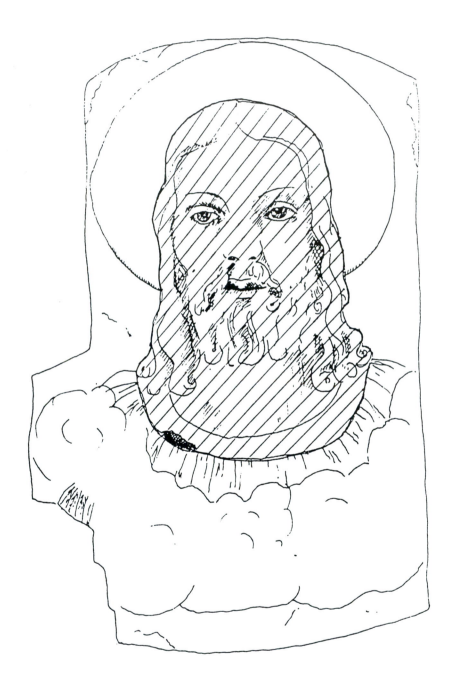

Figure 16.1 Head of Christ. The cross-hatched area shows the extent of the terracotta cast. The rest of the sculpture is carved limestone. The dark area on the neckband denotes the presence of a green glaze.

In the survey of pigment cross-sections, an original layer of gold on a yellow ground was identified on the halo beneath two later stages of regilding. Separating the individual layers of gilding proved to be difficult, so to avoid the loss of any of the original layer, only the latest regilding was removed: a fleur-de-lys pattern in red glaze was revealed. There was a similar problem with the gilding on the neck band, but in this instance the cross section showed traces of a red glaze and black paint, indicating that it was originally decorated with a red and black pattern. Much of the sixteenth-century brown pigment on the hair and beard survived, but large areas of the flesh paint on the face and neck were missing. However, where they were still intact, wisps of brown curls were painted over the flesh, effecting a subtle transition from the sculpted detail. Little paint remained on the eyes, and only small traces of pink on the lips. The gathered tunic retained traces of a purple pigment, a mixture of azurite blue and red lake, similar to the cuffs on the effigy tunic. The lead white on the clouds was generally intact. The sky behind the head is painted a deep azurite blue: the colour is intense towards the top, but gradually becomes paler towards the clouds as the ratio of azurite to lead white is reduced. The white of the relief clouds is extended onto the flat background, illusionistically continuing their form into two dimensions.

The Seraphs or Cherubs
Thermoluminescence dating carried out at the Research Laboratory for Archaeology and the History of Art of Oxford University, and the analysis of pigment cross-sections, ruled out the suggestion that the two seraph heads were later additions.[14] They are exactly contemporary with the effigy and head of Christ. Like the latter, they were mounted on blocks of stone, but the white plaster with which they were attached dated from the late nineteenth-century reconstruction. They were both removed from their backing stones. Their method of construction entailed a combination of casting and modelling techniques: they were both cast in moulds and, when at the leather-hard stage, were placed onto large slabs of wet clay. The chest of the seraph was then modelled in clay directly onto the backing slab. A method of modelling similar to that employed for the manufacture of coil pots was used, so that the structure was hollow and the last piece of the form was completed with a plug of clay. The two outstretched wings were added at either side. Two large apertures were cut through the back of the supporting clay slab to open the cavities formed by the head and chest areas. This allowed a safe, even firing (plate 63).[15]

It was clear from the photograph published in 1894 that the left seraph was already quite badly deteriorated. Removal of the overpaint revealed extensive white plaster repair to the lower wings, and partial repair to the other two. Beneath the plaster, the terracotta was soft and friable, and much of the surface had been lost. The consolidation methods used were the same as those on the effigy. The right seraph was in generally good condition. Large amounts of pink plaster on the back of the seraph are the only evidence of the original fixing. The wings retained traces of the original copper resinate green pigment with highlights of a paler, more yellow green; the hair was brown and a large amount of the polychromy on the face and neck also survived. The area of terracotta between the head and wings was found to be painted the same azurite and lead-white blue as found

[14] This report is dated 21 March 1990. The seraphs or cherubs are here shown in the conventional Italian manner, with putto-like heads surrounded by wings: in English Gothic art, they are shown as adult individuals and are given bodies, arms and legs. It seems impossible to decide whether Torrigiano's figures depicted seraphs or cherubs, given that the wing colour is appropriate to neither. It is doubtful that he gave the matter any thought.

[15] The apertures cut through the backing of the right cherub were very imprecisely cut, suggesting the haste with which the figure was made.

behind the head of Christ. The whole of the lunette must have been decorated in an intense sky-blue with painted clouds and gilded haloes behind each of the heads (small traces of the haloes behind the cherubs also survive: gold with a yellow overglaze and outlined with a black edge-line and a finer black line painted just inside).

The removal of the overpaint layers from the effigy and three heads revealed that about 60 per cent of the original polychromy survived intact. A final decision had to be made as to whether it was acceptable to inpaint layers where the decoration was missing. Because of the subtlety of the polychrome layers and glazes and the relatively large areas which would require inpainting, it was decided that retouching should be restricted to areas in joints and breaks, and to small areas between closely positioned paint fragments. The decision to expose the original polychromy could be justified by the role the paint played in emphasising and articulating the sculptural forms, and by the fact that the overpaintings had distorted the overall homogeneity of the monument to the extent that the cherub heads were often stigmatised as inferior later work. Secondly, it allowed access for consolidation treatment to the friable areas of terracotta. It was clear that polychromy had once played an important part in determining the aesthetic impact of Torrigiano's monument, and that its recovery had not necessitated the loss of aesthetically or historically important overpaintings. Finally, conservation work had not falsified the original painted surfaces by extensive retouching or repainting.

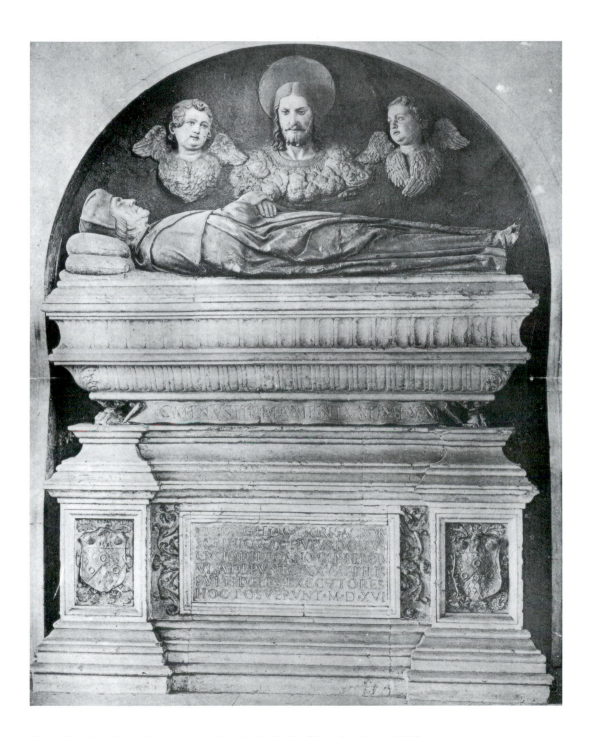

Plate 56 *Dr Yonge* Tomb, in position in the Rolls Chapel, prior to 1895.

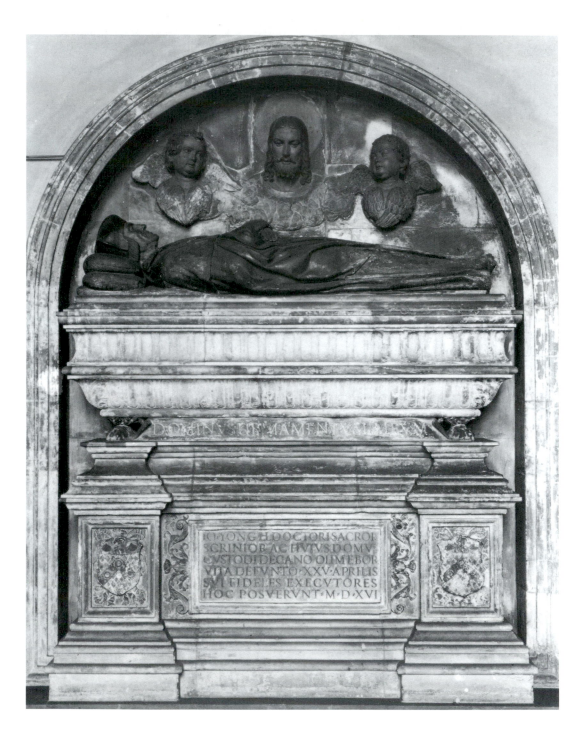

Plate 57 *Dr Yonge* Tomb, in position in the Rolls Chapel, after 1895 reconstruction.

Plate 58 *Dr Yonge* Tomb: detail of deterioration of the stone mouldings.

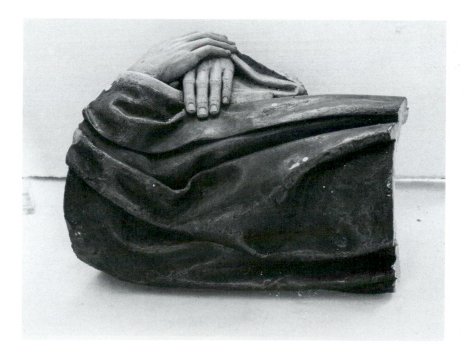

Plate 59 *Dr Yonge* effigy: detail of torso section

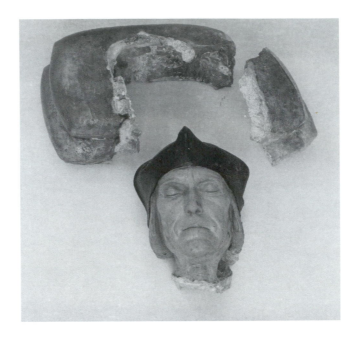

Plate 60 *Dr Yonge* effigy: detail showing the contour of the effigy head and cushions where the joint opened during firing.

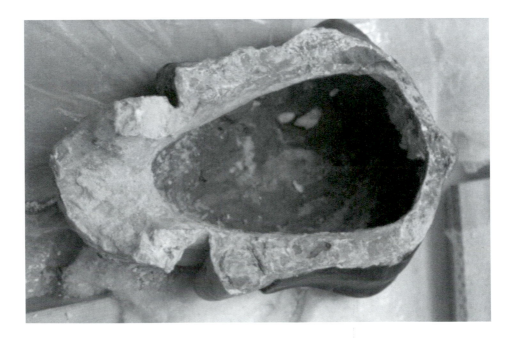

Plate 61 *Dr Yonge* effigy: rear view of effigy head. The hollow cast retains finger marks made when the clay was pressed into the mould.

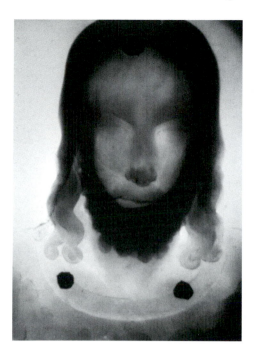

Plate 62 X-Ray photograph of *Head of Christ* from the *Dr Yonge* tomb.

Plate 63 Rear view of left-hand seraph.

CHAPTER 17

A VIEW OF SCULPTURE CONSERVATION IN FINLAND

L. Wikström

Public Concern

Normal daily life creates routines. People tend to use the same traffic routes, buses, shops and restaurants. The consequence is that environmental elements will become part of our routine and turn into passive and self-evident features. Outdoor sculptures in squares, parks, streets and building facades usually suffer this fate. However, the status quo can be easily disturbed. In Finland the competition for a statue in memory of our controversial wartime president Risto Ryti produced a storm of protest in favour of traditional portraiture and against modern non-figurative forms. Letters to the Editor of *Helsingin Sanomat* show that the 'ordinary man' wants the Ryti monument to show a perfect likeness while artists feel that an abstract form can express analogue messages. Even influential politicians have participated in the discussion, defending a proper life-size portrait.[1]

Once attention has been provoked it is not easily dampened. An indication of this is the public argument about the friendly donation of a statue named *The World Peace* to Helsinki City by its twin city, Moscow. The statue, designed by the People's Artist Oleg S. Kirjuhin, was donated in 1983, but it took seven years before it was erected. Some opponents of *The World Peace* wanted the gift to be rejected, and others still are of the opinion that it was given too central a location.

Opinions for and against the sculpture have even resulted in comic reactions and interference. *The World Peace* was covered with tar and feathers only one year after it was unveiled. Yet this kind of active attention only makes the statue even more interesting. After all, this is a monument of a past political era and idealism, in the pure style of Socialist Realism. From the point of view of conservation and preservation the statue has a particularly important value as an historical document though it is much less important in aesthetic or artistic terms (plate 64).

Fortunately not all attitudes to sculpture in Helsinki are so negative. Our most beloved statue is *Havis Amanda* made by Ville Vallgren at the turn of the century. Every year on the last day of April at 6.00p.m. young matriculated students gather around her and the fountain. *Havis Amanda* is washed and given the white student's cap. Later in the summer coins are thrown in the wishing well and every now and then police must fish swimmers out of the pool.

Those who are responsible for the maintenance of public sculptures are naturally very concerned about these tarring, feathering, washing and capping operations. In Helsinki almost all outdoor sculptures are part of the collection of the Helsinki City Art Museum. The City Engineer's office is responsible for the whole assembly of the sculptures, including the foundations and pedestals. Traditionally the Municipal Park Department takes care of maintenance. Neither of these offices has sculpture conservators in its service.

Helsinki has actually been a pioneer in Finland in starting a training programme for a special sculpture maintenance group. In 1990 a small selected group of employees from the Municipal Park Department participated on the course and this group will be responsible for the maintenance

[1] *Helsingin Sanomat* 08.11.91, 24.01.92, *Ilta Sanomat* 06.05.92.

of outdoor bronze sculptures in the city area. The aim of the two-week course was to give the participants an idea about the meaning of public art, to illuminate the attitudes of various professionals and authorities toward public art and to demonstrate the causes of deterioration as well as to teach them how sculptures are maintained. Speakers included the director of the Helsinki City Art Museum, an art historian specializing in sculptures, a sculptor, a founder and a planning engineer. The sculpture conservator lectured about the basic principles of conservation and acted as the instructor for the practical work. The course lectures were recorded in a manual. The intention is that the maintenance work will be based on a condition survey covering all public sculptures in the city area. This survey, as well as necessary conservation interventions, will be carried out by a private sculpture conservator.

Multidisciplined Co-operation

As it is obvious that bronze sculptures face problems in the outdoor environment in Finland, it is only natural that the Association of Finnish Sculptors has played an active role in trying to collect more information about the causes of decay and the preservation principles of bronze sculptures as well as trying to construct a training programme for various professionals working in this field. Unfortunately, resources to implement this kind of education are very limited due to inadequate financial support. Even the work of the so-called Bronze Group, established by the association in 1990, has been suspended.[2] The Bronze Group consists of artists, art historians, founders, corrosion scientists, museum administrators and conservators, and it began its work by making a literary study of internationally used cleaning, protection and research methods in sculpture conservation. The advantages and disadvantages of these methods were also recorded. The study indicated clearly that the problem of the conservation of outdoor bronzes is far from being solved. For the field survey fifteen bronze sculptures in Helsinki were chosen. They represented various ages and different micro-climates. Technically the statues were both sand and lost-wax cast. No differences in the quality between sand and lost-wax castings could be identified. However, comparison between statues produced with sand-casting technique, for example, showed marked differences in the porosity of the cast. Surprisingly, the pedestals were in a very poor condition (plate 65).

The field survey proved that deterioration processes are complicated, even in Helsinki, and that the correct identification of the causes of deterioration will demand a significant improvement in research resources. On the other hand, this is unlikely to happen unless the necessity for appropriate laboratory tests and research is understood and accepted.

In the final report the Bronze Group emphasised the importance of training for founders, sculptors, art historians and conservators. All parties need to be fully aware of how the sculptures, their materials and structures, react with the environment. Conservators considered it very important that museum administrators and conservators could agree on a common policy for the maintenance and conservation of outdoor sculptures.

The Conservator in Focus

An example of a long-term conservation project where the policy has to be especially well defined is the forthcoming conservation of the twelve nearly twice life-size Apostle statues on the roof of Helsinki Cathedral.[3] These zinc sculptures belong to the church. They are mentioned in all the

[2] *Pronssityöryhmän tutkimusprojektin loppuraportti* 04.03.92.
[3] *Helsingin tuomiohirhon Apostoliveistokset*, Loppuraportti 12.10.92 Oy Ars Longa Ab, Lena Wikström ja Minrja Kanerva.

major foreign articles and publications on the production and use of zinc and in the 1845-47 catalogue of the Berlin foundry, S. P. Deveranne, they were said to be the largest zinc sculptures in the world. They were sand-cast in pieces of various sizes, which were soldered together. The Apostles were erected in 1849 and the original mounting contract still exists, although it is not particularly informative.

During the condition survey in 1992, made by a private sculpture conservator (plate 66), it was found that some joints are open and that they have been repaired earlier. It is also obvious that the statues have originally been painted white. Traces of paint were found on all statues in the sleeve ends and in cavities (plate 67). No archival information about later paint treatments has been found. The structure of the armature and its condition was unknown: therefore it was examined and documented. The results were very alarming because the wrought iron support is heavily corroded. In fact some of the armatures have totally lost their ability to act as supports and the statues are basically standing on their zinc cloaks.

The cathedral was designed by the most famous architect in Finland, Carl Ludwig Engel. The Apostle statues are, however, not part of his original design. They have therefore been criticized many times during their 140 year history; the last time was some twenty-five years ago when the cathedral was restored. Now, as they have to be restored, a lively discussion will surely arise about their removal, or at least about the conservators' proposal to paint them again. There will be interesting questions about preservation and interference, and the conservator will inevitably be in the firing line.

The Lonely Conservator

It can also happen that a private conservator can be left completely alone with a young marble nude in a cellar with all the ethical responsibilities that it entails. A life-sized privately owned marble statue, in a small country town in Finland, is an unusual conservation object for a private sculpture conservator, especially when the statue originates in Rome and was donated to Finland via St. Petersburg. The statue, *The Reposing Satyr*, had been standing for decades in a restaurant without maintenance and had become dark from yellowed resin. Therefore, it gave the impression of being a wax figure. When the owner, a Finnish-Swedish Gentlemen's Club, considered selling the statue, it was decided to have the figure cleaned. An independent position, an unusual opportunity to work with an antique statue, and a client's commercial intentions are all factors which require an exceptionally disciplined approach in defining the aims of the conservation. The conservator must have adequate knowledge to foresee the result of the interventions. The ability to transmit the information to the client is vitally important and the decisions have to be mutually acceptable.

Working in an intimate relation with *The Reposing Satyr* raised many questions concerning his origin as well as his authenticity. The Satyr has been reassembled by using parts from different statues and the study of the composition showed that all the joints have been smoothed to fit together. Some anatomical defects were also indications of different origins. During the work it was possible to obtain new information about the structure, composition and marble quality of the statue. Yet the main question of his origin was still open and puzzling. The passionate affection for the marble youth was finally transmitted to an archaeologist, who began some art-historical research.[4] As the result of these studies it is now known that *The Reposing Satyr* is Roman and that it once belonged to the Villa Albani collection. In the 1780s the Russian Prince Yusupov purchased a large collection of paintings and sculptures in Rome including the satyr. After the

[4] Pietilä Castrén-Leena: A copy of the Praxitelian Anapauomenos in Finland', ARCTOS, *Acta Philologica Fennica*. Yliopistopaino, Helsinki 1992.

Russian Revolution the Yusupov collection was dismantled and the satyr found its way to Finland as a donation to a Finnish antique dealer. Thus the conservator has contributed to the identification of the only life-sized Roman statue in Finland.

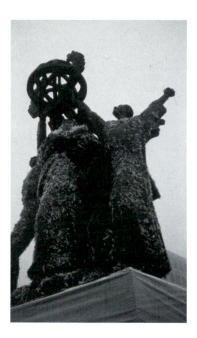

Plate 64 Oleg S Kirjuhin, *The World Peace,* tarred and feathered.

Plate 65 A survey of the outdoor sculptures in Helsinki showed that many of the modern sculptures were badly cast and finished: both core materials and core pins have been left in this statue.

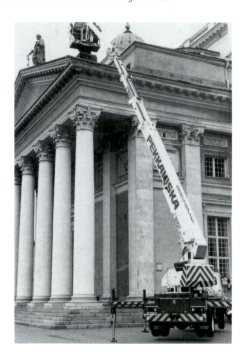

Plate 66 Zinc sculptures on the roof of Helsinki Cathedral are documented and examined.

Plate 67 The original white colour is completely worn away and the surface is corroded.

CHAPTER 18

VARIATIONS IN THE SURFACE OF STONE OWING TO THE PRESENCE OF ORGANIC AND INORGANIC SUBSTANCES

A. Parronchi

In this paper, I propose to discuss the problems inherent in the conservation of non-polychrome marble sculptures, whose artistic-expressive value is given priority over the aims of conservation.

The fundamental problems at the heart of the cleaning controversy are, in my opinion, reconcilable if one pays closer attention to the processes of change through time. If one views a section of a sculpture one can gain a stratigraphic view, stratum by stratum, of the process of alteration. From this we can distinguish three categories (colour plate LI): the internal A, the surface B, and the external C, processes of alteration. The internal process A affects the basic material components of marble. The intermediate surface alteration B includes the surfaces of the marble, the treatment of both original and subsequent surfaces and the inner band of particles from atmospheric deposits. Finally, the process of external alteration C, concerns particles deposited on the surface from the atmosphere.

Examining the process of alteration to the surface, we can see a phenomenon of reciprocal interaction between the three components present: the marble, the surface treatment and the atmospheric deposits. Parts of the surface transformation of the marble become absorbed by the surface treatments. These in turn have a tendency to penetrate, at the bottom, the internal crystalline structure and at the top to absorb particles from the atmosphere.

Enlarged under a microscope the situation seems more or less chaotic in relation to the state of decay. This chaos is, however, really the best expression of the phenomenon of ageing.

In dealing with this irreversible situation there are two alternatives for cleaning: to intervene radically by removing the deposits - which would, however, entail a further erosion of the fundamental material - or to remove only the atmospheric deposits, thus avoiding interference with the ageing of the marble itself. When choosing the second option one has to be cautious because of the soluble characteristic of chalk, which is found both in the surface deposits to be removed and in all the products derived from the constituent materials which have to be protected. One should also add that an exercise conducted primarily 'ad umido' can provoke an unnatural breakdown of the strata, thus compromising the result. By maintaining the superficial changes caused by the ageing process one can regulate how such changes are seen both in the shape of the sculpture and in the techniques adopted.

Colour variations are accentuated by the presence of an oxalic film. These films are found primarily on marbles displayed outside and were intended to be protective treatments. However, they have performed and continue to perform their protective function. With restoration the marble regains expressive values that are quite distinct from the original but adhere to the natural ageing process of the work of art. The first example is of the original protective treatment on the late sixteenth-century marble high relief in the centre of the façade of the Basilica of S. Trinità in

Florence (colour plates LII-LIV).[1] In this particular case we can say that the original surface was not coloured. The colour variations produced on the surface of the film assume a vast range of brown tones from the darkest, where the deposits are the most consistent, to the lightest, which correspond to the most exposed part of the relief. Here, damage has been caused by the atmospheric agents because the film is completely erased. The second example is of a non-original film on a plaque, part oriental marble (colour plate LV), part S. Giuliano limestone (colour plate LVI), from the architrave of the S. Ranieri door of the Duomo, Pisa.[2] It is certain that the treatment is not original: we know this because of the presence of the film on the broken parts of the work. The date of the elements of the work, however, is uncertain; some historians date the whole marble central decoration as Roman, whereas others only date part of it as Roman. The upper frame and the lower part which effectively supports the structure are universally considered to be medieval.

The relief is clearly in an advanced state of decay. Confronting the two surfaces one can see a similar oxalic film treatment (colour plate LVII). The difference between this relief and the first example discussed is that under the first surface of the Pisa marble there is a stratum of chalk, which may be a kind of preparatory layer.

As we can see from detailed diagrams of the work in hand, the surfaces are obscured by a white veil caused by the deposits on the surface (colour plate LV). These deposits are not uniform and are most prevalent in the more horizontal areas. Moreover, there are a number of colour variations on the central band where there are darker tones corresponding to the most heavy deposits. By contrast, in the upper frame the dark tones can be seen both where the deposits are heaviest and underneath where the surface suffers more from rising gases. The under part is analogous to the central band. We can conclude that by maintaining the film there is no surface damage and there is also a protective effect.

Different techniques can be seen on sculptures that are kept inside where lighter treatments were used. Sources dating back as far as the fourteenth century tell us of substances such as pumice stone, Tripoli chalk and straw being used to create a finer finish on a sculpture, as Vasari said, 'to give the finishing touch to the figure, adding to its sweetness, softness and refinement'.[3] It is necessary to remember, however, that such treatments applied directly to the work reflect the taste of the era as well as the creativity of the artist. The examples shown are from the cleaning of the Michelangelo marbles in the New Sacristy: they illustrate how the degree of finish combined with the presence of organic substances determines the 'chiaroscuro' effects.[4] The smooth surfaces after the removal of the deposits became very shiny, showing, however, slight tonal variations corresponding to the residual scratching (colour plate LVIII). These could be interpreted as clumsy attempts at cleaning. However, if we examine other areas where the scratches are more numerous, such as in the detail showing *Night*'s new leg, we can note that the course of the scratches runs symmetrical to an imaginary line that is the centre of the calf (colour plate LIX). This appears also on other similar surfaces where the original work of the artist is more evident. The rough surfaces, in contrast with the shiny areas visible on the more jutting surfaces, highlight the fine modelling of the figure. The sheen on parts of the sculpture could be due to human contact over time, but similarities can be found in less accessible areas, such as the statues of the Dukes on the walls of the sacristy (colour plate LX).

[1] V. Martelli, 'Pietro Bernini e figli', *Commentari*, 4 (1953), 136-7.
[2] P. Sanpaolesi, 'La facciata della Cattedrale di Pisa', *Rivista dell'istituto Nazionale di Archaeologia e Storia dell'Arte*, 5-6 (1956-57), 298.
[3] G. Vasari, *Le Opere di Giorgio Vasari*, Edizioni Sansoni, 1981, I Libro, Introduzione alla scultura, p. 155.
[4] F. Panichi and A. Parronchi, *Michelangelo: The Medici Chapel*, London, 1994, pp.208-213.

The last case of surface variations we shall examine occurs on Michelangelo's *Battle* (colour plate LXI).[5] The excessive browning of the surface is due to the use of linseed oil to remove the last plaster-mould which was made of it. Underneath, we found the presence of waxes, preserved together with residues whose removal would have compromised the integrity of the work's surface.

Acknowledgements
Special thanks to the Soprintendenze di Firenze, to the Enti: dell'Opera Primaziale Pisana and to the Casa Buonarroti in Florence, who supervised these restoration projects.

[5] A. Parronchi, *Il Giardino di S.Marco*, Florence, 1992, pp.61-2.

CHAPTER 19

THE DISPLAY AND CONSERVATION OF SCULPTURE AT PETWORTH

T. Proudfoot and C. Rowell

Petworth House, West Sussex, contains the finest single collection of pictures and sculpture[1] in the care of the National Trust (plate 68). Overall, there are 700 pictures and 150 pieces of sculpture. Following the gift of the house by the 3rd Lord Leconfield in 1947, the collections at Petworth were rearranged on behalf of the Trust by Anthony Blunt in 1952-53, and much redecoration was undertaken at the same time and subsequently. The crowded, miscellaneous and symmetrical picture hangs shown in Turner's views of the rooms of c.1827[2] (colour plate LXII) were undone and the character of the house was fundamentally altered. Turner's gouaches-cum-watercolours also indicate how the sculpture was displayed both on pedestals and pier tables in several rooms. The Trust is currently engaged upon a reassessment of its 1950s approach with the aim of reviving the spirit of Petworth in the lifetime of the 3rd Earl of Egremont (1751-1837), the celebrated patron of Turner and contemporary painters and sculptors. This involves a review of the the conservation and display of the eighty-five pieces of Antique sculpture mainly collected by the 3rd Earl's father, the 2nd Earl of Egremont (1710-63). The intention is to preserve evidence of burial deposits and Antique and restorers' patination by undertaking structural repairs without cleaning. This also maintains a homogeneity of appearance between the sculpture and the often damaged and heavily patinated pictures and frames.

The restoration of the North Gallery between 1990 and 1993 initiated the re-appraisal of the public rooms which is based on extensive research, principally in the Petworth House Archives.[3] The North Gallery was originally intended for the display of Antique sculpture (colour plate LXIII).[4] Built in 1754-63 by Matthew Brettingham the Elder (1699-1769) for the 2nd Earl of Egremont, its narrow rectangular shape, northern side-lighting, niches for full-length sculpture and brackets for busts is directly comparable to Brettingham's gallery at Holkham, Norfolk, also built in the 1750s for Lord Egremont's friend, the 1st Earl of Leicester. Egremont's agents in Rome were

[1] M. Wyndham, *Catalogue of the Collection of the Greek and Roman Antiquities in the Possession of Lord Leconfield*, London, 1915. Miss Wyndham's introduction (pp.xvii-xxiii) is a brief account of the formation of the Petworth collection of Antique sculpture, citing J. Dallaway, *Anecdotes of the Arts in England...*, London, 1800, pp. 278 ff., and *Of Statuary...*, London, 1816, pp. 318 ff. The inventory numbers quoted in this article refer to Miss Wyndham's catalogue.

[2] Turner's paintings of Petworth (in watercolour and gouache on blue paper; approximately 140mm x 190mm) form part of the Turner Bequest in the Tate Gallery; see M. Butlin, M. Luther and I. Warrell, *Turner at Petworth, Painter and Patron*, the Tate Gallery, 1989. Butlin *et al.* suggest 1827 as their likely date.

[3] For accounts of the history and restoration of the North Gallery, and of the Trust's plans for other rooms at Petworth, see M. Hall, 'Petworth House, Sussex', *Country Life*, 187/23 (1993), 128-33, and C. Rowell, 'The North Gallery at Petworth: An historical re-appraisal', *Apollo*, 138 (1993), 29-36. The Petworth House Archives are owned by Lord Egremont and administered by the West Sussex Record Office, Chichester.

[4] The 1764 inventory of Petworth (Petworth House Archives PHA 7514) lists the sculpture in the North Gallery and in other rooms.

the younger Matthew Brettingham (1725-1803) and Gavin Hamilton (1723-98), who employed Italian restorers. At least one piece was sent to England in a fragmentary state and was made up later. The restoration of the *Torso restored as Dionysos* (No. 14)[5] was undertaken (1832-35) by an Irish sculptor extensively patronised by the 3rd Earl, John Edward Carew (1785-1868).

It has been presumed that several other sculptures despatched from Italy in the 1750s were restored in England. Miss Margaret Wyndham stated in 1904[6] that Carew 'was commissioned to repair the damage and make the restorations, and nearly all the pieces reveal his touch'. There is, however, no documentary evidence for this assertion. According to James Dallaway in 1816[7]: 'At the time of his [the 2nd Earl's] death in 1763, the cases containing these statues were not unpacked, so that their distribution and arrangement were by the arrangement of their present noble possessor (George, 3rd Earl)'. Miss Wyndham also recorded that 'After George, Lord Egremont, had unpacked the statues, Petworth House became known locally as "A home for the wounded"'. In fact, the 1764 inventory reveals that Brettingham's North Gallery contained eleven full-length statues and twelve busts, and that there were two full-length statues and twenty-three busts on display elsewhere in the house. However, the 'Dairy Wash House' contained 'four Marble Statues' and 'four Marble Busts' and these could have been some of the pieces requiring subsequent restoration. Also, statues and busts from Italy were still clearing the customs in 1765, two years after the second Earl's death.

Between 1824 and 1827, the North Gallery was extended by the 3rd Earl of Egremont, to house his collection of British sculpture and pictures (colour plate LXIV). The North Gallery, with its top-lighting and simple detailing, is most comparable to the British Institution by George Dance the Younger (1788) and Dulwich College Picture Gallery by Sir John Soane (1811-1815). It was exceptional for the fact that Antique and Neo-Classical sculpture was displayed together with the 3rd Earl's extensive collection of British pictures and twenty-four Old Masters.[8] In England, large collections of pictures and sculpture were usually shown in separate galleries at this date.

The approach to the display of sculpture in the North Gallery has been conditioned by its predominantly dingy appearance. The marks of restoration and surface dirt are apparent on many pieces. The pictures and picture frames are also dark or heavily patinated. A dark red wall colour has been chosen to minimise such imperfections and this accords with the Trust's desire that the Gallery should look established and as untouched as possible despite three years of work. In the 3rd Earl's day, all the principal rooms at Petworth were white or red. Turner's gouache of c.1827[9] shows that the gallery was originally painted white. Paint analysis showed that this was a pure

[5] Carew restored the *Torso*, with the assistance of the marble-mason James Welch, by the addition of 'head, arms and legs' between 1832 and 1835 at a cost of £525. The fragment was 'from Rome, and taken out of the Tiber'. A cast by Sir Francis Chantrey was sent to Carew who began the 'model' in London and finished the carving of the marble in Brighton. Sir Richard Westmacott (in whose studio Carew had begun his career and who saw the *Torso* before restoration) stated: 'There was monstrous difficulty in the work, there is more trouble making restorations, than in making statues; it requires so much consideration'. (This information derives from one of two reports of the action brought by Carew against the 3rd Earl's executors: *Report of the Trial of the Cause Carew against Burrell, Bt, and Another, Executors of the Late Earl of Egremont...London,* 1840, p.18 *et seq.*).

[6] *Op. cit.*, in note 1.

[7] *Op. cit.*, in note 1.

[8] For the earliest list of pictures and sculpture in the North Gallery as extended by the 3rd Earl, see H.W. Phillips, MS. 'Catalogue of Pictures at Petworth, 1835' including a 'List of Statues in the North Gallery' and a location plan, Victoria & Albert Museum MS 86FF67.

[9] Turner Bequest CCXLIV-13.

bright white rather than a more subtle tone. However, by c.1865, the date of a watercolour by Mrs Percy Wyndham, the gallery was red. In the course of stripping off the 1930s woodchip paper, painted terracotta pink in the 1950s, a dark red Pompeian scheme of c.1870 was discovered. Enough survived to be left exposed - the remainder was painted to match (colour plate LXV). The result is sympathetic and is in accord with mid-nineteenth century experience at the British Museum.[10] There, as at Petworth, the galleries were painted a 'light grey' or white. By 1839, however, the Elgin Room was red and by c.1850 the other galleries were painted 'a very dark rich colour', 'a strong red', to reduce the contrast between sculpture dirtied by London smog and a light background. *The Builder* declared in 1851 that this was 'far superior to the blank white walls and ceilings formerly in vogue'.[11] In 1857, John Ruskin wrote that 'Beautiful sculpture should be set off beautifully - i.e. with dark walls round it to throw out its profile...'.[12]

A central figure in the British Museum debates about display was the sculptor, Sir Richard Westmacott (1775-1856), represented by two works in the North Gallery. Among the 3rd Earl's other advisers was Sir Francis Chantrey (1781-1841), who was also consulted at the British Museum. The restoration of the North Gallery has reinstated the top-lighting designed by Chantrey and Thomas Phillips (1770-1845), the painter. Brettingham's original North Gallery (1754-63) was side-lit from the north and, although the middle section of the gallery, the central corridor (1824-25), has always been top-lit, the north bay (1826-7) was originally side-lit by thermal windows, as shown in one of Turner's gouaches.[13] The room was designed around Flaxman's *St Michael overcoming Satan* (1819-26). However, top-lighting is advantageous because it allows more wall-space for display than side-lighting. This was clearly the reason for the blocking-up of the thermal windows in the north bay and their replacement by a central skylight in 1830. John Britton (1827) described top-lighting as 'preferable to any other [form of lighting] for a display of works of art'.[14]

The result of rebuilding the skylights to the designs of 1839 and 1843[15] in the North Gallery has been a considerable improvement in the amount and quality of (controlled)[16] natural light falling on the pictures and sculpture. This also has the effect of heightening the imperfections of the works of art on display. Conservation of both pictures and sculpture before the completion of the North Gallery's restoration was intentionally limited to essential repair so that a full assessment could be made later. This had the benefit of preserving evidence of any Antique or eighteenth-century and early nineteenth-century restorer's patination. Unfortunately, some pieces, such as the *Dionysos* (No. 14), were cleaned before the current non-cleaning policy was implemented. This has resulted in the kind of disharmony that we are now at pains to avoid. It has been necessary to tone down the most obvious examples.

From 1813, the 3rd Earl commissioned works from the leading British sculptors of the day: Flaxman, Westmacott, Rossi, Chantrey and numerous works by the Irish sculptor, Carew. The intention is to leave these uncleaned also - certainly until further investigation of the surfaces has been carried out. Hugh Honour has demonstrated that Canova 'usually washed his statues, when

[10] I. Jenkins, *Archaeologists and Aesthetes in the Sculpture Galleries of the British Museum 1800-1939*, the British Museum, 1992. See especially chapter 3, 'Light, Colour and Dirt', pp. 41-55.

[11] *The Builder 9* (15 February 1851), 99.

[12] Quoted in Jenkins, *op. cit.*, in note 10, p. 45.

[13] Turner Bequest CCXLIV-25.

[14] J. Britton, *The Union of Architecture, Sculpture and Painting*, London, 1827, p. 18.

[15] Originally (1824 and 1830) the skylights had sloping sides. In 1839, the ceiling of the north bay was raised and a straight-sided skylight was substituted. The skylights of the central corridor were rebuilt to match in 1843.

[16] A dual system of blackout and daylight blinds maintains the light at a conservation level.

completely finished, with a kind of yellow tinge, to give them an appearance of antiques...'.[17] Lest such patination be disturbed, it is therefore preferable to leave the Neo-Classical works at Petworth untouched for the time being pending research.

To return to the Antique sculpture: there are three historical links between the Petworth collection and the Italian restorer Bartolomeo Cavaceppi (1716-99). First, two of the Petworth statues - the *Statue of Ganymede*, No. 1, and the *Female Portrait Statue*, traditionally called '*Agrippina as Ceres*', No. 3 (plate 69) - are engraved in Cavaceppi's published record of his restorations, the *Raccolta d'antiche statue...*(1768-72).[18] Secondly, Cavaceppi was the principal restorer of the great collector Cardinal Alessandro Albani (1692-1779), whose Villa Albani (1755-62) in Rome was almost as influential as the Papal museums in terms of the display of sculpture. The *Bust of a Boy with a Bulla* (No. 41) is known to have an Albani provenance[19] and it is to be hoped that further research may fill out the Petworth connection with Albani and his circle. Thirdly, until 1776, Cavaceppi was the restorer usually employed by Gavin Hamilton, the excavator, artist and dealer who acted as the 2nd Earl of Egremont's agent in Rome. Dr Gerard Vaughan has shown that Hamilton was critical of over-restored pieces, drawing attention to his own more conservative policy of leaving statues 'a little corroded and stained'.[20] Cavaceppi made a similar claim in the *Raccolta* and, though in practice both men condoned more radical restoration, Dr Vaughan believes that in the 1750s and 60s (the period of the 2nd Earl's collecting) collectors were inclined to share Cavaceppi's published view that obvious joins and cracks increased the illusion of antiquity. From the 1770s onwards, taste changed and Cavaceppi's pupil and rival, Carlo Albacini (d.1807) was one of the restorers who catered for a less obvious, smoother and more refined style of restoration. It is interesting that a visitor to Petworth in 1776 described the marbles as 'lamentably patch'd'.[21]

The conservation of statuary in the Petworth collection has revealed preliminary evidence of applied patination[22] by the restorers Cavaceppi, Carew and others. It was during the conservation and cleaning in 1984 of the *Torso restored as Dionysos* (No. 14) (plates 70-71) that our attention was first drawn to the possibility of surface treatments lying unrecognised on the sculptures. Later, we analysed surface deposits upon three other restored Antique statues (Nos. 1, 15 and 18) which

[17] H. Honour, 'Canova's Studio Practice - II: 1792-1822', *Burlington Magazine*, Volume CXIV No. 829, April 1972, p. 219, quoting Baron d'Uklanski in 1808.

[18] B. Cavaceppi, *Raccolta d'antiche statue, busti, bassorilievi ed altre sculture restaurate da B. Cavaceppi, sculptore Romano*, Rome, 1768-72, especially in the section in vol. 1: 'Dell'arte di ben restaurare le antiche statue'. For the Petworth *Ganymede* (No. 1) see vol. 1 pl. xiii; the *Female Portrait Statue* traditionally known as '*Agrippina as Ceres*' (No. 3) is vol. 1. pl. xii.

[19] M. Wyndham, *op. cit.*, in note 1, pp. 67-68.

[20] G. Vaughan, 'Albacini and his English Patrons', *Journal of the History of Collections* 3 no. 2 (1991) pp. 183-197. For the quotation by Hamilton see p. 187.

[21] Annabel Yorke, Lady Polwarth, to her mother, Marchioness Grey (August 20 1776). '...On Sunday morning we drove over to Petworth...I really lik'd some of the statues in a gallery fitted up by the late Lord, particularly two sitting consular figures [Nos. 15 & 19], one standing, - still finer, and the drapery of a Ceres [No. 3], but they are all lamentably patch'd.' (Bedfordshire Record Office, Lucas MSS. L30/9/60/83). We are grateful to Mr Gervase Jackson-Stops for this reference.

[22] We are grateful to Mrs Catherine Hassall of University College London Painting Analysis Ltd. for her analysis of the patinations. Inorganic material was identified by polarised light microscopy, U.V. fluorescence microscopy and EDX elemental analysis using a Jeol 820 scanning electron microscope. Organic material was analysed by thermal microscopy and differential scanning calorimetry.

were also consistent with J. Paul's[23] account of early restorers' glazes.

The 1984 conservation of the *Torso restored as Dionysos* was similar to that of its neighbour in the gallery - *Group of Pan and Olympus* (No. 12) (plates 72-73).[24] Their stark, white appearance after cleaning exemplifies the generally accepted treatment of restored Antique sculpture this century, and is in marked contrast to our present policy at Petworth. On the advice of the British Museum in the 1970s, the house staff had cleaned these and several other sculptures with sepiolite packs. Their aim was to brighten the marble to an appearance approaching the lighter Neo-Classical pieces. Fortunately, sepiolite proved too expensive and the cleaning programme was abandoned, but not before several pieces were rendered unsightly and half-cleaned. The cleaning of the *Dionysos* and *Pan and Olympus* was completed by conservators. Recent repairs have been more conservative, concentrating on replacing decayed and expanded structural fixings, with minimal disturbance to the surface apart from the toning of stains caused by the ill-advised 1970s cleaning programme.

The *Dionysos* is notable both for its fine Roman torso and for the additions made by J.E. Carew. The 3rd Earl wrote to Carew c.1832: 'I wonder if you could restore the Antique body which I have at Petworth, and give legs, arms etc'.[25] Carew also added the head. The seated panther (by Cavaceppi?) was incorporated in the composition. Carew took considerable trouble to reduce and obscure his interference with the *Torso*. Cavaceppi's *Raccolta* stresses that it is the role of the restorer to *enlighten* the Antique fragment by his repairs and discreet additions. In the case of the *Dionysos*, Carew let in small slithers of marble to maximise the amount of Roman torso that could be saved. Carew also used plaster to unite the hair ribbon (part of his new head) to the torso rather than cut into the marble. The identification of coloured mortar within the locks of hair proved the most important discovery. Only a small amount remained after the sepiolite cleaning, but enough to indicate an overall patination on Carew's head which would, presumably, have originally tinted his other repairs. Microscopy and x-ray diffraction identified the mortar as being a lime coat with pigments of yellow and brown iron oxides. Accordingly, when the 1984 treatment was recently reviewed, refixing of the cleaned statue was followed by a light discolouration with tinted cosmolloid wax to emulate Carew's patination.

Next, we studied the patination of two statues of seated men (Nos. 15 and 19). We were interested in the general covering of burial dirt that remained, seemingly undisturbed, on the rear of both sculptures. In recent years our experience of the repair and conservation of Antique buildings and sculpture in Western Turkey has enabled us to broadly identify the configurations of burial marks. We looked to our investigation of No. 15 to serve as a bench-mark by which artificial burial patinations could be compared.

The *Seated Statue of a Man* (No. 15) (plate 74)[26] is a composition of a second-century AD seated figure, restored after 1738 by the addition of a third-century head of Emperor Gallienus and of the two arms and a foot. The cross section of the burial deposits taken from No. 15 indicates a reddish/brown material containing silicates and iron oxides. There is no trace of binder (plate 75).

[23] J. Paul, 'Antikenergänzung und Ent-Restaurierung', *Kunstchronik*, 25 (1972), pp. 85-112.

[24] This group was purchased by the 3rd Earl of Egremont for £126 at Lord Bessborough's sale, 6 April, 1801. The photograph published by Miss Wyndham shows it in its state prior to cleaning, although Pan's fig-leaf drapery had been removed before 1984. (See M. Wyndham, *op. cit.*, in note 1, pp. 21-22 and plate 12).

[25] Carew, 1840, p. 158 *op. cit.*, in note 5.

[26] As recorded by Miss Wyndham (*op. cit.*, in note 1, p. 62) No. 15 (and No. 19) is listed in the 1738 inventory of the Palazzo Barberini, Rome: 'una statua a sedere rappresentante uomo togato, senza testa, senza braccia, e mancante di un piede'...

By contrast, the cross section of the patination found on the arm indicates a binder of gypsum plaster; the pigment particles are much larger than the burial oxides. This is the restorer's patination. Both burial clays and the arm patination can be easily removed by water. From the rear one can appreciate the function of the patination in uniting the disparate elements of the statue: the new arm is of Carrara marble, the Antique body and head of Pentelic marble, smoothed down and coloured over in the course of restoration.

In the case of the *Statue of an Amazon* (No. 18) (plate 76),[27] the head and torso, united by restorers, both derive from fifth-century Greek Amazon types. There are some strong Cavaceppi trademarks in the composition - the helmet, tree trunk and stock between arm and torso are all identified by Dr Seymour Howard as being typical of Cavaceppi. Despite Cavaceppi's respect for the Antique and his reluctance to touch the original sculpture as expressed in the *Raccolta*, there is evidence here of his exuberant use of the chisel to put gouge marks on the skirt and to visually lighten the drapery. Also there seemed to be a suspiciously large amount of white burial marks within the gouges.

We chose three areas for examination: some burial accretions 5 inches above the hemline; the drapery gouge marks; the suspiciously darkened stock between arm and torso. Under magnification, by as little as x 20, we were clearly able to see pigmented mortars that covered most of the surface. Not only were the burial accretions on the hemline false and composed of iron oxides with vermilion, the gouge marks had been picked out in gypsum and possibly toned in white. The stock had been covered in such thick paint and mortar that a craquelure was discernible under magnification x8. Again, this provides clear evidence of Cavaceppi's intervention.

For the Antonine *Statue of Ganymede* (No. 1) (plate 77),[28] Cavaceppi is known to have provided the head, the right arm, the eagle's beak and the lower half of the left wing. The flat granular appearance of the rest of the sculpture would indicate his hand on most of the carving. We found little pigment on the sculpture, save on the eagle's beak, but examination of the surface showed it to be strangely and thoroughly etched (plate 78). The surface markings by their somewhat blistery appearance are similar to those on the *Bust of Julia Mammaea* at Holkham - Michaelis *Ancient Marbles of Great Britain* (1882) No. 10 - a known fake artificially aged by chemicals.

We found strong readings of chlorine upon the *Ganymede*. The statue is uncleaned and is not reported to have suffered on its voyage to Petworth. It is therefore an important survival (like No. 3) of a published Cavaceppi restoration in its original state. We strongly suspect the surface to have been comprehensively etched by Cavaceppi using hydrochloric acid.

Finally, we turn to the recent repair of the fourth-century restored *Statue of a Boy Holding a Pig* (No. 53) (plate 79).[29] Structural consolidation was carried out without any significant cleaning of the surface. Rusting ferrous fixings set in rosin in the knees, trunk and hand, were removed by a combination of locally applied solvent, heat and pressure. Replacements in stainless steel were inserted into polyester resin, and the piece re-assembled. Surface dirt and dust were lightly swabbed off under magnification. Fills were made up with Paraloid B72 and pigment (plate 80). We were almost convinced by the burial marks on the trunk and body, but we decided that the Roman soil could not be that black and oily (plate 81). The cross-section shows that the burial marks are indeed a false patination composed of animal glue and a black organic material reading as phosphorus from (possibly) bone black (plate 82).

[27] M. Wyndham, *op. cit.*, in note 1, pp. 32-35 and plates 18 and 18A.

[28] M. Wyndham, *op. cit.*, in note 1, pp. 1-2 and plate 1.

[29] M. Wyndham, *op. cit.*, in note 1, pp. 84-85 and plate 53.

These preliminary investigations at Petworth indicate that curators and conservators need to be aware of restorers' practice and collectors' taste in relation to the repair and surface treatment of Antique statuary. Even obvious joins and cracks should not be simply regarded as deterioration to be reversed. As we have shown, the coloured waxes, stains and mortars used by early restorers are an essential and distinctive element of the appearance of the restored statue. It should be remembered that the restoration of Antique sculpture involved the often highly sensitive and sophisticated reworking of fragmentary and unpromising material. Dallaway rightly praised 'Cavaceppi, Cardelli and Pacili in particular' for the 'wonderful intelligence and skill' of their restoration of 'fragments and torsos'. The working practices of such restorers should be taken into account in the conservation and display of Antique statuary. This has proved especially important at Petworth given its rarity as a setting for the largest surviving eighteenth-century collection of Antique sculpture in a British country house.

Plate 68 Petworth House from the west. The top-lit North Gallery is to the left.

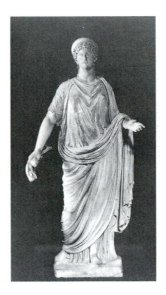

Plate 69 *Female Portrait Statue* (No. 3), Roman adaptation of a Greek original of the end of the fifth century B.C., restored and published by Bartolomeo Cavaceppi (1716-99). Parian marble, H. 1.93m.

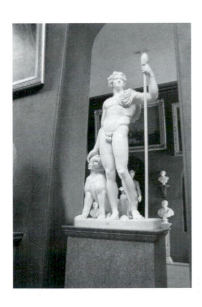

Plate 70 *Torso restored as Dionysos* (No. 14). Roman torso with additions (1832-35) by J.E. Carew (1785-1868). Marble, H. 2.07m.

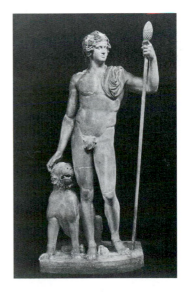

Plate 71 *Torso restored as Dionysos* (No. 14). This shows the appearance of the statue before cleaning in the 1970s and in 1984.

Plate 72 *Group of Pan and Olympus* (No. 12). Roman, marble H. 1.48m. Acquired 1801 by the 3rd Earl of Egremont.

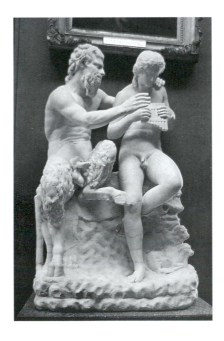

Plate 73 *Group of Pan and Olympus* (No. 12) after cleaning.

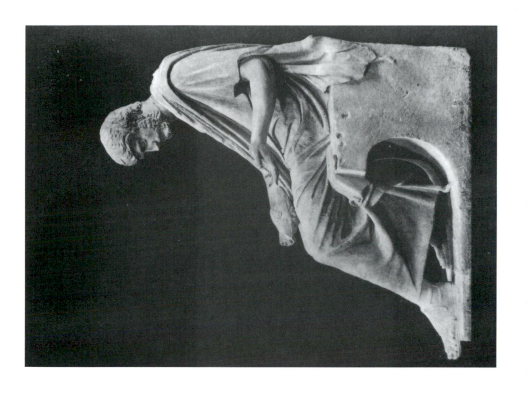

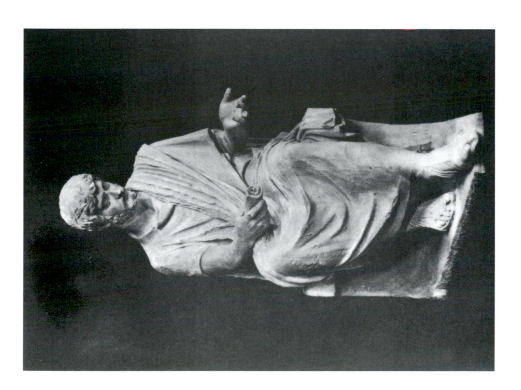

Plate 74 *Seated Statue of a Man* (No. 15). Roman, second century AD, with third century AD head of Emperor Gallienus. Marble, H. 1.50m.

189

Plate 75 *Seated statue of a Man* (No. 15). Close-up view of burial stains.

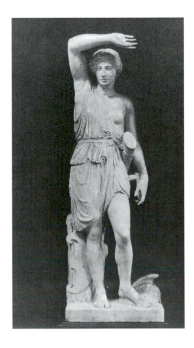

Plate 76 *Statue of an Amazon* (No.18). Roman copy of a Greek bronze statue of the fifth century BC (cf. the *Mattei Amazon* in the Vatican). Marble. H. 2.0m.

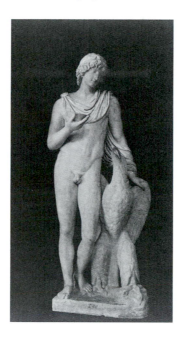

Plate 77 *Statue of Ganymede* (No. 1). Roman, second century AD, restored and published by Bartolomeo Cavaceppi (1716-99). Marble. H. 1.89m.

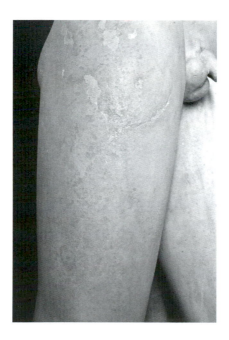

Plate 78 *Statue of Ganymede* (No. 1). Close-up of simulated weathering upon right leg.

Plate 79 *Statue of a Boy holding a Pig* (No. 53), Roman, probably first half of the second century AD, adapted from a Greek fifth-century BC type. Parian marble, H. 1.25m.

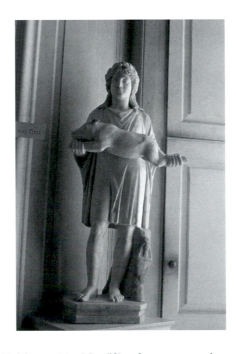

Plate 80 *Statue of a Boy Holding a Pig* (No. 53), after conservation.

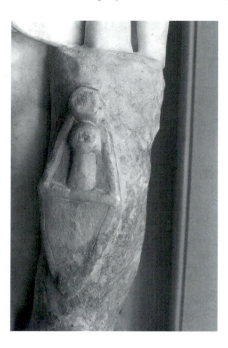

Plate 81 *Statue of a Boy Holding a Pig* (No. 53), close-up of trunk, showing burial dirt.

Plate 82 *Statue of a Boy Holding a Pig* (No. 53), magnification (x1000) of simulated burial dirt comprising animal glue with bone black.

CHAPTER 20

SOME OBSERVATIONS AND REFLECTIONS ON THE RESTORATION OF ANTIQUE SCULPTURE IN THE EIGHTEENTH CENTURY

G. Vaughan

From around 1800, a growing number of connoisseurs and younger critics in England began to question the well-established and hitherto unchallenged principle of the restoration of ancient sculpture. In a period which saw a notable increase in excavations - not just in Italy, but at important sites in Greece and Asia Minor - and the parallel rise of an increasingly scientific archaeological method, this was inevitable.[1] The symbolic break with accepting the principle of restoration, established since the Renaissance, occurred in 1816 when the British Museum made the decision - after a long debate - *not* to restore the Elgin Marbles.[2]

In 1812 James Dallaway, a scholar and connoisseur of remarkable skills, and the first historian ever to attempt a systematic assessment of the contents of English private collections,[3] published a denunciation of the Rome-based dealers in, and restorers of, classical antiquities.[4] He selected as a subject of particular derision, the so-called *Jenkins Venus* (plate 83), which remains today as the centrepiece of Robert Adam's spectacular neo-classical sculpture gallery at Newby Hall in Yorkshire. The statue had been acquired by William Weddell in Rome in 1765, while on the Grand Tour, as part of the ready-made collection of antiquities which he purchased *en bloc* from Thomas Jenkins. Jenkins was the dealer and banker who dominated the art market in Rome during the second half of the eighteenth century; hundreds of highly-restored antiquities passed through Jenkins' hands into collections not only in England but throughout Europe (plate 84).[5] Dallaway wrote about this statue, as part of an attack upon Jenkins and the methods he employed:

[1] In the first volume of the Society of Dilettanti's important *Specimens of Ancient Sculpture*, London 1809, Richard Payne Knight (who had been assisted by Charles Townley in planning the text and illustrations), made various criticisms of the practice of restoration, and insisted that the engravings indicate modern restorations by dotted lines.

[2] On this see esp. J. Rothenberg, *'Descensus ad Terram': The Acquisition and Reception of the Elgin Marbles* New York and London, 1977, p. 185, and W. St. Clair, *Lord Elgin and the Marbles,* Oxford, 1983 (2nd edn), pp. 152-3. It is known that Lord Elgin himself presumed the Parthenon marbles would be restored, in 1803 inviting Canova to consider the job. Canova refused with the memorable statement that 'it would be sacrilege in him or any man to presume to touch them with a chisel.' See I. Jenkins, *Archaeologists and Aesthetes in the Sculpture Galleries of the British Museum 1800-1939,* London, 1992, p. 232, n. 57. It is ironic that in the same year, Thorvaldsen commenced work, for Ludwig of Bavaria, on the full restoration of the Aegina Marbles, the only comparable body of original Greek sculpture to find its way into a European collection.

[3] J. Dallaway, *Anecdotes of the Arts in England,* London, 1800.

[4] J. Dallaway, 'Biographical memoirs of the late Charles Towneley,' in *General Chronicle and Literary Magazine* 5 (May 1812), p. 37 (privately printed as a pamphlet, London, 1814).

[5] On Jenkins (1722-1798) see esp. T. Ashby, 'Thomas Jenkins in Rome,' *Papers of the British School at Rome* 6 (1913), 487-511 and B. Ford, 'Thomas Jenkins: Banker, Dealer and Unofficial Agent' *Apollo,* 99 (June 1974), 416-25.

When Lord Tavistock (father of the present Duke of Bedford) was at Rome, he commissioned Gavin Hamilton[6] to collect statues or busts of merit and curiosity, for his intended gallery. Mr Hamilton soon after discovered a Venus of such exquisite proportions and finishing as to rival the far-famed statue De Medici - but the head was wanting. Jenkins had procured from the cellars of the Barbarini Palace, in which an infinite number of fragments had been deposited, a most beautiful head of a Pudicitia. As the perfecting a statue was ever his object, he offered Mr Hamilton a hundred sequins for his headless statue, knowing how exactly he could render it complete; and added, that 'He did not understand the taste of English virtuosi, who had no value for statues *without heads*; and that Lord Tavistock would not give him a guinea for the finest torso ever discovered'. The crafty statue-dealer prevailed, and by the skill of Cavaceppi,[7] having removed the veil from Pudicitia, a perfect Venus arose, and her charms were first presented to Mr Weddell, a determined collector.[8]

This is as representative an example as any of the eighteenth-century insistence upon the principle of restoration. Clearly a system of values prevailed very different to those commonly held today, when the condition and authenticity of the object were less important than considerations about subject matter and the decorative role the object would play in its eventual setting. It must be remembered that restorers from the Renaissance onwards nearly always tried to convert fragmented busts and torsos into instantly recognisable classical subjects by applying appropriate attributes.

This paper, then, is concerned with investigating the context in which antique statues were restored in eighteenth-century Rome, and is a plea to leave restorations intact whenever possible, to be respected as important documents of eighteenth-century taste. The recent revival of interest in what one might call the social history of excavated antiquities and their restoration and eventual display,[9] and the history and role of cast collections, suggests that today, restored statues are less at risk of dismemberment by zealots and purists than they were a decade or two ago.

We now know very much more than we used to about eighteenth-century restorers and their methods, and are no longer obliged to refer in neutral terms to 'period' restorations. The recovery of new documents has allowed the restoration of more and more statues to be given to particular artists, and from this has grown a recognition of particular workshop styles.[10] Almost without exception, antique marbles bought by the British while on the Grand Tour were restored in Rome, and were normally not even offered for sale until the dealers had had them thoroughly overhauled and refurbished by their in-house restorers. If a statue needed attention on its arrival in England, or if the purchaser decided that he wanted after all a different pose of a new arm or leg, then local

[6] Gavin Hamilton (1723-1798), the Rome-based Scottish neo-classical painter, who supplemented his income through excavations and art dealing.

[7] Bartolomeo Cavaceppi (c.1716-1799), the leading restorer in Rome in the middle two quarters of the 18th century, through whose studio passed vast numbers of statues sold on to collectors throughout Europe, but most notably in England. Cavaceppi published a three volume *Raccolta d'antiche statue....*, Rome, 1768-72, in which his principal restorations were recorded by engravings.

[8] Dallaway 1812, *op. cit.*, p. 38.

[9] Best exemplified by studies such as F. Haskell and N. Penny, *Taste and the Antique: The Lure of Classical Sculpture 1500-1900*, New Haven and London, 1981, and more recently by I. Jenkins, *op. cit.*, on the acquisition and display of sculpture in the British Museum.

[10] In Liverpool, for example, good progress is being made by a group of scholars working in collaboration with Ed Southworth of the Liverpool Museum on the Ince Blundell collection of antiquities, in identifying restorations by Cavaceppi, Piranesi and others.

sculptors were certainly available. Joseph Nollekens was the principal amongst them, and it is worth quoting some observations on his restoration technique recorded in J.T. Smith's life of Nollekens:

> His method of mending antiques was rather curious: he would mix the dust of the sort of stone he was mending, with his plaster; so that when dry, if the antiques were of Pentallic marble, the sparkling of the stone-dust in a measure disguised the joining or mended parts. Mr Roubiliac, when he had to mend a broken antique, would mix grated Gloucester cheese with his plaster, adding the grounds of porter and the yolk of an egg; which mixture, when dry, forms a very hard cement.[11]

The revival of interest in the practice and principles of eighteenth century restoration really begins in the 1950s with two remarkable pieces of research. Carlo Pietrangeli's *Scavi e Scoperte di Antichità sotto il Pontificato di Pio Sesto*, published in 1956, documented in a methodical way the process by which antique statues destined for the new Vatican sculpture galleries were restored in the final third of the eighteenth century. Then, in 1958, Seymour Howard submitted to Chicago his pioneering thesis on the restorer Bartolomeo Cavaceppi, documenting significant numbers of his restorations in English and other collections, and suggesting attributions in many instances where no documents existed. The thesis was followed by a series of influential articles in the 1960s and 1970s, and it is particularly relevant that in 1980 Garland chose to publish Howard's thesis, submitted more than twenty years earlier.[12]

The availability of this research has made the process of identifying Cavaceppi's restorations considerably easier, and his restoration of statues at Petworth, for example, is dealt with elsewhere in this volume. There were, of course, other restorers active in Rome, and many of their works are now being identified in English collections. The Petworth *Pan and Apollo* is a case in point (plates 72-73). It is known that the statue - a variation of the well-known prototypes then in the Ludovisi and Farnese collections in Rome and Naples respectively - was purchased by Lord Egremont at the Bessborough sale of 1801.[13] Nothing has been known about its earlier provenance, but documents in the papers of Charles Townley[14] prove that Townley himself had purchased it in Rome in 1768, from the studio of Pietro Pacilli (1716-73), an important though largely forgotten Roman sculptor/restorer of the third quarter of the eighteenth century. Townley had in due course re-sold it to Thomas Jenkins who then sold it to Lord Bessborough: no doubt Townley had parted with it on account of the high degree of restoration.

A particularly notable development in the contemporary revival of interest in eighteenth-century restoration concerns the changing fortunes of the *Lansdowne Hercules*, one of the finest Graeco-Roman marble sculptures in the Getty Museum (plates 85-86).[15] The story of its excavation at Hadrian's Villa in 1791, its purchase by the dealer Thomas Jenkins, and his subsequent sale of the statue to Lord Lansdowne, is too complex to dwell upon here. Lord Lansdowne was delighted

[11] J.T. Smith, *Nollekens and His Times: Comprehending a Life of that Celebrated Sculptor, and Memoirs of Several Contemporary Artists*, London, 1828, pp. 305-6.

[12] S. Howard, '*Bartolomeo Cavaceppi, Eighteenth Century Restorer*' (Garland, 1980, PhD thesis, Chicago, 1958).

[13] See esp. A. Michaels, *Ancient Marbles in Great Britain*, Cambridge, 1882, p. 603, and on the type generally Haskell & Penny, *op. cit.*, pp. 286-8. See also above, p. 183, where the statue is referred to as *Pan and Olympus*, the identification in Margaret Wyndham's plate.

[14] The Townley Papers were acquired by the British Museum in 1992.

[15] See esp. S. Howard, *The Lansdowne Herakles*, Los Angeles, 1978.

with his purchase, and in due course it became one of the most celebrated statues in the Lansdowne House Sculpture Gallery, designed by Sir Robert Smirke and completed by 1819. The Lansdowne House antiquities collection survived intact until 1930 when it was sold by Christies, and eventually the statue of Hercules was acquired by J.P. Getty. When in 1976, rusting of the internal iron rods seemed to pose a danger of splitting the marble, the Museum decided to dismantle the statue. The decision was then taken not to replace the eighteenth-century restorations, and instead the missing parts were replaced by fibreglass cast shells based upon models which were judged more appropriate. The eighteenth-century polish was removed and the restorations were discarded. One is obliged to question, however, if anything was really gained in visual and archaeological terms by this procedure. Certainly, an important phase of the statue's social history had been discarded along with the restorations.

Documents in the Townley Papers prove conclusively that Carlo Albacini, the leading sculptor-restorer in Rome in the final quarter of the eighteenth century,[16] was responsible for the restoration. (It should be noted that Seymour Howard had always suspected this might be the case though without supporting evidence). A masterpiece, therefore, by one of the eighteenth century's finest restorers seemed to have been irretrievably lost. However, ideas and taste have again changed, and the Getty has taken the enlightened decision to restore Albacini's restorations, thus allowing the statue to reflect once again the taste of the age of neo-classicism.

One could, of course, construct an ever-growing list of interesting case studies, but three, reflecting the policies of museums in Rome, Naples and Oxford, will be sufficient to demonstrate the range of possible approaches, and the difficulties presented by perceptions of authenticity and/or infelicitous restoration.

The most appropriate case study is the *Apollo Belvedere* of the Vatican (plates 87-88), precisely because in the eighteenth century it was arguably the most famous and admired work of art in the world. From the 1530s when Montorsoli applied the marble additions with which it was admired and copied, until 1924, when the restorations were removed by the Vatican Museum, visitors to the Vatican sculpture galleries saw a complete figure.[17] For four centuries visitors viewed a restored statue, and it was the restored statue which was copied on innumerable occasions, populating countless gardens and neo-Roman interiors throughout Europe. It is disappointing that today visitors to the Belvedere Courtyard of the Vatican are deprived of seeing an antiquity of remarkable interest and quality *as interpreted* by the High Renaissance, notwithstanding its place amongst the greatest concentration of High Renaissance architecture and art works in the world. What has really been achieved by the removal of the Renaissance restorations? Overall, however, the Vatican has an excellent record in preserving the mid to late eighteenth-century Museo Pio-Clementino, which contains the finest and largest collection of intact eighteenth-century restorations in any museum. These great eighteenth-century sculpture galleries, tailor-made as a repository for highly-restored marble statues, remain as the perfect expression of eighteenth-century taste for the antique (plate 89).

The same applies to the Museo Nazionale in Naples, which contains within the Farnese collection an outstanding group of restorations by Carlo Albacini. It has to be said, however, that even a restorer of Albacini's undoubted ability could make errors of judgement, and the sheer size

[16] See further, G. Vaughan, 'Albacini and his English Patrons', *Journal of the History of Collections* 3/2 (1991), 194-5 and, most recently, J. Podany, 'Restoring what wasn't there: reconsideration of the eighteenth-century restorations to the Lansdowne *Herakles* in the collection of the J. Paul Getty Museum', in A. Oddy (ed.), *Restoration: Is it acceptable?*, London, 1994 (British Museum Occasional Paper, 99), pp. 9-18.

[17] For a full discussion of the statue see Haskell and Penny, *op. cit.*, pp. 148-51.

of the commission he received from the King of Naples in 1786, to restore the entire Farnese collection prior to its removal from Rome to Naples, exhausted and overwhelmed him.

One of Albacini's most drastic restorations for Naples was the conversion of a statue of a seated *Roma* - as it had always been in Palazzo Farnese - into a beautiful but inauthentic *Apollo with the Lyre* (plate 90). But perhaps the most infelicitous restoration of all was Albacini's application of a reworked Roman head to the archaising group, reflecting the work of Kritios, then known as *The Gladiators* but today retitled *The Tyrannicides* (plate 91). The choice of so inappropriate a Roman head was extraordinary, and the Naples Museum, despite its general resolve to preserve Albacini's restorations, has felt compelled to remove it, and replace it with a more suitable cast. On both aesthetic and scholarly grounds it is difficult to do other than support this action (plate 92).

So there is already inconsistency in the point of view presented in this paper. While the Getty Museum has been criticized for replacing Albacini's restorations with casts of what it regarded as more suitable models, the Naples Museum is now applauded for a similar course of action. Quite simply, there are good restorations and bad restorations, and the worst restorations must be recognized for what they are. A notable example of the last category is the statue of a *Roman Lady* in the Ince Blundell collection in the Liverpool Museum (plate 93). The head, work of the third century AD, is in itself rather fine, but it sits incongruously upon a body reflecting Hellenistic work of the third century BC. This is not in itself a reason for detaching the two parts, and to do so would be absurd in the context of the collection of highly-restored antique marbles to which it belongs.

When faced with a similar incongruity, in the case of the statue of *Sappho* (acquired at the Hope collection sale at Deepdene in 1917) the Ashmolean Museum has opted to remove the head, and display it separately beside the body, as an independent entity (plate 94). The head is clearly of a Sappho type, but the archaising body is now displayed simply as a *Peplophorus*. As this statue does not occur in the early catalogues of the Hope collection, it has always been presumed that it came to Deepdene much later.[18] However, a document has now emerged proving that Thomas Hope himself purchased the statue in 1800 for 15 guineas at the sale in London of the collection of Lord Cawdor,[19] which means that the statue had existed in its restored form at least since the late eighteenth century. The removal of the head is on the whole regrettable, although in the context of the seventeenth-century Arundel collection surrounding it in the Randolph Gallery, which contains many other headless or fragmented statues, its appearance is not visually distracting.

Certainly, no-one would consider dismantling Piranesi's spectacular *Newdigate Candelabra* (plates 95-96), which stand in the same gallery. Constructed in the early 1770s around a group of original antique fragments excavated at Hadrian's Villa, the candelabra cannot be seen as anything more than visually impressive examples of neo-classical taste. By way of comparison, the British Museum's *Piranesi Vase* was analysed by Susan Walker (prior to its reconstruction for the 1990 *Fake?* exhibition), who concluded that around seventy per cent of the vase was entirely modern work.[20]

[18] G.B. Waywell, *The Lever and Hope Sculptures: Ancient Sculptures in the Lady Lever Art Gallery, Port Sunlight, and a Catalogue of the Ancient Sculptures Formerly in the Hope Collection, London and Deepdene*, Berlin, 1986, nos 21 and 50, at pp. 81-2, 93.

[19] 'A Catalogue of a Most Notable, Capital, and Valuable Collection of Antique Marble Statues and Bustoes....the Property of The Right Hon. Lord Cawdor...' Skinner and Dyke, 5 & 6 June 1800; lot 37 (copy annotated by Charles Townley, Townley Papers, British Museum).

[20] On the British Museum's Piranesi Vase, see esp. the entry by G. Vaughan in M. Jones (ed.), *Fake? The Art of Deception*, London, 1990 (BMP), p. 133. It is interesting to note that once in its history the BM did

It is perhaps appropriate to conclude this catalogue of mistreated eighteenth-century restorations with one of the most perplexing modern examples of amputation. For centuries the *Barberini Faun* (plate 97), in the Glyptothek in Munich since 1820, had been one of the sights of Rome, one of the most prized possessions of the Barberini family.[21] It cannot be denied that throughout its history its appearance had regularly changed, with three separate restorations recorded in the seventeenth century. The final restoration, defining the form in which it was purchased by Crown Prince Ludwig of Bavaria in 1814, was undertaken by Vincenzo Pacetti in 1799, who replaced earlier stucco restorations with a new marble thigh, leg and hanging arm. The left leg was, of course, entirely Pacetti's invention, but again it must be questioned whether the removal of Pacetti's additions (Pacetti's left leg only was subsequently replaced) is appropriate in visual and aesthetic terms, most particularly given the neo-classical setting designed for it in its restored state. It could be argued that the amputations and then partial replacement preclude a full appreciation of what one might call the statue's social history and hardly represent a satisfactory solution.

Conclusion

As an art historian with an interest in the phenomenon of restoration in the eighteenth century, and the context in which statues were displayed, admired and copied, where do I stand? It must be clear from what I have written above that, *prima facie*, I would always want to respect period restorations, and leave them intact, most especially if the restoration is of high quality and attributable to a particular restorer or workshop. If a statue continues to be displayed in an eighteenth-century setting, with other similarly restored statues, then removal should be unthinkable, even if the restoration is of mediocre quality. My view is that restorations should only be removed if they are so ludicrous, inept and unsightly as to inhibit a proper appreciation of the sculpture.

destroy an original work by Piranesi, although it was obviously unaware at the time of what it was doing. Charles Townley erected in the library at his house in Park Street Westminster a marble chimneypiece into which were set original fragments of antique marble (clearly visible in Zoffany's famous conversation piece of Townley and his friends surrounded by his collection, Towneley Hall Museum and Art Gallery, Burnley). When the Townley Marbles were removed from Townley's house to the BM after his death in 1805, the fragments were prised from the modern chimneypiece. Documents in the Townley Papers prove conclusively that the chimneypiece was by Piranesi, brought from Rome to London around 1770.

[21] On the statue and its various restorations see Haskell & Penny, *op. cit.*, pp. 202-5.

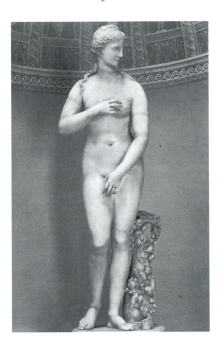

Plate 83 *The Jenkins Venus,* restored by Cavaceppi before 1765.

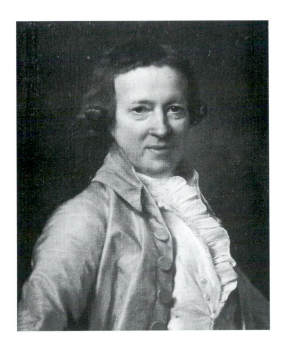

Plate 84 *Portrait of Thomas Jenkins* (1791), by Anton Maron (1733-1808).

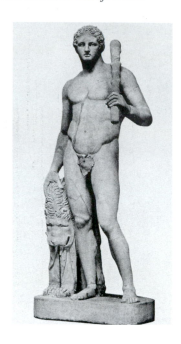

Plate 85 *The Lansdowne Hercules,* as restored by Albacini, 1791-2.

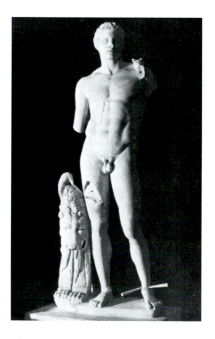

Plate 86 *The Lansdowne Hercules,* with all Albacini's restorations removed, before further conservation.

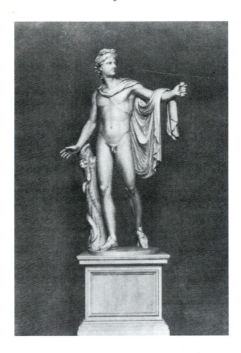

Plate 87 *The Apollo Belvedere,* as restored by Montorsoli. Engraving from G.B. Visconti, *Il Museo Pio-Clementino,* Rome, 1782, Vol. 1, pl.vii.

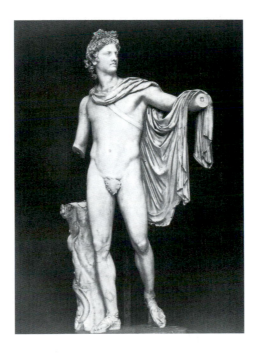

Plate 88 *Apollo Belvedere* with restorations removed.

Plate 89 *La Galleria delle Statue*, Museo Pio-Clementino, Vatican Museums, designed by Alessandro Dori, c.1770. Engraving by V. Feoli, after F. Miccinelli.

Plate 90 *Apollo with Lyre,* with modern additions by Albacini, late 1780s.

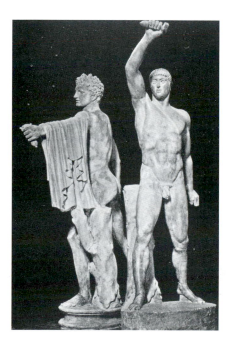

Plate 91 *The Tyrannicides,* restored as *The Gladiators* by Albacini, late 1780s. Note the inappropriate head applied to the left figure.

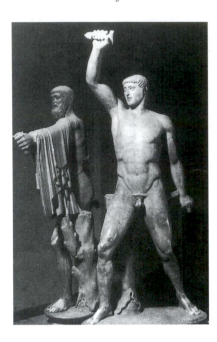

Plate 92 *The Tyrannicides,* with the Albacini head removed and replaced with a cast of an archaising head.

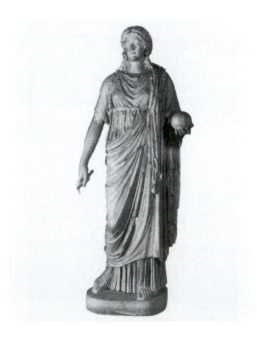

Plate 93 Roman statue of a Hellenistic type with early 3rd century head of a woman attached, restored as the muse *Urania.*

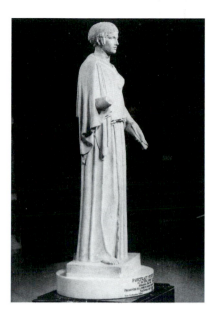

Plate 94 Statue of a *Peplophorus,* Roman copy reflecting a 5th century BC Greek original traditionally associated with Pheidias; the head (now removed) is a Roman copy of the *Sappho* type. Photographed as sold in 1917 from the Hope Collection, Deepdene; the 18th century restorations have been removed.

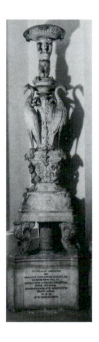

Plate 95 *The Newdigate Candelabra,* studio of Piranesi, early 1770s.

Plate 96 *The Newdigate Candelabra,* studio of Piranesi, early 1770s.

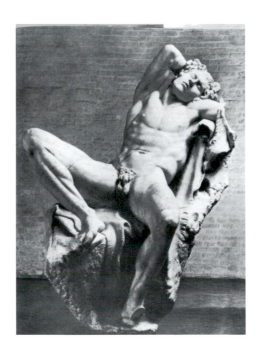

Plate 97 *The Barberini Faun,* as restored by Vincenzo Pacetti, 1799.

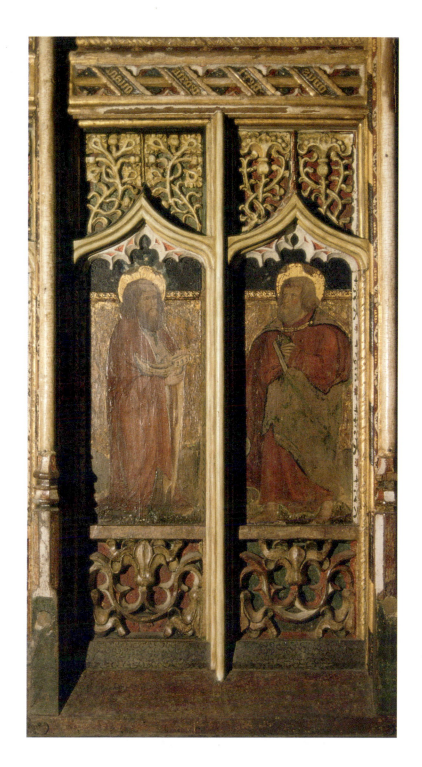

I Worstead, St Mary, Chancel Screen, *Sts. Simon and Jude.*

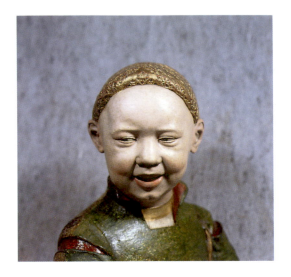

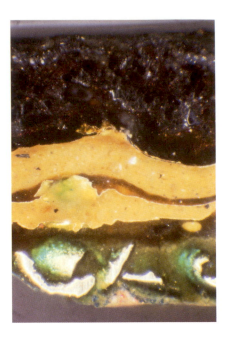

II Bust of a laughing child,
attributed to Guido Mazzoni.
Polychrome terracotta. After conservation.

III Paint cross-section of Mazzoni bust
showing the original paint layers covered by
overpaint of black and yellow priming (x175).

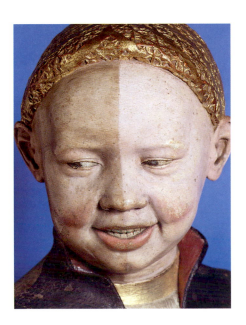

IV Mazzoni bust, showing the face half cleaned.

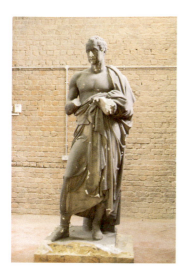

V Marble sculpture of *Huskisson* by John Gibson,
showing the heavy pollution resulting from
100 hundred years of exposure in the English climate.

VI Detail of colour plate V, showing the left-hand side of the marble
cleaned by laser and on the right-hand side the black pollution crust.

VII Cross-section of the marble surface of *Huskisson* taken under u/v light (x 100).

VIII *Taddei Tondo* by Michelangelo. Detail of Sepiolite clay poultice applied during cleaning.

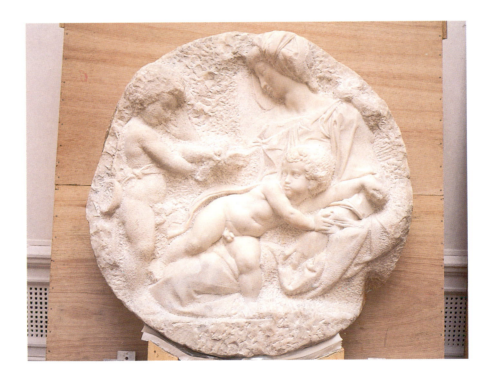

IX *Taddei Tondo* after cleaning.

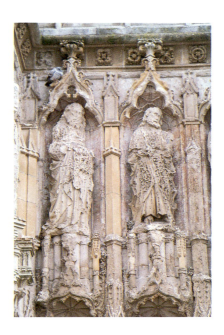

X West front of Exeter Cathedral. Detail taken in the early 1970s showing considerable traces of pigmentation remaining before they were removed or covered by restoration with lime shelter coatings.

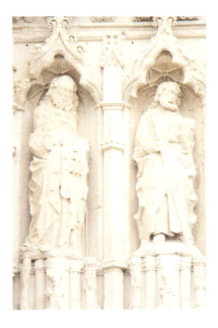

XI West front of Exeter Cathedral. Same detail as colour plate X showing the sculptures completely covered with lime and no traces of the original pigment visible.

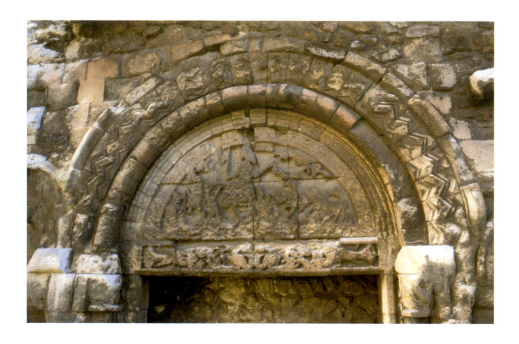

XII Rochester Cathedral: dorter doorway in 1989 before conservation.

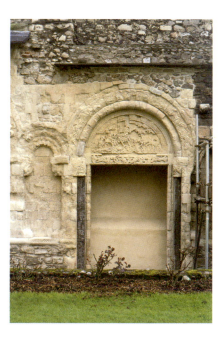

XIII Rochester Cathedral: scale drawing by John Atherton Bowen of the west elevation of the dorter doorway, illustrating incised lettering.

XIV Rochester Cathedral: dorter doorway in 1990 after conservation treatment.

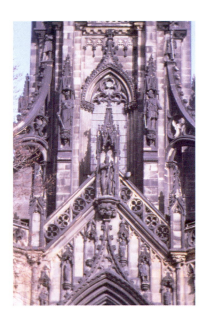

XV *Scott Monument Edinburgh;* designed by William Kemp in 1846 on death of Sir Walter Scott, poet and novelist.

XVI Detail: illustrating iron staining and salt efflorescence below parapet catchment and retention area.

XVII Detail: illustrating surface loss and exposure of Zone 4 from trapped water, salt and clay expansion behind thick abundance of sculptural detail.

XVIII Detail: illustrating area of core and panel testing.

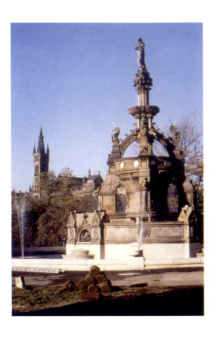

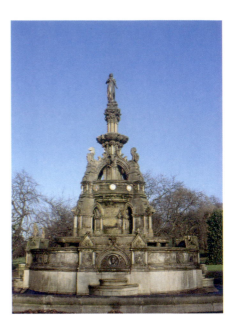

XIX *The Stewart Memorial Fountain:* immediately after cleaning, 1988, showing patchy variable clean with iron staining.

XX The fountain: three years after cleaning and a continuous water flow, 1991 (switched off for sludge removal and biociding).

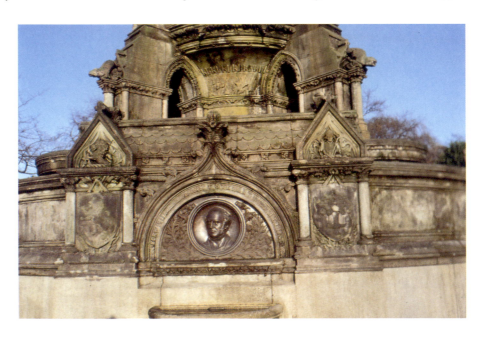

XXI Detail: long-term effects showing heavy algal growth, iron staining and etched 'marble' pillars, 1991.

XXII Detail: increased organic growth and discoloration, five years after cleaning, 1993.

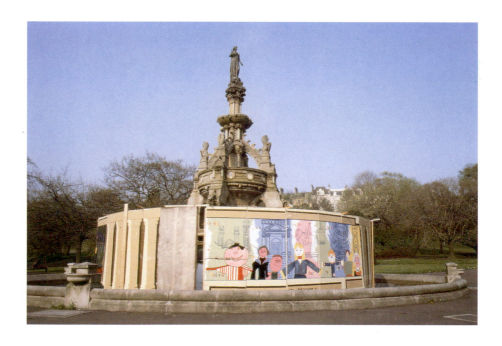

XXIII The fountain: switched off due to problems with outflow piping system and boarded up against vandalism, 1993.

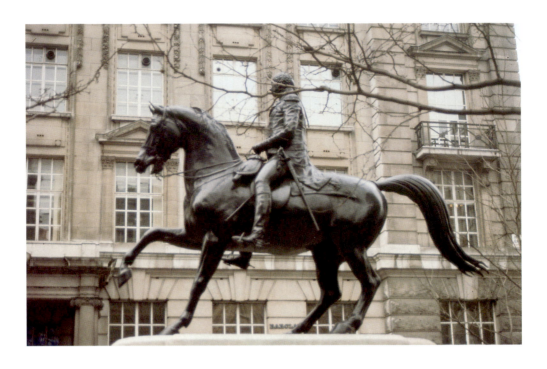

XXIV M.C. Wyatt, *George III* (1836), originally described as a 'gorgeous gold colour'.

XXV Henry Fehr, *Rescue of Andromeda* corrosion beneath wax coating.

XXVI Henry Fehr, *Rescue of Andromeda* brown colour beneath wax coating.

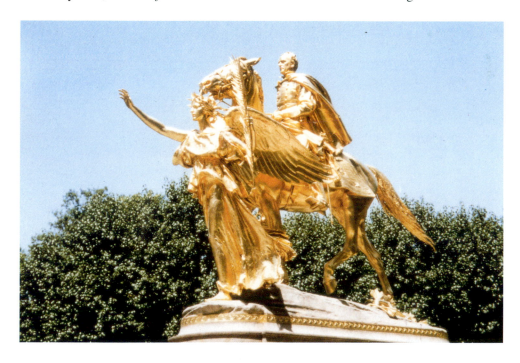

XXVII Augustus Saint-Gaudens, *General Sherman and Victory* (1903).

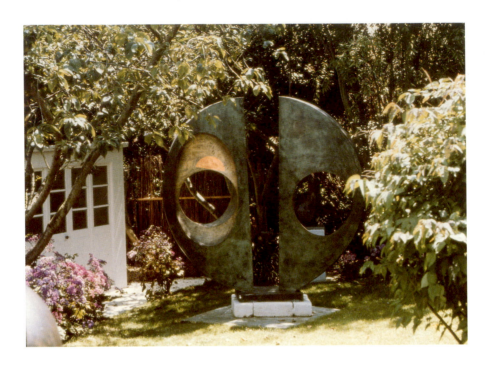

XXVIII Barbara Hepworth, *Two Forms (Divided Circle)* (1969), original polished gold interior.

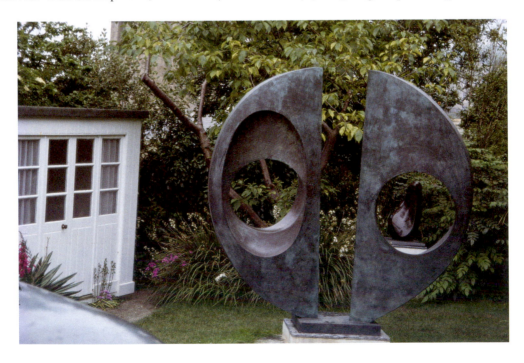

XXIX Barbara Hepworth, *Two Forms (Divided Circle)*, gold interior now mostly brown.

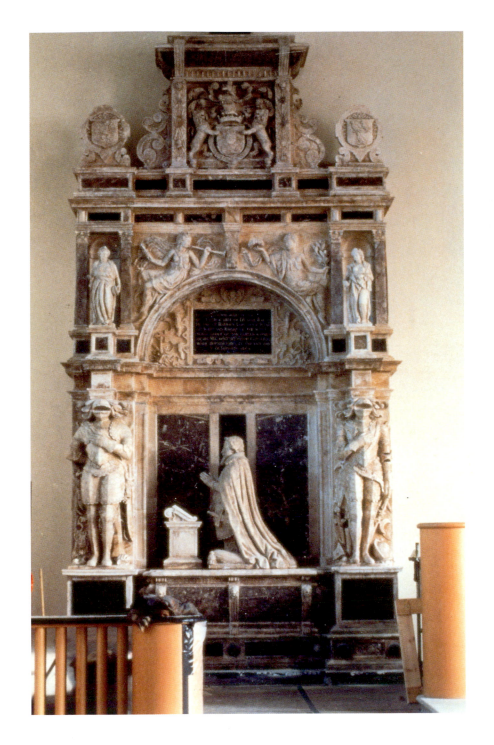

XXX Completed conservation and restoration of the *George Home* monument,
by Maximilian Colt.

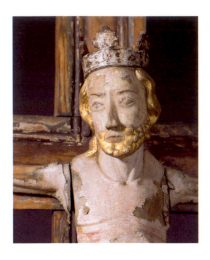

XXXI Detail of the Haug Crucifix, before recent treatment.

XXXII Detail of the Christ figure after partial treatment. The remaining secondary paint was removed mechanically with a scalpel. The treated areas are marked by a white line. The central part of the crown, the whole head apart from half the mouth, the left part of the figure's chest, the left arm and part of the cross behind it have been treated.

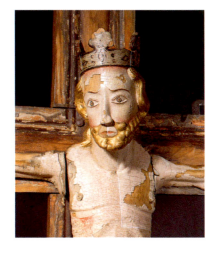

XXXIII Detail of the flesh areas, showing the stepwise pattern of damage, mainly following the network of age craquelure.

XXXIV The right eye of the Christ figure before treatment. Most of the original paint is still covered with overpaint.

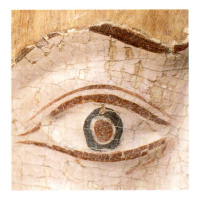

XXXV The right eye of the Christ figure after mechanical removal of the overpaint with a scalpel.

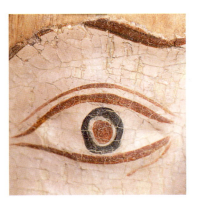

XXXVI The Christ figure's right eye after treatment.

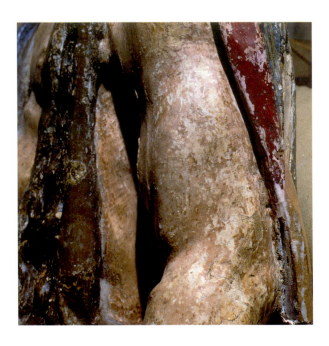

XXXVII Francesco di Giorgio, *St John the Baptist,* detail of the left arm of the figure before modern conservation (Opera del Duomo, Siena).

XXXVIII Cecco di Pietro, Polyptych of Agnano, detail of the Madonna's throne (Cassa di Risparmio, Pisa).

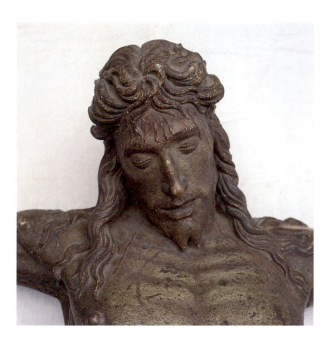

XXXIX Antonio da Sangallo, *Crucifix,* detail of the head before conservation
(San Domenico di Fiesole).

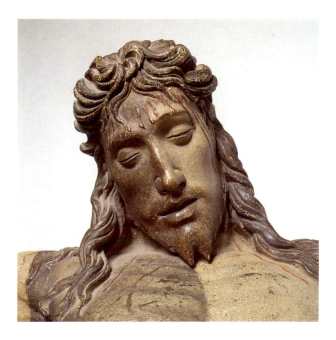

XL Antonio da Sangallo, *Crucifix,* detail of the head, half cleaned
(San Domenico di Fiesole).

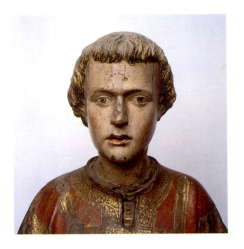

XLI Francesco di Valdambrino, *St Stephen,* detail of the head (Museo della Collegiata, Empoli).

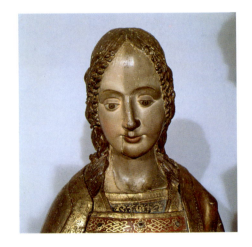

XLII Marches, late fifteenth century, *Madonna in Adoration*, detail of the head half cleaned (Museo Nazionale del Bargello, Florence).

XLIII Marches, late fifteenth century, *Madonna in Adoration*, the figure after conservation (Museo Nazionale del Bargello, Florence).

XLIV Jacopo della Quercia, *Seated Madonna,* after conservation (Museo Statale di Palazzo Taglieschi, Anghiari).

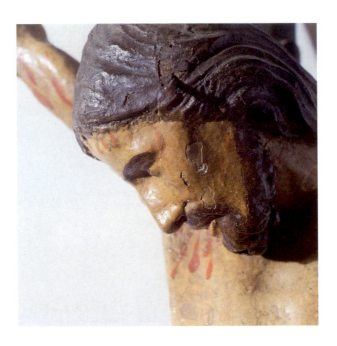

XLV Giovanni Pisano, *Crucifix,* detail of the head before conservation (Cathedral, Massa Marittima).

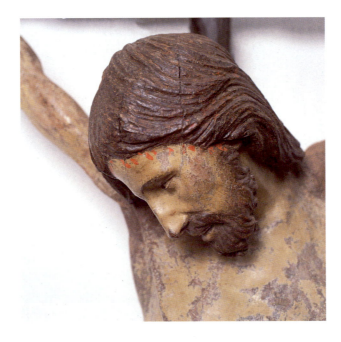

XLVI Giovanni Pisano, *Crucifix,* detail of the head after conservation (Cathedral, Massa Marittima).

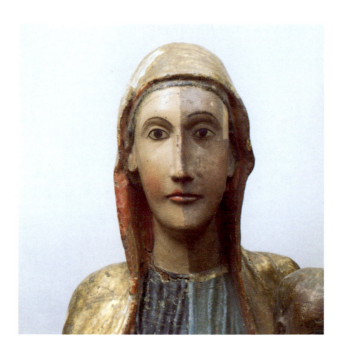

XLVII Thirteenth-century *Madonna and child*, detail of the head half cleaned (Cathedral, Arezzo).

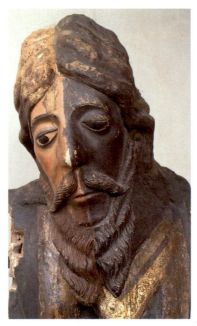

XLVIII Probably eighth century, *Volto Santo,* detail of the head half cleaned (Cathedral Sansepolcro).

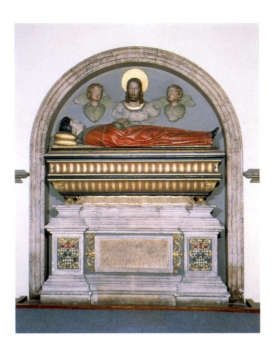

XLIX Tomb of *Dr John Yonge* (PRO), before recent conservation, showing the extent of the 1956 restoration and repainting.

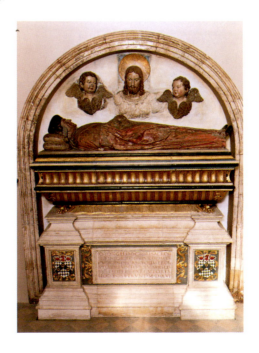

L Tomb of *Dr Yonge* after recent conservation.

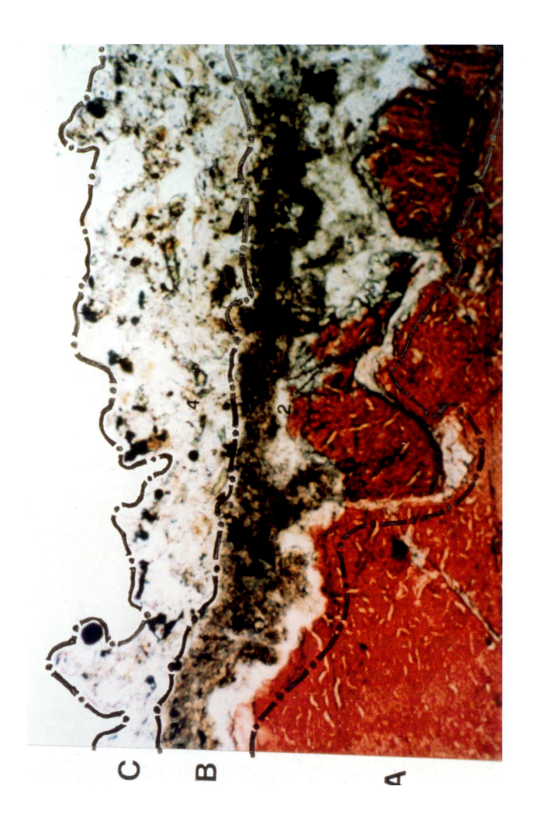

LI Duomo, Pisa, oriental marble. Stratigraphy at x200 magnification, showing three categories.

LII G. Caccini, *Holy Trinity*, S. Trinità, Florence. Detail of the marble high relief situated at the centre of the façade, before conservation.

LIII G. Caccini, *Holy Trinity*, S. Trinità, Florence. Detail of the marble high relief situated at the centre of the façade, during conservation.

LIV G. Caccini, *Holy Trinity*, S. Trinità, Florence. Detail of the marble high relief situated at the centre of the façade, during conservation.

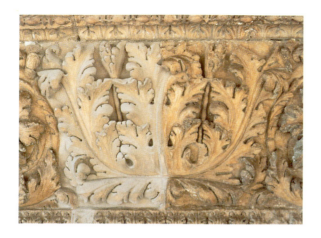

LV *S. Ranieri door*, Duomo, Pisa. Detail of the central band of the architrave, in oriental marble, during conservation.

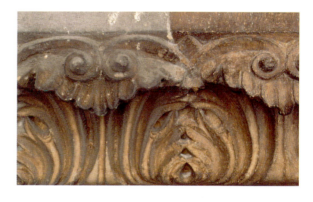

LVI *S. Ranieri door*, Duomo, Pisa. Detail of the central band of the architrave, in S. Giuliano limestone, during conservation.

LVII Stratigraphic comparison (x200 magnification) of two samples: the first, on the left, the marble high relief of the *Holy Trinity*, the second, on the right, from the marble high relief in Pisa.

LVIII Michelangelo, *Night*, New Sacristy, S. Lorenzo, Florence. Detail of left breast, after cleaning, a highly polished surfaced.

LIX Michelangelo, *Night*, New Sacristy, S. Lorenzo, Florence. Detail of right leg, during the cleaning process.

LX Michelangelo, *Duke Giuliano*. Close-up detail of the left hand, after cleaning. The type of finish of the surface is clearly visible. Viewed from a distance, it stresses and enhances the line.

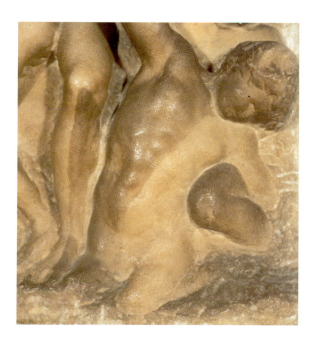

LXI Michelangelo, *Battle* relief, Casa Buonarotti collection. Detail during conservation.

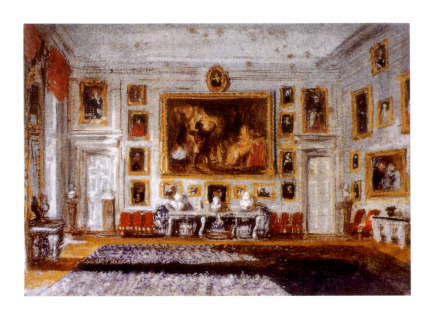

LXII Petworth House, *The Square Dining Room* by J.M.W. Turner RA, (1775-1851) c.1827. Gouache and watercolour, 14 x 19cm. The decoration, picture-hang and arrangement of sculpture and porcelain have recently been recreated.

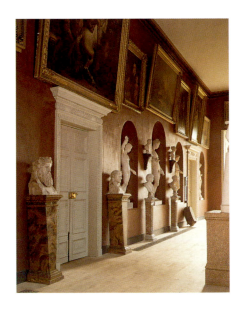

LXIII The 2nd Earl of Egremont's sculpture gallery (1754-63), the present south corridor, looking west. As at Holkham, Norfolk, there was originally a fireplace with a sculpture niche above, in place of the central door. The eighteenth-century wall-colour was grey-blue. The pictures were added by the 3rd Earl after 1824.

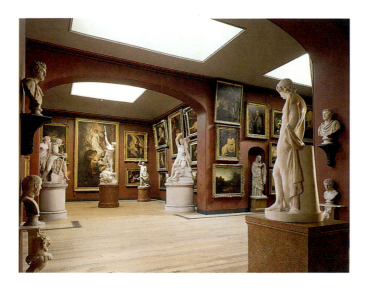

LXIV The North Gallery as extended by the 3rd Earl, 1824-27: looking towards the north bay from the south corridor. In the centre of the north bay is Flaxman's *St Michael Overcoming Satan* (1819-26) flanked by colossal groups by J.E. Carew.

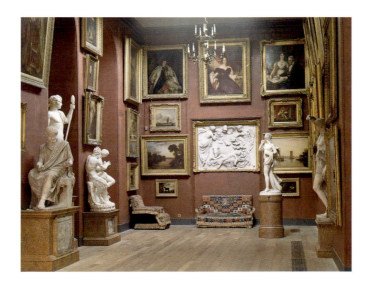

LXV The west end of the central corridor. Westmacott's newly framed relief, *The Dream of Horace* (1823) is flanked by two Turners recorded in these positions c.1839-45. The surviving patination on the *Seated Statue of a Man* (No. 15) left and the *Statue of an Amazon* (No 18) right contrasts with the two Antique statues cleaned in 1984: the *Torso restored as Dionysos* (No.14) and the *Pan and Olympus* (No. 12). Note the newly recreated porphyry decoration of the plinths (originally applied c. 1824-7). The paintwork of the left wall is c. 1870 and was uncovered intact. The facing wall was painted to match.